OXFORD CLASSICAL MONOGRAPHS

Published under the supervision of a Committee of the Faculty of Literae Humaniores in the University of Oxford

The aim of the Oxford Classical Monographs series is to publish books based on the best theses on Greek and Latin literature, ancient history, and ancient philosophy examined by the Faculty Board of Literae Humaniores.

The Fall of Troy
in Early Greek Poetry
and Art

Michael J. Anderson

CLARENDON PRESS · OXFORD
1997

Oxford University Press, Walton Street, Oxford OX2 6DP
Oxford New York
Athens Auckland Bangkok Bogota Bombay
Buenos Aires Calcutta Cape Town Dar es Salaam
Delhi Florence Hong Kong Istanbul Karachi
Kuala Lumpur Madras Madrid Melbourne
Mexico City Nairobi Paris Singapore
Taipei Tokyo Toronto
and associated companies in
Berlin Ibadan

Oxford is a trade mark of Oxford University Press

Published in the United States
by Oxford University Press Inc., New York

British Library Cataloguing in Publication Data
Data available

Library of Congress Cataloging in Publication Data
Data available

ISBN 0–19–815064–4

1 3 5 7 9 10 8 6 4 2

Typeset by Graphicraft Typesetters Ltd., Hong Kong
Printed in Great Britain on acid-free paper by
Biddles Ltd., Guildford and King's Lynn

Acknowledgements

This book originated as a doctoral thesis under the supervision of Oliver Taplin, whose extraordinary appreciation for Greek poetry and art has influenced every chapter. This project has also profited from the instructive criticism of Nicholas Richardson and Martin Robertson, who served as examiners of my Oxford thesis. Bob Connor, Christiane Sourvinou-Inwood, and Robin Osborne each read portions of the text and offered insightful suggestions. For his generous assistance with papyrological questions I owe many thanks to Peter Parsons; and I remain ever grateful to Robert Guy, who first kindled my interest in Attic vase-painting. The staff at the Oxford University Press have provided invaluable assistance in preparing the typescript for publication. Responsibility for any errors, of course, rests solely with me. A generous scholarship from the Marshall Aid Commemoration Commission allowed me to begin work on the project in Oxford, and a Mellon Fellowship from Columbia University's Society of Fellows enabled me to develop the doctoral thesis into a book. I thank the Society for the Promotion of Hellenic Studies for permitting me to reprint portions of an article I published in the 1995 volume of the *Journal of Hellenic Studies*, and I thank the following museums and organizations for allowing me to reproduce illustrations of objects in their collections: the Archaeological Receipts Fund, Athens; the Museum of Fine Arts, Boston; the Capitoline Museum, Rome; the Archaeological Museum of Ferrara; the J. Paul Getty Museum, Malibu; the Musée du Louvre, Paris; Monumenti Musei e Gallerie Pontificie, the Vatican. Finally, for their steadfast support and encouragement, I thank my family.

M.J.A.

Contents

List of Illustrations

Abbreviations and Conventions

Works of Literature

Ag.	*Agamemnon*	*Il.*	*Iliad*
Aith.	*Aithiopis*	*IP*	*Iliou Persis*
Andr.	*Andromache*	*Kyp.*	*Kypria*
Bib.	*Bibliotheke* (Apollodoros)	*MI*	*Mikra Ilias*
Cho.	*Choephoroi*	*Nost.*	*Nostoi*
Epit.	*Epitome* (Apollodoros)	*Od.*	*Odyssey*
Eum.	*Eumenides*	*Tro.*	*Troades*
Hek.	*Hekabe*		

Reference Works

ABV J. D. Beazley, *Attic Black-Figure Vase-Painters* (Oxford, 1956).

ARV J. D. Beazley, *Attic Red-Figure Vase-Painters*[2] (Oxford, 1963).

BA T. H. Carpenter, *Beazley Addenda* (Oxford, 1989).

LIMC *Lexicon Iconographicum Mythologiae Classicae*

Para. J. D. Beazley, *Paralipomena* (Oxford, 1971).

General Terms

arg.	argumentum	met.	metope
Cat. no.	Catalogue number	test.	testimonium
fr(r).	fragment(s)		

* indicates an illustration.

I usually employ the transliterated forms of Greek proper names (with k for Greek κ), rather than the Latin spellings. Where different authors spell names differently, I follow the form employed by the author under discussion.

I use 'Ilioupersis' as a general term to refer to the myth of Troy's destruction. *Iliou Persis* refers to a specific poetic narration of the Ilioupersis (e.g. the *Iliou Persis* of Stesichoros).

The principal critical editions cited in this book are: for epic, Allen

and Monro (1917, 1919, 1920, and 1920), Bernabé (1987), M. Davies (1988); for lyric, Page (1962), Page (1968), M. Davies (1991) (*post* D. L. Page), and Maehler (1975 and 1987) (*post* B. Snell); for Aischylos, Page (1972) and M. L. West (1990); for Euripides, Murray (1902, 1913, and 1913) and Diggle (1981 and 1984); for tragic fragments, Kannicht and Snell (1981), Radt (1977), and Radt (1985).

Prologue

One of the most comprehensive visual representations of the Ilioupersis to survive from antiquity is found on a small Graeco-Roman relief plaque now in the Capitoline Museum, one of a group of such plaques known collectively as the Tabulae Iliacae (Cat. no. 1*—Fig. 1).[1] Theodoros, as the artist identifies himself in an inscription, allotted approximately one-half of the tablet's figured surface to the capture of Troy, represented in the form of a walled city, viewed from a nearby elevated perspective.[2] The walls outline a roughly square area, within which the artist has distributed several familiar components of the myth among three horizontal registers, each demarcated by a significant architectural element. The trapezoidal precinct of Athena, framed by a three-sided colonnade embracing the goddess's temple within, forms the uppermost of the three registers. Here stands the wooden horse, and directly in front of the temple Aias attacks the Trojan princess Kassandra. The middle register is defined by the royal palace and two flanking temples. In the courtyard of the palace King Priam sits in supplication at the altar of Zeus, under attack from Neoptolemos, and to the right of the palace Menelaos recovers his wife Helen at the temple of Aphrodite. The lower register of the city consists of an open area dominated by the massive Skaian gates. Among the figures here we find Akamas and Demophon rescuing their grandmother

[1] For a comprehensive discussion of the Tabulae, their date and manufacture, see Sadurska (1964). For discussion of the literary and iconographic sources of the Ilioupersis scenes on the Tabulae see Horsfall (1979).

[2] An inscription on the plaque claims that the artist based his representation on the *Iliou Persis* of Stesichoros, an epic-like poem in lyric verse probably composed in the early 6th c. The true degree of kinship between the poem and the plaque, however, may be only slight. The plaque seems less a specific illustration of Stesichoros' poem than a collection of traditional Ilioupersis scenes as recounted in various sources. In fact, Horsfall (1979) 43, doubting that Theodoros had any direct knowledge of Stesichoros' poem, writes that 'to cite the more obscure Stesichorus in place of the conventional Arctinus as the author of an *Iliou Persis* was but to score a good point'. For further discussion of the relationship between the plaque and the poetic accounts of Troy's fall, see Horsfall (pp. 35–43). On Theodoros see ibid. 27 and Sadurska (1964) 9–10.

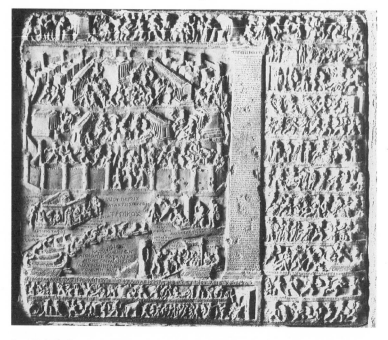

1. Relief plaque, Cat. no. 1. Scenes of the Trojan War. (By courtesy of Roma, Musei Capitolini.)

Aithra, and in the gateway itself is Aineias, accompanied by his son and father, all escaping from the destruction behind them. Just outside the gates of the city lie the tomb of Hektor, where the Trojan captives await the impending voyage to Greece, and the tomb of Achilles, where Neoptolemos slaughters the Trojan princess Polyxene. At the bottom of the tableau the ships of the Achaians lie along the shoreline, and Aineias embarks together with fellow Trojan survivors on a journey to the West.

Other sections of the tablet feature chapters from the *Iliad* and from two lost epic poems, the *Aithiopis* and the *Mikra Ilias*. Theodoros depicted these scenes individually within small, rectangular panels arranged in rows and columns—in comic-strip fashion—along the four sides of the plaque,[3] thereby surrounding the walled city of Troy

[3] Although the left column of illustrations is missing, the subject-matter of the entire plaque is recorded by an inscription in the central panel.

with a sequence of events leading to its ultimate capture.[4] Similar arrangements are found on several of the Tabulae Iliacae, the sack of Troy occupying the centre while scenes of the *Iliad* and other poems are distributed along the periphery.[5] One of the tablets shows the Ilioupersis surrounded on three sides with illustrations of the *Iliad* and below with illustrations of the *Odyssey*, with events which precede and events which follow the capture.[6]

These examples of narrative mapping, though beyond the chronological boundaries of the present study, provide us with a comprehensive model for the Ilioupersis myth as it emerged in the art and poetry of the Archaic and early Classical periods. The myth consists in essence of a cluster of elements and episodes, among them the wooden horse, the attack on Kassandra, the murder of Priam. The Tabulae Iliacae neatly combine these components, linking them with one another through the physical architecture of the city. This cluster of episodes, in turn, lies at a pivotal point within a much larger story. Ten years of war between Greeks and Trojans reach a climax in this final act of conquest, while at the same time the conquest serves also as the point of departure for several tales of wandering and misfortune—ten years of wandering, in fact, in the case of Odysseus. The geometric centrality of the Ilioupersis within the Tabulae reflects the narrative and thematic centrality of the Ilioupersis within the myth of Troy as a whole.[7]

Individual documents of the Archaic period rarely offer us views of the saga so comprehensive as those of the Tabulae. The Athenian tragedians served their audiences only thin slices of the larger tale. Early artists captured moments of the Trojan saga, freezing limited groups of notable characters into easily recognizable icons. And the more successful of the monumental epics of Troy devote themselves to a particular character and to that character's particularly momentous experiences. Though formally distinct, however, each of these compositional units involved both composer and audience in a process of

[4] Cf. Horsfall (1979) 37.

[5] See Sadurska (1964) 15 for a list of the tablets and their subjects. Approximately seven of those listed feature(d) representations of the Ilioupersis.

[6] This plaque is now lost, but a detailed drawing made in the 19th c. preserves the composition; see Sadurska (1964) 48 and Horsfall (1979) 36. See also Kossatz-Deissmann (1981) p. 112, no. 459 for a reproduction of the drawing.

[7] Horsfall (1979) 37 analyses the geometric arrangement of the Capitoline plaque similarly and identifies the departure of Aineias as the central point within the cycle or κύκλος of surrounding events.

negotiation with a larger complex of Trojan myth. Understood collect-
ively, Trojan narratives form a kind of ideal Tabula Iliaca, a gradually
evolving body of myth and legend, shaped but not fixed by tradition,
sufficiently malleable to accommodate imaginative expansion, suffi-
ciently rigid to resist radical re-formation. New Trojan narratives ac-
knowledged this imaginary tabula and adhered to its plots, characters,
and themes, while they also recast and reconfigured the pre-established
features of the map in attempts to open, enlarge, and stabilize their
own niches in the tablet. The poets and artists who treated the Trojan
myth worked within this system while simultaneously expanding it
and enhancing the significance of its many elements.

In this book I attempt to demonstrate that, as on the Capitoline
plaque, the Ilioupersis occupies a prominent and central space also
on the abstract Tabula Iliaca of the Trojan saga. I outline the nar-
rative architecture holding the Ilioupersis episodes in place next to
one another and bracing this cluster at the hub of the surrounding
episodes of war and nostos. Rather than simply asking, for example,
how a character acts at the Ilioupersis, I ask how a character's action
at the Ilioupersis complements that of another character, and how
it reflects or anticipates action elsewhere in the saga. How do the
assorted episodes, the assorted narrative pieces of Troy's fall, comple-
ment one another, and how do they reflect and unify the wider story
of Troy? In terms of composition, when telling and retelling stories of
Troy, what formal means did poets and artists employ to shape and
arrange the narrative pieces into a coherent myth?

The first part of the book scans the *Iliad*, the *Odyssey*, and the sur-
viving fragments of lost Trojan epics for allusions to the Ilioupersis,
for the recurrence of themes closely associated with the Ilioupersis, and
the replication of narrative patterns distinctive to the Ilioupersis.
The survey shows that, under the influence of the epic poets, the
Trojan saga was not merely a constellation of nearby episodes, but
a dynamic system of interactive narrative parts with the fall of the
city at its gravitational core. In the second part of the book I observe
images of the Ilioupersis in three fifth-century tragedies, again with
an eye to the structural coherence of the ideal Tabula Iliaca. In his
Troades Euripides confronts the Ilioupersis directly, attempting to
capture and conglomerate within a single drama the excess of suf-
fering unleashed by the fall of the city. Aischylos' *Agamemnon* and
Euripides' *Andromache* view Troy instead from an oblique perspect-
ive. The capture of the city rests on the horizon, a recent conquest in

a distant land, but both dramatists reflect repeatedly upon that monumental past event and incorporate it uncomfortably into the present, invoking the fall of Troy as a model for the subsequent downfalls of Agamemnon and Neoptolemos in Greece. Early Greek art, the subject of the third part of the book, traditionally isolated mythic events from one another within iconic frames and would therefore seem to discourage the comprehensive manner of investigation pursued here. Nevertheless, several artists of the Archaic and early Classical periods look beyond the boundaries of the individual icons by combining two or more Ilioupersis episodes within the same work, or by juxtaposing Ilioupersis images with Trojan episodes external to the sack. In analysing such works, I hope to demonstrate how artfully the storytellers of early Greece, both poets and painters, shaped the events of the Ilioupersis in relation to one another, and how deeply they rooted these events within the larger saga of Troy.

PART I

The Ilioupersis as Focal Point within the Trojan Saga

Introduction

Two remarkably similar human sacrifices are recorded within the Trojan epic poems. Before setting sail from Aulis, the Achaian army sacrifices Iphigeneia to Artemis, and after conquering Troy, they sacrifice Polyxene to the shade of Achilles.[1] The victim in each case is the daughter of a commander: Iphigeneia is a child of Agamemnon, most powerful of the Achaian chieftains, and Polyxene is a daughter of Priam, king of Troy. Achilles plays a part in both sacrifices: Iphigeneia is lured to Aulis upon the pretext of marriage with the hero, and Polyxene is sacrificed upon his tomb to serve as his concubine in death. Furthermore, each sacrifice is performed as a prerequisite to the departure of the Achaian fleet: they must sacrifice Iphigeneia in order to sail to Troy, and they must sacrifice Polyxene in order to sail home. Finally, the two sacrifices stand at complementary positions within the saga: the sacrifice of Iphigeneia comes at the beginning of the war, that of Polyxene at the war's conclusion.

Such events may be termed 'correlative'. The high degree of correspondence between the two episodes indicates more than mere coincidental likeness, and more than repeated borrowing from a common pool of mythological motifs. Although we cannot determine whether one story provided the epic poets with the model or the inspiration for the other, the multiple parallels suggest that the development of the two episodes has been subject to mutual influence. The similarities reflect poetic interaction between the episodes themselves, a borrowing or an exchange of motifs which took place as the stories were retold and the saga evolved. The resulting correlation bestows upon the saga as a whole a sense of structural unity, as the frame of maiden sacrifices neatly encompasses the war within.

In the following pages I identify and analyse several such correlations between episodes of the Ilioupersis myth and other segments of

[1] For the relevant sources see the more detailed discussion of these episodes below in § 3.3.

the Trojan saga as represented in the early epic poetry of the Greeks. Such a project might in some respects resemble comparative mythological studies which attempt to recognize similar patterns among myths of different civilizations and thereby explore the migration, continuity, and development of myth across land and time. The present study, however, looks at a more tightly framed and internally coherent body of mythic material, in which a few particularized types of correlation may be more closely traced. Instead of exploring correlations between myths of neighbouring societies, it observes the interaction of poets working within a relatively unified culture, within a relatively harmonious artistic tradition, and within a network of myths united by the common element of Troy. The early Greek epic poems of Troy, as the physical embodiment of an evolving mythic and poetic tradition, form a kind of laboratory in which we can observe the interaction of myths by studying the overlapping and reduplication of narrative motifs and patterns, an oral equivalent of intertextuality. To structure a study in this manner, around the more abstract relationships between myth and myth rather than around relationships between myth and history, or myth and religion, involves risking a loss of immediate social relevance. Yet in observing interaction within the body of myth, we come to recognize more readily the ideas and images which most captivated the minds of the poets and which, we might then argue, were of greatest interest to the society in which the myths developed.

This type of appoach to the early Greek epic is by no means revolutionary; nor should the specific tools employed, to be discussed below, strike students of the epic as particularly innovative. But the project does depart from the mainstream of previous scholarship in at least one significant respect. In choosing the Ilioupersis episodes as the starting-point for analysis, it shifts the focus away from the traditions embodied in the *Iliad* and the *Odyssey*, which for obvious practical reasons have generally served as fundamental bases for studies of the early epic.[2] It is only natural, given the existence of these two monumental poems, that we look upon the larger story of Troy primarily from the perspective of these two poems, and in turn that the wider saga be studied as a means of enhancing our understanding of

[2] Welcker, Monro, Wilamowitz, Bethe, and Kullmann, to name a few, have contributed much to scholarship on the Ilioupersis. None, however, has made a comprehensive assessment of the interrelationships between the Ilioupersis and the rest of the saga.

these two songs. But from the theoretical perspective outlined in the general introduction to this book, the Ilioupersis myth, as perhaps the most deeply interconnected and narratologically significant of all chapters in the Trojan saga, provides an ideal focal point for analysis of epic myth-making.[3] And the surviving evidence for this tradition, though hardly so abundant as the poetry of the *Iliad* and the *Odyssey*, is nevertheless sufficient to allow this approach.

While I will occasionally call upon other Archaic and later poets as witnesses, the primary source to be considered here is the corpus of epic poetry which treated the war against Troy.[4] Out of the vast repertoire of Trojan myth once narrated among the early epic bards, eight poems survived in written form into the Classical and Hellenistic periods: *Kypria, Iliad, Aithiopis, Mikra Ilias, Iliou Persis, Nostoi, Odyssey,* and *Telegoneia.*[5] While the *Iliad* and *Odyssey* continued to be read widely throughout antiquity, the six other poems gradually drifted into obscurity, and today only fragments survive.[6] Herodotos and Aristotle are the earliest authors to preserve details of the poems, but the majority of fragments come from later periods, many from the scholia of the *Iliad* and the *Odyssey*. A few features of the *Mikra Ilias* have been recorded by Pausanias (10. 25–7), who compares Polygnotos' famed painting of the Ilioupersis in Delphi with the account narrated in the lost epic poem (*MI* frr. 10–15, 17, 18, 20, and 22). The mythographic *Epitome* of Apollodoros offers a concise

[3] Part of the greatness of the *Iliad*, of course, lies precisely in the fact that, while the poem's plot does not naturally lie at the narrative focal point of the saga, while it does not actually recount the traditional climax of the Trojan story, or even of the Achilles story, nevertheless the poem draws these events into itself. Achilles' death is prefigured and pre-enacted in the death of Patroklos, and the fall of the city is prefigured in the fall of Hektor.

[4] Also of use as potential sources for the early myth are Stesichoros' *Iliou Persis*, Euripides' *Hekabe* and *Troades*, Vergil's *Aeneid*, and the late epic poems of Tryphiodoros (3rd or 4th c. AD) and Quintus Smyrnaeus (4th c. AD).

[5] The fragments of the lost poems have recently been edited by Bernabé (1987) and by M. Davies (1988). Since Bernabé's edition contains an extensive apparatus of mythological references, it has proved the more useful to my research, and I cite from Bernabé throughout. A *comparatio numerorum* for relevant fragments printed by Davies is provided in the Appendix. See Bernabé, pp. xx–xxi for a list of previous editions. For discussion of the contents of the poems see M. Davies (1989*b*), Huxley (1969) 123–73, and Monro (1901) 340–84. For a comprehensive survey of early versions of the Ilioupersis myth see Gantz (1993) 646–59.

[6] Here is not the place to defend or attack the relative poetic qualities of the various epics. For arguments in favour of the aesthetic superiority of the *Iliad* and *Odyssey* see the provocative article of Griffin (1977) on the 'uniqueness' of Homer. Nagy (1992) 29 offers a more cautious assessment.

survey of the entire story of Troy as it might have appeared in the epic poems, but in many details Apollodoros appears to have drawn his material from various traditions, early Greek epic being only one of many.

The single most important source for the lost poems is a series of summaries recorded under the name of Proklos.[7] As epitomized by Proklos, the poems form a complete and continuous narrative of the Trojan War from beginning to end, a unity referred to in antiquity as the 'epic cycle'.[8] Proklos' summary of the *Kypria* includes an account of the marriage of Peleus and Thetis, the abduction of Helen, and the first nine years of the war. The *Kypria* summary ends at the point in the story where the *Iliad* begins, and where the *Iliad* ends, the *Aithiopis* summary begins. *Aithiopis* is followed by *Mikra Ilias*, and so forth, until the narrative reaches the death of Odysseus in the *Telegoneia*.

This image of the poems as instalments in a single, continuous story, while true to the spirit of the saga, is not a pure reflection of the poems themselves. Although Proklos' summary of the *Mikra Ilias*, for example, ends at the eve of the sack, Aristotle and Pausanias inform us, in contrast, that the poem included an account of the sack. In other words, the poem did not end where Proklos' summary ends, and we must conclude that the narrative span of the *Mikra Ilias* was wider than that epitomized by Proklos. Likewise, the *Iliou Persis* may have begun at a point earlier than that indicated in the summary. The purpose of the summaries was not only to outline the poems themselves, but also to present a continuous narrative, and in the process the integrity of the poems was not fully maintained. While Proklos' summaries are, I believe, generally precise and highly valuable representations of the poems, neither they nor the other sources are infallible.[9]

[7] This Proklos is thought to be the Neoplatonic philosopher of the 5th c., although some have preferred to identify the author with a 2nd-c. figure. Bernabé (1987) prints Proklos' summaries together with the fragments of each poem. In citing or referring to the summaries I follow the line-numbering as printed by Bernabé. Thus '*Kyp*. arg. 1–2' is equivalent to 'lines 1–2 of Proklos' *Kypria* summary as printed by Bernabé'.

[8] Monro (1901) 341 understands the 'epic cycle' to be a collection of epic material: not just prose summaries, but actual poems stitched together. Alternatively, the 'cycle' might have meant no more than a collection of summaries, and not the poetry *per se*. Nagy (1992) 37 discusses the possible meaning of the term 'cycle'.

[9] We may suspect further tampering elsewhere in the summaries. The most notorious example involves a disagreement between Herodotos and Proklos over a detail of the *Kypria*. At *Il*. 6. 288–92 it is recorded that Paris, after abducting Helen, stopped in Sidon before returning with her to Troy. Herodotos, 2. 117 (*Kyp*. test. 4 and fr. 14)

Although ancient scholars attributed each of the poems to specific poets, I avoid designating them with the names of authors, both because there are serious doubts about the truth of the authorship testimonia, and because I prefer to emphasize the collective authorship of the myths which the poems represent.[10] A single epic genius whom we call Homer may have constructed and composed the *Iliad*, but that same genius, even if he once sang every word of the text now transmitted, was neither the sole creator of the poetry nor the sole sculptor of the myth presented within the poem.[11] Much of the myth in the *Iliad*, like the poem's language, is the product of poetic evolution conducted over generations through repeated oral performance, and the same is true for the other Trojan epics.[12] The authorship of the final, written generation of epic poetry presents an intriguing subject of study, as does the very development of the concept of individual authorship. But the present study must forgo preoccupation with authorship so as not to cloud the analysis of the traditions, the products of untold generations of nameless singers.

The subject of chronology poses similar dangers. If we picture the *Iliad* and the *Mikra Ilias* simply as poems conceived and written down at a specific point in time, the first earlier than the second, then we cannot reasonably speak of the influence of the second on the composition or contents of the first.[13] But turning to the traditions accumulated in the poems, and accepting the premiss that many of the

contrasts this passage with the account of the *Kypria*, in which, says Herodotos, Paris sails with Helen directly to Troy. Proklos' summary of the *Kypria*, in direct contradiction of Herodotos, includes the stop in Sidon. It is unlikely that Herodotos is confused, and we should assume rather that Herodotos knew another version of the poem, or that an epitomizer has added the detail to the summary of the *Kypria*, in order to harmonize this poem with *Iliad* 6.

[10] While some ancient scholars maintained that the cyclic poems were the work of Homer, others attributed them to a range of nebulous authors. Traces of the dispute can be witnessed already in Herodotos (2. 117 = *Kyp*. test. 4 and fr. 14). Wilamowitz-Moellendorf (1884) 344–52 and 370–1 argues persuasively against the validity of the authorship testimonia.

[11] For a recent comprehensive assessment of Homer's shaping of the *Iliad* see Taplin (1992).

[12] In the *Kypria* and the *Mikra Ilias*, both of which narrated large segments of the war, several traditional tales have been collected and compiled into single epics. Aristotle, *Poetics* 1459ᵃ comments on the composite nature of these poems. Bethe (1922) 284–5 offers a compelling description of the process of coalition. The *Nostoi* seems also to have been a composite poem.

[13] The poems all reached their final form before the 5th c. BC. See M. Davies (1989a) for a review of the major arguments regarding the dating of the cyclic poems.

traditions in the *Mikra Ilias* evolved contemporaneously with the *Iliad* tradition, we can indeed discuss the possibility that *Mikra Ilias* traditions influenced *Iliad* traditions. Here, however, the potential chronological debates multiply. In cases of correlative myths, we may want to determine which myth influenced which, or which elements of which myth influenced which elements of another, and which originated first. Such mapping of a mythic ancestry, in the absence of substantive written evidence, is far more hazardous than the charting of a manuscript stemma. As with questions of authorship, the chronological complexities of the evolving saga can ultimately be answered only with extreme speculation and will therefore remain secondary concerns in the present study.[14] While questions of primacy will occasionally arise, of primary importance will be the compositional dialogue itself, the nature of the correlations among the mythopoetic traditions.

To analyse correlations within this body of epic material I rely upon observation of three principal poetic phenomena, which often occur in conjunction with one another. The first may be termed narrative continuity. While any Trojan tale, in so far as it relates to Troy, automatically shares an affinity with every other Trojan tale, certain episodes exhibit particularly tight narrative ties with one another. Such ties are often rooted in the notion of cause and effect, as is the case with the deaths of Patroklos and Hektor in the *Iliad*. The earlier event is part of a narrative sequence reaching a climax in the death of Hektor, and when traced beyond the bounds of the *Iliad*, the sequence leads also to the death of Achilles. Even events years apart in a narrative sequence can exhibit immediate narrative consistency. Menelaos' ultimate retrieval of Helen from Troy, for example, provides the long-awaited answer to her original abduction at the hands of Paris.

A second criterion useful in determining correlation is structural or compositional similarity.[15] If a similar action or a series of similar

[14] Like the present work, Fehling's recent analyses of the structure and evolution of the Trojan story (1989 and 1991) consider the Ilioupersis as a primary force of cohesion. But whereas he views the penetration of the god-built, invincible walls as the original foundation-stone of the entire mythic structure and traces the development of the story from there, my less historically oriented investigation distributes its attention among the many components of the Ilioupersis without pinpointing origins or original principles.

[15] Here my methods are similar to those of the school of neo-analysis, also termed 'motivgeschichtliche Analysierung', on which see especially Kullmann (1991) and

actions is performed in two episodes, we may identify an analogical link between these episodes. Such structural reflections are a natural product of oral composition, since the singing story-tellers would frequently draw narrative material from a common pool of motifs, just as they would draw poetic language from a common pool of verbal formulas. Traditional motifs—the steps involved in arming, for example, the various ways of fighting and slaying, and the steps involved in sacrifice—were employed as poetic building blocks to expand and enhance a performance.[16] At times, however, shared motifs can indicate a more direct correlation between two episodes: when, for example, a series of motifs is exclusive to only two episodes, when the episodes involve the same cast of characters, or when they also exhibit some narrative affinity with each other. If two episodes stand linked in a narrative relationship of cause and effect, and if these two episodes also share a complex compositional pattern, the likeness probably stems from more than coincidental selection of motifs. It is not by chance alone that the death of Patroklos and the death of Achilles resemble one another. In such cases, one of the episodes may have been created in direct imitation of the other, or they may have been subject to mutual influence, assimilated to one another by repeated exchange of motifs between them. Such controlled replication is a fundamental principle in the growth of epic poetry and in the poetic evolution of myth itself.[17]

Edwards (1991) 15–19. Kullmann (1960) explores many of the correlations between the *Iliad* and other segments of the saga. The present thesis applies similar critical techniques to the saga, but from the central perspective of the Ilioupersis. Basic to the research of neo-analysis is attention to actions—in a grammatical sense, to the verbs of the narrative—an interest associated particularly with V. Propp and his work on the folktale. Unlike Propp, however, who sought a universal sequence of actions fundamental to the body of material he analysed, neo-analytical studies look for particularized sequences of action occurring in limited numbers, attempting thereby to establish specific correlations between two or more episodes. While the neo-analytical concept of motif remains grounded in the concept of action or verb, also incorporated into the determination of specificity are subjects, adjectives, and adverbs.

[16] Fenik (1968) offers a detailed analysis of this compositional phenomenon. In that it seeks typical motif sequences based on actions not specific to characters, Fenik's work shares closer affinities with the work of V. Propp than do neo-analytical studies.

[17] I do not mean to equate myth with poetry. As Graf (1993) 2 writes of myth, 'It transcends the text: it is the subject matter, a plot fixed in broad outline and with characters no less fixed, which the individual poet is free to alter only within limits.' Nevertheless, it must be recognized that the poets, while they did not have a monopoly on myth, were one of the most powerful forces not only in the transmission, but also in the shaping and even the creation of myth in the Archaic and Classical periods. In discussing the relationship between myth and epic poetry, Graf (pp. 57–68) points

To recognize narrative continuity requires knowledge of the plots of the myths, and Proklos' summaries and similar bodies of evidence will provide sufficient information to establish many cases of cause and effect. Since compositional analogies too can often be detected merely by observation of detailed plot outlines, here again our study is not heavily impeded by the loss of the poetry itself. When available, however, the words of the poets allow us to probe more delicately the processes whereby compositional analogies developed. Looking at the poetry directly, we can ask whether and to what extent the poets themselves comprehended this business of reduplicating motifs: whether they simply reproduced motifs as building blocks for the moment, a means of lengthening the present song, or whether in some cases they recognized the specific correlations they were producing and exploited the correlations for emotional and aesthetic purposes. Between the major exploits of Achilles and those of his son Neoptolemos exist several intricate narrative analogies, easily discernible in Proklos' summaries. A poet, however, by drawing attention to the relationship between father and son, merely by designating the son with his patronymic in a particular context, can amplify the underlying correlations and might utilize those correlations to generate intense emotion or bitter irony.

The third phenomenon to be considered is allusion, reference within one episode of the saga to another moment or episode, and unlike the first two categories of observation, the third depends in all but a few cases on the availability of poetry, and not just knowledge of plot.[18] While capable of fulfilling many poetic functions, in terms of mythic correlation, allusion is a poet's means of stitching two episodes together, of comparing and contrasting one episode with another, and of expanding the present moment by opening a window onto a wider

out how poets reshaped the narratives of myth for narrative purposes, but he seems also to suggest that a reshaped version is a step further removed from the essence of the myth itself. This view is useful when we approach myth for archaeological purposes, when we attempt to sift through the layers of poetic accretion in search of the fragments of a primal Indo-European belief system. But the distinction between myth and its poetic vehicle in the Archaic period cannot be so sharply defined. The poetic mutation, once popularized and—to borrow a concept from Nagy (1992)—diffused, becomes part of the mythic tradition.

[18] I will occasionally make use of the narratological terminology promoted by de Jong (1989), who designates future and past allusion with the terms 'prolepsis' and 'analepsis', and distinguishes also between 'internal' and 'external' allusions according to whether they refer to points within or beyond the present poem.

narrative. Allusions may be explicit or implicit; intensity and specificity may vary. Extended allusions sometimes become narratives in their own right, secondary narratives delivered by characters within the primary narrative of the poet. When in *Iliad* 2, for example, Odysseus recalls the divine omen given to the fleet at Aulis, the allusion grows into a short tale. In such cases poets are not averse to manipulating or enhancing traditional elements of the tale to suit the present narrative context. Thus, in addition to Ilioupersis traditions developed in poetry which took the fall of Troy as its primary subject for narration, we may find Ilioupersis traditions developed or reconfigured within and under the influence of other narrative contexts.

In organizing the discussion, I have attempted to treat relevant events of the Ilioupersis both thematically and in the order in which they occur in the general narrative of the myth, beginning with the wooden horse. The result is a four-part discussion, the first three parts of which cohere internally as essays on deception (Ch. 1), family structures (Chs. 2–4), and nostos or retribution (Ch. 5). The fourth section moves beyond the previously defined boundaries of the Trojan saga to explore correlations with Spartan myths and with the Herakles saga (Ch. 6). In addition, while concentrating on those episodes of the Ilioupersis which exhibit the strongest correlations to non-Ilioupersis episodes, I have not attempted to analyse every known detail of the Ilioupersis tradition.

1

The Wooden Horse

1.1 The Wooden Horse and the Palladion

The tale of the wooden horse, at once one of the most renowned and most enigmatic elements of the Trojan tradition, finds remarkable narrative complements in two earlier episodes of the saga.[1] Although insufficient for unravelling the mysteries of the cultural and poetic origins of this unusual creature, analysis of its relationship with the two correlative episodes can illuminate how the poets understood the statue and defined its function within the saga.[2]

The first of these correlative episodes, the theft of the Palladion, was narrated in the *Mikra Ilias* (*MI* arg. 17–18) and is conveniently summarized by Apollodoros. When compelled to reveal the secrets protecting Troy from destruction, the prophet Helenos informs the Achaians that they must retrieve from the city the Palladion, the holy image of Athena, since Troy will never fall while this statue remains within (τούτου γὰρ ἔνδον ὄντος οὐ δύνασθαι τὴν πόλιν ἁλῶναι—*Epit.* 5. 10).[3] Odysseus and Diomedes consequently steal into Troy under the cover of darkness and bring the statue back to the Achaian camp.[4] The episode is linked conditionally with the Ilioupersis: if the Achaians do not retrieve the statue, then they will

[1] The most complete early account of the horse is found at *Od.* 8. 487–520, discussed below in §5.2. Both *Mikra Ilias* and *Iliou Persis* narrated the building and implementation of the wooden horse; see *MI* arg. 14–23, *IP* arg. 3–13 and *IP* fr. 2. The late Greek epic poems of Quintus Smyrnaeus (12. 117–50) and Tryphiodoros (57–105) both describe the construction of the horse with elaborate ecphrasis, perhaps in reflection of early epic accounts.

[2] On the questions raised by the horse, its inspiration, historical models, symbolic and religious significance, see Hainsworth in Heubeck *et al.* (1988) 379 and Faraone (1992) 94–112.

[3] Proklos records at *MI* arg. 6–7 that Helenos gives information to the Achaians, but his brief summary fails to mention the Palladion. On the protective power of the statue see also Dio. Hal. 1. 68 = *IP* fr. 1.

[4] See *MI* arg. 17–18, *MI* fr. 25, and *Epit.* 5. 13. Sophokles dramatized the episode in his *Lakainai*, for which see Radt's (1977) edition of the fragments, pp. 328–30.

never succeed in capturing Troy. It also serves as a reflective prelude to coming events, the small-scale penetration accomplished by Odysseus and Diomedes anticipating the monumental act of penetration to follow, the ruse of the wooden horse.

The Palladion itself mirrors the wooden horse in two significant respects. Both horse and Palladion are statues, and both are associated with the goddess Athena. While the Palladion is her holy image, the horse is built through her intervention and is later dedicated to her twice. First the Achaians offer it to Athena under false pretences, to deceive the Trojans into believing that they have surrendered and returned home.[5] Then the Trojans appropriate the statue for themselves and again dedicate it to Athena, this time before her temple in the citadel of Troy (*IP* arg. 3–6).[6] Furthermore, these two sanctified statues fill complementary roles within the narrative. In essence, the Achaians steal one statue and offer another in exchange, and the Trojans accept the horse as a replacement for the Palladion. This process of substitution, however, is flawed in one crucial detail. While the first statue guarantees Troy protection from its enemies—the city cannot be taken while the sacred Palladion remains within its walls— the second statue, once accepted within the walls, guarantees the city's destruction.[7] Palladion and horse are analogous objects with opposing functions.

In Proklos' summary of the *Mikra Ilias* the theft of the Palladion is sandwiched between the conception of the horse and its deployment. In other words, if Proklos' recording of the sequence of events can be trusted, the two episodes are interwoven in the poem's narrative.[8]

[5] According to Apollodoros, *Epit.* 5. 15, the Achaians affix to the statue a sign reading: 'The Greeks [dedicated this statue] as a thank-offering to Athena for the return home' (τῆς οἴκον ἀνακομιδῆς Ἕλληνες Ἀθηνᾷ χαριστήριον). Since, however, forms of writing are found infrequently in early epic, this sign may be a relatively late invention, and earlier bards may have used a different device. Vergil employs Sinon to convey this dedicatory information in *Aeneid* 2.

[6] The earliest record of the event is found at *Od.* 8. 509. Compare also Apollodoros, *Epit.* 5. 17.

[7] For an early epic association between the acceptance of the horse and the destruction of the city see *Od.* 8. 511–12: 'for the city was fated to be destroyed upon enveloping the great wooden horse' (αἶσα γὰρ ἦν ἀπολέσθαι, ἐπὴν πόλις ἀμφικαλύψῃ | δουράτεον μέγαν ἵππον). Vergil too treats the actual passage of the horse within the walls as a momentous and ominous event: the statue stumbles four times as the Trojans drag it across the threshold at *Aeneid* 2. 241–3.

[8] Proklos records the inspiration and building of the horse at *MI* arg. 14, the retrieval of the Palladion at *MI* arg. 17–18, and the implementation of the horse at *MI* arg. 19–20. Some confusion over the sequence of events is caused by the inclusion

Although it cannot reveal which object arose first, Palladion or horse, or which episode exerted greater influence on the composition of the other, this overlapping would at least suggest that the poets appreciated the affinities between the two episodes and that they were consciously responsible for exploiting and enhancing, if not originally devising, the complementarity. While direct evidence of how the early bards developed the correspondence is lost, a trace may have survived in the account of Vergil, who likewise recognized the analogy and wove together the tales of the Palladion and the horse. Vergil's Sinon explains to the Trojans that the theft of the Palladion roused the wrath of Athena against the Achaians, who therefore built and dedicated the horse specifically as an offering of atonement (*Aeneid* 2. 162–84, and particularly 2. 183–4: 'hanc pro Palladio moniti, pro numine laeso | effigiem statuere, nefas quae triste piaret'). The first statue, Sinon claims, is now on its way back to Greece, but the Achaians have erected the statue of the horse as a substitute offering to the goddess. Vergil thereby acknowledges the complementarity of the two objects. Moreover, Vergil further assimilates the wooden horse to the Palladion by having Sinon falsely endow it with protective powers. If brought within the walls of the city, Sinon claims, the statue will bring the Trojans success in a subsequent confrontation with the Greeks—an insidious inversion of the actual effect intended by the Achaians (*Aeneid* 2. 185–94). Thus the poet manipulates the correlation between Palladion and horse to multiply the layers of deceitful misrepresentation blinding the Trojans. Sinon is not, as he claims, a victim and enemy of Odysseus, but rather his clever colleague; and the horse is not, as Sinon claims, a means of redressing the wrong committed in the theft of the Palladion, but rather a complementary step in the plot to capture the city.

1.2 The Wooden Horse and the Ships of Paris

Another series of narrative analogies connects the tale of the wooden horse to an event located at the beginning of the saga, the abduction of Helen from Sparta. In conception, manufacture, and deployment, the horse is a precise narrative parallel to the ships which convey

of another stealthy raid into Troy at lines 15–17. The rapid juxtaposition of two similar raids appears unusual, and Proklos or his source may be misrepresenting the poem or superimposing details of two poems, perhaps the *Mikra Ilias* and the *Iliou Persis*.

Paris to Sparta, whence he abducts Helen and initiates the conflict with the Achaians.[9] The existence of these ships is attested both in Proklos' summary of the *Kypria* and in the *Iliad*. Proklos writes of Paris, 'And then, following the advice of Aphrodite, he builds ships' (ἔπειτα δὲ Ἀφροδίτης ὑποθεμένης ναυπηγεῖται—*Kyp.* arg. 9). And a battle scene in the *Iliad* records the name of the builder:

Μηριόνης δὲ Φέρεκλον ἐνήρατο, τέκτονος υἱὸν
Ἁρμονίδεω, ὃς χερσὶν ἐπίστατο δαίδαλα πάντα
τεύχειν· ἔξοχα γάρ μιν ἐφίλατο Παλλὰς Ἀθήνη·
ὃς καὶ Ἀλεξάνδρῳ τεκτήνατο νῆας ἐΐσας
ἀρχεκάκους, αἳ πᾶσι κακὸν Τρώεσσι γένοντο
οἷ τ' αὐτῷ, ἐπεὶ οὔ τι θεῶν ἐκ θέσφατα ᾔδη.

And Meriones slew Phereklos, the son of the builder
Harmonides, who knew how to build all manner of things
with his hands; for Pallas Athena loved him exceedingly;
he built the well-balanced ships for Alexandros,
the start of ills, ships which brought ills to all the Trojans
and to him too, since he did not know the prophecies of the gods.

(*Il.* 5. 59–64)

The building of Paris' ships, though only briefly sketched in these sources, might easily have provided material for a substantial slice of poetry. Both the *Iliad* and the *Odyssey* witness the poets' delight in detailed description of ships and their movements. Poets narrating the voyage of the Argonauts must have shown similar enthusiasm for this subject and probably devoted particular attention to the building of the *Argo*.[10] The *Odyssey* preserves a small-scale reflection of the ship-building process in the construction of Odysseus' raft, a necessary step in his departure from Circe's isle and a prelude to his confrontation with his old enemy Poseidon. With this might also be compared the perhaps unexpected, but certainly not intrusive, assembly of Priam's cart in *Iliad* 24, which forms part of the solemn preparation for Priam's momentous journey to the tent of Achilles. Similarly, as a prelude to Paris' momentous journey to Sparta, the building and launching of his ships merited and probably received a fair share of attention from the poets. At the same time, however, the attention afforded to the ships of Paris seems somewhat anomalous

[9] Despite the proliferation of attempts to explain the horse, no scholar to my knowledge has yet explored this narrative correlation.
[10] See Apollodoros, 1. 9. 16 and cf. Apollonios Rhodios.

when contrasted with the treatment of the 'thousand ships' of the Achaian fleet. Although the catalogue in *Iliad* 2 records precisely how many ships conveyed the various contingents to Troy, the actual building of these ships is not mentioned. The ships frequently serve as the scene of action, even as the scene of battle, but the poet never recalls their construction or their past history. The building of Paris' ships thus stands alone in the remains of the Trojan cycle as the most significant building project of its kind.[11]

Turning back from this discussion of ships and their construction to the wooden horse, we might now perceive the horse as a kind of ship in disguise. While it shares obvious similarities with the Palladion, as noted above, in design and function the horse much more closely resembles a ship. Like a ship, it is in essence a large, wooden structure designed to carry men—fifty or a hundred men according to some reports, making it roughly analogous with a ship in terms of dimensions and capacity.[12] Coincidentally, both Apollodoros and Proklos describe the process of putting men inside the horse with the word ἐμβιβάζω, a term regularly used of putting people on board a ship (*MI* arg. 19 and *Epit.* 5. 15). Whether or not their use of this verb reflects an early epic practice of treating the horse in terms of a ship cannot be ascertained, but at least two later poets explored the metaphor.[13] The chorus of Euripides' *Troades* recalls that the Trojans

[11] Another instance of ship-building is mentioned at *Il.* 2. 664—not of ships built for the voyage to Troy, but of ships involved in the past history of Tlepolemos.

[12] The number of warriors lodged within the horse differed widely among the various accounts. According to Apollodoros, thirteen warriors entered the horse in the *Mikra Ilias*, although he knows of another unspecified tradition that gives the number as fifty (*Epit.* 5. 14, *MI* fr. 8). Eustathios records that Stesichoros lodged one hundred men in the horse, while others included only twelve (Eust. *Od.* 1698. 2; Stesichoros, fr. 199). This divergence between large and small numbers might stem from a difference between the epic *Mikra Ilias* and *Iliou Persis* traditions. There is no record of how many men the epic *Iliou Persis* placed within the horse, but a scholion on Vergil's *Aeneid* notes that Arktinos, reputed author of the *Iliou Persis*, recorded the size of the horse as 150 ft. long and 50 ft. wide (*IP* fr. 2)—dimensions suggesting a maximum capacity closer to one hundred men than to twelve. It seems likely then that while the smaller number derives from the *Mikra Ilias* tradition, the larger stems from the *Iliou Persis*. This difference in number may also reflect differing conceptions of the horse's function. A band of one hundred presents a formidable attack force, while a band of twelve is more likely simply to overpower the city guards and open the gates to the other Achaians.

[13] A parallel between the horse and one other naval episode may be noted here. Apollodoros, *Epit.* 5. 20 records Echion as the first to jump from the horse and the first to die. This detail parallels Protesilaos' jump from the Achaian ships as they land at Troy (*Il.* 2. 698–702; *Kyp.* arg. 53–4 and fr. 26; Apollodoros, *Epit.* 3. 30).

hauled the horse to their citadel with ropes, as if hauling a ship (κλωστοῦ δ' ἀμφιβόλοις λίνοιο ναὸς ὡσεὶ | σκάφος κελαινόν . . . — *Tro.* 537–9). And the late epic poet Quintus Smyrnaeus compares the dragging of the horse into the city to the launching of a ship (12. 427–34).

While the horse's structure lends itself well to comparison with ships, the narrative treatment suggests a particular affinity with the ships of Paris. First of all, the two building processes follow a similar sequence. Although Paris might conceivably have hired a ship or borrowed one from his father, he instead has the ships constructed for the occasion. Likewise, the Achaians build the horse especially for the occasion. Inspiration for each project originates with a goddess— Aphrodite for Paris' ships (Ἀφροδίτης ὑποθεμένης—*Kyp.* arg. 9) and Athena for the wooden horse (κατ' Ἀθηνᾶς προαίρεσιν—*MI* arg. 14). In both cases the builder seems to have been developed into a note-worthy figure. Epeios earns fame in the saga as the builder of the wooden horse, and the *Iliad* remembers Harmonides as the builder of Paris' ships (*Il.* 5. 60).[14] As architects, both Harmonides and Epeios share the patronage of the goddess Athena.[15]

In addition to these analogies between the two objects and their manufacture, another series of parallels, anchored in the theme of unheeded prophecy, links the departure of Paris' ships with the Tro-jan discovery of the horse. Both Helenos and Kassandra deliver pre-dictions shortly after the building of the ships:

ἔπειτα δὲ . . . ναυπηγεῖται, καὶ Ἕλενος περὶ τῶν μελλόντων αὐτοῖς προθεσπίζει, καὶ ἡ Ἀφροδίτη Αἰνείαν συμπλεῖν αὐτῷ κελεύει, καὶ Κασσάνδρα περὶ τῶν μελλόντων προδηλοῖ.

And then . . . he builds ships, and Helenos prophesies to them regarding the future, and Aphrodite bids Aineias sail with him, and Kassandra reveals future events. (*Kyp.* arg. 9–11)

Interspersed as they are among the building of the ships and Paris' departure, the prophecies of Helenos and Kassandra must refer at least in part to the disastrous consequences of Paris' expedition, the war that he is to initiate by abducting the wife of Menelaos. These

[14] On the figure of Epeios see *MI* arg. 19. Note that the *Iliad* passage concerning the building of the ships is ambiguous and could also be read to indicate that Phereklos, son of Harmonides, is the builder; compare *Kyp.* fr. (*dubium*) 37 on the ambiguity.

[15] See *Od.* 8. 493 and Stesichoros, *Iliou Persis* fr. 200 for Athena as patron of Epeios. See *Il.* 5. 61 for Athena and Harmonides.

seers already know that the ships are to bring ills to all the Trojans (ἀρχεκάκους, αἳ πᾶσι κακὸν Τρώεσσι γένοντο—*Il*. 5. 63). They understand the prophecies of which Harmonides was completely unaware (ἐπεὶ οὔ τι θεῶν ἐκ θέσφατα ᾔδη—*Il*. 5. 64). On the basis of these surviving fragments, an early epic song narrating the building and departure of the ships would presumably have sounded a mixture of celebration and doom, a striking dissonance arising between the two incompatible moods. We may imagine Paris, spurred on by Aphrodite, displaying youthful exuberance and eagerly anticipating his marriage to Helen, and perhaps the royal family and the populace of Troy share his eagerness for success. But this atmosphere of celebration is clouded by the prophecies of Helenos and Kassandra, who alone perceive the inevitable consequences of Paris' departure.

The mixed tone of celebration and doom in this episode is echoed when the Trojans discover the wooden horse and receive it into their city. The Trojans rejoice in the false belief that the Achaians have departed, and they prepare to conduct the horse into the city under the false impression of victory.[16] With the death of Laokoon an undercurrent of doom interrupts the celebration, and Aineias, in contrast to his previous participation in the plan of Paris, here perceives the danger of the situation and leaves the city.[17] The rest of the Trojans, however, maintain their decision to accept the horse into the city and resume their celebrations. Vergil, perhaps following an earlier epic tradition, allows the Trojan priest some real suspicion of the danger posed by the horse, and Apollodoros, recording his intervention, terms Laokoon a 'mantis' or seer (*Epit*. 5. 17). Thus, in his unsuccessful attempt to open the Trojans' eyes to the danger, Laokoon comes to resemble Helenos and Kassandra, who attempt unsuccessfully to prevent the launching of Paris' ships. According to Apollodoros, Kassandra too tries to dissuade the Trojans from receiving the horse into the city by warning of the danger within (Κασσάνδρας δὲ λεγούσης ἔνοπλον ἐν αὐτῷ δύναμιν εἶναι—*Epit*. 5. 17).[18] She thereby repeats the role she played in the earlier episode,

[16] *IP* arg. 3–7; *Epit*. 5. 16–17. See also Stesichoros, *Iliou Persis* fr. S88.

[17] *IP* arg. 7–9; see Ch. 4 for further discussion of Laokoon's death and its significance for Aineias, and Ch. 10 for Sophokles' treatment of the episode.

[18] Proklos' failure to mention the prophecy of Kassandra at the Ilioupersis does not automatically condemn it as a non-epic addition. It is possible, however, that this prophecy was incorporated into the Ilioupersis tradition at a late stage in the development of the myth, perhaps as a deliberate parallel to her role in the *Kypria*.

delivering prophecies to a heedless and doomed audience. The poetic force of both episodes thus relies heavily on a kind of dramatic irony, an uneasy tension between the mood of celebration and the threat of dangers posed to the city as revealed in prophetic warnings.

The basic narrative link underpinning this complex series of analogies, as well as the stimulus promoting them, is the simple complementarity between beginning and end. The building and launching of Paris' ships engenders the conflict, and the building of the horse and its acceptance into Troy brings the conflict to a close. This narrative correlation may also be defined more narrowly in terms of Helen: at the beginning of the story Paris builds ships to steal her from Sparta, and at the end of the war the Achaians build the horse to retrieve her from Troy.[19] Standing at opposite ends of the story, ships and horse both function as tools to capture Helen, the first to abduct her and the second to rescue her from her abductors. The poets, with some appreciation for the natural narrative complementarity of the two episodes, developed beginning and end, ships and horse, as reflections of one another.[20] They sculpted the horse to resemble the ships, and vice versa. Likewise, they shaped the departure of the ships and the Trojan acceptance of the horse as reflections of one another.

The correlations, while indicative of a poetic desire to impart balance and closure to the saga, also suggest a notion of justice at work among the story-tellers, or rather, an attempt to impose moral logic on the myth. It requires no deep analysis to conclude that the abduction of Helen leads to the destruction of Troy and to the retrieval of Helen, but the poets underline that simple correlation between initial and final episodes with a series of more subtle structural parallels in an attempt to define the relationship with greater precision. The narrative analogies between the ships and the horse create a relationship of action and complementary reaction, of cause and parallel effect, and thereby intensify the theme of retaliation, like for like. The voyage

[19] While the horse may more frequently be interpreted as the means by which the Achaians capture Troy, the complementary tales of Helen and Menelaos in *Odyssey* 4 suggest an association specifically between the deployment of the horse and the retrieval of Helen. According to Helen, when Odysseus met with her secretly just prior to the final attack and informed her of the Achaian plan, i.e. the wooden horse, she rejoiced at her imminent rescue. And Menelaos, in response, recalls that Helen circled the horse and endangered the men within, hinting suspiciously at her indifference to or unwillingness for rescue. For further discussion of these tales see Ch. 5.

[20] For an early 5th-c. visual demonstration of the complementarity between Helen's abduction and retrieval see §14.2.

of Paris, it might also be noted, initiates a pattern of deceit to be answered with the wooden horse. The ships convey him to the home of Menelaos, where his goal will be the seduction or abduction of his host's wife. At the Ilioupersis, in turn, just as Menelaos welcomes Paris, so the Trojans invite the horse into their city, without realizing that it cloaks a hostile intent to requite Paris' initial injustice.

Once again, it is impossible to observe precisely how the correlation was acknowledged and exploited in the earlier poetry. It is conceivable that the prophecies of Helenos and Kassandra as recorded in Proklos' *Kypria* summary anticipated the destruction of Troy and even voiced an association between the launching of the ships and the retributive response that would come in the form of the wooden horse. As in the case of the Palladion, where Vergil offers a possible parallel to earlier epic treatments, here again a later poet offers an intriguing link. While narrating the construction of the wooden horse, Tryphiodoros recalls the construction of the ships of Paris:

> καὶ δὴ τέμνετο δοῦρα καὶ ἐς πεδίον κατέβαινεν
> Ἴδης ἐξ αὐτῆς, ὁπόθεν καὶ πρόσθε Φέρεκλος
> νῆας Ἀλεξάνδρῳ τεκτήνατο, πήματος ἀρχήν.

> And he felled timber and brought it into the plain
> from Ida, the very place whence Phereklos had previously
> built ships for Alexandros, the beginning of grief.

> (Tryphiodoros, 59–61)

The Achaians fell timber for the horse on Mt. Ida, the very same mountain that previously provided timber for Paris' ships. Tryphiodoros links the two episodes with an explicit recollection of the past, joining end and beginning in a single moment, initiating the monumental process of closure soon to reach a climax with the return of Helen to Menelaos.

2

Family Ties

Among the many forces of cohesion uniting the Ilioupersis episodes, one of the simplest and strongest is the theme of family and family dissolution. The fall of Troy is in essence the fall of its ruling family. While early poets and artists did not ignore the widespread suffering of all the Trojans at the capture of their city (as exemplified on the Mykonos Ilioupersis pithos, discussed in Ch. 11 below), the microcosmic city-family consisting of Priam, his wife, daughters and daughters-in-law, and his remaining sons and sons-in-law, lies at the heart of the myth. It is their stories, their suffering at the hands of their enemies, that the artistic and poetic traditions chose to canonize. Priam, the sources tell us, king of Troy and patriarch of the family, is slain in the palace at the altar of Zeus Herkeios. His daughter Kassandra is dragged by the lesser Aias from her position of supplication at the statue of Athena and is later awarded to Agamemnon as his concubine. Priam's son Deiphobos, who appropriated Helen after the death of his brother Paris, dies in a confrontation with Helen's Achaian husband, Menelaos; and the 'daughter-in-law' Helen returns to her former family. In the immediate aftermath of the capture, Priam's wife Hekabe is enslaved to Odysseus, and their daughter Polyxene is sacrificed at the tomb of Achilles. Daughter-in-law Andromache falls to Neoptolemos; and her son Astyanax, grandson of Priam and one of the last remaining heirs to his throne, is hurled from the towers of the city. So falls the family of Priam, and so falls Troy.

This dissolving of the family, a fundamental unifying component of the Ilioupersis episodes, also winds its way through several chapters of the saga leading toward the fall of Troy, as Priam's sons and other relatives die one after another. Achilles' ambush of the Trojan prince Troilos, once narrated in the lost epic *Kypria* and recalled in book 24 of the *Iliad*, formed an early chapter in the process of disintegration. More familiar to us is the blow to Priam's family dramatized in the closing books of the *Iliad*. Here, as the Achaians overcome

one of the city's major heroes, praised as the city's sole defence and comparable to the city wall itself, the poem focuses on the much more personal and poignant meaning of Hektor's death for his kin— the loss of son, brother, husband, and father. On the opposing side, the poem transforms Achilles from a relatively disinterested enemy of Troy (for example, 1. 152–7) into the principal agent of the plague which is slowly killing off Priam's children (see especially 21. 99– 105, 22. 44–7, and 24. 493–501).

While the close of the *Iliad* advertises Hektor as the greatest and last of Priam's fifty sons, and gives the impression that his death leaves the entire family broken and defeated (24. 493–501), the process is not quite so swift, and the erosion continues beyond the *Iliad* with the deaths of other Trojan princes and of a few more distant relations. Memnon, Achilles' last great victim, is the son of Priam's brother Tithonos. Eurypylos, imported after the death of Memnon and defeated by Achilles' son Neoptolemos, has a more disputed pedi- gree, but is identified as another of Priam's nephews by a scholion on *Odyssey* 11. 521, his mother Astyoche here identified as Priam's sister. Sophokles was later to tighten the ties between Priam and Eurypylos by having the king mourn his death as if mourning for his own son—perhaps with an echo of Hektor's death in the background (fr. 210. 70–7 Radt). Paris, another victim of the later battles, falls to Philoktetes—a not entirely disagreeable loss, but still a significant wound to the royal house. How many princes the early narratives preserved for the climactic butchery of the Ilioupersis is not known, but Deiphobos at least was among the ranks. Vergil, perhaps inno- vating, continues the pattern with the slaughter of Polites before the very eyes of his father—that act a horrific prelude to the murder of the patriarch himself at the close of *Aeneid* 2. Here finally, with the possible exception of Polydoros, the poets kill off the last of the fifty sons lamented by Priam in *Iliad* 24, and the eradication of Priam's household is complete.

2.1 The Murder of Priam

Proklos' summary of the *Iliou Persis* records that Neoptolemos slays the Trojan king at the altar of Zeus Herkeios, where he has taken

refuge.[1] Callously disregarding the sanctity of the location, the religious focal point of Priam's palace, Neoptolemos not only violates the rights of the suppliant, but commits murder at the very altar and pollutes the sanctuary with human blood. While this version of the murder became canonical among works of art and poetry, a slightly different version of Priam's death was narrated in the *Mikra Ilias*. Pausanias contrasts the two as follows:

Πρίαμον δὲ ⟨οὐκ⟩ ἀποθανεῖν ἔφη Λέσχεως ἐπὶ τῇ ἐσχάρᾳ τοῦ Ἑρκείου, ἀλλὰ ἀποσπασθέντα ἀπὸ τοῦ βωμοῦ πάρεργον τῷ Νεοπτολέμῳ πρὸς ταῖς τῆς οἰκίας γενέσθαι θύραις.

Lesches said that Priam did not die at the altar of Zeus Herkeios, but was dragged from the altar and fell victim to Neoptolemos at the gates of his home. (Pausanias 10. 27. 2 = *MI* fr. 16)

Here the murder has been shifted away from the altar of Zeus and relocated at the doors of the palace, perhaps in an attempt to diminish the theme of sacrilege so prominent in the canonical account of the *Iliou Persis*. Pausanias fails to specify whether Neoptolemos or some other Achaian drags Priam from the altar, leaving Neoptolemos' part in the activity ambiguous. Nevertheless, the altar of Zeus has not been wholly excised from the episode, and this version might be interpreted as an elaboration rather than a contradiction of the more familiar tradition.

In addition to the two accounts of Priam's death preserved in the fragments of the *Mikra Ilias* and *Iliou Persis*, we have also an extraordinarily vivid allusion to the episode in *Iliad* 22, a passage which will serve as the focal point of the present discussion:

πρὸς δ' ἐμὲ τὸν δύστηνον ἔτι φρονέοντ' ἐλέησον,
δύσμορον, ὅν ῥα πατὴρ Κρονίδης ἐπὶ γήραος οὐδῷ
αἴσῃ ἐν ἀργαλέῃ φθίσει, κακὰ πόλλ' ἐπιδόντα,
υἷάς τ' ὀλλυμένους ἑλκειθείσας τε θύγατρας,
καὶ θαλάμους κεραϊζομένους, καὶ νήπια τέκνα
βαλλόμενα προτὶ γαίῃ ἐν αἰνῇ δηϊοτῆτι,
ἑλκομένας τε νυοὺς ὀλοῇς ὑπὸ χερσὶν Ἀχαιῶν.

[1] IP arg. 13–14: καὶ Νεοπτόλεμος μὲν ἀποκτείνει Πρίαμον ἐπὶ τὸν τοῦ Διὸς τοῦ Ἑρκείου βωμὸν καταφυγόντα. Cf. the account of Apollodoros, *Epit.* 5. 21: καὶ Νεοπτόλεμος μὲν ἐπὶ τοῦ ἑρκείου Διὸς βωμοῦ καταφεύγοντα Πρίαμον ἀνεῖλεν. Despite a slight variation in syntax, the two accounts are identical, both placing the murder at the altar.

αὐτὸν δ' ἂν πύματόν με κύνες πρώτῃσι θύρῃσι
ὠμησταὶ ἐρύουσιν, ἐπεί κέ τις ὀξέϊ χαλκῷ
τύψας ἠὲ βαλὼν ῥεθέων ἐκ θυμὸν ἕληται,
οὓς τρέφον ἐν μεγάροισι τραπεζῆας θυραωρούς,
οἵ κ' ἐμὸν αἷμα πιόντες ἀλύσσοντες περὶ θυμῷ
κείσοντ' ἐν προθύροισι.

Have pity upon wretched me while I still live,
ill-fated me, whom father Kronides on the threshold of old age
will destroy in a grievous end, as I behold many woes,
sons destroyed and daughters dragged away,
and marriage chambers ruined, and infant children
flung to the earth in dread battle,
and daughters-in-law dragged away by the deadly hands of the Achaians.
And me last of all blood-thirsty dogs will maul at the outer gates
when someone, smiting me with sharp bronze
or striking from afar, takes the life from my limbs,
dogs which I raised in the palace, table-fed door guardians,
who will drink my blood, frenzied exceedingly in their hearts,
and lie in the doorway.

 (*Il.* 22. 59–71)

Priam's vision is not technically an account of the city's capture,
but an evocation, a vision of the sack as it might take place. Like all
allusions it operates within multiple levels of context simultaneously.
While derived in part from Ilioupersis tradition, the passage is influ-
enced also by its immediate narrative surrounding in *Iliad* 22 and by
the wider plot and general themes of the *Iliad*. My task in the follow-
ing pages is to assess the many internal, Iliadic influences at work
in this passage and to trace its relationship to external Ilioupersis
traditions.

Priam delivers these lines at the opening of *Iliad* 22, while Hektor
is standing before the city gates, and Achilles is returning speedily
across the plain in anticipation of a confrontation with his most hated
adversary. Fearing for his son's life, Priam begs Hektor to seek pro-
tection within the walls, and his plea ends with this warning of the
disaster to come should Hektor now fall to Achilles. Priam thereby
links the two events, the death of his son and the fall of the city,
in a relationship of inevitable result. Elsewhere Hektor is repeatedly
acknowledged as the city's principal guardian. In book 6, for ex-
ample, the poet relates the name of Astyanax—literally 'lord of the
city'—to his father's singular role as defender of Troy: 'Hektor called

him Skamandrios, but the others | Astyanax; for Hektor alone pre-served the city' (τόν ῥ̓ Ἕκτωρ καλέεσκε Σκαμάνδριον, αὐτὰρ οἱ ἄλλοι | Ἀστυάνακτ᾽ οἷος γὰρ ἐρύετο Ἴλιον Ἕκτωρ—6. 402–3). Equating the death of his son Hektor with the loss of this guardian and sole hope of delivery, Priam infers the fall of the city as the nat-ural consequence.

Like the canonical poetic and artistic traditions, Priam conceives of the Ilioupersis in microcosmic terms as the dissolution of his family. The men to be slain are his sons, the women enslaved are his daugh-ters and daughters-in-law.[2] Included in the carnage are his infant grandchildren (νήπια τέκνα) and the scene which he imagines cul-minates with the death of the oldest generation, of Priam himself. Although we need not read here allusions to specific events of the sack, several details of Priam's vision are reminiscent of events nar-rated in the *Iliou Persis* and *Mikra Ilias*. Priam's son Deiphobos will die in the attack, presumably along with several brothers (*IP* arg. 15). Priam's daughters Polyxene and Kassandra will be taken captive. The reference to daughters-in-law (ἑλκομένας τε νυοὺς—22. 65) corresponds to the fate of Andromache. Finally, the image of children dashed to the ground (νήπια τέκνα | βαλλόμενα προτὶ γαίη—22. 63–4) will be realized in the death of Astyanax, hurled from the walls of the city by Neoptolemos according to the *Mikra Ilias*.[3]

The image of the ransacked palace in the midst of the vision (καὶ θαλάμους κεραϊζομένους—22. 63) is a small detail, but one inte-grally related to the theme of family suffering, if we understand the 'thalamoi' as the sleeping-quarters of Priam's offspring. Our most detailed description of these chambers is found in *Iliad* 6, during Hektor's final visit to his home and family.

Ἀλλ᾽ ὅτε δὴ Πριάμοιο δόμον περικαλλέ᾽ ἵκανε,
ξεστῇς αἰθούσῃσι τετυγμένον—αὐτὰρ ἐν αὐτῷ
πεντήκοντ᾽ ἔνεσαν θάλαμοι ξεστοῖο λίθοιο,
πλησίον ἀλλήλων δεδμημένοι· ἔνθα δὲ παῖδες
κοιμῶντο Πριάμοιο παρὰ μνηστῇς ἀλόχοισι·
κουράων δ᾽ ἑτέρωθεν ἐναντίοι ἔνδοθεν αὐλῆς

[2] Cf. Kleopatra's description of a city sack at *Il.* 9. 593–4: 'They kill the men, fire levels the city, | and other men take away the children and deep-girdled women' (ἄνδρας μὲν κτείνουσι, πόλιν δέ τε πῦρ ἀμαθύνει, | τέκνα δέ τ᾽ ἄλλοι ἄγουσι βαθυζώνους τε γυναῖκας).

[3] For the fates of Priam's family members as recorded in the epic poems see below, §3.1–3.

δώδεκ᾽ ἔσαν τέγεοι θάλαμοι ξεστοῖο λίθοιο,
πλησίον ἀλλήλων δεδμημένοι· ἔνθα δὲ γαμβροὶ
κοιμῶντο Πριάμοιο παρ᾽ αἰδοίης ἀλόχοισιν.

But when he reached the beautiful house of Priam,
fashioned with polished corridors—in it
were fifty marriage chambers of polished stone,
built next to one another; there the sons
of Priam slept beside their wedded wives;
and for the daughters, on the other side, opposite, within the courtyard
were twelve roofed marriage chambers of polished stone,
built next to one another; there Priam's sons-in-law
slept beside their wedded wives.

(Il. 6. 242–50)

This is the poet's conception of the house of Priam, thrown abruptly into relief by the anacoluthon at the beginning of the description (6. 243). The attention of the poet is attracted not to the ornament of the building or the edifice *per se*, nor to the status of this building as seat of Priam's power, but to its inhabitants and their activities as reflected in the architecture. The description of the palace provides a blueprint of the enormous royal family that resides within. Fifty rooms house the fifty sons of Priam and their wives. Twelve more house his daughters and their husbands.[4] Furthermore, if we read in the verb κοιμῶντο ('sleep'—6. 246 and 250) an indication of procreation, then the image of the palace also carries within it the seeds of a further generation, a glimpse of Priam's grandchildren.[5]

Underlying the word 'thalamoi' in Priam's apocalyptic vision of book 22 is this same image of the palace as a cluster of domestic quarters. While these marriage chambers, home to Priam's sons and daughters and their spouses, are devastated (καὶ θαλάμους κεραϊζομένους—22. 63), the sons and sons-in-law themselves are slain, the daughters and daughters-in-law enslaved. The destruction of the edifice mirrors the dissolution of the family that dwells within it. The analogy extends also to the infant children, formerly begotten and born within these chambers, but now destroyed together with the 'thalamoi' that witnessed their conception. The physical *oikos* and the human *oikos*, house and household, come to an end simultaneously,

[4] Hektor and Paris are given their own homes later in book 6, perhaps an Iliadic innovation upon a traditional image of Priam's family living under one roof.
[5] Taplin (1992) 117 writes of this image of the palace, 'The fine building is the breeding-ground of a great dynasty.'

and any continuation of Priam's line or revival of his family through further procreation is denied. Several centuries later Vergil again recognized the symbolic significance of the architecture of Priam's palace when, in recording its destruction, he wrote, 'those fifty marriage chambers, ample hope of grandchildren' ('quinquaginta illi thalami, spes ampla nepotum'—*Aeneid* 2. 503).

The repeated emphasis on the family in Priam's vision is undoubtedly influenced by other Ilioupersis narratives, of which the suffering of Priam's family formed the core, and in which that suffering may have been more elaborately reflected in the destruction of the palace. At the same time, strong local motivation governs the choice and presentation of particular details. Priam anticipates the Ilioupersis specifically in terms of family dissolution because he is directing his arguments specifically toward Hektor. In essence the father is saying, 'Now I am losing you, my son, and soon I will lose the remainder of my family.' Just as Priam will here *witness* the death of his son from the walls of Troy, so he imagines himself as a spectator also at the Ilioupersis, watching the suffering of the rest of his family as a prelude to his own death (κακὰ πόλλ᾽ ἐπιδόντα—*Il.* 22. 61). Furthermore, the references to the infant children and to daughters-in-law, whether or not we understand them as poetic allusions to the death of Astyanax and the enslavement of Andromache, bring the warning even closer to Hektor. As Hektor himself has anticipated already in *Iliad* 6, it is not merely the family of Priam, but his own family, his wife and son, that will suffer at the sack in consequence of his defeat.[6] In particular, Priam's placement of daughters-in-law in the list of victims—not joined hastily with sons and daughters in 22. 62, but postponed until the close of the family list and treated in a full line at 22. 65—is meant to appeal directly to Hektor as a warning of his own wife's future suffering.

The present circumstances of Hektor have exerted particular influence on the climax of Priam's warning, his vision of his own death. Though vague in describing the manner of the killing (τύψας ἠὲ βαλών—22. 68), Priam specifies in gruesome detail how the palace dogs will mutilate his corpse, eating his flesh and drinking his blood (22. 66-7, 70, and 74-6). Not by coincidence, only a few lines later Hekabe warns against a similar fate for the corpse of her son: 'far away from us | by the ships of the Achaians swift dogs will devour

[6] See §3.2 for Hektor's final conversation with Andromache.

you' (ἄνευθε δέ σε μέγα νῶϊν | Ἀργείων παρὰ νηυσὶ κύνες ταχέες κατέδονται—22. 88–9). Her fears accurately reflect Achilles' intentions to deny Hektor's corpse the rights of burial and instead to leave it exposed to the dogs of the Achaian camp (for example, 22. 346–8 and 354).[7] The poet has fashioned the image of Priam's death on the model of Hektor's anticipated mutilation. Like son, like father. The curious end of the passage, in which Priam contrasts the mutilation of an old man's corpse with the treatment of the young (22. 71–6), is a further product of this correspondence between Priam and Hektor. Priam's words imply, 'You may not be moved by fears for the violation of your own corpse, but at least be moved by the anticipated mutilation of my corpse, since for an old man this is a disgrace of the highest magnitude.'

A similar analogy underlies the positioning of Priam's body at the doorway of the palace, a feature mentioned three times in the passage (22. 66, 69, and 71) and echoed in the metaphor 'at the threshold of old age' (ἐπὶ γήραος οὐδῷ—22. 60). The location of Priam's body here at the palace gates is influenced by the position of his addressee Hektor.[8] The son has now taken a position at the Skaian gates, the entrance to the city, while the father imagines himself lying at another set of gates, the entrance to the household. For the significance of this liminal position we turn again to book 6, where Hektor leaves the battle and briefly re-enters the city for what is to be his last visit. The gates of the city appear in this book as the formal boundary between the spheres of battle without and family within, and Hektor's passage through the Skaian gates marks his departure from the one and entrance into the other:

> Ἕκτωρ δ' ὡς Σκαιάς τε πύλας καὶ φηγὸν ἵκανεν,
> ἀμφ' ἄρα μιν Τρώων ἄλοχοι θέον ἠδὲ θύγατρες
> εἰρόμεναι παῖδάς τε κασιγνήτους τε ἔτας τε
> καὶ πόσιας.

As Hektor reached the Skaian gates and the oak,
around him ran the wives and daughters of the Trojans,
asking after their sons and brothers and brothers-in-law
and husbands.

(*Il.* 6. 237–40)

[7] For the mutilation of Hektor's corpse see Segal (1971) *passim*.

[8] The door or gateway of the palace courtyard seems to be meant; cf. *Il.* 24. 323.

Upon reaching the gate Hektor is immediately met by the women of the city, the wives and daughters of the Trojans, seeking information about their male relatives participating in the battle outside.[9] The women are clustered within while the men fight beyond the walls. It is here, within the city, that we see the grand plan of the palace, blueprint of the family sphere which Hektor has entered. Here too he meets successively with several female members of his family: Hekabe (accompanied by a daughter, Laodike), Helen, and Andromache. Each of the three tempts him to remain within the domestic sphere, but in each case his recognition of his duties on the battlefield draws him away.[10]

The last of these meetings brings Hektor from his own home, where he expected to find Andromache, back to the Skaian gates, to the liminal point whence his journey inward began. Previously questioned here by Trojan wives, mothers, and sisters, he is now confronted by his own wife. The subject of their conversation—Andromache's pleas to keep Hektor within and his insistence on returning to the battle—is dramatically reflected in their location in the gateway, at the established boundary between the sphere of family and the sphere of battle; and at the end of their meeting they each turn from this threshold to their own respective spheres.[11] In his final words to his wife Hektor instructs her to re-enter the home and resume her own domestic duties (6. 490–1). War, he reminds her, is the concern of men (6. 492–3). Returning to book 22, we see Hektor at this same dividing line. He stands alone before the gates, while his father and mother plead with him from the tower to enter the city. The battle with Achilles awaits him without, and the family awaits him within; and as in book 6, here again he chooses the battle.

It is this dramatic positioning of Hektor on the threshold of the city that has motivated Priam's image of himself at the threshold of the palace. The theme of liminality has extended from the primary into the secondary narrative plane, and even into the dimension of metaphor at 22. 60.[12] Like Hektor's stance at the gates, Priam's position

[9] Taplin (1992) 117 also discusses this physical division between the two realms.
[10] For this sequence see esp. Griffin (1980) 6–7. [11] See Taplin (1992) 120.
[12] The theme of liminality extends into the dimension of metaphor with the phrase 'on the threshold of old-age' (ἐπὶ γήραος οὐδῷ), which must refer in Priam's case to the passage between old age and death. As the palace doorway is breached, and death and destruction extend their reign to the space within, the palace becomes Priam's vehicle to the house of death.

at the doorway highlights a division between the spheres. This door-
way functions both as means of entry into the house and, like the
gates of the city, as a form of protection for the family.[13] The fall of
Hektor will eventually mean the penetration of the city gates and
the fall of the families within, and the vision of Priam's corpse in the
doorway reflects this process on a smaller scale.[14] The normal bound-
aries between the world without and the family within have disinteg-
rated in the sack. The doorway has been violated, and Priam's corpse
lies at the threshold in a powerful image of that violation. Ironically,
the dogs which he imagines mutilating his corpse are identified spe-
cifically as the household dogs, raised at the table to be guardians of
the doorway ($\tau\rho\alpha\pi\epsilon\zeta\hat{\eta}\alpha s$ $\theta\upsilon\rho\alpha\omega\rho\omicron\acute{u}s$—22. 259). Their proper func-
tion is to protect, not to destroy the family; yet in the turmoil which
overturns the traditional barriers, their role is inverted.

Epic Accounts of Priam's Death in Light of the Iliad

In addition to giving us an Iliadic preview of Troy's fall, Priam's
vision points toward elements that may have formed part of the *Iliou
Persis*, the *Mikra Ilias*, and other early narratives of the sack. The
emphasis on the threshold of the house in the *Iliad*, while motivated
through analogy with the position of Hektor before the gates of Troy,
suggests also that the threshold may have featured prominently in
the Ilioupersis tradition. This is attested at least for the *Mikra Ilias*,
which locates the murder at the doorway. In addition, a comprehens-
ive narration of the episode would naturally involve the penetration
of the palace and the crossing of the palace gates. Writing centuries
later, but perhaps influenced by early epic accounts, Vergil spends
several lines recounting how the Achaians, led by Neoptolemos, bored
through the doors of the palace (*Aeneid* 2. 469–505). The passage

[13] Cf. Agamemnon's vow to destroy Priam's palace and specifically its 'doors'
($\theta\acute{\upsilon}\rho\epsilon\tau\rho\alpha$) at *Il.* 2. 414–15. Agamemnon's emphasis on the doorway is probably motiv-
ated by the same factors underlying the present passage: the doorway is the point of
penetration.

[14] An excessively literal reading of the passage will detect inconsistencies. How could
Priam himself be murdered at the doorway, presumably the point of entrance for the
Greeks, and yet observe the deaths of his grandchildren and the enslavement of the
women within? We might conjecture that the Greeks entered by another way, or that
Priam was murdered elsewhere before being dragged to the doorway. Such conjec-
ture, however, would be superfluous. The poet is concerned less with logistics than
with the expressive power of the images chosen.

opens with an image of Neoptolemos at the threshold ('vestibulum ante ipsum primoque in limine Pyrrhus'—*Aeneid* 2. 469).[15] As the Greeks break a small opening through the palace door, Vergil allows us a glimpse through this opening, first to the guards at the entrance, and then further inside to the family sphere of the mothers housed within (*Aeneid* 2. 479–88). The doorway is thereby represented as the passage, division, and barrier between the domestic sphere within and the sphere of battle without. At length the barrier falls and the external sphere spills into the internal.

Priam's vision in *Iliad* 22 also compels us to explore further how other accounts of Priam's death might have incorporated the theme of family. While the location of the murder at the altar of Zeus Herkeios in the *Iliou Persis* colours the scene with the obvious theme of sacrilege, comparison with the Iliadic treatment of the murder highlights the specifically domestic significance of Zeus' altar. Like the doorway and the marriage chambers mentioned in *Iliad* 22, the altar of Zeus Herkeios is a prominent physical component of Priam's house, particularly symbolic of the family domain. Zeus Herkeios is the god of the household, father Zeus in a very literal sense. His altar stands in the middle of the courtyard (the ἕρκος) as an architectural and religious focal point of the domestic realm.[16] As the altar symbolizes the family, so Priam's death at this altar symbolizes the destruction of the family.

This household symbolism is doubled in the *Mikra Ilias*, where Priam is dragged away from the altar of Zeus and killed at the doors of the house (*MI* fr. 16), the alternative setting not simply replacing the altar, but rather complementing it. The narration thus focuses on two significant architectural components instead of one: the altar situated at the centre of the household, and the doorway serving as its principal point of entry and exit. As the initial breaching of the doorway's barrier represents the invasion of Priam's house and his household, the subsequent death of Priam at the doorway in the

[15] Cf. also *Aeneid* 2. 499–500, where Aeneas observes Neoptolemos and the Atrides 'on the threshold'.

[16] The altar of Zeus Herkeios is a prominent feature in Odysseus' house: 'there many times | Laertes and Odysseus burned the thigh-bones of oxen' (ἔνθ' ἄρα πολλὰ | Λαέρτης Ὀδυσεύς τε βοῶν ἐπὶ μηρί' ἔκηαν—*Od.* 22. 334–6). Cf. also Priam's libation to Zeus 'in the middle of the courtyard' (ἐν μέσῳ ἕρκεϊ) at *Il.* 24. 306 before he sets out to retrieve the body of his son. Achilles makes a similar libation 'in the middle of the courtyard' at *Il.* 16. 231.

Mikra Ilias completes the frame, again reflecting the violation of the domestic sphere.[17]

Possible Chronology of the Epic Accounts of the Murder of Priam

Any attempt to determine the chronological relationship between early epic passages is a matter of speculation and can never be absolute, as the epic was a living, oral tradition which allowed mutual and repeated overlapping. The preceding discussion, however, suggests a logical chronological progression among the three known epic versions of Priam's death. Common to both *Iliou Persis* and *Mikra Ilias* are Priam, Neoptolemos, and the altar of Zeus Herkeios, but in the *Mikra Ilias* the location of the murder has been altered: Priam is dragged from the altar and murdered instead at the doorway of the palace. The account recorded in the *Mikra Ilias* is an adaptation, a development upon the earlier account recorded in the *Iliou Persis*.

The stimulus for the shift, I suggest, comes from Priam's vision of his death in *Iliad* 22. Though knowing the precise location of Priam's murder to be the altar of Zeus, the poet of *Iliad* 22 suppresses this information, preferring to evoke the future rather than simply to disclose it outright. Moreover, as a tale of religious sacrilege, the death of Priam as related in the *Iliou Persis* is sharply discordant with the general ethos of the *Iliad*. The poem's aversion to the story is especially apparent in book 24, where, as I will argue below, Achilles' merciful treatment of Priam contrasts with Neoptolemos' sacrilegious treatment of him. To avoid the suggestion of sacrilege in Priam's Ilioupersis vision of book 22, the poet leaves the precise manner of Priam's death ambiguous, fails to mention the altar of Zeus, and introduces instead the doorway as a substitute. The theme of sacrilege is thereby removed, while the theme of domestic dissolution is maintained. The *Mikra Ilias*, assembled after the composition of Priam's vision in *Iliad* 22, includes both altar and doorway, thereby attempting to reconcile the tradition recorded in the *Iliou Persis* with the innovation of the *Iliad*.

2.2 Neoptolemos

In analysing the murder of Priam, one might easily neglect the sacrilegious aggressor and the other family involved, the line of

[17] In his note to Apollodoros' account of the murder (*Epit.* 5. 21), Frazer (1921) ii. 236 remarks, 'According to Lesches, the ruthless Neoptolemos dragged Priam from the altar and despatched him *at his own door*' (my italics).

the Peleids. Though famed as one of the principal warriors at the
Ilioupersis, Neoptolemos enjoys a surprisingly short career within the
Trojan cycle. It is not until after the death of his father Achilles, near
the end of the war, that the Achaians enlist his aid.[18] He arrives,
drives the Trojans into the city, and then participates in the sack—
apparently all in the space of only a few days. Like the Trojan allies
Penthesileia and Memnon, his late arrival sparks only a brief period
of excitement before his work is finished. Despite the suddenness of
his appearance, however, and the short span of his military career,
Neoptolemos is no mere human *deus ex machina*. Though technically
a new character, Neoptolemos is introduced as heir to the recently
departed Achilles—not a shadow of his father, but a worthy successor.
Inheriting Achilles' prowess as a warrior, Neoptolemos replaces him
as the best of the Achaians and thereby slides smoothly into a role
prepared for him during the last ten years at Troy. In the following
pages I outline the network of narrative correlations associating the
son with the father and then return once more to the murder of Priam
to assess its relevance to the father–son relationship.[19]

The epic poets marked the succession from Achilles to Neoptolemos
with a sequence of links between the two, clearly discernible even in
Proklos' brief summary of the *Mikra Ilias*:

καὶ Νεοπτόλεμον Ὀδυσσεὺς ἐκ Σκύρου ἀγαγὼν τὰ ὅπλα δίδωσι τὰ τοῦ
πατρός· καὶ Ἀχιλλεὺς αὐτῷ φαντάζεται. Εὐρύπυλος δὲ ὁ Τηλέφου
ἐπίκουρος τοῖς Τρωσὶ παραγίνεται, καὶ ἀριστεύοντα αὐτὸν ἀποκτείνει
Νεοπτόλεμος. καὶ οἱ Τρῶες πολιορκοῦνται.

[18] According to Apollodoros, *Epit.* 5. 10, Helenos reveals to the Achaians that they
require the aid of Neoptolemos to capture Troy. The same sequence underlies *MI* arg.
6–8.

[19] Neoptolemos' inheritance of his father's role at Troy is paralleled in the Theban
epic cycle, where the seven heroes who initiate the war against Thebes are them-
selves unsuccessful, and it is left instead for their seven sons to capture the city. In the
Trojan cycle, at least in the *Iliad*, the Theban paradigm is evoked through the figure
of Diomedes, or as he is frequently designated, Tydides. See in particular *Il.* 4. 365–
410 for the relationship between the Seven and their sons. Bethe (1922) frequently
remarks on the correlation between Neoptolemos and his father; e.g. on p. 218 he
calls Neoptolemos the 'Ebenbild des Vaters . . . und Vollender dessen, was diesem das
Schicksal versagt hatte'. Discussing the cult of Neoptolemos at Delphi, Fontenrose
(1960) writes 'I am certain that Achilles and Neoptolemos are one and the same
Thessalian hero or god. The distinction between them may have its origin in epic
poetry. Neoptolemos simply repeats his father Achilles . . .'. To support his theory he
then lists twenty-one similarities between the myths of Achilles and Neoptolemos.
Here I shall use some of the same material, but for a different purpose, to demonstrate
how the poets shaped the careers of father and son in relation to one another.

Odysseus, having brought Neoptolemos from Skyros, gives him the arms of his father; and [a phantom of] Achilles appears to him. Eurypylos, son of Telephos, arrives as an ally to the Trojans, and Neoptolemos kills him in the midst of his [Eurypylos'] success. And the Trojans are besieged. (*MI* arg. 10–14)

The arms of Achilles, fashioned and richly adorned by Hephaistos in *Iliad* 18, weapons which after the death of Achilles become the subject of a celebrated quarrel between Aias and Odysseus (*Aith.* arg. 23–4, *MI* arg. 3–4, *Od.* 11. 543–8), fall at last into the possession of Achilles' son, their rightful owner. The transmission of the arms, the warrior's battle outfit, symbolizes Neoptolemos' assumption of his father's role in the war against Troy. Like Patroklos, who doubles for Achilles by wearing his armour, Neoptolemos becomes a second Achilles by inheriting his father's weapons. But unlike Patroklos, Neoptolemos is no temporary substitute for his father. The former, the *Iliad* notes, fails to take Achilles' spear along with the remaining armour (*Il.* 16. 140–4)—an omission symbolic of his failure to assume the role of Achilles fully.[20] Neoptolemos, on the other hand, receives all of the arms, spear included (*MI* fr. 5), and as he soon demonstrates on the battlefield, he knows how to use them effectively.

Shortly after receiving the arms, Neoptolemos is visited by his father's spirit (καὶ Ἀχιλλεὺς αὐτῷ φαντάζεται). The subject of their conversation is not recorded. Perhaps Achilles instructs his son in the proper use of the armour. He might have inspired Neoptolemos on the eve of his entry into battle, perhaps with the common epic sentiment of a father wishing to find in his son a worthy successor.[21] Maybe the restless ghost has left unfulfilled some task which he now asks his son to complete. Whatever the reasons for the visitation, the mere fact that the ghost of Achilles visits Neoptolemos indicates the close association between father and son. Here again the poets define Neoptolemos' role in the epic in terms of his father.

In the following episode Neoptolemos assumes in earnest his part as successor to Achilles. Perhaps inspired by the encounter with his father's ghost, he makes a glorious entry into the war with the defeat of Eurypylos and the consequent rout of the Trojans into the city

[20] On the significance of Patroklos' failure to take the spear see Edwards (1987) 260.

[21] See Odysseus' encounter with Achilles' spirit in *Od.* 11. 492–537, where Achilles is eager to learn of the achievements of his son. Cf. also Hektor's wishes for his son's success at *Il.* 6. 476–81.

(*MI* arg. 12–14). These successes closely parallel Achilles' recent victory over Memnon, as recorded in Proklos' summary of the *Aithiopis*:

Μέμνων δὲ παραγίνεται τοῖς Τρωσὶ βοηθήσων . . . ἔπειτα Ἀχιλλεὺς
Μέμνονα κτείνει . . . τρεψάμενος δ' Ἀχιλλεὺς τοὺς Τρῶας καὶ εἰς τὴν
πόλιν συνεισπεσὼν ὑπὸ Πάριδος ἀναιρεῖται καὶ Ἀπόλλωνος.

And Memnon arrives to aid the Trojans . . . Then Achilles slays Memnon . . . And Achilles, having routed the Trojans and rushed together with them into the city, is slain by Paris and Apollo. (*Aith.* arg. 10–16)

Both Memnon and Eurypylos enlist at a late stage in the war.[22] Both of them die shortly after their entry into the war. In both cases the defeat of the ally results in the retreat of the Trojans to within the city. And presumably it is Neoptolemos who, like his father before him, leads the rout of the Trojans. Neoptolemos' first battle is constructed as a step-by-step re-enactment of Achilles' last battle, with one major exception: Neoptolemos survives. The same sequence that brings Achilles' career to an end begins the career of Neoptolemos.

A tangible poetic trace of the epic connection between the two battles is preserved in *Odyssey* 11, where Odysseus recounts Neoptolemos' accomplishments to the spirit of Achilles. Here he singles out the victory over Eurypylos as particularly praiseworthy:

ἀλλ' οἷον τὸν Τηλεφίδην κατενήρατο χαλκῷ,
ἥρω' Εὐρύπυλον, πολλοὶ δ' ἀμφ' αὐτὸν ἑταῖροι
Κήτειοι κτείνοντο γυναίων εἵνεκα δώρων.
κεῖνον δὴ κάλλιστον ἴδον μετὰ Μέμνονα δῖον.

Oh how he slew with bronze the son of Telephos,
the hero Eurypylos, and many Keteian companions
were slain about him because of the womanly gifts.
And he was the most beautiful I saw after godlike Memnon.

(*Od.* 11. 519–22)

The final remark, comparing Eurypylos with Memnon, is a curious ending to the tale and may be derived from a traditional epic perception of the one hero in terms of the other.[23] Patterned as a double of

[22] In addition, both are distant relations to the Trojan ruling family. Memnon is the son of Priam's cousin, Eurypylos a son of Priam's sister.

[23] The brief reference to 'womanly gifts' indicates that the poet is familiar with the tradition. For details of the myth see *MI* fr. 29. Priam sends to Eurypylos' mother a golden vine wrought by Hephaistos, and she in turn, enticed by this bribe, sends her son to Troy in command of a Mysian force.

Memnon, Eurypylos even looks like him. In the immediate context, where Odysseus directs his narrative of Neoptolemos' victory toward Achilles, the remark implies a connection also between Achilles and Neoptolemos.[24] In comparing Eurypylos with Memnon, the poet is comparing the adversary of Neoptolemos with the adversary of Achilles. While praising Achilles' son as a victorious hero, Odysseus also implicitly recognizes Achilles' own achievements as the standard by which Neoptolemos is to be judged.

In addition to functioning as a parallel to Achilles' last great opponent, Memnon, Eurypylos also evokes the spirit of his father Telephos, the very first of Achilles' opponents in the campaign against Troy. Proklos records the encounter between Telephos and Achilles in his summary of the *Kypria*:

ἔπειτα ἀναχθέντες Τευθρανίᾳ προσίσχουσι καὶ ταύτην ὡς Ἴλιον ἐπόρθουν.
Τήλεφος δὲ ἐκβοηθεῖ Θέρσανδρόν τε τὸν Πολυνείκους κτείνει καὶ αὐτὸς
ὑπὸ Ἀχιλλέως τιτρώσκεται.

Then after sailing they land at Teuthrania and attack, thinking it to be Ilios. And Telephos goes to assist and slays Thersandros son of Polyneikes and is himself wounded by Achilles. (*Kyp.* arg. 36–8)

When the Achaian contingent sails to the Troad for the first time, they mistake the city of Teuthrania for Troy and attack it. Telephos joins in battle against the Achaians and is wounded by Achilles.[25] The sequence is analogous to the later arrival of Neoptolemos in the Troad. Like Telephos, his son Eurypylos will later come to the aid of a city under attack from the Achaians. Telephos confronts Achilles, while his son Eurypylos confronts Achilles' son Neoptolemos. For both Achilles and Neoptolemos, these are the first major military encounters in the war, and both father and son are successful. In other words, the second conflict is patterned as a replay of the first in the subsequent generation.[26] The epic poets are likely to have underlined this narrative correlation through the use of Eurypylos' patronymic, as for example at *Odyssey* 11. 519, where he is designated 'Telephides' (τὸν Τηλεφίδην).[27]

[24] In the narratological terms advocated by de Jong (1989), Achilles would be designated as the primary narratee and focalizee.

[25] See Wilamowitz-Moellendorff (1884) 152–3 and Bethe (1922) 153 and 237–40 for discussion of the role of Telephos in the *Kypria*.

[26] Bethe (1922) 284 compares the two battles similarly.

[27] Cf. *MI* arg. 12: Εὐρύπυλος δὲ ὁ Τηλέφου.

The continuation of the story of Telephos in the *Kypria* reveals a further connection between the two episodes:

ἀποπλέουσι δὲ αὐτοῖς ἐκ τῆς Μυσίας χειμὼν ἐπιπίπτει καὶ διασκεδάννυνται. Ἀχιλλεὺς δὲ Σκύρῳ προσσχὼν γαμεῖ τὴν Λυκομήδους θυγατέρα Δηϊδάμειαν. ἔπειτα Τήλεφον κατὰ μαντείαν παραγενόμενον εἰς Ἄργος ἰᾶται Ἀχιλλεὺς ὡς ἡγεμόνα γενησόμενον τοῦ ἐπ᾽ Ἴλιον πλοῦ.

As they sail from Mysia a storm falls upon them and they are scattered. And Achilleus, landing on Skyros, marries Deidameia, the daughter of Lykomedes. Then Telephos comes to Argos in accordance with an oracle and Achilles heals him so that he may serve as guide for the voyage to Ilios. (*Kyp.* arg. 38–42)

Shortly after the earlier confrontation, it seems, an oracle directs Telephos to Argos, where the Achaians have reassembled their fleet, and there Achilles himself heals the wound.[28] Not by chance, it is in this narrative context, immediately after the wounding of Telephos and before the healing, that Achilles comes to Skyros and marries Deidameia, and it is at precisely this point in the saga that Achilles begets Neoptolemos, who is later to confront the son of Telephos.[29] Thus both blueprint and building material for the future conflict are prepared at the time of the first confrontation between Achilles and Telephos.[30]

By the eve of the sack, Neoptolemos is firmly established as successor of Achilles. He has inherited his father's weapons and with them has symbolically duplicated his father's battles against Memnon and Telephos. As he enters the final battle against the Trojans, he inherits also the savagery of his father's temperament, as witnessed most clearly in the *Iliad* after the death of Patroklos. According to a note of Pausanias on a scene in Polygnotos' Ilioupersis painting probably deriving from the *Mikra Ilias*, Neoptolemos kills a certain Astynoos

[28] See also *Kyp.* frr. 20 and 22.

[29] Although Proklos' summary of the *Kypria* contains no mention of Neoptolemos, fr. 21 (Pausanias, 10. 26. 4), which discusses Neoptolemos' name, is evidence for his inclusion in the poem. We might therefore surmise that he was introduced in the context of Achilles' sojourn on Skyros. Cf. also *Il.* 19. 326–7 and 331–3 for the location of Neoptolemos on Skyros. Schol. *Il.* 19. 326 (*Kyp.* fr. 19) states that Peleus, to avoid sending Achilles on the campaign against Troy, hid him on Skyros, disguised as a girl, and that it was at this time that Achilles fathered Neoptolemos. The fragment is inconsistent with Proklos' summary, unless we accept two visits to the island. Davies (1988) prints the evidence as 'fr. incerti loci intra cyclum epicum no. 4'.

[30] Cf. the genealogical predispositioning of Aias and the sons of Thessalos, discussed in §6.1 below.

after the latter has fallen on his knees, presumably to plead for mercy
(Pausanias, 10. 26. 4 = *MI* fr. 13).[31] The episode resembles Achilles'
treatment of Lykaon, a son of Priam, who in *Iliad* 21 falls on the
ground before Achilles, grasps his knees, and beseeches him for mercy,
promising a rich ransom, but all in vain. Whether or not a strong
narrative correspondence could be established between these two
episodes, the evidence of Pausanias at the very least demonstrates a
similarity of temperament between the Neoptolemos of the *Mikra Ilias*
and the Achilles of *Iliad* 19–22.[32] Along with valour and strength,
Neoptolemos has inherited Achilles' wrath ($\mu\hat{\eta}\nu\iota\varsigma$) and has acquired
a passion for slaughter perhaps rooted in a desire to avenge his father's
death.

The sequence of correlations between Achilles and Neoptolemos
reaches its inevitable climax with the dialectic between Priam's suc-
cessful supplication of Achilles in *Iliad* 24 and his fatal encounter
with Neoptolemos at the Ilioupersis. Given the intensity of the cor-
relations witnessed thus far, the deeds of the son practically doubling
the acts of the father, it is impossible not to recognize reverbera-
tions within one or both of these two climactic partner scenes. The
son whose every step so far has been modelled on the career of his
father is at last granted his own variation on the crowning episode
of the Iliadic tradition, the ransoming of Hektor's corpse. But while
Achilles' wrath subsides at the gripping plea of the bereaved father
of *Iliad* 24, Neoptolemos knows no restraint and savagely murders
the king, in violation of the sanctuary afforded by the altar of Zeus.

While acknowledging a correlation in act and in temperament
between Achilles and Neoptolemos, the *Iliad* carefully dissociates the
two, ultimately distinguishing its own hero's actions from the sub-
sequent sacrilegious crime of Neoptolemos. Although Priam comes
to no harm in book 24, the poem nevertheless devotes considerable

[31] Describing Polygnotos' depiction of the Ilioupersis, Pausanias writes, 'Astynoos,
whom Lescheos also mentions, has fallen to his knees and Neoptolemos strikes him
with a sword' (Ἀστύνοον δέ, οὗ δὴ ἐποιήσατο καὶ Λέσχεως μνήμην, πεπτωκότα
ἐς γόνυ ὁ Νεοπτόλεμος ξίφει παίει). Here I assume that the entire scene is derived
from the *Mikra Ilias*, although Pausanias' account does not make this certain. For
further discussion of this scene and Polygnotos' painting see §14.1.

[32] The prominence of the sword in both cases suggests the possibility of a direct
correlation between the episodes. Recall that Achilles first attacks Lykaon with his
spear (*Il.* 21. 67–72), but later kills him with his sword (*Il.* 21. 116–18). Pausanias
records specifically that Neoptolemos strikes Astynoos with a sword. Unfortunately,
Astynoos' paternity is not preserved. If he were a son of Priam, the case for a correla-
tion would be further strengthened.

attention to the possibility of the kind of violence later to emerge. Hekabe reacts to Priam's proposed mission to Achilles with fear for his life:

εἰ γάρ σ' αἱρήσει καὶ ἐσόψεται ὀφθαλμοῖσιν,
ὠμηστὴς καὶ ἄπιστος ἀνὴρ ὅ γε, οὔ σ' ἐλεήσει,
οὐδέ τί σ' αἰδέσεται.

If he seizes and looks upon you with his eyes,
that bloodthirsty and untrustworthy man, he will not pity you,
nor grant you any respect.

(*Il.* 24. 206–8)

The man who has killed her son and mistreated his corpse (*Il.* 24. 204–5, 208–13) cannot now be expected to show mercy to the father. During the mission her warning is echoed by Achilles himself:

τῶ νῦν μή μοι μᾶλλον ἐν ἄλγεσι θυμὸν ὀρίνῃς,
μή σε, γέρον, οὐδ' αὐτὸν ἐνὶ κλισίῃσιν ἐάσω
καὶ ἱκέτην περ ἐόντα, Διὸς δ' ἀλίτωμαι ἐφετμάς.

So do not raise my anger further in grief,
lest I not spare even you here in the tent, old man,
and violate the injunctions of Zeus, although you are a suppliant.

(*Il.* 24. 568–70)

Although Achilles recognizes Priam's suppliant status and the protection afforded him by Zeus, when angered by Priam's impatience (*Il.* 24. 553–5), he threatens to ignore Zeus' injunctions and to kill Priam despite his suppliant status. The violence, however, remains suppressed, Achilles treats the suppliant with respect, and the old man returns safely to Troy. Zeus' assurance to Priam is fulfilled: 'for he is not senseless, not imprudent, not wicked, | but will earnestly spare the suppliant man' (οὔτε γάρ ἐστ' ἄφρων οὔτ' ἄσκοπος οὔτ' ἀλιτήμων, | ἀλλὰ μάλ' ἐνδυκέως ἱκέτεω πεφιδήσεται ἀνδρός—*Il.* 24. 157–8). While intensifying the drama of the present episode, these undercurrents of violence also reflect Priam's future confrontation with Achilles' son, where the threats will become reality. There Priam is again presented under the protection of Zeus, situated at the very altar of the god. But unlike his father, Neoptolemos will disregard the suppliant's sanctity and Zeus' injunctions, and in doing so will condemn himself as 'senseless', 'imprudent', and 'wicked'.

The tendency to oppose Achilles and Neoptolemos may have been operative also in narratives of Priam's murder, and a glance ahead

to Vergil shows how. During Neoptolemos' rampage at the palace, immediately after he has slain Polites before the very eyes of Priam, the king contrasts Neoptolemos' behaviour with that of his father:

> sed iura fidemque
> supplicis erubuit corpusque exsangue sepulcro
> reddidit Hectoreum meque in mea regna remisit.
>
> Rather he respected
> the rights and faith of the suppliant and returned Hektor's
> bloodless body for burial and sent me back to my kingdom.

<div align="right">(Aeneid 2. 541–3)</div>

With this allusion Vergil explicitly contrasts the past peaceful encounter between Priam and Achilles with the present hostile encounter between Priam and Neoptolemos. In response to Priam's outburst (and to the throw of a javelin) Neoptolemos sends him to Hades with a sarcastic command: that he himself inform Achilles of the behaviour of his degenerate son ('degenerem'—*Aeneid* 2. 549).

Tryphiodoros, while his account of Priam's death is far less detailed than Vergil's, again includes a recollection of the previous encounter:

> οὐδὲ λιτάων
> ἔκλυεν, οὐ Πηλῆος ὁρώμενος ἥλικα χαίτην
> ᾐδέσατ᾽, ἧς ὕπο θυμὸν ἀπέκλασεν ἠδὲ γέροντος
> καίπερ ἐὼν βαρύμηνις ἐφείσατο τὸ πρὶν Ἀχιλλεύς
>
> nor did he listen to
> his prayers, did not feel reverence seeing the ageing head of Peleus,
> before which Achilles, though deep in wrath,
> had previously broken his anger and spared the old man.

<div align="right">(Tryphiodoros, 636–9)</div>

Tryphiodoros recalls here Priam's first words to Achilles, in which the old man compares himself with Achilles' own father Peleus (*Il.* 24. 486–92). While the memory of his father Peleus aroused pity in the heart of Achilles, Neoptolemos is instead spurred on to violence by the memory of his father. In Quintus Smyrnaeus' account of the murder we find yet another recollection of Priam's meeting with Achilles. Here the king boldly instructs Neoptolemos to kill him, with the added wish that Achilles had killed him previously when he ransomed the body of Hektor (13. 226–36). Given the prevalence of

allusion in these later accounts, it is unlikely that the Archaic poets failed to exploit so fruitful a correlation.

Further reverberations of Neoptolemos' crime appear in a few other passages of the surviving early epic. In Andromache's recollection of the sack of Thebe in *Iliad* 6, which is closely modelled on the sack of Troy and the destruction of its ruling family, one element contrasts sharply with the future sack.[33] When Achilles kills Andromache's father Eetion, he allows the body proper funeral rites:

> οὐδέ μιν ἐξενάριξε, σεβάσσατο γὰρ τό γε θυμῷ,
> ἀλλ᾽ ἄρα μιν κατέκηε σὺν ἔντεσι δαιδαλέοισιν
> ἠδ᾽ ἐπὶ σῆμ᾽ ἔχεεν· περὶ δὲ πτελέας ἐφύτευσαν
> νύμφαι ὀρεστιάδες, κοῦραι Διὸς αἰγιόχοιο.

He did not strip him of armour, for he felt shame in his heart,
but burned him with his well-wrought arms
and heaped a marker over him; and mountain nymphs,
daughters of aegis-bearing Zeus, grew elm trees around it.

(*Il.* 6. 417–20)

This attention to Achilles' piety (σεβάσσατο) and to the honourable funeral of Andromache's father seems of little relevance in the immediate context, where the essential theme is the death of the father and Andromache's bereavement. But the detail grows in significance when viewed in conjunction with future events. As the poem progresses, Achilles will shed the layer of respect which he showed for Eetion's body and will reveal in his contrasting mutilation of Hektor's corpse a pitiless, savage heart, not to be sated until his reconciliation with Priam in book 24.[34] Eetion's death is a negation of Hektor's fate, as is suggested by the negative formulation, the emphatic denial that Achilles stripped Eetion of his arms: 'he did *not* strip him . . . | *but rather* he burned him . . .' (οὐδέ μιν ἐξενάριξε . . . | ἀλλ᾽ ἄρα μιν κατέκηε . . .). Taken a step further and analysed in comparison with the future sack of Troy, Eetion's funeral may function also as a foil for the ultimate fate of Priam. In the context of the Trojan saga as a whole these lines might be read to imply, 'Neoptolemos killed Priam dishonourably, *but* Achilles treated Eetion with honour.' The piety of Achilles is contrasted with the impiety of

[33] For further discussion of this passage see §3.2 below.

[34] Zarker (1965) 114 observes that Achilles' chivalrous behaviour in this passage contrasts with his later brutality in the *Iliad*, and Taplin (1986) 18 contrasts Achilles' respectful treatment of Eetion with his harsh treatment of Hektor's corpse.

his son—the same contrast underlying book 24 and Priam's embassy to Achilles.

Implicit condemnation of Neoptolemos' act can also be observed in the *Odyssey*. In book 11, as Odysseus narrates to Achilles the brave deeds of his son at the end of the war, he omits any mention of Neoptolemos' most notorious deed, the murder of Priam:

> ὁ δέ με μάλα πόλλ' ἱκέτευεν
> ἱππόθεν ἐξέμεναι, ξίφεος δ' ἐπεμαίετο κώπην
> καὶ δόρυ χαλκοβαρές, κακὰ δὲ Τρώεσσι μενοίνα.
> ἀλλ' ὅτε δὴ Πριάμοιο πόλιν διεπέρσαμεν αἰπήν,
> μοῖραν καὶ γέρας ἐσθλὸν ἔχων ἐπὶ νηὸς ἔβαινεν
> ἀσκηθής . . .

> And he pleaded with me repeatedly
> to exit the horse and kept fingering the handle of his sword
> and the spear of heavy bronze, and he thought of woes for the Trojans,
> but when we had destroyed the lofty city of Priam,
> taking his share of spoils and honour, he embarked
> unharmed . . .

> (*Od.* 11. 530–5)

Odysseus' narrative proceeds from the hiding of the warriors within the horse directly to the division of spoils, ignoring details of the attack itself. The image of Neoptolemos eager to unleash his weapons, already imagining his assault on the Trojans, might stimulate the audience to expect some subsequent narration of the planned assault, but Odysseus leaves that expectation unfulfilled. The missing element, of course, is the slaying of Priam, the most memorable of Neoptolemos' Ilioupersis achievements. This episode would complete the narrative chain, but the sacrilegious and brutal assault would also sit uncomfortably in Odysseus' encomium of the hero. So just as in book 9 of the *Iliad* Odysseus censures the less palatable portion of Agamemnon's peace-offering to Achilles, now narrating to Achilles the glorious deeds of his son Neoptolemos, he wisely passes over this unsavoury morsel in silence.[35]

[35] For a possible negative echo of Neoptolemos' crime at *Od.* 22. 330–80, see §5.2 below.

3

Daughters and Daughters-in-Law

Of the twelve daughters and the many daughters-in-law who inhab-
ited Priam's palace, Ilioupersis sources focus their attention primar-
ily on three: Kassandra, Polyxene, and Andromache. The rest, Helen
excepted, seem not to have been elevated to canonical status in the
tradition. Apollodoros records that a chasm opens in the earth to
engulf Laodike (*Epit.* 5. 25), the princess accompanying Hekabe at
her meeting with Hektor in *Iliad* 6; but, although Lykophron's allu-
sion to the fate of Laodike at *Alexandra* 316–22 would suggest an
earlier, possibly Classical treatment, the episode remained on the
periphery of the tradition, and no evidence associates it with the early
epic. Pausanias lists the names of several other Trojan women in his
commentary on Polygnotos' Ilioupersis, but few reappear in other
sources, verbal or visual.

3.1 Kassandra

Curiously analogous to the sacrilegious end of Priam is the fate of
his beautiful daughter Kassandra, attacked by Aias in the temple
of Athena during the nocturnal battle.[1] Proklos records the episode
in his *Iliou Persis* summary: 'Aias son of Oileus, violently dragging
Kassandra away [from the statue], in the process overturns the statue
of Athena' (Κασσάνδραν δὲ Αἴας ὁ Ἰλέως πρὸς βίαν ἀποσπῶν
συνεφέλκεται τὸ τῆς Ἀθηνᾶς ξόανον—IP arg. 15–16). Like her fa-
ther Priam, who takes shelter at the altar of Zeus on the night of the
attack, Kassandra seeks divine protection at a religious sanctuary,
but in vain. Just as Neoptolemos ignores Priam's suppliant status at
the altar of Zeus, so Aias ignores Kassandra's rights as a suppliant of

[1] For Kassandra's participation in the earlier episode of the wooden horse see §1.2
above.

Athena, and in dragging her from the sanctuary, commits an act of sacrilege against the goddess. The familial relationship between the two offended deities, Zeus and his virgin daughter Athena, is appropriately analogous to that between the human victims, Priam and his daughter Kassandra. Together the two episodes not only incriminate the Achaian attackers for their reckless fury, but also convey a sense of divine abandonment. As Athena spurns the prayers of the Trojan women in *Iliad* 6 and Apollo deserts Hektor in *Iliad* 22, so the gods now appear to have forsaken the Trojans utterly.[2]

Apollodoros' account of the incident offers a few additional details, indicating a sexual motive for the attack: 'Lokrian Aias, seeing Kassandra embracing the statue of Athena, overpowers [rapes] her; because of this the statue looks toward the sky' (Αἴας δὲ ὁ Λοκρὸς Κασάνδραν ὁρῶν περιπεπλεγμένην τῷ ξοάνῳ τῆς Ἀθηνᾶς βιάζεται· διὰ ⟨τοῦ⟩το τὸ ξόανον εἰς οὐρανὸν βλέπει—*Epit.* 5. 22). Several elements in this account suggest sexual motivation. The word βιάζεται, though it may at times mean simply 'force', 'overpower', or 'use violence against', in this charged context carries also an implication of sexual force, as elsewhere in Apollodoros' compendium.[3] Apollodoros' attention to Aias' sense of sight (ὁρῶν), a detail hardly worthy of inclusion in so brief a summary unless it derives from a significant detail in a poem or traditional account, may also imply sexual arousal. Sight and lust are similarly paired in one popular epic account of the reunion of Helen and Menelaos, where the rage of the attacking male viewer dissipates at the sight of Helen's body.[4] According to Apollodoros then, Aias' intention is not merely to attack, but to rape one of Priam's most beautiful daughters at the very sanctuary of a virgin goddess. Here again the deity makes no motion to intervene, but the statue does at least respond with the aversion of its eyes. Though the pose might appear prudish in a burlesque context, here it clearly indicates divine disapproval of Aias' behaviour.[5]

[2] The myth of Kassandra's ambivalent relationship with Apollo echoes the abandonment theme (e.g. Aischylos, *Agamemnon* 1080–2). Whether this tale lies in the background of Aias' attack cannot be determined.

[3] Cf. the use of this word in Nessos' attack on Deianeira at *Bib.* 2. 151: ὁ δὲ πορθμεύων αὐτὴν ἐπεχείρει βιάζεσθαι.

[4] See Ch. 8 n. 32 for the evidence of Sch. Arist. *Lys.* 155 = *MI* fr. 19, and see §13.5 for an iconographic pairing of the two episodes.

[5] 6th- and 5th-c. vase-painters depict the statue in a variety of significant poses, discussed below in §12.2.

Aias' reprehensible reaction to the sight of Kassandra harmonizes thematically with several other accounts of Kassandra's beauty given in earlier chapters of the saga. At *Iliad* 24. 699 she is compared with Aphrodite—a rare distinction, as Taplin observes, awarded elsewhere in the *Iliad* only to Briseis (19. 282).[6] In book 13 her beauty has attracted the attention of Othryoneus, who has joined the war with hopes of marrying her—'he asked for the most beautiful of Priam's daughters' (ἤτεε δὲ Πριάμοιο θυγατρῶν εἶδος ἀρίστην—*Il.* 13. 365)—and has promised in return to drive the Achaians away from Troy (*Il.* 13. 363–9). The *Mikra Ilias* seems to have narrated a similar story of another late-arriving suitor, Koroibos, whose bid for the hand of Kassandra also met with failure.[7] With the violation and dissolution of the family at the Ilioupersis, these socially accepted proposals degenerate into the illegitimate advances of Achaian invaders. The same beauty which drew the attention of the suitors, now rouses the unholy desires of Aias,[8] and finally attracts the interest of the Achaian commander Agamemnon, who selects her as his personal prize from among the spoils of the conquest.[9]

While Kassandra herself appears only rarely in the *Iliad*, and the poem seems either ignorant of or indifferent to her future suffering, Kassandra's fate shares many features with the story of Chryseis, whose abduction motivates the opening scenes of the *Iliad*. Like Kassandra, enslaved to Agamemnon at the sack of Troy, Chryseis has been captured at the sack of Thebe, and in the division of spoils among the Achaian chieftains, she too falls to Agamemnon (*Il.* 1. 366–9). Both captives are linked with the god Apollo. Kassandra's gift of prophecy derives from her association with the mantic god, and Chryseis is the daughter of Chryses, priest of Apollo (*Il.* 1. 370). In addition, Kassandra and Chryseis are each at the centre of a case of divine vengeance against the Achaians. When Agamemnon refuses

[6] Taplin (1992) 280.

[7] For Koroibos see *MI* fr. 15 and Pap. Rylands 22, which Bernabé (1987) prints as *MI* arg. no. 2. At *Aeneid* 2. 402–26 he dies while attempting to defend his betrothed.

[8] Whether or not Aias fulfilled his intentions may have varied among the epic accounts. S. West (1990) 3 has argued against actual violation on the grounds that Agamemnon, who later takes Kassandra as his concubine, would have deemed her unsuitable if already violated. In the *Iliad*, however, Agamemnon declares no objection to Briseis, who has previously been serving as concubine to Achilles.

[9] Kassandra's enslavement to Agamemnon is attested already at *Od.* 11. 421–3. Although Proklos fails to specify the detail, it may be understood as part of the division of spoils mentioned at *IP* arg. 21 (καὶ τὰ λοιπὰ λάφυρα διανέμονται).

to relinquish his captive, her father Chryses invokes the wrath of
Apollo against the entire army. Aias, in turn, by attacking Kassandra
in the temple of Athena, rouses the goddess's anger not only against
himself, but against all the Achaians who fail to redress his wrong.[10]

Fragments of the *Kypria*, which contained an account of the
sack of Thebe, reveal a further connection between Chryseis and
Kassandra. According to Eustathios, the *Kypria* narrated that Chryseis
came to Thebe to perform or take part in a sacrifice to Artemis (ἐπὶ
θυσίαν Ἀρτέμιδος ἐλθοῦσα, ὡς ὁ τὰ Κύπρια γράψας ἔφη—
Eustathios on *Il.* 1. 366, p. 119 = *Kyp.* fr. 28. I). A scholion on *Iliad* 1.
366 (*Kyp.* fr. 28. II) records that Chryseis' hostess Iphinoe, a sister of
Eetion, performs a sacrifice to Artemis (εἰς Θήβας δὲ ἤκουσα ἡ
Χρυσηὶς πρὸς Ἰφινόην, τὴν Ἠετίωνος ἀδελφήν, Ἄκτορος δὲ
θυγατέρα, θύουσαν Ἀρτέμιδι ἥλω ὑπὸ Ἀχιλλέως). The evidence
suggests that the Achaians captured the city while Iphinoe was per-
forming a sacrifice, which Chryseis was attending, and thus, like the
abduction of Kassandra, the abduction of Chryseis seems to have been
set within a context of sacrilege.

Given the number of close analogies, it is difficult to deny that
a poetic process of assimilation underlies the correlation. Since
Kassandra's is the more familiar story and the Ilioupersis the more
monumental capture, Kassandra seems more likely to have provided
the model for Chryseis than vice versa, but this does not preclude the
possibility that accounts of Kassandra's fate at the Ilioupersis were in
turn enriched by details borrowed from Chryseis episodes. That the
poets took the relationship a step further and developed a dialogue of
narrative significance between the two figures is doubtful. Although
the poets were shaping Thebe into a miniature Troy and replicating
Ilioupersis events and themes in this smaller capture, the relation-
ship between Kassandra and Chryseis does not achieve the kind of
complexity exemplified in the dialectic between Achilles and Neop-
tolemos, where the father–son succession lends greater effect to the
parallels and inspires explicit allusions. The re-emergence of another
actual narration of Thebe's destruction, like Andromache's recollec-
tion in *Iliad* 6, might prove otherwise, but the evidence presently avail-
able favours only a compositional relationship, one in which travelling
motifs enhance the plots of partner episodes but do not encourage a
more active narrative dialogue.

[10] See §5.1 below for discussion of the crime and its penalty.

3.2 Andromache and Astyanax

The enslavement of Andromache, Priam's daughter-in-law, and the murder of Astyanax, Priam's grandson, form another major chapter in the dissolution of Troy's royal family and another major bridge between *Iliad* and Ilioupersis. According to Proklos' *Iliou Persis* summary, which records the two events in conjunction, Neoptolemos receives Andromache as his share in the spoils and Odysseus murders her son (καὶ 'Οδυσσέως Ἀστυάνακτα ἀνελόντος Νεοπτόλεμος Ἀνδρομάχην γέρας λαμβάνει—*IP* arg. 20–1). Fragment 21 of the *Mikra Ilias* again records the two events side by side, but instead of Odysseus, Neoptolemos is here identified as the child's murderer:

αὐτὰρ Ἀχιλλῆος μεγαθύμου φαίδιμος υἱὸς
Ἑκτορέην ἄλοχον κάταγεν κοίλας ἐπὶ νῆας.
παῖδα δ᾽ ἑλὼν ἐκ κόλπου ἐϋπλοκάμοιο τιθήνης
ῥῖψε ποδὸς τεταγὼν ἀπὸ πύργου, τὸν δὲ πεσόντα
ἔλλαβε πορφύρεος θάνατος καὶ μοῖρα κραταιή.

The brilliant son of great-spirited Achilles
led Hektor's wife to the hollow ships,
and snatching the child from the bosom of his lovely-haired nurse,
took him by the foot and hurled him from a tower, and when he fell
dark death and mighty fate took hold of him.

(*MI* fr. 21. 1–5)

Here the role of Neoptolemos expands, while that of Odysseus diminishes. The fragment by itself, however, does not deny the possibility of Odysseus' involvement; nor can we rule out the possibility that the *Iliou Persis* allowed Neoptolemos a share in the murder.

As in Euripides' *Troades* (721–5), Odysseus' involvement as narrated in the *Iliou Persis* conforms with his traditional characterization as shrewd counsellor to the Achaians. By executing the son of Troy's greatest hero, he guards against the possible reprisals of future generations. Shifting its attention to Neoptolemos, fragment 21 of the *Mikra Ilias* integrates the murder of Astyanax instead into the series of events correlating Neoptolemos with his father Achilles. As in the case of Telephos and Eurypylos, here again the second generation resumes a conflict begun by the first, when the son of Achilles murders the son of Hektor. This theme of filial succession also underlies the enslavement of Andromache in both poems. By slaying Hektor, Achilles has technically earned possession of his wife, but in the ultimate

absence of Achilles she falls instead to the hero's son.[11] Having inherited Achilles' armour, battle prowess, and temperament, Neoptolemos now inherits also the Trojan captive originally destined for his father.

Although this fragment is disappointing in its brevity and lack of narrative detail, as if composed for a summary catalogue rather than a monumental or dramatic epic, it nevertheless offers a rare glimpse of how poets could embed genealogical associations into the language of the Ilioupersis poems. Neoptolemos is identified not by name, but as the 'brilliant son of great-spirited Achilles' (Ἀχιλλῆος μεγαθύμου φαίδιμος υἱὸς—*MI* fr. 21. 1). Similarly, instead of using the name Andromache, the poet designates the captive woman as 'Hektor's wife' (Ἑκτορέην ἄλοχον—*MI* fr. 21. 2), and by analogy the designation of Astyanax as 'child' (παῖδα—*MI* fr. 21. 3) implies 'child of Hektor'. More than formulaic circumlocutions, these paternal and conjugal designations project the past conflict onto the present. To say that 'the son of Achilles' enslaves 'Hektor's wife' and murders 'Hektor's child' is to arouse the memory of Achilles' victory over Hektor and to interpret the present as a consequence of that past defeat.

The correlation between the Iliadic tale of Hektor's defeat and the suffering of his wife and son at the Ilioupersis is audible also in a few noted passages of the *Iliad* itself. In her lament over the corpse of Hektor in book 24, Andromache simultaneously anticipates the fall of the entire city as a consequence of her husband's death (*Il.* 24. 729–30) and implicitly links the predicted destruction of the city with the death of her child: 'I do not think he | will reach adolescence; before that his city will be utterly | destroyed' (οὐδέ μιν οἴω | ἥβην ἵξεσθαι· πρὶν γὰρ πόλις ἥδε κατ᾽ ἄκρης | πέρσεται—*Il.* 24. 728–9). Furthermore, she continues, the women of the city formerly protected by Hektor will be led away in the ships of the Achaians with herself among them (*Il.* 24. 730–2). As in book 22, where Hektor's resolve to face Achilles prompts Priam to envision the ultimate consequences for the royal family, Hektor's death evokes a similar prediction from Andromache here in book 24. The poet is again forging an explicit narrative link between the close of this work and that imminent chapter of the saga.

The lines that follow this statement witness an even more precise correspondence between the *Iliad* and Ilioupersis traditions. Revising the previous assessment of her son's fate in a brief moment of

[11] Cf. Achilles' acquisition of Briseis as explained at *Il.* 19. 291–300.

optimism, Andromache now considers two possible alternatives for the boy (*Il.* 24. 732–8). Either he will be enslaved together with his mother, or some Achaian, whose relative has been slain by Hektor, 'will take him by the hand and hurl him from a tower, dismal destruction' (ῥίψει χειρὸς ἑλὼν ἀπὸ πύργου, λυγρὸν ὄλεθρον—*Il.* 24. 735). This very same motif appears in fragment 21 of the *Mikra Ilias*, which records that Neoptolemos 'took him by the foot and hurled him from a tower' (ῥῖψε ποδὸς τεταγὼν ἀπὸ πύργου—*MI* fr. 21. 4). Common to the two passages is the formulaic phrase ῥίπτειν . . . ἀπὸ πύργου, occurring at the same position within the hexameter in both *Iliad* and *Mikra Ilias*.[12] The variation between 'hand' and 'foot' in *Iliad* and *Mikra Ilias* respectively—the body-part by which the child is grabbed—rather than indicating a divergence between mythic traditions, results merely from differences in the metrical environment. Since the future form ῥίψει fills an initial spondee in *Iliad* 24. 735, the line will not accommodate the words ποδὸς τεταγών, and hence the permutation χειρὸς ἑλών occurs instead. Despite this minor metrical discrepancy, the formulas are parallel and the basic image pictured by both poems is the same: an Achaian warrior grasps the child and hurls him from the tower.

Although the correlation is undeniable, attempts to chart precisely the chronological evolution of the motif between the two sources will inevitably run aground in personal preference or indecision. Did the poet of *Iliad* 24 compose Andromache's vision in imitation of a pre-existing Ilioupersis tradition, or did the Ilioupersis tradition adopt the image from the *Iliad*? Since Hektor's influence in the saga appears to be concentrated in the *Iliad*, he has sometimes been deemed an Iliadic invention. Accordingly, Hektor's wife and child may also be christened Iliadic offspring, and their eventual fates as anticipated in *Iliad* 24 might therefore be interpreted as specifically Iliadic innovations.[13] The cursory narration of the murder in fragment 21 of the *Mikra Ilias* would seem more likely to have been composed in imitation of *Iliad* 24 than to have provided a model for it. We need not assume, however, that fragment 21 of the *Mikra Ilias* was the only epic narration of this motif in an Ilioupersis context, and we cannot rule out a more complicated ancestry for the child's death, involving a series of

[12] Also shared by both passages, but without a similarity in diction, is the subsequent mention of the child's death.

[13] See Monro (1901) 369. More recently Kullmann (1960), wishing to see Hektor as a relatively late addition to the saga, has argued similarly.

mutual interactions. While the figure of Hektor may indeed have risen to prominence initially within an Iliadic tale and then exerted influence over other sections of the saga, those other sections of the saga may in turn have exercised influence over the further development of the Iliadic tradition.

My own preference is to interpret the *Iliad* passage as an artful allusion to events which we know will take place at the Ilioupersis, a poetic means of contributing a further dimension to Andromache's suffering.[14] As the epic tradition of Priam's death at the hands of Neoptolemos is reflected in *Iliad* 22 and 24, so too the *Iliad* deliberately reflects the traditional death of Astyanax.[15] Yet I think of this not primarily as firm evidence for the chronological priority of an Ilioupersis narrative, but as a further indication that Iliad and Ilioupersis traditions evolved side by side. In fact, the same poet might have contributed the detail of the child's death to both Iliadic and Ilioupersis narratives, with only a few days or weeks separating the performances. Furthermore, even if we suppose that the detail of Astyanax's death did emerge first in the Iliadic tradition, we must nevertheless acknowledge that, in duplicating that motif at the Ilioupersis, the epic poets have manipulated and reshaped the Iliadic tradition also, opening an unavoidable channel of communication between Andromache's vision in *Iliad* 24 and the eventual murder of her child at the Ilioupersis. Hearing her speech and knowing the traditions of Troy's fall, we cannot help but anticipate the traditional fall of the child from the walls of Troy.

Iliad 6 offers another series of correspondences with the Ilioupersis tradition of Astyanax and Andromache. Our first glimpse of the Ilioupersis here surfaces in Andromache's narrative of her family history, in which she recalls to Hektor how Achilles attacked her home city of Thebe, slew her father Eetion and her seven brothers, took possession of the city's herds and flocks, and took her mother captive (*Il.* 6. 414–26). In this episode the poet recalls Thebe's fall as

[14] Macleod (1982) 151, commenting on *Il.* 24. 734–8, asserts that Homer knew the tradition of Astyanax hurled from the wall. He compares the counterbalancing of possibilities in Andromache's speech—enslavement or death—with *Il.* 21. 113, where, Macleod notes, 'Achilles predicts that he will be killed either by a spear, or by an arrow (the truth; cf. 21. 278).'

[15] The balancing of possibilities in Andromache's speech—slavery or death—might also reflect a tale of dispute among the Achaians over the fate of Astyanax. Euripides, *Troades* 721—νικᾷ δ' Ὀδυσσεὺς ἐν Πανέλλησιν λέγων . . . —implies that the Achaians debated the fate of the child.

an artful reflection of the eventual destruction of Troy and its ruling family.[16] Thebe itself, situated beneath wooded Plakos, is a replica of Troy (Ilios), situated in the plain of Ida.[17] Like Priam and Troy, Eetion and Thebe come to an end simultaneously, and the death of the king and the sack of his city are intimately connected through repeated juxtaposition in lines 414–16: 'Achilles killed my father, he sacked Thebe, he killed Eetion.' In addition to the king, Achilles kills his seven sons—a diluted echo of the fifty sons of Priam and their deaths at the hands of Achilles. And like the women of Priam's family, Andromache's mother is taken captive by the victors. As in the case of Troy, the sack of Thebe consists in essence of the destruction of its ruling family: the men are slain and the women enslaved. The passage looks back upon a past which the poets have created in the image of Andromache's future. Having suffered the loss of one family at the sack of Thebe, she will soon suffer the same at the sack of Troy.

Further images of the sack surface as the parting conversation between husband and wife continues. Meeting now for the last time, Hektor and Andromache already perceive the disaster ahead, though they suppress their fears behind forced cheerfulness and false hopes. Hektor senses that the Achaians will take Andromache captive, and he even envisions her weeping in her future servitude:

> καί ποτέ τις εἴπῃσιν ἰδὼν κατὰ δάκρυ χέουσαν·
> ῾῾Ἕκτορος ἥδε γυνή, ὃς ἀριστεύεσκε μάχεσθαι
> Τρώων ἱπποδάμων, ὅτε Ἴλιον ἀμφιμάχοντο.᾽᾽

> And seeing you shedding tears, someone might one day say,
> 'This is the wife of Hektor, who was the best in battle
> of the horse-taming Trojans, when they fought round Ilios.'

> (*Il.* 6. 459–61)

Though Hektor, as he himself tells us, is the best of the Trojan warriors, his superior prowess nevertheless cannot save his wife from her fate of slavery. Also ironic here is the fact that Andromache's marital identity as wife of Hektor will determine the nature of her slavery, as

[16] Cf. Taplin (1986) 19, who writes, 'the neighbouring cities prefigure the fate of Troy. Their men, young and old, their women, and their splendid possessions have suffered the fate which is closing in on the city of Priam.' Note also that the *Iliad* recalls the sack of Thebe in several other passages by drawing attention to possessions gained by Achilles in that victory: a lyre at 9. 186–9, the horse Pedasos at 16. 152–4, and a lump of iron at 23. 826–9.

[17] See e.g. *Il.* 13. 13–14, one of many passages which reveal the proximity of Troy to Ida.

we know from the *Mikra Ilias*, where she will be awarded to the son of Hektor's arch enemy.

Like Andromache, Astyanax too acquires an identity in book 6 largely dependent on his relation to Hektor. The poet labels the child with his patronymic 'Hektorides' at 6. 401 and then proceeds to explain that the very name 'Astyanax' derives from his father's role as defender of the city (6. 402–3). Just as he imagines a future spectator identifying Andromache as the wife of Hektor, best of the Trojans, the father also imagines the future of his son in terms of himself, though in altruistic terms: 'one day someone might say "this man is far superior to his father"' (καί ποτέ τις εἴποι "πατρός γ' ὅδε πολλὸν ἀμείνων"—6. 479). But of course, Hektor's hopes for his son's success contrast bitterly with the child's ultimate fate, and ironically, it is the boy's identity as son of Hektor that will eventually determine his death.

Two features of the encounter in particular seem to anticipate the future murder. First, the present meeting between Hektor and his son takes place at the Skaian gates (6. 392–3), presumably the same tower from which the child is later hurled to his death (*Iliad* 24. 735, *MI* fr. 21. 4). Second, the dramatic poet incorporates an image of the future into the staging of the present scene when the father reaches out to his child and, frightened by the sight of the helmet, the infant shrinks back into the bosom of the nurse:

Ὣς εἰπὼν οὗ παιδὸς ὀρέξατο φαίδιμος Ἕκτωρ·
ἂψ δ' ὁ πάϊς πρὸς κόλπον ἐϋζώνοιο τιθήνης
ἐκλίνθη ἰάχων, πατρὸς φίλου ὄψιν ἀτυχθείς.

Having said this, shining Hektor reached out to his child;
but the child shrank back to the bosom of his well-girdled nurse,
crying, startled by the sight of his own father.

(*Il.* 6. 466–8)

This eerie scene pre-enacts the future encounter between Neoptolemos and Astyanax, where instead of Hektor, Neoptolemos will reach out for the child and attempt to take him from the bosom of the nurse (παῖδα δ' ἑλὼν ἐκ κόλπου ἐϋπλοκάμοιο τιθήνης—*MI* fr. 21. 3).[18]

[18] *MI* fr. 21. 3 and *Il.* 6. 467 exhibit striking formulaic similarity. As in the case of similarity between *MI* fr. 21. 4 and *Il.* 24. 735, however, the fragment from the *Mikra Ilias* is brief, and we might imagine a more detailed version of the scene in which, as in the encounter between father and son, the child shrinks into the bosom of the nurse at the sight of Neoptolemos.

In *Iliad* 6 the child himself seems to anticipate already the horrifying future that awaits him.

3.3 Polyxene

Proklos ends his *Iliou Persis* summary with a note on the sacrifice of Polyxene, another daughter of the royal household (ἔπειτα ἐμπρήσαντες τὴν πόλιν Πολυξένην σφαγιάζουσιν ἐπὶ τὸν τοῦ Ἀχιλλέως τάφον—IP arg. 22–3). Though unable to participate in the capture of Troy, Achilles is not deprived of his share in the spoils of the conquered city. Like Agamemnon, he is rewarded for his past services with a daughter of the Trojan king, whom the Achaians deliver to him by means of a sacrifice at his tomb.[19] The Achaians may not have conceived of this honour for the dead hero on their own initiative. According to a brief report delivered by the chorus of Euripides' *Hekabe*, the ghost of Achilles himself visits the victorious army and issues a demand for the sacrifice, thereby generating considerable contention among the Achaian chieftains, some of whom advocate compliance while others hesitate. At one point Kassandra is considered a candidate for the sacrifice, but Odysseus resolves the conflict in favour of Polyxene (*Hek.* 107–39). Thus the epic tradition behind Euripides' narration, if indeed he is following epic sources, incorporated motifs similar to those found at the opening of the *Iliad*, where the distribution of captive women from Thebe also provokes discord among the Achaian chieftains.

Early iconography of the episode designates Neoptolemos as the agent of the sacrifice. On an Attic amphora dated to the second quarter of the sixth century, three warriors hold Polyxene over the tomb while Neoptolemos, identified by an inscription, plunges a sword into her throat (Cat. no. 3). Among the literary sources Neoptolemos is first identified as the agent in a fragment of Ibykos.[20] The sacrifice

[19] Cf. the sacrifice of twelve Trojans on the funeral pyre of Patroklos at *Il.* 23. 173–83. In *Iliad* 9 Agamemnon promises Achilles twenty of the most highly valued Trojan captives, and the sacrifice of Polyxene might have been interpreted by the poets as fulfilment of that or some similar pledge.

[20] Schol. Euripides, *Hek.* 224 = Ibykos, fr. 307. Schol. *Hek.* 41 (*Kyp.* fr. 34) records that, according to the *Kypria*, Polyxene dies from wounds inflicted by Odysseus and Diomedes during the Ilioupersis, and that Neoptolemos buries her. The detail seems out of place in the *Kypria*, and the scholiast may be mistaken, but Polyxene's future may have been revealed through prophecy. See Bernabé (1987) 62 for bibliography concerning the fragment.

thus adds yet another link between Achilles and Neoptolemos, the son who succeeds his father at Troy and here assures payment of the tribute owed to his father's memory.[21] The genealogical ties will figure prominently again in Euripides' dramatic narration of the sacrifice at *Hekabe* 523–82. At line 523, for example, Neoptolemos is designated as Ἀχιλλέως παῖς, 'son of Achilles' (similarly at lines 528–9), and at line 534 he addresses Achilles Ὦ παῖ Πηλέως, πατὴρ δ' ἐμός, 'son of Peleus, and my father'.

If we look further afield in the saga, the ghastly murder of Polyxene cannot fail to evoke memories of a very similar episode which occurred much earlier in the cycle:

μηνίσασα δὲ ἡ θεὸς ἐπέσχεν αὐτοὺς τοῦ πλοῦ χειμῶνας ἐπιπέμπουσα.
Κάλχαντος δὲ εἰπόντος τὴν τῆς θεοῦ μῆνιν καὶ Ἰφιγένειαν κελεύσαντος
θύειν τῇ Ἀρτέμιδι, ὡς ἐπὶ γάμον αὐτὴν Ἀχιλλεῖ μεταπεμψάμενοι θύειν
ἐπιχειροῦσιν.

Exercising her wrath, the goddess prevents them from sailing by sending storms. When Kalchas has revealed the goddess's wrath and bid them sacrifice Iphigeneia to Artemis, they summon her on the pretext of marriage to Achilles and undertake the sacrifice. (*Kyp.* arg. 45–7)

Similarities between these two rare examples of maiden sacrifice abound. In each case the victim is an unmarried daughter of a commander—Polyxene is the daughter of the king of Troy, and Iphigeneia the daughter of the most powerful of the Achaian chieftains. Achilles plays a significant role in both sacrifices and shares a semi-erotic relationship with both victims. Polyxene is sacrificed upon his tomb as a concubine for him in death, and Iphigeneia is lured to Aulis on the pretext of marriage with the hero (ὡς ἐπὶ γάμον—*Kyp.* arg. 46–7). Furthermore, the two sacrifices stand at complementary narrative positions within the saga. The Achaians sacrifice Iphigeneia at the beginning of the campaign as a prelude to their voyage to Troy,

[21] It is surprising that, given the emphasis on the ghost's appearance in Euripides' *Hekabe* and in Sophokles' *Polyxene*, Proklos fails to record this supernatural phenomenon in his *Iliou Persis* summary. Proklos may simply have ignored this detail, it may have belonged to the *Mikra Ilias* but not to the *Iliou Persis*, or it may have postdated the epic entirely and appeared first with Sophokles. One speculative assessment of the chronological development of the ghost's appearance follows. As Proklos records in the *Mikra Ilias* summary, Achilles' ghost appears to Neoptolemos shortly after the latter's arrival at Troy and instructs his son, among other things, to sacrifice Polyxene at his tomb after the capture of the city. A later poet, perhaps Sophokles, then duplicated the appearance of the ghost or postponed it, thereby achieving closer narrative proximity between the ghost's demand and the sacrifice.

and they sacrifice Polyxene at the war's conclusion.[22] The latter sacrifice too, when viewed in the context of the nostoi which follow, forms a prelude to a naval departure, and in Euripides' *Hekabe* the ghost of Achilles plays a role analogous to that of Artemis at Aulis, not only demanding the sacrifice, but also preventing the Greek fleet from sailing until the demand is met: 'Achilles held back the entire Hellenic force, | as they directed the sea oar towards home ($\kappa\alpha\tau\acute{\epsilon}\sigma\chi'$ $Ἀχιλλεὺς$ $πᾶν$ $στράτευμ'$ $Ἑλληνικόν,$ | $πρὸς$ $οἶκον$ $εὐθύνοντας$ $ἐναλίαν$ $πλάτην$—*Hek.* 38–9).[23] As at Aulis, the sacrifice of a maiden becomes a prerequisite without which the fleet cannot sail.

[22] See Burkert (1983) 63–7 on the sacrifice of maidens prior to expeditions of hunting and war.

[23] See also *Hekabe* 538–41, where Neoptolemos, as he performs the sacrifice, prays to his father to release the ships and grant them a safe return to Greece.

4

Aineias

According to Proklos' summary of the *Iliou Persis*, Aineias departs from Troy together with a group of followers immediately after the death of Laokoon, which he perceives as a sign of approaching disaster:

ἐν αὐτῷ δὲ τούτῳ δύο δράκοντες ἐπιφανέντες τόν τε Λαοκόωντα καὶ τὸν ἕτερον τῶν παίδων διαφθείρουσιν. ἐπὶ δὲ τῷ τέρατι δυσφορήσαντες οἱ περὶ τὸν Αἰνείαν ὑπεξῆλθον εἰς τὴν Ἴδην.

And at this moment two serpents appear and devour both Laokoon and one of his two sons. Stirred by the sign, the followers of Aineias withdraw secretly to Ida. (*IP* arg. 7–9)

Set immediately prior to the attack of the Achaians, Aineias' escape from Troy contrasts with the widespread suffering that is to follow. Aineias perceives and takes precautions against the impending danger while the rest of Troy, as Proklos and Apollodoros tell us, celebrates the putative retreat of the Achaians. Aineias thereby avoids the destruction that catches the other Trojans by surprise. Another tradition, for which the most famous witness is Vergil's *Aeneid*, places the escape not prior to, but during the attack itself and thereby allows Aineias to confront the invaders heroically before his final retreat. The result is the same, however: Aineias survives the disaster that destroys the vast majority of the remaining Trojans.

Viewed specifically in terms of Troy's noble families, the survival of Aineias forms an antithesis to the fate suffered by his cousins the Priamids. As Proklos is careful to tell us, it is not Aineias alone, but his household that survives (οἱ περὶ τὸν Αἰνείαν—*IP* arg. 9).[1] While the Greeks dissolve the family of Priam—slay his sons, enslave the women, and murder Priam himself in his ancestral home—Aineias

[1] While the phrase οἱ περί may sometimes be used periphrastically simply to iden-tify an individual (οἱ περὶ *x* may mean no more than *x*), in this instance, as used by an epitomizer who chooses words with economy and precision, there can be little doubt that the phrase denotes a group of followers.

escapes with his family intact.[2] The image of Aineias carrying his father Anchises to safety, already current among vase-painters by the later sixth century, perhaps belonged to the scene of family departure in the epic *Iliou Persis*.[3] The son dutifully rescues his father, while the ageing Priam is left to die together with his offspring.

Aineias' evasion of capture at the Ilioupersis is one of several near misses experienced by the hero over the course of the Trojan War. In *Iliad* 5 he comes close to death at the hands of Diomedes but is rescued by Aphrodite and Apollo (5. 311–17 and 431–48). In *Iliad* 20 he barely escapes alive from an encounter with Achilles; this time it is Poseidon who intervenes to snatch the would-be victim from the battlefield. In the course of the latter encounter, Aineias and Achilles recall also another meeting which Aineias only just survived (20. 89–93 and 187–94). While Aineias was herding cattle on Mt. Ida, Achilles attacked and captured the cattle but failed to capture Aineias himself, who fled to the city of Lyrnessos. Achilles subsequently destroyed the city, but Aineias escaped him there too. This sequence of earlier events is recorded also by Proklos in his *Kypria* summary: 'then he [Achilles] drives away the cattle of Aineias, and he sacks Lyrnessos and Pedasos' (κἄπειτα ἀπελαύνει τὰς Αἰνείου βοῦς, καὶ Λυρνησσὸν καὶ Πήδασον πορθεῖ . . . —*Kyp.* arg. 61–2).[4] Given the cursory manner in which Aineias introduces the tale in *Iliad* 20, it is reasonable to assume that the Iliadic allusions derive from an earlier tradition which was ultimately codified in the *Kypria*.[5]

Thus, prior to the Ilioupersis, the saga contains three incidents in which Aineias is threatened and escapes. As Odysseus' character is defined by his repeated acts of cunning, so Aineias is tagged for repeated survival. In the words of Poseidon at *Iliad* 20. 302, 'it is fated for him to escape' (μόριμον δέ οἵ ἐστ' ἀλέασθαι). Escape is a motif which functions for Aineias like a traditional epithet, attaching to him in several prominent episodes. The poets recognized this as

[2] The family of Antenor, spared during the attack by the intervention of Odysseus, offers a similar contrast to the family of Priam. Pausanias, 10. 26. 7–8 records the episode, and his evidence suggests that the rescue was narrated in the *Mikra Ilias*; compare *MI* fr. 12 = Pausanias, 10. 26. 7. Neither Proklos nor Apollodoros mentions the event. [3] See §12.4 for iconographic representations of Aineias' escape.

[4] *Il.* 20. 191–4 specifies Aineias' flight to Lyrnessos, Achilles' attack, and Aineias' escape. Proklos' failure to mention Aineias' escape from Lyrnessos is a result of his attempt to form a concise summary and not necessarily an indication that the event was not narrated in the *Kypria*.

[5] Lyrnessos is also the site of Briseis' enslavement (*Il.* 2. 690–1 and 20. 60).

a characteristic, and they replicated the motif throughout the saga, usually introducing a benevolent divinity as rescuer. When the several near misses are observed together, the escape from the sack of Troy appears as the climax to the series, and the earlier episodes serve as narrative echoes of that momentous ending, rehearsals in which Aineias practises for his last and greatest escape. The escape from Lyrnessos, in particular, reflects the monumentality of the Ilioupersis. In both episodes the Greeks sack an entire city, and Aineias survives both sacks.

Just as Aineias' final escape resonates elsewhere in the saga, so too the contrast between his ultimate survival and the ultimate dissolution of Priam's family spawns parallels in earlier chapters. Aineias' near-fatal encounter with Achilles in *Iliad* 20 was composed in deliberate anticipation of Hektor's fatal encounter with the same hero in *Iliad* 22, the encounter that will leave Priam bereft of a son and the city bereft of its most valuable defender.[6] At the opening of the earlier encounter we find Achilles hunting eagerly for Hektor when Aineias intervenes:

> αὐτὰρ Ἀχιλλεὺς
> Ἕκτορος ἄντα μάλιστα λιλαίετο δῦναι ὅμιλον
> Πριαμίδεω· τοῦ γάρ ῥα μάλιστά ἑ θυμὸς ἀνώγει
> αἵματος ἆσαι Ἄρηα ταλαύρινον πολεμιστήν.
> Αἰνείαν δ' ἰθὺς λαοσσόος ὦρσεν Ἀπόλλων
> ἀντία Πηλεΐωνος, ἐνῆκε δέ οἱ μένος ἠΰ.

> But Achilles
> longed most of all to plunge into battle against Hektor,
> son of Priam; for with *his* blood most of all his heart bid him
> sate the shield-bearing warrior Ares.
> But it was Aineias whom Apollo driver of the host roused
> against the son of Peleus, and he inspired him with great courage.

(*Il.* 20. 75–80)

The poet interjects Aineias here not only as a narrative diversion, a means of delay, but as a deliberate foil to his cousin Hektor, son of Priam (20. 77). In his engagement with Achilles Aineias rehearses a role to be played by Hektor in book 22. Both of these Trojan heroes

[6] For the role of Aineias in the *Iliad* see esp. Smith (1981), and Edwards (1991) in his commentary on book 20. For the contrast between Aineias and Hektor see Smith, pp. 45–6.

face the invincible Achaian, but Poseidon's timely intervention spares Aineias, while Apollo abandons Hektor to a lonely death at the hands of Achilles. Here in the final days of the *Iliad*, the Trojans pre-enact the final days of the city, when the last of the Priamids will die and Aineias will escape the disaster.

As if to highlight the distinction between the two families, Aineias has graciously provided us with a genealogical map in his lengthy address to Achilles (*Il.* 20. 215–40).

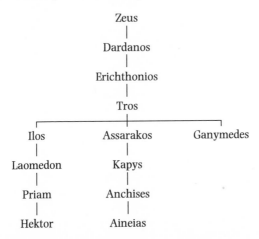

```
                         Zeus
                          |
                       Dardanos
                          |
                      Erichthonios
                          |
                         Tros
        ┌─────────────────┼─────────────────┐
       Ilos            Assarakos          Ganymedes
        |                  |
     Laomedon            Kapys
        |                  |
      Priam            Anchises
        |                  |
      Hektor            Aineias
```

The tree begins with a succession from Dardanos, son of Zeus, to Dardanos' son Erichthonios and to his son Tros (20. 215–30). At this point the tree splits into three branches with Tros' three sons: Ilos, Assarakos, and Ganymedes (20. 231–2). Ganymedes was taken to Olympus and consequently leaves no descendants in Troy (20. 233–5). So Aineias turns to the descendants of Ilos and Assarakos and balances the two lines of succession against one another. Ilos sired Laomedon, who in turn sired Priam and four other sons (20. 236–8). Assarakos fathered Kapys, who in turn fathered Anchises (20. 239). Ending with the present generation of warriors, Aineias balances the offspring of Anchises against the offspring of Priam: 'Anchises begat me, and Priam begat godlike Hektor' (αὐτὰρ ἔμ' Ἀγχίσης, Πρίαμος δὲ τέχ' Ἕκτορα δῖον—20. 240). Aineias delivers this account of his ancestry to illustrate to Achilles his own nobility, to set himself on a par with Hektor and to set his family on a par with that of Priam. At the same time, however, the tree highlights the

genealogical gulf between the ancestries of Hektor and Aineias. Hektor follows Ilos, Laomedon, and Priam in a line of succession soon to die out, and Aineias belongs to the distinct line of Assarakos, Kapys, and Anchises, the line of Dardanos' descendants destined to rule over the Trojans.[7]

It is left to Poseidon, the god who eventually rescues Aineias from his encounter with Achilles, to make explicit the distinction between the fates of the two lines. As Aineias prepares to face death at the hands of Achilles, Poseidon delivers the following singular petition to the gods on behalf of a Trojan enemy:

> ἀλλ' ἄγεθ' ἡμεῖς πέρ μιν ὑπὲκ θανάτου ἀγάγωμεν,
> μή πως καὶ Κρονίδης κεχολώσεται, αἴ κεν Ἀχιλλεὺς
> τόνδε κατακτείνῃ· μόριμον δέ οἵ ἐστ' ἀλέασθαι,
> ὄφρα μὴ ἄσπερμος γενεὴ καὶ ἄφαντος ὄληται
> Δαρδάνου, ὃν Κρονίδης περὶ πάντων φίλατο παίδων,
> οἳ ἔθεν ἐξεγένοντο γυναικῶν τε θνητάων.
> ἤδη γὰρ Πριάμου γενεὴν ἤχθηρε Κρονίων·
> νῦν δὲ δὴ Αἰνείαο βίη Τρώεσσιν ἀνάξει
> καὶ παίδων παῖδες, τοί κεν μετόπισθε γένωνται.

But come, let us ourselves lead him from death,
lest Kronides be angered, if Achilles
should kill him; for it is fated for him to escape,
so that the race of Dardanos not die, without seed and unseen,
Dardanos, whom Kronides loved beyond all the children
who were born from him and from mortal women.
For Kronion hates already the race of Priam;
and now the might of Aineias will rule the Trojans,
and the sons of his sons, who are born hereafter.

(*Il.* 20. 300–8)

The dissolution of Priam's line, the line now hateful to Zeus, is already under way in the *Iliad* and will soon be completed at the sack of the city. The race of Dardanos, however, must not perish completely and is henceforth to survive through Aineias, fated survivor of the Ilioupersis.[8]

That this genealogical contrast between the survival of Aineias'

[7] Evidence for the genealogy of Priam and Aineias is also provided in the Hesiodic Catalogue; see M. L. West (1985) 96–7.

[8] Cf. *Homeric Hymn to Aphrodite* 196–7.

family and the dissolution of Priam's family was also explored in Ilioupersis narratives is witnessed by Proklos' account of Laokoon's death, the omen which motivates Aineias' departure from the city in the epic *Iliou Persis*: 'And at this moment two serpents appear and devour both Laokoon and one of his two sons. Stirred by the sign, the followers of Aineias withdrew to Ida.' (*IP* arg. 7–9). To understand the connection between the Laokoon episode and Aineias' departure, allegorical interpretation is required. For the Trojans as a whole the serpents which arrive from the sea and attack Laokoon— an event described by Proklos as an 'omen' (τέρας—*IP* arg. 9) and by Apollodoros as a 'sign' (σημεῖον—*Epit.* 5. 18)—symbolically anticipate the coming of the Greeks from the sea, the return of the ships from Tenedos. Just as the snakes devour Laokoon, so the Achaians will devour all of Troy. The two snakes were probably meant to represent the two Atreidai, as do the two eagles in the omen recalled in the parodos of Aischylos' *Agamemnon*. For Aineias, however, the omen carries further significance. While some accounts of the omen record that the serpents devour Laokoon together with his sons, Proklos carefully specifies in his *Iliou Persis* summary that Laokoon and only one of his two children die (τόν τε Λαοκόωντα καὶ τὸν ἕτερον τῶν παίδων—*IP* arg. 8).[9] The significance of this detail has long been recognized: Laokoon's two children correspond to the two branches of Troy's royal family, only one of which is to survive the sack.[10] The death of the one son embodies the fall of the Priamids, and the survival of the other symbolizes the escape of Aineias and his family. The alternative tradition, according to which both sons die, would seem to refer symbolically only to the utter destruction of Priam's line without reference to the survival of Aineias. Thus Vergil, who has father and both children die, does not make the omen the immediate stimulus for his hero's departure. Such allegorical interpretation of an epic episode might seem out of place, but for the fact that the death of Laokoon takes place during a sacrifice and serves as an omen. Like the omen recalled by Odysseus in *Iliad* 2, it invites allegorical exegesis.

The final ascendancy of Aineias' family, while reflected at the

[9] The *Iliou Persis* seems to be unique in this detail. In Apollodoros' account, where the omen is not directly associated with the departure of Aineias, both sons die. See Frazer (1921) ii. 233 for the permutations of the tale.

[10] This detail is elucidated already by Carl Robert (1881) 192. M. Davies (1989*b*) 74–5 acknowledges the possibility with hesitation.

Ilioupersis and in the *Iliad* by means of contrast between the fates of Aineias and the Priamids, is reflected in the *Iliad* also in terms of rivalry and discord between the two lines. The theme surfaces first in the story of Aineias' horses at *Iliad* 5. 259–73. As compensation for the abduction of Ganymede, Zeus gave to Tros the world's finest horses, which were later inherited by Laomedon.[11] Though not granted an official share in these horses, Anchises secretly bred horses of his own from their stock (τῆς γενεῆς ἔκλεψεν ἄναξ ἀνδρῶν Ἀγχίσης, | λάθρῃ Λαομέδοντος ὑποσχὼν θήλεας ἵππους—5. 268–9). Six horses were born, of which Anchises gave two to his son Aineias. The story reflects discord among the Trojan nobles. Instead of distributing the horses equally among his descendants, Tros passes them only to his successors on the throne of Troy. They are thus symbols of royal prestige, like a crown or sceptre, objects which belong only to the Trojan king.[12] In stealing from this lineage, from the blood of the royal horses, Anchises steals symbols of kingship, thereby appropriating royal prestige for himself and his son Aineias. After the sack of Troy, when the line of Anchises succeeds the line of Priam, this symbolic appropriation becomes reality. The theft of the horses' lineage anticipates the actual transfer of the Trojan kingship from one line to the other.

In two other *Iliad* passages the rivalry is centred upon Aineias himself. In *Iliad* 13 Deiphobos finds Aineias sulking on the sidelines, resenting Priam's failure to honour him in accordance with his merit: 'He found him at the edge of the battle | standing; for he was forever harbouring wrath against godlike Priam, | because he did not honour him among men, brave though he was' (τὸν δ' ὕστατον εὗρεν ὁμίλου | ἑσταότ'· αἰεὶ γὰρ Πριάμῳ ἐπεμήνιε δίῳ, | οὕνεκ' ἄρ' ἐσθλὸν ἐόντα μετ' ἀνδράσιν οὔ τι τίεσκεν—13. 459–61). Aineias' physical stance in this passage, on the margins of the battle, reflects his subordinate status within the Trojan hierarchy and his consequent emotional distance from the king. The same theme of resentment emerges in a taunt aimed at Aineias by the less sympathetic Achilles in *Iliad* 20 (178–83). As in book 13, where Aineias' sulking was motivated by a lack of honour (οὔ τι τίεσκεν), here again honour is at issue. Has Aineias been spurred on to the present confrontation by his

[11] The origin of these horses is explored similarly at *Homeric Hymn to Aphrodite* 202–17. These horses of Laomedon are the same horses promised to Herakles; see Apollodoros, *Bib.* 2. 5. 9.

[12] Cf. also the horses of King Erichthonios at *Il.* 20. 220–9.

desire to rule over the Trojans, Achilles asks, his desire to obtain 'the honour belonging to Priam' ($\tau\iota\mu\hat{\eta}s$ $\tau\hat{\eta}s$ $\Pi\rho\iota\acute{\alpha}\mu\upsilon$—20. 181)?[13] Even if Aineias should succeed, Achilles warns, Priam would not grant him the kingship; 'for Priam has sons of his own' ($\epsilon\grave{\iota}\sigma\grave{\iota}\nu$ $\gamma\acute{\alpha}\rho$ $\upsilon\acute{\iota}$ $\pi\alpha\hat{\iota}\delta\epsilon s$—20. 183). But Achilles is mistaken in his assessment of the future, just as he is mistaken in his assessment of the outcome of the present encounter (20. 194–5). His taunt is an ironic contradiction of actual events of the saga, an inverted reflection of Aineias' ascendancy after the Ilioupersis. When Priam's line is finally extinguished at the sack, Aineias will indeed receive the honour previously denied him, together with the honour presently possessed by Priam. As Poseidon soon tells us, instead of Priam and his sons, Aineias and his descendants will henceforth rule over the Trojans ($\nu\hat{\upsilon}\nu$ $\delta\grave{\epsilon}$ $\delta\grave{\eta}$ $A\grave{\iota}\nu\epsilon\acute{\iota}\alpha o$ $\beta\acute{\iota}\eta$ $T\rho\acute{\omega}\epsilon\sigma\sigma\iota\nu$ $\grave{\alpha}\nu\acute{\alpha}\xi\epsilon\iota$ | $\kappa\alpha\grave{\iota}$ $\pi\alpha\acute{\iota}\delta\omega\nu$ $\pi\alpha\hat{\iota}\delta\epsilon s$, $\tauο\acute{\iota}$ $\kappa\epsilon\nu$ $\mu\epsilon\tau\acute{\omega}\pi\iota\sigma\theta\epsilon$ $\gamma\acute{\epsilon}\nu\omega\nu\tau\alpha\iota$—20. 307–8).

Thus far we have explored the tensions developed between the Priamids and the family of Aineias, the victims of the Ilioupersis and its fortunate survivors. In the *Iliad* this tension surfaces in recollections of rivalry and mild enmity between the two family lines and is ultimately played out in the contrast between Aineias' escape from Achilles and Hektor's subsequent death, reflective of Aineias' traditional ascendancy at the Ilioupersis. The *Iliad* goes a step further, however, and employs Aineias, the archetypal other in the Trojan genealogy, also as a foil to the Achaian hero Achilles. The taunt aimed by Achilles at Aineias in book 20, while ironically anticipating Aineias' ultimate ascendancy, also underlines an ironic correlation between Aineias and Achilles himself. Achilles' portrayal of Aineias as a second-class member of the Trojan ruling family in several respects reflects his own status within the Achaian army.[14] Although he is the 'best of the Achaians', Achilles himself does not rule them. Like Aineias, who is denied a share in the honour of Priam, Achilles is denied his merited share of honour by Agamemnon—a disparity central to the plot of the *Iliad*. Like Aineias, who reacts to dishonour from Priam by sulking on the sidelines in book 13, Achilles withdraws from the battle, and the quarters to which he retreats are located on the margins of the Achaian camp. In harbouring 'wrath' against Priam ($\grave{\epsilon}\pi\epsilon\mu\acute{\eta}\nu\iota\epsilon$—13. 460), Aineias adopts the emotion for

[13] Nagy (1979) 266 recognizes the verbal correspondence between *Il.* 13. 459–60 and 20. 178–9. [14] Nagy (1979) 265–7 discusses the Achilles/Aineias parallel.

which Achilles is most famous: 'Sing, goddess, the wrath . . .' (*Μῆνιν
ἄειδε, θεά . . .* —1. 1).

In response to Achilles' insult in *Iliad* 20, Aineias defends his own
nobility and in the process points out the genealogical similarity be-
tween himself and his opponent:

φασὶ σὲ μὲν Πηλῆος ἀμύμονος ἔκγονον εἶναι,
μητρὸς δ' ἐκ Θέτιδος καλλιπλοκάμου ἁλοσύδνης·
αὐτὰρ ἐγὼν υἱὸς μεγαλήτορος Ἀγχίσαο
εὔχομαι ἐκγεγάμεν, μήτηρ δέ μοί ἐστ' Ἀφροδίτη·
τῶν δὴ νῦν ἕτεροί γε φίλον παῖδα κλαύσονται
σήμερον.

They say you are the offspring of excellent Peleus,
and that lovely-tressed Thetis of the sea is your mother;
but I boast to have been born the son of great-hearted Anchises,
and my mother is Aphrodite;
of these now one pair or the other will weep for their dear son
today.

(*Il.* 20. 206–11)

Like the subsequent genealogical speech, which puts Aineias on a
par with Hektor, this speech puts him on a genealogical par with
Achilles, as the son of a hero and a goddess.[15] Here already, however,
is a glimpse of the ultimate distinction between the two: although not
today (20. 211), Thetis will indeed weep for the death of her son in
the not too distant future.[16] Achilles, as we are repeatedly reminded
over the course of the final books (by his horse Xanthos and later by
Hektor), is doomed to die before the capture of Troy, while Aineias
is fated to survive the capture.[17] The closing books of the *Iliad* thus

[15] Cf. the parallel genealogies of Achilles and Memnon in the *Aithiopis*. In Attic
vase-painting this parallelism gives rise to compositions in which the battle between
Achilles and Memnon is flanked by their anxious mothers, Thetis and Eos.

[16] *Aith.* arg. 20–1 records that Thetis mourns her son together with the Muses
and her sister Nereids (καὶ Θέτις ἀφικομένη σὺν Μούσαις καὶ ταῖς ἀδελφαῖς θρηνεῖ
τὸν παῖδα).

[17] With reference to the rock which Aineias prepares to hurl at Achilles at *Il.* 20.
285–91, Nagy (1979) 274 notes that warriors who initiate rock-throwing are else-
where victorious over their opponents and suggests that behind this scene may be an
external tradition in which Aineias did in fact wound his opponent. There is, however,
an explanation closer at hand for the application of the rock-victory motif here. The
poet is strongly influenced by the eventual survival of Aineias in contrast to the death
of Achilles. Since Aineias is the real victor in the long run, he can therefore be allowed
to initiate the victory pattern of rock-throwing.

employ Aineias systematically as a force of opposition, pitting his fate against the fates of both Hektor and Achilles, outlining the contrast in each case with a dazzling display of genealogy, thereby anticipating and even pre-enacting the hero's ultimate survival.

Taking Aineias' elaborate role at the close of the *Iliad* as a model, we can now reassess his earlier escape from Lyrnessos. Aineias' confrontation with Achilles on Mt. Ida appears in Proklos' *Kypria* summary only shortly before Troilos' fatal encounter with the same Greek hero: 'and then he [Achilles] drives away the cattle of Aineias, and he sacks Lyrnessos and Pedasos and all of the surrounding cities, and he slays Troilos' (κἄπειτα ἀπελαύνει τὰς Αἰνείου βοῦς, καὶ Λυρνησσὸν καὶ Πήδασον πορθεῖ καὶ συχνὰς τῶν περιοικίδων πόλεων, καὶ Τρωΐλον φονεύει—*Kyp*. arg. 61–3). So closely joined in the narrative sequence, if we can trust Proklos as a reliable witness, the Aineias and Troilos episodes appear to have been composed to balance each other, as were the Aineias and Hektor episodes in *Iliad* 20 and 22. In both the Aineias episode and the Troilos episode the attacker is Achilles. The first attack, the attack on Aineias, is located on Ida, and the second, the attack on Troilos, is also traditionally located beyond the protection of Troy's walls. Furthermore, the early iconographic evidence records several stages in the Troilos story, just as the *Kypria* and the *Iliad* divide Aineias' encounter with Achilles into distinct stages.[18] First Achilles lies in wait for Troilos at a fountain-house outside Troy, and then Troilos attempts to escape on horseback while Achilles pursues on foot. The artists place the murder itself at an altar, identified by later sources as the altar of Apollo at Thymbra, where Troilos has sought refuge from his pursuer. This sequence of ambush and pursuit closely parallels the two-stage encounter between Achilles and Aineias, the first stage being the initial attack on Mt. Ida, and the second Aineias' subsequent flight to the city of Lyrnessos. In fact, a scene on a late seventh-century Boiotian relief pithos, convincingly identified as Achilles and the cattle of Aineias, features Achilles in the same pose of ambush which he assumes in representations of the attack on Troilos.[19] Just as the escape of Aineias at the Ilioupersis will

[18] Gantz (1993) 597–603 provides a comprehensive survey of the early poetic and iconographic evidence for the death of Troilos. See also Kossatz-Deissmann (1981) 72–95.

[19] Boston MFA 99.505, *c*.625 BC, M. E. Caskey (1976) figs. 23 and 31, Kossatz-Deissmann (1981) no. 389. Achilles is represented on the body of the vessel. In addition, Caskey (pp. 34–6) identifies the scene on the neck of the pithos as Aineias taking

be set in contrast to the demise of Priam's family, so Aineias' earlier escape from Achilles serves as an antithetical prelude to the flight of Troilos. Aineias survives, and Troilos does not. The fact that the *Iliad* refers to the previous encounter between Aineias and Achilles in such detail might suggest that the poet is borrowing elements of the Troilos and Aineias legends in addition to Ilioupersis elements in constructing the opposition between Aineias and Hektor.

Of Aineias' three escapes prior to the Ilioupersis, the close encounter with Diomedes in *Iliad* 5 exhibits the weakest analogy to his final departure from Troy. Stronger than any correspondence with the Ilioupersis are the links uniting this episode with *Iliad* 20. Diomedes' rampage in the poem's earlier books anticipates Achilles' rampage towards the poem's close, and Diomedes' encounter with Aineias in book 5 reflects Achilles' similarly interrupted encounter with the same hero in book 20.[20] Although the traditional Ilioupersis paradigm of escape remains active in the background of the earlier episode, the correspondence between this episode and the Ilioupersis is secondary, mediated by the intervening escape in *Iliad* 20. Again there is an obvious partner scene involving a Priamid: Paris' confrontation with Menelaos in book 3. But the relationship between these two partner scenes differs significantly from the previously discussed examples, in that the similarities between them outweigh the contrasts. Both Aineias and his cousin Priamid survive through the intervention of the gods. What we have in books 3 and 5 is less a pre-enactment of the Ilioupersis than an inverted anticipation of books 20 and 22. Paris and Aineias both elude their opponents in the earlier chapters; but while Aineias is again rescued in book 20, Hektor in book 22 will not share the good fortune of his brother.

Finally, I draw attention to one further system of correlations among Aineias' escape from Troy and earlier episodes. Proklos specifies that upon their withdrawal from the city, Aineias and his followers seek refuge on Mt. Ida (εἰς τὴν Ἴδην—IP arg. 9). A recurrent element in the story of Troy, Ida is the site of Paris' ill-omened judgement, a seat from which the gods observe battles in the plain below,

refuge from Achilles at a sanctuary of Apollo in Lyrnessos. If this interpretation is correct, then the pithos gives us also an Aineias scene analogous to the sacrilegious murder of Troilos at the altar of Apollo.

[20] Richardson (1993) 10, surveying studies of large-scale ring composition in the *Iliad*, comments on the pairing of Diomedes' military successes in book 5 and those of Achilles in books 20–1.

the source of timber when the Trojans build ships and funeral pyres, and when the Achaians build the wooden horse. Aineias holds particularly close ties with the mountain. It is here that Aphrodite seduces Anchises and conceives her child ("Ἴδης ἐν κνημοῖσι according to *Il.* 2. 821).[21] Like his father, Aineias herds cattle here, and the mountain is the site of his first encounter with Achilles (*Il.* 20. 90–1 and 188–90). Since Ida figures so prominently in the landscape of the hero's past, it is not surprising that he retreats here on the eve of Troy's destruction.

The place of refuge, the familiar haunt, however, is not all that Ida signifies for the hero. Aineias reminds us of Ida's importance in the early history of Troy while recounting his ancestry to Achilles in *Iliad* 20:

Δάρδανον αὖ πρῶτον τέκετο νεφεληγερέτα Ζεύς,
κτίσσε δὲ Δαρδανίην, ἐπεὶ οὔ πω Ἴλιος ἱρὴ
ἐν πεδίῳ πεπόλιστο, πόλις μερόπων ἀνθρώπων,
ἀλλ' ἔθ' ὑπωρείας ᾤκεον πολυπίδακος Ἴδης.

First Zeus the cloud-gatherer begat Dardanos,
and he founded Dardania, since sacred Ilios,
city of men, had not yet been walled in the plain,
but they dwelled still on the slopes of Ida with its many springs.

(*Il.* 20. 215–18)

In the time of Dardanos the city of Ilios had not yet been built in the plain, and the Dardanians inhabited instead the slopes of Ida. Dardanos himself had no connections with the city around which Trojans and Achaians were to wage their ten-year war. The city belongs rather to Ilos, its eponymous founder, and his descendants. Under Ilos' son Laomedon, Apollo and Poseidon built the city walls (e.g. *Il.* 7. 452–3). And throughout the Trojan War, until its capture, the city is ruled by Laomedon's son Priam.

The close ties between the physical city and the line of Ilos, Laomedon, and Priam contrast with the recurrent alienation of Aineias' family, which often finds itself more at home on Mt. Ida. Anchises and Aineias traditionally herd cattle here while Priam and his family dwell in the city below. Paris too leads a similar, pastoral lifestyle on Ida until he is recognized as a son of Priam and reintegrated

[21] The *Homeric Hymn to Aphrodite*, which recounts in great detail Aphrodite's amorous encounter with the cowherd Anchises on the slopes of Ida, records also that Aineias is raised by nymphs residing on Mt. Ida (256–73).

into the royal family, into the city of Troy.[22] The epic poets defined the pastoral slopes of Ida in opposition to the city of Troy, and Aineias' frequent association with the mountain reflects his distance from the family of Priam which rules the city. Consequently, his final journey to Mt. Ida in the *Iliou Persis* reinforces the theme of division between the two branches of the Trojan genealogy: Priam's family, the family of the city, dies together with its city, while Anchises' family seeks refuge in its familiar home (ὑπεξῆλθον εἰς τὴν Ἴδην). In addition, Aineias' journey to Mt. Ida reflects a wider, 'historical' division in the ancestry of the Trojans, since it was here on the mountain that Dardanos and his immediate successors lived before the existence of the city in the plain below (*Il.* 20. 215–18). After the destruction of the physical city and its line of rulers, Aineias, fated henceforth to rule over the race of Dardanos (*Il.* 20. 300–8), leads his people back to the mountain where his ancestor once reigned.

[22] Apollodoros, *Bib.* 3. 12. 5. See Stinton (1965) for the early tradition of Paris. Cf. also Laomedon's illegitimate son Boukolion, who herded sheep (*Il.* 6. 21–8).

5

Nostoi

5.1 Aias and Neoptolemos

In the formulaic diction of the *Iliad* the theme of *persis*, destruction, is often intertwined with the theme of *nostos*, the return to the fatherland which will follow the conquest of the city. In a strikingly alliterative line of book 1, for example, Chryses wishes the Achaians success in sacking Troy and returning home: 'to pound the polis of Priam and arrive safely home' (ἐκπέρσαι Πριάμοιο πόλιν, εὖ δ'οἴκαδ' ἱκέσθαι—1. 19). Persis and nostos are again juxtaposed within a single line when Agamemnon in book 2 recalls Zeus' promise of victory and return: 'who solemnly promised me | that having destroyed well-walled Ilios, I would return home' (ὅς πρὶν μέν μοι ὑπέσχετο καὶ κατένευσεν | Ἴλιον ἐκπέρσαντ' εὐτείχεον ἀπονέεσθαι—2. 112–13). Later in book 2 Odysseus uses this same phrase in reference to an oath previously pledged by the Achaians (2. 288), and Hera repeats the words in book 5 when she recalls a promise which she and Athena made to Menelaos (5. 716). The formulaic combination neatly encapsulates the two ultimate goals of the Achaians: not only to destroy Troy, but to destroy Troy in order that they may return to their homes.

The *Iliad* makes dramatic use of the nostos-persis relationship in book 2, where Agamemnon tests the army's resolve by tempting the soldiers with the offer of immediate retreat. Zeus, Agamemnon recalls, previously promised both victory and return, persis and nostos (2. 112–13). But nine years of war have failed to bring victory, and Agamemnon consequently proposes that the Achaians now abandon the campaign: 'let us flee with the ships to our own fatherland; | for no longer shall we take Troy of the wide streets' (φεύγωμεν σὺν νηυσὶ φίλην ἐς πατρίδα γαῖαν· | οὐ γὰρ ἔτι Τροίην αἱρήσομεν εὐρυάγυιαν—2. 140–1). After beginning his speech with the traditional formula of persis followed by nostos, Agamemnon ends by inverting the established order in a devious attempt to rally the troops. Contrary to his crooked intention, the desire for nostos does in fact

override the goal of persis, and the army sets off eagerly toward the ships. Had Hera not intervened, the result would have been premature return (Ἔνθα κεν . . . ὑπέρμορα νόστος ἐτύχθη—2. 155), meaning a return prior to the capture of the city. The danger passes when Odysseus calls the Achaians to order and, repeating the formula of sack and return, reminds them of the oath that compels them to destroy the city before returning home (Ἴλιον ἐκπέρσαντ᾽ εὐτείχεον ἀπονέεσθαι—2. 288). The formula which Agamemnon foolishly distorted now reverts to its original form in the mouth of the more authoritative speaker. Situated in the wake of Achilles' recent threat of departure (1. 169–71), this false embarkation dramatically reaffirms the group's ultimate goal of destroying Troy. Agamemnon's verbal manœuvre nearly inspires the troops to imitate Achilles' renegade behaviour, but the poet intervenes to counter the anti-heroic, anti-formulaic movement and to reassert that the persis of the city must precede any nostos.

The poets deployed this motif of early withdrawal at a number of other points in the saga. With the Trojans pressing dangerously close to the Achaian camp, Agamemnon proposes a retreat to the ships in earnest in *Iliad* 9. Speaking before the chieftains, he again begins by recalling the promise of Zeus (9. 19–20), and he closes with the same proposal of departure he suggested in book 2 (9. 27–8), but now Agamemnon's motion, though genuine, incites no actual movement toward the ships. Playing the role previously assigned to Odysseus, Diomedes immediately contradicts Agamemnon and staunchly reaffirms the goal of conquest (9. 32–49). As in the earlier situation, the threat of a comprehensive early withdrawal again offsets the individual departure threat of Achilles, who does not consider himself bound to the goal of persis (9. 421–9). Proklos' *Kypria* summary records yet another threat of premature nostos, and this time it is Achilles himself who provides the voice of restraint: 'then when the Achaians start to depart for home, Achilles holds them back' (εἶτα ἀπονοστεῖν ὡρμημένους τοὺς Ἀχαιοὺς Ἀχιλλεὺς κατέχει—*Kyp.* arg. 61). Details of the episode are unkown, but as it follows closely in the summary upon a divinely arranged meeting between Achilles and Helen, it may have served to reaffirm the army's resolve to recover her. Finally, the most spectacular variation on the nostos theme occurs on the eve of the sack, when the Achaians pretend to abandon the campaign and feign a return to their homes, but in fact withdraw only to Tenedos.

When, in such poems as the *Odyssey* and the epic *Nostoi*, the long-awaited journey finally does materialize, the hopes of the Achaians for an end to their distress are contradicted by a new series of adversities. Setting out from Troy with the wrath of Athena close behind, much of the fleet is lost in a violent storm (e.g. *Od.* 3. 130–6, *Nost.* arg. 12–13). A false beacon lit by Nauplios, vengeance for Odysseus' earlier intrigues against his son Palamedes, lures many of the ships to destruction when they reach Euboia (Apollodoros, *Epit.* 6. 7–11).[1] Among those that escape these disasters, Odysseus serves a ten-year sentence of wandering and captivity before his ultimate arrival in Ithaka; Menelaos is waylaid in Egypt; while his brother Agamemnon, reaching home safely, nevertheless meets death at the hands of the deceptive Klytaimestra and her accomplice Aigisthos (e.g. *Od.* 3. 253–311, 4. 512–37, and 11. 404–39). And like Agamemnon, Diomedes too discovers that his wife Aigialeia has been unfaithful to him in his absence (Apollodoros, *Epit.* 6. 9).[2]

The Ilioupersis serves as the introduction, the geographic and narrative point of departure for these subsequent tales of adversity. It is not simply the conclusion of the fighting, as the weary Achaians had hoped, but the first chapter in the second volume of the saga. The ten years of war leading to Troy's capture find a precise counterbalance in the ten years of wandering which follow for Odysseus. It is, moreover, to a large degree the nature of the Ilioupersis that determines the nature of the nostoi. Nostos not only follows persis temporally, as in the formulaic promise of Zeus to Agamemnon, but actively pursues persis with the force of justice. Just as Paris' crime is punished with the ultimate destruction of Troy, so too the wrongs committed by the Achaians in sacking Troy are punished as they return to Greece. Retribution binds together persis and nostos in a simple cause-and-effect relationship.

The storm which besets the Achaian fleet is a direct result of Aias' notorious crime, his sacrilegious treatment of Kassandra before the very image of the goddess Athena. Euripides illuminates the traditional sequence of events most clearly in the prologue of his *Troades*, where Athena, angered by the offence of Aias and by the failure of

[1] The earliest evidence for the story of Nauplios belongs to the 5th c. BC. For the possibility that Nauplios' deception formed part of the epic *Nostoi* see Frazer (1921) ii. 248–9.

[2] See Bernabé (1987) 94 for references to the myth and the possibility of its inclusion in the epic *Nostoi*.

the Achaians to punish him as he deserves (69–73), enlists the assistance of Zeus and Poseidon to brew a storm of retribution (74–97). Though originally incited by the crime of an individual, Athena's wrath is generalized against the Achaian army—like the wrath of Apollo which in *Iliad* 1 visits the entire camp in response to the impiety of a single man. The Achaians, Apollodoros tells us, informed by Kalchas of the divine anger, would have punished Aias with death had he not sought refuge as a suppliant at the altar of Athena (*Epit.* 5. 23).[3] Aias escapes through this hypocritical about-face, but the goddess is now doubly insulted, and her wrath grows to menace the entire Achaian fleet.[4]

Some form of this tradition is witnessed already in a few passages of the *Odyssey*. Narrating the death of Aias in book 4, Menelaos describes the hero as 'hateful to Athena' (ἐχθόμενός . . . Ἀθήνῃ—4. 502). The narrator refuses to specify the sacrilegious attack on Kassandra as the cause, but no other known tale will so readily explain the goddess's hostility. The poem skirts the subject also when Nestor in book 3 recounts the departure from Troy:

αὐτὰρ ἐπεὶ Πριάμοιο πόλιν διεπέρσαμεν αἰπήν,
βῆμεν δ' ἐν νήεσσι, θεὸς δ' ἐκέδασσεν Ἀχαιούς,
καὶ τότε δὴ Ζεὺς λυγρὸν ἐνὶ φρεσὶ μήδετο νόστον
Ἀργείοις, ἐπεὶ οὔ τι νοήμονες οὐδὲ δίκαιοι
πάντες ἔσαν· τῶ σφεων πολέες κακὸν οἶτον ἐπέσπον
μήνιος ἐξ ὀλοῆς γλαυκώπιδος ὀβριμοπάτρης,
ἥ τ' ἔριν Ἀτρεΐδῃσι μετ' ἀμφοτέροισιν ἔθηκε.

But when we destroyed the lofty city of Priam,
and we went in the ships, and the god scattered the Achaians,
then Zeus devised in his mind a dismal homecoming
for the Argives, because they were neither mindful nor just,
not all of them; therefore many of them met a wretched end
because of the baneful wrath of the grey-eyed mighty-fathered goddess,
who placed strife between the two Atreidai.

(*Od.* 3. 130–6)

[3] Compare *IP* arg. 16–18 and Pausanias, 1. 15. 2 and 10. 26. 3 on Polygnotos' depictions of the attack.

[4] At *Tro.* 69–73, where Athena explains to Poseidon the reason for her wrath, Euripides notes that Athena's anger is particularly fierce because it was she who helped the Achaians to sack the city. It is therefore doubly wrong of the Achaians to neglect her.

Nestor's tale begins with the Ilioupersis, the narrative point of departure and probable fuel for the ensuing blast of retribution. Proceeding to the storm, Nestor first offers a general assessment of the divine mechanism driving the catastrophe: Zeus was angry with the Achaians because not all of them were mindful and just. Finally Nestor couples the disaster with the wrath of Athena, another tacit nod toward the heinous offence recently committed in her sanctuary. Similarly, when Hermes relates the disastrous Achaian nostoi to Kalypso in book 5, the poet again specifies Athena as the hostile divinity responsible for the storm at sea (5. 108–9)—another probable allusion to the crime of Aias. As Odysseus conceals the murder of Priam from Achilles in book 11, so the narrators in these episodes are reluctant to dwell upon the disreputable behaviour of Aias, but the allusions leave little doubt that the crime and its extended punishment were well known to the epic bards and their early audiences.

The agent of the original crime is naturally singled out for special treatment at the hands of Athena, the offended deity. Apollodoros records that the goddess herself struck Aias' ship with a thunderbolt (*Epit.* 6. 5).[5] A fragment of Alkaios forges a particularly immediate relationship between the crime and its punishment (fr. S262).[6] After narrating Aias' attack upon Kassandra, Alkaios proceeds directly to an image of Athena travelling over the sea and stirring up the waves, as if the storm followed instantaneously upon the rape. With no delay Athena proves herself to be the divinity 'most severe to temple-plundering mortals' (\dot{a} $\theta\acute{\epsilon}\omega\nu$ | $\theta\nu\acute{a}\tauοι]\sigma\iota$ $\theta\epsilon\omega\sigma\acute{\upsilon}\lambda\alpha\iota\sigma\iota$ $\pi\acute{a}\nu\tau\omega\nu$ | $\alphaἰνο]\tau\acute{a}\tau\alpha$ $\mu\alpha\kappa\acute{a}\rho\omega\nu$ $\pi\acute{\epsilon}\phi\upsilon\kappa\epsilon$—fr. S262. 17–19). Aias may have had to wait several days for his execution in epic narratives, but Alkaios' lyrics vault the intervening time and unite crime and punishment under a firm, unequivocal yoke.[7]

The *Odyssey* chose a more subtle device for enhancing the correlation between the two events. Narrating the death of Aias in book 4, Menelaos tells us that after Aias' ship is destroyed in the storm, Poseidon intervenes to bring the hero to safety on some nearby rocks. Despite Athena's wrath ($\kappaαὶ$ $\dot{\epsilon}\chi\theta\acute{ο}\mu\epsilon\nuό\varsigma$ $\pi\epsilon\rho$ $Ἀθήνῃ$—4. 502)

[5] Cf. Euripides, *Tro.* 80–1, where Athena tells Poseidon that Zeus has promised her use of his thunderbolts ($\dot{\epsilon}\muοὶ$ $\delta\dot{\epsilon}$ $\delta\acute{ω}\sigma\epsilon\iota\nu$ $\phi\eta\sigmaὶ$ $\pi\hat{\upsilon}\rho$ $\kappa\epsilon\rhoαύνιον,$ | $\betaάλλειν$ $Ἀχαιοὺς$ $\nuαῦς$ $\tau\epsilon$ $\pi\iota\mu\pi\rhoάναι$ $\pi\upsilon\rhoί$).

[6] On the fragments of this poem see Fowler (1979) and Koenen (1981).

[7] The late Archaic iconography of Kassandra's rape, on which see §12.2 below, also develops a close association between the crime and its punishment.

the god offers Aias the hope of survival. Aias, in turn, without regard to Poseidon's benevolence, claims that he has 'escaped the great sea against the will of the gods' (φῆ ῥ' ἀέκητι θεῶν φυγέειν μέγα λαῖτμα θαλάσσης—4. 504). Poseidon responds by striking the rock with his trident and returning Aias to the waves. Here the poet has spun Aias' death into a cautionary fable by echoing dramatically the hero's original act of impiety. Aias' blasphemous boast parallels his previous sacrilegious offence at Troy, evoked only a few lines earlier through the reference to Athena's wrath. As he nears punishment for his previous crime, Aias is granted a reprieve; but instead of repaying his benefactor with gratitude, he repeats his irreverent behaviour toward the gods and his punishment is consequently resumed.

For the murder of Priam, the other major act of sacrilege committed during the sack, divine retribution plots a more circuitous course. In his *Nostoi* summary Proklos records that Neoptolemos, warned of the dangers on the sea routes by his grandmother Thetis, makes his way back to Greece safely by land (*Nost.* arg. 13–14). Not long afterwards, however, death catches up with the hero in Delphi at the instigation of Apollo, from the hands either of Orestes or a local inhabitant.[8] It is not certain that the early epic poets treated Neoptolemos' end, since it is not attested in the poetic sources until the early fifth century, but the existence of his tomb at Delphi would argue that the story of the hero's murder had long been known.[9]

Pindar's sixth *Paean* offers the most direct poetic assessment of the sequence of sacrilege and retribution. Because Neoptolemos slew Priam at the altar (γέ[ρον]θ' ὅ[τι] Πρίαμον | π[ρ]ὸς ἑρκεῖον ἤναρε βωμὸν ἐ[π- | εν]θορόντα—*Paian* 6. 113–15 SM), Apollo slays Neoptolemos at the omphalos in his own sanctuary (ἐν τεμέ]νεϊ φίλῳ γᾶς παρ' ὀμφαλὸν εὐρύν—6. 120). As Alkaios juxtaposes the image of Aias in the temple of Athena with the subsequent storm at sea, so Pindar here sets side by side the crime and punishment of Neoptolemos. Moreover, in addition to simply repaying Neoptolemos for his crime at Troy, the punishment accurately reflects the crime. Blood spilled in the sanctuary is followed by further bloodshed in the sanctuary.[10]

[8] On the multiplicity of Neoptolemos traditions see Frazer (1921) ii. 254–5 and Gantz (1993) 687–94.

[9] Fontenrose (1960) 206–7 suggests that the association between Neoptolemos and Delphi arose in the first decade of the 6th c., perhaps earlier.

[10] Tryphiodoros alludes to Neoptolemos' death within his account of the crime against Priam and Zeus (640–3). Poets were not, however, obliged to recognize

According to Pausanias this fitting punishment eventually became regarded as a standard example of tit-for-tat:

Νεοπτολέμῳ γὰρ τῷ Ἀχιλλέως ἀποκτείναντι Πρίαμον ἐπὶ τῇ ἐσχάρᾳ τοῦ Ἑρκείου συνέπεσε καὶ αὐτὸν ἐν Δελφοῖς πρὸς τῷ βωμῷ τοῦ Ἀπόλλωνος ἀποσφαγῆναι, καὶ ἀπὸ τούτου τὸ παθεῖν ὁποῖόν τις καὶ ἔδρασε Νεοπτολέμαιον τίσιν ὀνομάζουσιν.

For after Neoptolemos the son of Achilles slew Priam at the hearth of the Herkeian god, it came to pass that he too was slaughtered in Delphi at the altar of Apollo, and hence to suffer what one has also inflicted is termed Neoptolemean recompense. (Pausanias, 4. 17. 4)

The modern equivalent of this ancient phrase is 'poetic justice', and no doubt the poets, so fond of moulding correlations between relevant episodes of the saga, had some hand in shaping the justice which visited Neoptolemos.

5.2 The Return of Odysseus

The feast on the cattle of the sun narrated in *Odyssey* 12 offers a lesson in nostos analogous to that of the Ilioupersis. While all the misadventures recounted in books 9–12 exact their toll on Odysseus' crew, this last journey is the most costly. To feast on the sacred cattle of Helios is to engage in sacrilege, and the sacrilege of the feast is reflected in the anomalies of the accompanying sacrifice: oak-leaves substituted for barley in the preparation of the victims (12. 356–8), and in the absence of wine a libation of water (12. 362–3). By partaking of this perverted and unholy banquet, Odysseus' men call down upon themselves the condemnation both of Helios and of Zeus, who subsequently sends them to the bottom of the sea in a storm of retribution (12. 374–419). In the poem's prologue, where the tale of the cattle assumes a position of eminence seemingly disproportionate to the brief narration in book 12, the poet describes the death of the men specifically as a loss of nostos: 'but he took away their day of return' (αὐτὰρ ὁ τοῖσιν ἀφείλετο νόστιμον ἦμαρ—1. 9). The same sentiment ends their story in book 12: 'the god denied return' (θεὸς δ' ἀποαίνυτο νόστον—12. 419). This critical test is at once a lesson in impiety and a lesson in nostos, two incompatible pursuits. Like the

the correlation. Although Euripides gives a full account of Neoptolemos' death in the *Andromache*, he suppresses any memory of Priam's murder.

Ilioupersis, Odysseus' initial point of departure (ἐπεὶ Τροίης ἱερὸν πτολίεθρον ἔπερσε—1. 2), the feast on the cattle of the sun is an act of sacrilege resulting in the loss of nostos. Only Odysseus, who takes no part in the forbidden feast, survives the storm of divine retribution which drowns the rest of his crew.

It is tempting to interpret Odysseus' prolonged and arduous journey from Troy to Ithaka as a form of retribution for his participation in the horrors of the Ilioupersis, the cattle of the sun eventually offering him the chance of reprieve. As a primary agent in the destruction of the holy city of Troy (1. 2), the city built by Poseidon, Odysseus might easily have invoked the god's wrath against him.[11] But if the epic poets ever launched this line of reasoning, the *Odyssey* has submerged it. While the poem remembers the Ilioupersis as the cause of bitter nostos for some, Odysseus is freed from negative associations with the sack. Athena, nemesis of the wicked Aias, honours the pious Odysseus with her patronage, and the poem explains Poseidon's wrath only as a result of Polyphemos' curse (9. 528–35 and 13. 341–3).[12] For Odysseus the Ilioupersis is viewed rather as a momentous achievement, which when recalled, serves to glorify and not to vilify the hero. The tales of Helen and Menelaos in book 4 and the tale of Demodokos in book 8 spotlight Odysseus' heroic role in the capture. The wooden horse, the ruse which finally brought victory to the Achaians, is memorialized as Odysseus' triumphant act of *dolos par excellence*. And after his cunning escape from the cave of Polyphemos, Odysseus reveals himself as 'Odysseus the sacker of cities' ('Οδυσσῆα πτολιπόρθιον—9. 504), a title commemorating his indispensable contribution to the conquest of Troy.

More than mere advertisement for the hero, the recollections of the Ilioupersis also underline a series of narrative correlations between the Ilioupersis and the *Odyssey*. When in book 22, for example, Athena wishes to arouse Odysseus' valour against the suitors, she stings him with reminders of his exploits at Troy, superimposing the past conflict onto the present:

[11] The prologue of Euripides' *Troades* explains Poseidon's wrath against the Greeks as a consequence of Troy's destruction.

[12] Both Poseidon and Athena are likely to have harboured wrath against Odysseus in the earlier accounts of the hero's nostos. This is one possible reason for Athena's failure to assist him in his initial adversities; for another view, see Clay's (1983) analysis of the rivalry between the hero and his patron. With regard to the implicit contrast between Odysseus and Aias Oileus, cf. also Athena's differing behaviour toward the two heroes at the funeral games of *Iliad* 23.

οὐκέτι σοί γ', 'Οδυσεῦ, μένος ἔμπεδον οὐδέ τις ἀλκή,
οἵη ὅτ' ἀμφ' Ἑλένῃ λευκωλένῳ εὐπατερείῃ
εἰνάετες Τρώεσσιν ἐμάρναο νωλεμὲς αἰεί,
πολλοὺς δ' ἄνδρας ἔπεφνες ἐν αἰνῇ δηϊοτῆτι,
σῇ δ' ἥλω βουλῇ Πριάμου πόλις εὐρυάγυια.
πῶς δὴ νῦν, ὅτε σόν γε δόμον καὶ κτήμαθ' ἱκάνεις,
ἄντα μνηστήρων ὀλοφύρεαι ἄλκιμος εἶναι;

No longer, Odysseus, do you have spirit or might
such as you had when over white-armed noble Helen
for nine years you fought the Trojans, ever relentlessly,
and you slew many men in dread battle,
and by your counsel Priam's city of wide streets was taken.
How is it that *now*, when you come to *your* home and possessions,
you shrink from bravery against the suitors?

(*Od.* 22. 226–32)

Confronting Odysseus with this stinging reminder of the past, Athena reveals that he now faces a challenge curiously reflective of the previous campaign against the Trojans.[13] Nine years of struggle led to the retrieval of Helen, and now nine years of wandering have led Odysseus to the rescue of his own wife. The Trojans, Helen's abductors and rival suitors, have been replaced by the suitors of Penelope. And in gaining access to his home disguised as a beggar, Odysseus has effectively mimicked his penetration of Troy in the wooden horse (σῇ βουλῇ—22. 230).[14] The epic mechanisms of myth manipulation, not content with the Ilioupersis as a mere recollection in the background of Odysseus' homecoming, have moulded Odysseus' return into an imitation of his previous achievements at Troy.

Three other passages witness a similar use of the Ilioupersis myth as a narrative complement to the present. The first is a pair of tales in book 4, both narrated to Telemachos in affirmation of his father's valour. Helen recalls how Odysseus, disguised as a beggar, entered the city on a spying mission, presumably in preparation for the subsequent deployment of the wooden horse (4. 242–64).[15] Helen recognizes

[13] Andersen (1977) 15 discusses the passage similarly.

[14] For the close association between Odysseus and the horse in myth and ritual see Burkert (1983) 159.

[15] Helen's statement at *Od.* 4. 256, 'and then he told me the entire plan of the Achaians' (καὶ τότε δή μοι πάντα νόον κατέλεξεν Ἀχαιῶν), and her following anticipation of rescue allow us to assume that the mission occurred shortly before the sack, and that Odysseus told her about the wooden horse. See also the account of the story at *MI* arg. 15–17, which places Odysseus' mission after the construction of the horse.

Odysseus, bathes him, clothes him, and promises not to reveal his identity to the Trojans. Odysseus in turn informs her of the plans of the Achaians, presumably their plans for capturing the city. The tale ends with Odysseus murdering several Trojans and making his way back to the Achaian camp to report his observations, while Helen is left eagerly awaiting her rescue. Proklos records a very similar tale in his *Mikra Ilias* summary (15–17), and it is possible that the poetic compilation of Trojan tales simply appropriated this tale from the *Odyssey*. The elliptical manner, however, in which Odysseus shares information with Helen at 4. 256 and with the Achaians at 4. 258 suggests prior familiarity with the general outline of the story, and therefore some external development may lie behind the form of the episode found in the *Odyssey*.[16]

The companion tale told subsequently by Menelaos attests to Odysseus' status as commander of the warriors lodged within the wooden horse (4. 271–89). Helen, the narrator recalls, accompanied by the Trojan Deiphobos, circles the horse while imitating the voices of the warriors' wives. Menelaos and Diomedes long to respond, but Odysseus restrains them; and when another of the soldiers, Antiklos, attempts to call out in response, Odysseus forcibly holds his mouth shut to save the men from discovery. Finally, Athena puts an end to the episode by leading Helen away from the horse. Since it is recorded that Antiklos appeared also in one of the cyclic poems, it seems probable that this tale, like Helen's narrative, found its way into the *Mikra Ilias*.[17] The tale looks very much like an Odyssean invention, but the possibility of a previous history external to the *Odyssey* cannot be entirely ruled out.[18]

[16] On the passage see in particular S. West in Heubeck *et al.* (1988) 208–11. That the tale underwent stages of composition is suggested by the doubling between lines 244–6 and 247–9, both relating Odysseus' disguise and subsequent entrance into the city in a slightly different manner. According to West's analysis, the latter entrance may be derived from the narrative of the *Mikra Ilias*, or at any rate from an antecedent Ilioupersis tradition.

[17] A scholion on lines 4. 285–9 notes their athetization by Aristarchos on the grounds that Antiklos is a figure 'from the cycle' (ἐκ τοῦ κύκλου—Schol. *Od.* 4. 285–9 = *MI* fr. 26). The remark has been taken as evidence for the inclusion of the story of Antiklos and Odysseus in a cyclic epic poem of the Ilioupersis; see Bernabé (1987) 83.

[18] S. West in Heubeck *et al.* (1988) 212 has noted that the story of Antiklos in lines 285–8 appears as an alternative to the story of Diomedes and Menelaos in lines 280–4. The tale seems therefore to have undergone at least two phases of composition. Furthermore, the hero Antiklos appears nowhere in the *Iliad*, and his speaking name— the one who 'calls back in response'—suggests an *ad hoc* invention. He is the man

Both stories flatter the hero. Helen compliments his cunning and bravery, Menelaos his wisdom and strength. At the same time, the stories comment also upon the character of their other major actor, Helen. With her own tale Helen declares herself the eager ally of Odysseus. She receives him with kindness, swears not to betray his disguise, and her heart is gladdened by the hope of an imminent release from her Trojan imprisonment. Menelaos' story, however, counters Helen's claim of loyalty with scepticism. Within his tale she appears in the company of Deiphobos, her second Trojan husband, and while she conceals Odysseus' identity in her own tale, here her actions threaten to expose the men inside the horse. Formerly Odysseus' partner, she is now transformed into his opponent. Thus, while at one level the stories are recounted for the benefit of Telemachos as a tribute to his father, at another level they constitute a dialogue between Menelaos and Helen, secondary narratees of each other's narratives, and conduct a debate over Helen's fidelity toward her Achaian benefactors. Did she truly long for rescue, or did she in fact attempt to sabotage the mission?[19]

Viewed in the wider context of the *Odyssey* these tales not only record the past achievements of Odysseus and Helen, but look forward to similar events in subsequent chapters of the poem. Helen's tale of her encounter with Odysseus in Troy exhibits striking parallels with Odysseus' imminent return to Penelope in Ithaka, where he will again conceal his identity under the disguise of a beggar (13. 429–39). Both of Odysseus' disguised entries take place shortly before the heroine's rescue, and in both Odysseus meets privately with the captive. Although Penelope herself is not granted the privilege of recognition, the nurse Eurykleia recognizes Odysseus despite his resistance to detection, and like Helen, she bathes him and swears an oath not to betray his secret (*Od.* 19. 467–502). While it is difficult to unveil

'who responds to Helen's calling', or perhaps his name reflects the agonistic purpose of Menelaos' story, to 'contradict' Helen's tale of self-glorification. The story as a whole forms a counterpart to the tale told by Helen and may therefore have been designed specifically in response to that first story, i.e. it may be an Odyssean invention. But the fidelity of Helen was also no doubt an important subject in the Ilioupersis tradition; compare Menelaos' mixed emotions at their reunion (*MI* fr. 19, discussed in §8.5 below). In an Ilioupersis poem this story would have provided a tantalizing comment on Helen's fidelity, and we cannot rule out the possibility that a story of her visit to the horse underwent development within an Ilioupersis narrative.

[19] On the characterizations of Helen in epic poetry see especially Kakridis (1971) 25–53.

the influence of this correlation on the Ilioupersis poems themselves, or to assess their contributions to this correlation, in the *Odyssey* at least it is clear that the poet recollects the Ilioupersis tale in terms of the future homecoming and has shaped the episodes in assimilation with one another. The prominence assigned to Odysseus in the retrieval of Helen anticipates his imminent performance in the rescue of his own wife, Penelope.

The interaction of Ilioupersis and *Odyssey* here also compels the audience to scrutinize the behaviour of the captive women jointly. Helen's self-portrayal as the devoted wife yearning for reunion with her true husband reflects and is reflected in Penelope's continued faithfulness to her absent husband Odysseus. Menelaos' alternative assessment of Helen's loyalties, while not so readily applicable to Penelope, nevertheless exposes the possibility of Penelope's infidelity, along the lines of Klytaimestra's *de facto* betrayal of Agamemnon—a possibility not to be overlooked by Odysseus.[20] The uncertainty clouding the relationship between Menelaos and his formerly estranged wife Helen thus casts an early shadow of apprehension on the relationship between Odysseus and Penelope.[21] Despite the recovery of Helen, Menelaos is unable to shed doubt and resentment completely. How then will Odysseus and Penelope overcome any lingering suspicions?

The next concentrated reference to the sack is found in book 8, where Odysseus begins and Demodokos finishes a narration of the sack of Troy, extending from the building of the wooden horse to the retrieval of Helen (8. 487–520). Several details of the passage are paralleled in Proklos' summaries of the *Mikra Ilias* and the *Iliou Persis*—a clear indication that the poet is familiar with a body of traditional Ilioupersis material.[22] Yet rather than pure reproduction, this passage represents skilful manipulation of tradition intended to

[20] Klytaimestra is used as a foil for Penelope elsewhere in the poem, e.g. at 11. 441–6, where Agamemnon explicitly contrasts the infidelity of his own wife with the fidelity of Penelope.

[21] The inclusion of Diomedes in Menelaos' tale may have been motivated by the tradition that his wife Aigialeia betrayed him upon his return home. While Menelaos' recollection questions the fidelity of his wife Helen, the reference to Diomedes subtly complements this theme of the unfaithful wife. See Bernabé (1987) 94 for references to the myth and the possibility of its inclusion in the epic *Nostoi*.

[22] These details include the building of the horse by Epeios and Athena (*Od.* 8. 493, *MI* arg. 14), the burning of the tents and the pretended departure of the Achaian fleet (*Od.* 8. 500–1, *MI* arg. 19–20), the dragging of the horse to the citadel and the ensuing debate (*Od.* 8. 503–9, *IP* arg. 3–6), and finally the confrontation between Menelaos and Deiphobos (*Od.* 8. 517–18, *IP* arg. 14–15).

highlight the role of Odysseus, and the spotlight shines on our hero from the very beginning:

> ἀλλ' ἄγε δὴ μετάβηθι καὶ ἵππου κόσμον ἄεισον
> δουρατέου, τὸν Ἐπειὸς ἐποίησεν σὺν Ἀθήνῃ,
> ὅν ποτ' ἐς ἀκρόπολιν δόλον ἤγαγε δῖος Ὀδυσσεύς,
> ἀνδρῶν ἐμπλήσας οἳ Ἴλιον ἐξαλάπαξαν.

But change themes now and sing of the design of the horse,
the wooden horse, which Epeios made with Athena,
which godlike Odysseus once led to the citadel in deceit,
having filled it with men who sacked Ilios.

(*Od.* 8. 492–5)

In requesting the story from Demodokos, the as-yet unidentified guest is careful to point out that Odysseus manned the horse and led it to the citadel of Troy. Demodokos' ensuing narration sustains this emphasis on the hero, as if in answer to Odysseus' request that the story be related 'correctly' (κατὰ μοῖραν—8. 496), and his image of the warriors within the horse clearly features Odysseus in the position of leadership: 'they were already seated *around famous Odysseus*, | concealed in the horse in the assembly of the Trojans' (τοὶ δ' ἤδη ἀγακλυτὸν ἀμφ' Ὀδυσῆα | ἦατ' ἐνὶ Τρώων ἀγορῇ κεκαλυμμένοι ἵππῳ—8. 502–3).

In addition to simply centring the narrative on Odysseus, the poet shrewdly overlooks any traditional details inconsistent with the present context of personal praise. Although Demodokos records the feigned departure of the fleet (8. 500–1), he fails to mention that these warriors later return from the ships to participate in the conquest.[23] Instead, all attention remains focused on the contingent within the horse and upon their leader Odysseus, as if they alone achieved the victory. While some Ilioupersis poems no doubt illuminated the more clandestine operations of the assailants, including the murders of sleeping Trojans, Demodokos leaves no room for such events in his carefully tailored narrative and instead portrays Odysseus only as valiant warrior.[24] As the Achaians emerge from the horse and disperse to

[23] Cf. *IP* arg. 11–12: 'The men sailing from Tenedos and the men from the wooden horse attack the enemy' (οἱ δὲ ἐκ Τενέδου προσπλεύσαντες καὶ οἱ ἐκ τοῦ δουρείου ἵππου ἐπιπίπτουσι τοῖς πολεμίοις).

[24] See Apollodoros, *Epit.* 5. 20–1 for the murder of sleeping Trojans. Cf. their unprepared state in Euripides, *Hek.* 914–22 and *Tro.* 542–50. The attack on the camp of Rhesos in *Iliad* 9 suggests that such activities were particularly appropriate to Odysseus.

various parts of the city, the bard places Odysseus together with Menelaos at the house of Deiphobos and in the 'fiercest of fighting' (αἰνότατον πόλεμον—8. 516–20).

Demodokos' song stimulates a multitude of transitions at the banquet of the Phaiakians. For the hero who will soon emerge from behind the curtain of anonymity, this eulogy serves as a grand formal introduction, a tribute to accomplishment coaxing and welcoming the accomplished guest onto the stage. The action of the embedded narrative in fact precipitates the action of the frame narrative, as the monumental sequence of disguise and revelation at the Ilioupersis neatly reflects Odysseus' consequent self-revelation to his hosts. To engineer the progression smoothly, the poet blends drama and pathos, using the song of Demodokos to elicit tears from Odysseus, and using Odysseus' tears in turn to elicit the disclosure of his identity. In addition, Demodokos' brief outline of Odysseus' Ilioupersis primes the audience for the much longer narrative delivered by the unmasked guest in books 9 to 12. Demodokos recounts not simply the capture of Troy, but chapter one of Odysseus' nostos, and the hero himself will soon complement this prelude with the ensuing chapters.

Beyond Odysseus' subsequent epic remembrances and the borders of the present banquet, Demodokos' song of praise also points towards the tasks still awaiting the hero in the second half of the poem. The spying mission recalled by Helen in book 4, as observed above, anticipates Odysseus' eventual return to Ithaka. In secretly entering his own home to rescue his own wife, the hero re-enacts the tale of his disguised entry into Troy. Demodokos' song negotiates a similar alliance between Troy and Ithaka when it reaches its climax in the battle against Deiphobos. Here Menelaos disposes of his Trojan rival with the aid of Odysseus, and as Proklos' *Iliou Persis* summary attests, the recovery of Helen is the logical consequence: 'Menelaos finds Helen and leads her to the ships, having slain Deiphobos' (Μενέλαος δὲ ἀνευρὼν Ἑλένην ἐπὶ τὰς ναῦς κατάγει, Δηΐφοβον φονεύσας—IP arg. 14–15). The poet has chosen to spotlight Odysseus' involvement in this particular venture not merely to display his battle prowess, but also to advertise his forthcoming success in the eventual rescue of Penelope, Odysseus' participation in the battle against Helen's suitor anticipating his later battle against his own wife's rival suitors.

Although the flattery aimed at Odysseus would suggest a distinctly Odyssean pedigree, Odysseus' assistance in Helen's rescue is not neces-

sarily unique to Demodokos' memory. The union might easily have found acceptance in the *Mikra Ilias* or *Iliou Persis* and may have spawned similar joint efforts elsewhere in the saga. Both the *Iliad* (3. 203–24) and Proklos' *Kypria* summary (arg. 55–6) record that in the earlier stages of the campaign Odysseus and Menelaos together visited Troy as envoys seeking the return of Helen (see also *Epit.* 3. 28–9). While the *Iliad* explains Odysseus' participation in this embassy as a result of his persuasive rhetorical abilities, this does not preclude additional motivation. Traditionally characterized as a man who strives for reunion with his wife, Odysseus is the obvious candidate when Menelaos requires a sympathetic assistant.

A final explicit recollection of the Ilioupersis is made by Odysseus during his visit to the underworld in book 11. When Achilles' shade requests news of his father and son, Odysseus responds with a flattering account of Neoptolemos' exploits at Troy, including his participation in the final military operation. Praising Neoptolemos for his zeal, Odysseus recalls that unlike the other warriors, who wept and trembled within the horse, Neoptolemos was constantly fingering the handle of his sword, eager to emerge from the horse and engage the Trojans in battle (11. 526–32). After the victory he received an honourable share of the spoils and left Troy without a single battle-scar (11. 533–7). While Odysseus' report concentrates primarily on the deeds of Neoptolemos, Odysseus himself is never far from the activity recorded. He points out to Achilles that he himself fetched Neoptolemos from Skyros to Troy (αὐτὸς γάρ μιν ἐγὼ . . . —11. 508–9), and while describing Neoptolemos' behaviour in the horse, he notes that he himself led the mission: 'all was placed under my command, both to open the trap and to shut it' (ἐμοὶ δ' ἐπὶ πάντ' ἐτέταλτο, | ἠμὲν ἀνακλῖναι πυκινὸν λόχον ἠδ' ἐπιθεῖναι—11. 524–5). These moments of self-reference, the latter in particular, may strike a suspicious reader as boastful digressions, diverting attention away from Neoptolemos and back to Odysseus, but they cannot be termed intrusive. In reminding Achilles of his own involvement and asserting his own authority, Odysseus establishes his credentials as a reliable judge of Neoptolemos' heroic behaviour. Moreover, the attention to Odysseus' participation here helps the poet sharpen the character contours of the anxious Neoptolemos, itching to spring upon the Trojans: 'He asked me repeatedly | for permission to exit from the horse' (ὁ δέ με μάλα πόλλ' ἱκέτευεν | ἱππόθεν ἐξέμεναι—11. 530–1). The young novice waits impatiently for his more experienced,

more prudent commander to give the signal for attack—a contrast perhaps traditional in early Ilioupersis narratives.[25]

The collaboration of Odysseus and Neoptolemos contributes also to the prevalent father–son theme which dominates the earliest books and culminates in the reunion and co-operation of Odysseus and Telemachos in Ithaka. In fact, it is probably the poem's consistent concern for fathers and sons which has determined the direction of Odysseus' conversation with Achilles. The first we hear of this theme in book 11 is Antikleia's news of Telemachos and Laertes, delivered to Odysseus in the earlier half of his visit to the underworld shades (11. 184–96). Just before the interview with Achilles, fathers and sons re-emerge in Agamemnon's tale of his betrayal at the hands of Klytaimestra and her lover, a tale rich in resonance with Odysseus' own imminent homecoming. After declaring with wavering confidence that Odysseus, unlike himself, will return home to a faithful wife (11. 441–50), Agamemnon adds that he can also look forward to reunion with his son, a pleasure which Klytaimestra cruelly denied her husband (11. 450–3). While Agamemnon's speech thus raises expectations of reunion, Odysseus' subsequent account of his partnership with Achilles' son at Troy offers a mild anticipatory reflection of the future alliance between Odysseus and his own son in Ithaka. Having acted previously as a kind of surrogate father for Neoptolemos in the absence of Achilles, Odysseus will soon repeat his role of paternal leadership with Telemachos.[26] Once again the *Odyssey* points out a subtle narrative analogy between the Ilioupersis tradition and Odysseus' homecoming. By maintaining attention to Odysseus' involvement, and without necessarily tampering with Ilioupersis tradition, the poet develops within the consolatory memorial to Neoptolemos' accomplishments an echo of reunion and victory yet to come.

Nearly as striking as Odysseus' tribute to Neoptolemos is his deliberate omission of Neoptolemos' notorious crime, his murder of Priam at the altar of Zeus Herkeios.[27] Just as the poem suppresses any

[25] Quintus Smyrnaeus, 12. 66–83 also contrasts the characters of Neoptolemos and Odysseus, perhaps in reflection of an early Ilioupersis tradition.

[26] The idea of Odysseus serving as a paternal figure for the young Neoptolemos may have been developed at greater length elsewhere in the saga. The episodes in which he brings Neoptolemos from Skyros and delivers to him the armour of Achilles would offer ample opportunity for this treatment, and Sophokles may have been following epic precedents when he examined this semi-paternal bond in his *Philoktetes*.

[27] See the end of §2.2 above.

association of Odysseus with misbehaviour at the Ilioupersis, so too it dissociates Neoptolemos from his notorious act of sacrilege. While deleted from book 11, however, the altar of Zeus Herkeios is afforded a curious prominence later in the poem. Towards the end of the battle scene in book 22, as the suitors fall one by one, Phemios debates with himself where best to seek refuge, whether to flee to the altar of Zeus Herkeios or to fall before Odysseus' knees (22. 334–6). He chooses the latter. After Telemachos encourages his father to spare the lives of Phemios and Medon, Odysseus instructs them to leave the hall, and the altar makes a second appearance: 'and they sat at the altar of great Zeus, | peering in all directions, ever expecting death' (ἑζέσθην δ' ἄρα τώ γε Διὸς μεγάλου ποτὶ βωμόν, | πάντοσε παπταίνοντε, φόνον ποτιδεγμένω αἰεί—22. 379–80). Since the altar of Zeus is a traditional feature of the Greek household, it is no surprise to find one at the home of Odysseus. Given the prominence of the altar in the Ilioupersis tradition, however, and given the general parallels between that tradition and Odysseus' homecoming, we may reasonably inter-pret the sustained emphasis on this altar as part of a wider narrative dialectic. Phemios' deliberation and rejection of the altar will remind us that Zeus' sanctuary was of no use to Priam, who in vain sought refuge there during the mass slaughter of the Trojans at the Ilioupersis. In so far as Phemios and Medon finally do find salvation at the altar of Zeus, the *Odyssey* asserts the piety of its hero in contrast to the sacrilegious behaviour recorded in the Ilioupersis tradition. Unlike Neoptolemos, who murdered Priam at the altar, Odysseus would not dare to violate the sanctuary of Zeus.

6

Correlative Episodes before the Achaian War against Troy

Two final examples of epic incidents correlative with the Ilioupersis, Herakles' campaign against Troy and Theseus' abduction of Helen, lie on the chronological periphery of the Trojan legend. Both events take place well before the outbreak of the Achaian war against Troy and belong primarily to antecedent generations of heroes, no longer active in the age of Agamemnon. A mythographic handbook like that of Apollodoros would prefer to catalogue Herakles' expedition against Troy not with the later campaign against the city, but among the hero's other contemporary adventures. And because the stories of the Dioskouroi are best represented in the work of poets affiliated with Sparta, we might, if categorizing the myth, group it more readily with Spartan legend than with Helen's later abduction. Yet, despite the narrative distance separating Herakles and Theseus from their Achaian and Trojan successors, a surprising degree of affiliation can be traced between the traditions. The creative activity of the poets was not restricted by mythological categories or geographical guidelines, and the extensive narrative interaction among these stories is evidence of wide migration of the epic tradition and mingling of diverse currents of myth.

6.1 Herakles Sacks Troy

A generation before the Achaians sailed against Troy under the leadership of Agamemnon, Herakles led a similar expedition, for which Apollodoros provides the most comprehensive summary account (*Bib.* 2. 5. 9 and 2. 6. 4). Since King Laomedon has cheated Apollo and Poseidon out of payment earned for building the walls of Troy, Poseidon sends a sea monster to ravage the land, and to appease the wrath of the gods Laomedon is compelled to tender his daughter

Hesione to the beast. Herakles intervenes, agreeing to rescue Hesione in return for Laomedon's prize horses, but after the successful rescue Laomedon again reneges and refuses Herakles the promised payment. Once more the king's miserly deceit exacts a greater penalty, as Herakles sails against the city with reinforcements and slays Laomedon together with all his sons but one. Finally, Hesione ransoms her brother Podarkes, who as last surviving prince succeeds his father on the throne of Troy. Two corrupt transactions are here succeeded by an honest sale, and in commemoration of the event Podarkes' name is changed to Priamos, interpreted to mean 'ransomed'.

Several references to this campaign in the *Iliad* witness its early familiarity among the epic poets. The poem knows of Herakles' battle with the sea monster (20. 144–8), of Laomedon's refusal to reward Herakles with the horses as promised (5. 640 and 5. 648–51), and of the sack itself (5. 640–2). Apollodoros and the *Iliad* agree also on the events which take place immediately after the sack. As Herakles sails away from Troy towards Kos, Apollodoros tells us, Hera sends storms to obstruct his path, and Zeus then suspends his wife from Olympus as punishment (*Bib.* 2. 7. 1). These same events are recalled in *Iliad* 14 by Hypnos, whose account includes mention of Kos as Herakles' intended destination (14. 255), the storms sent by Hera (14. 253–4), and Zeus' consequent wrath (14. 256–7). The close correlation suggests that most, if not all, of Apollodoros' details derive from a tradition which was already well established before the *Iliad* reached its final stages of development.

Several obvious parallels ally the campaign of Herakles with the later campaign of the Achaians. Both expeditions are directed against the same city, Trojan deceit lies at the root of both endeavours, and punishment ultimately arrives for the Trojans in the capture and destruction of their city. Both disturbances originate within the Trojan royal family, which logically becomes the primary target of aggression, and the slaying of Laomedon and his sons mirrors the extended regicide at the Ilioupersis, where Priam falls together with his remaining heirs.[1] Furthermore, despite different agents with different motives, the winds which blow Herakles off course after he departs from Troy

[1] At *Il.* 5. 642 Tlepolemos describes the first sack with a metaphor of bereavement: 'He stormed the city of Ilios and widowed the streets' (Ἰλίου ἐξαλάπαξε πόλιν, χήρωσε δ' ἀγυιάς). This striking metaphor suggests bloodshed, particularly male bloodshed, on a massive scale, and may have been inspired by the slaying of Laomedon and his sons, an act which widowed the women of the city and, metaphorically, the city itself.

might remind us of the winds that devastate the Achaian fleet as it sails back to Greece.[2]

Beyond these general parallels the two sacks share a common casualty in the figure of Priam, prominent as a child at the first attack and as an old man at the second. Apollodoros records that Herakles slays Laomedon and all of his sons with the sole exception of Priam, ransomed to become king of Troy (*Bib.* 2. 6. 4). Spared during the earlier catastrophe, Priam meets death instead at the subsequent capture of the city, where his murder forms a climactic scene of brutality and sacrilege. While the first Ilioupersis effects Priam's coronation, the second deposes him. The later campaign thus resumes and completes the process of extermination begun with the first, as mercy gives way to regicide. The young Priam also finds a close double in his grandson Astyanax. After Herakles has killed Laomedon and his family, all hope for the continuation of the ruling line of Troy rests in Podarkes, only a child at the time of the conquest.[3] And at the later Ilioupersis hope for the future rests in the infant Astyanax, who is temporarily reprieved from the fate befalling his grandfather and uncles. The prince's survival would again mean the preservation of the house of Priam, but the second wave of invaders, redressing the disastrous oversight of their predecessor, opt for complete extermination. Unlike ransomed Podarkes, Astyanax is allowed no second chance (see §3.2).

Other genealogical links between the two campaigns appear in the ancestry of the Achaian heroes. Herakles' major companion in the sack was Telamon, whose sons Aias and Teuker number among the greatest warriors in the second campaign. As in the Theban saga, where sons complete the destruction intended by their fathers, successive generations participate also in the successive campaigns against Troy. Pindar exploits this genealogical correlation to the full in his encomium for the mythological heroes of Aigina in *Isthmian* 6. Herakles, Pindar tells us, seeking an ally to accompany him against Troy, arrives at the home of Telamon while the family is celebrating a marriage.[4] As libations are poured, Herakles prays to Zeus and asks him to give Telamon an exceptionally brave son. An eagle appears, signifying

[2] On the storms which strike the Achaian fleet after the Ilioupersis see §5.1.

[3] For the youth of Priam at the first sack see Frazer (1921) i. 246 n. 2.

[4] This is according to von der Mühll's restoration of line 36: ἀλλ' Αἰακίδαν καλέων | ἐς πλόον ⟨γάμον vel γάμους⟩ κύρησεν δαινυμένων—more compelling than the plain alternative κεῖνον.

Zeus' assent, and Telamon is instructed to name his son Aias, 'eagle', in commemoration of the omen (6. 24–56).[5] Pindar thereby sows into the first campaign the seeds of the second. Aias' conception, located on the very eve of his father's departure for Troy, already anticipates his own participation in the future expedition against that same city.[6]

Herakles' visit to Kos, following immediately after his success at Troy, generates another genealogical alliance between the two campaigns. The Iliadic catalogue of ships records Pheidippos and Antiphos, leaders of the contingent of the Koans and their neighbours, as sons of Thessalos and grandsons of Herakles (*Il.* 2. 676–9). For the particular circumstances under which Herakles sires Thessalos we turn to later writers. Apollodoros records that the Koans greet Herakles with hostility, in response to which he captures the city and slays its king, Eurypylos (*Bib.* 2. 7. 1). Filling in the final elements of the myth, a scholiast of the *Iliad* tells us that Herakles fathers Thessalos by Chalkiope, the daughter of Eurypylos (Schol. *Il.* 2. 677), and we may therefore deduce that Herakles begets Thessalos shortly after his conquest at Troy. Although this correlation involves two successive generations instead of one, here again the genealogy of the heroes guides us from one campaign to the next. As in the case of Telamonian Aias, tradition roots heroes of the second campaign into the context of the earlier conflict. The sons of Thessalos, who is born in the aftermath of the first sack, will later follow in the footsteps of their grandfather by joining the Achaian expedition against Troy.[7]

Another instance of Heraklean ancestry provides the material for a verbal taunt in *Iliad* 5, where the Heraklid Tlepolemos confronts Sarpedon, a son of Zeus. Mocking Sarpedon's claim of divine paternity, Tlepolemos boasts the superiority of his own father Herakles and recalls his earlier success at Troy: 'he sacked the city of Ilios with

[5] The story is also related by Apollodoros, *Bib.* 3. 12. 7.

[6] This genealogical link between the two campaigns is also recorded in the pedimental sculptures of the temple of Athena Aphaia on Aigina. On the east pediment was depicted the first campaign of Herakles and Telamon against Laomedon, while a scene from the later war filled the west pediment. For discussion of the pediments see Ohly (1986) 55–68.

[7] This manner of genealogical predispositioning is also witnessed at the marriage of Peleus and Thetis. The marriage feast gives rise to the judgement of Paris and thereby initiates events leading to the Trojan War, while the marriage itself gives rise to the conception of Achilles. Cf. also the conception of Neoptolemos, set in the initial stages of the campaign against Troy (§2.2).

only six ships and with fewer men' (ἐξ οἵης σὺν νηυσὶ καὶ ἀνδράσι παυροτέροισιν | Ἰλίου ἐξαλάπαξε πόλιν—*Il.* 5. 641–2). Sarpedon in turn deflects the boast by transforming it into a reflection of Tlepolemos' inferiority. Herakles, Sarpedon admits, destroyed Ilios: '*he* destroyed sacred Ilios' (κεῖνος ἀπώλεσεν Ἴλιον ἱρὴν—5. 648). But unlike his father, Sarpedon continues, Tlepolemos will win only death here at Troy: 'but *you* I say will find here blood and black death from me' (σοὶ δ' ἐγὼ ἐνθάδε φημὶ φόνον καὶ κῆρα μέλαιναν | ἐξ ἐμέθεν τεύξεσθαι—5. 652–3). If Tlepolemos had any hopes of replicating his father's achievements, Sarpedon puts an end to them.[8]

While the conquering spirit of Herakles lives on in his descendants, a more powerful memorial to his past conquest survives in his bow. Apollodoros specifies bow and arrows as the weapons with which Herakles slew Laomedon and his sons (κατατοξεύσας Λαομέδοντα καὶ τοὺς παῖδας αὐτοῦ—*Bib.* 2. 6. 4). Pindar, writing of this entire expedition to the East, reports that 'Herakles did not stint in the use of his heavy-voiced bow-string' (σφετέρας δ' οὐ φείσατο | χερσὶν βαρυφθόγγοιο νευρᾶς | Ἡρακλέης—*Isthmian* 6. 33–5). And the bow is attested also in the pedimental sculpture of the temple of Athena Aphaia, where Herakles is depicted shooting at his Trojan opponents. The bow that once assisted Herakles in his conquest of Troy is called upon again in the final year of the later campaign, when Helenos, or Kalchas according to some sources, reveals that the Achaians will never achieve their aims without this charmed weapon.[9] Since Herakles' death his bow has passed into the hands of Philoktetes, who, after a ten-year forced leave of absence, is now recalled into the army. The elaborate tale of the snake-bite, Philoktetes' abandonment on Lemnos, and his eventual return to the army, serves among its other functions to dramatize the importance of the bow as the sack draws near.

Once reintegrated into the army, Philoktetes introduces the weapon into battle in a confrontation with Paris, who has recently demonstrated his own skill in archery by killing Achilles. Instead of Neoptolemos or Menelaos, both of whom hold personal grievances

[8] Tlepolemos' birth, unlike that of Aias and Thessalos, is not rooted in the tradition of the earlier sack of Troy. Note, however, that Tlepolemos' introduction in the catalogue of ships includes reference to his father Herakles as a sacker of cities (πέρσας ἄστεα πολλὰ διοτρεφέων αἰζηῶ ν—*Il.* 2. 660).

[9] *MI* arg. 6–8, and Apollodoros, *Epit.* 5. 8. The earliest evidence for this story is *Il.* 2. 716–25. See also Pindar, *Pythian* 1. 50–5.

against Paris, the poets give Philoktetes the honour of slaying the villain because Philoktetes carries the bow of Herakles.[10] Bow is appropriately pitted against bow, and the bow of Herakles prevails. Furthermore, with the death of the Trojan prince, the bow repeats its achievements of the earlier sack, when Herakles wielded it against Laomedon and his sons. In Philoktetes and the bow we see, if not Herakles resurrected, at least a worthy successor to Herakles, and his achievements rightly earned him high praise from Pindar as the destroyer of Troy: 'the archer son of Poias, who pounded the polis of Priam and ended the pains of the Danaans' (Ποίαντος υἱὸν τοξόταν· ὃς Πριάμοιο πόλιν πέρσεν, τελεύτα- | σέν τε πόνους Δαναοῖς— *Pythian* 1. 54).[11]

6.2 *The Dioskouroi Sack Athens*

Another peripheral tale exhibiting extensive thematic doubling with the Trojan saga and particularly close links with the Ilioupersis is that of Helen's first abduction at the hands of Theseus. Apollodoros provides a convenient summary:

γενομένην δὲ αὐτὴν [sc. Ἑλένην] κάλλει διαπρεπῆ Θησεὺς ἁρπάσας εἰς Ἀφίδνας ἐκόμισε. Πολυδεύκης δὲ καὶ Κάστωρ ἐπιστρατεύσαντες, ἐν Ἅιδου Θησέως ὄντος, αἴρουσι τὴν πόλιν καὶ τὴν Ἑλένην λαμβάνουσι, καὶ τὴν Θησέως μητέρα Αἴθραν ἄγουσιν αἰχμάλωτον.

When fame of her [Helen's] beauty had spread, Theseus abducted her and took her to Aphidnai. While Theseus was in the underworld, Polydeukes and Kastor invaded, captured the city and took Helen, and they enslaved Theseus' mother, Aithra. (*Bib.* 3. 10. 7)[12]

[10] Although Menelaos does not slay Paris, he does, according to *MI* arg. 8–9, abuse the corpse.

[11] The relationship between the two campaigns is explored further by Sophokles in his *Philoktetes*, in which Herakles himself, the previous conqueror, reappears; see esp. lines 1339–40. Another connection between the story of Herakles and that of Philoktetes—invented or revived in the 5th c.—is Chryse, a goddess who shares her name with her island abode. Herakles stopped at the island of Chryse on his journey to Troy and there offered sacrifice to the goddess. And according to some sources, it was on this same island (and not Tenedos) that the snake bit Philoktetes; see *Philoktetes* 270. Attic vase-paintings attest the popularity of the latter story in the late 5th and early 4th centuries. See Boardman (1990) 112 and Froning (1986).

[12] See Schol. *Il.* 3. 242 (*Kyp.* fr. 13) for a similar summary. For an earlier record of the invasion see Herodotos, 9. 73.

Further details appear in various sources. Helen is reported to be either 10 or 12 years of age at the time of the abduction.[13] Peirithoos assisted Theseus in the abduction, and in return Theseus assisted Peirithoos in his unsuccessful attempt to abduct Persephone.[14] It was for this reason that Theseus was in the underworld when the Dioskouroi attacked. Instead of Aphidnai, Athens itself is sometimes identified as the city sacked by the Dioskouroi, and perhaps both cities came under attack.[15] After the Lakedaimonian victory the sons of Theseus fled Athens, and Menestheus was instated as king (*Epit.* 1. 23). Apollodoros follows this incident with the arrival of Helen's suitors in Sparta, the first step toward her subsequent abduction at the hands of Paris (*Bib.* 3. 10. 8).

Like Aineias, destined to survive not only at the Ilioupersis, but also at the sack of Lyrnessos, Helen is doomed by the epic poets to repeated abduction, and the general parallelism between her two abductions is intriguing. Both abductors are equipped with a companion in their undertakings: Theseus with Peirithoos, and Paris with Aineias.[16] In response to both sacks, a campaign is launched by a pair of brothers, the Dioskouroi in the first instance and the Atreidai in the second. In both cases the abductor himself is absent when Helen is rescued. Theseus is in the underworld with Peirithoos, as good as dead, and Paris has been slain in battle. At the end of the campaigns, the cities are captured and plundered, and the women are enslaved.

The earlier abduction is reported to have been narrated in the cyclic epics and is likely to have been incorporated into the *Kypria* (Schol. *Il.* 3. 242 = *Kyp.* fr. 13). Rather than forming an independent episode in the poem, it was perhaps recounted at a secondary level of narration, told by one of the characters as background to the primary narrative. The sections of the poem devoted to the deeds of Kastor and

[13] See Apollodoros, *Epit.* 1. 23, with Frazer (1921) ii. 152 n. 1.

[14] *Epit.* 1. 23. See also the proto-Korinthian aryballos, Paris Louvre CA 617, for an iconographic conflation of the episodes: two warriors abduct Helen (Theseus and Peirithoos) and two mounted riders come to her rescue (the Dioskouroi). On the interpretation of the iconography see Kahil (1988) p. 507, no. 28.

[15] Herodotos specifies Aphidnai. Apollodoros, *Epit.* 1. 23 mentions Athens. Schol. *Il.* 3. 242 includes attacks on both cities. The depiction of Helen's recovery on the chest of Kypselos included an inscription naming Athens as the place where Aithra was captured (Pausanias, 1. 41. 4). See Herter (1936) for a discussion of the two alternatives.

[16] *Kyp.* arg. 10–11: 'and Aphrodite bids Aineias sail with him' (καὶ ἡ Ἀφροδίτη Αἰνείαν συμπλεῖν αὐτῷ κελεύει). Aphrodite naturally chooses her son as companion to her devotee Paris. Attic vase-painters sometimes include Aineias when depicting Helen's abduction (e.g. Cat. no. 18*).

Polydeukes (*Kyp.* arg. 21–4) would have provided a suitable narrative context for recollections of their victory in Attika. Another possible home for the story is Menelaos' visit to Pylos, where Nestor narrates several tales analogous to the present situation: 'and Nestor, digressing, relates to him how Epopeus was attacked after dishonouring the daughter of Lykourgos . . . and the story of Theseus and Ariadne' (Νέστωρ δὲ ἐν παρεκβάσει διηγεῖται αὐτῷ ὡς Ἐπωπεὺς φθείρας τὴν Λυκούργου θυγατέρα ἐξεπορθήθη . . . καὶ τὰ περὶ Θησέα καὶ Ἀριάδνην—*Kyp.* arg. 27–9). The situation resembles Telemachos' visit to Sparta in *Odyssey* 4, where tales of past accomplishment serve to encourage a disheartened traveller. The story of Helen's previous abduction would have offered another apt example in this context, where the memories of her past recovery might have roused Menelaos' spirits for success in the coming campaign against Troy. As with the tale told by Helen, here again the retrospection on similar antecedent events might tempt a poet to assimilate further the embedded and framing narratives.

Although neither *Iliad* nor *Odyssey* makes extensive use of the parallelism, two passages of *Iliad* 3 suggest that the story was known to the Iliadic bards and that the correlations were recognized. At Helen's first appearance she is attended by two servants, one of whom is 'Aithra, daughter of Pittheus' (*Il.* 3. 143–4). Since this Aithra, daughter of the king of Troezen, can be none other than the mother of Theseus, the passage presupposes the story of Helen's previous abduction. Theseus' mother, taken captive at the sack of Athens and enslaved to Helen, appears here in *Iliad* 3 still in servitude.[17] Shortly after this passage the poet adds a further reminiscence of the previous abduction, when, observing the Achaian contingent massed before Troy, Helen searches in vain for her brothers Kastor and Polydeukes. While she hopes they might have joined the expedition to rescue her, the poet informs us that they have already died and have been buried in Sparta (3. 234–44). Helen's fruitless search for her brothers may be read as a kind of honourable mention, inviting the listener to remember that the Dioskouroi, though absent from the present war, did once participate in a campaign to retrieve their sister.[18]

[17] Although Kirk (1985) 282 follows Aristarchos and rejects the line as an Athenian interpolation, it is defended by van der Valk (1964) 436 and Herter (1936) 193.

[18] The relatively slim acknowledgement of the first abduction in the Homeric works does not condemn the story as a late myth or a late addition to the epic corpus. Factors such as political preferences may have facilitated or hindered the story's diffusion into

The strongest link between the two sacks is forged through the reappearance of Aithra at the sack of Troy, where she is finally released from servitude by her grandsons, Akamas and Demophon.[19] Like Priam and the bow of Herakles, features which correlate the two captures of Troy, Aithra reappears at the Ilioupersis as a physical reminder of the campaign against Attika and the sack of Aphidnai. As a consequence of that previous abduction a city was sacked and its women were taken captive—the fate now suffered by Troy and its inhabitants. Observing the two misfortunes through the eyes of the captive, enslaved and released, we might also read some ethical commentary on the fate of Helen's abductors. Aithra was previously enslaved specifically as a result of Theseus' offence, but by assisting the Achaians in their war against Helen's present kidnappers, Akamas and Demophon redeem their father's offence and thereby earn the release of their grandmother. Misbehaviour enslaved her, while a good deed now leads to her release. Meanwhile, the women of Troy are now beginning their sentence of slavery as punishment for Paris' analogous transgression.

An Iconographic Correlation between Troy and Athens

A painted scene on a proto-Korinthian aryballos dated to the early seventh century BC has been convincingly identified as the recovery of Helen by her brothers, although unusual iconographic features confuse the interpretation.[20] To the left and right of the scene are

certain geographic regions and certain poetic traditions. The story of Helen's rescue by the Dioskouroi found favour at an early stage among audiences in Sparta, where the Dioskouroi were worshipped as heroes. Towards the end of the 7th c. Alkman treated the myth (fr. 21: Pausanias, 1. 41. 4 and Schol. *Il.* 3. 242). And Stesichoros, famed for two poems about Helen's second abduction in addition to his *Iliou Persis*, may have entertained his Spartan hosts also with the story of Helen's first abduction. Athens, in contrast, was a less likely environment for the narration of Spartan achievements against Attika. By the end of the 6th c. a form of the story was established in the repertoire of the Attic vase-painters. It was not, however, the sack of Aphidnai/Athens that interested the audience, but rather the abduction of Helen, a scene focused on the exploit of the Athenian hero, Theseus.

[19] IP arg. 21–2: 'Demophon and Akamas find Aithra and take her with them' (Δημοφῶν δὲ καὶ Ἀκάμας Αἴθραν εὑρόντες ἄγουσι μεθ᾽ ἑαυτῶν). IP fr. 6: 'And lord Agamemnon bestowed gifts upon the sons of Theseus and great-hearted Menestheus, shepherd of the people' (Θησείδαις δ᾽ ἔπορεν δῶρα κρείων Ἀγαμέμνων | ἠδὲ Μενεσθῆϊ μεγαλήτορι ποιμένι λαῶν). See also MI fr. 20. For a discussion of the literary and iconographic sources see Kron (1981).

[20] Oxford, Ashmolean Museum G146, from Thebes; Kron (1981) no. 53 and Kahil (1988) no. 56. For the identification of the scene see also Elderkin (1934).

mounted male figures, both facing right, most likely the Dioskouroi, who traditionally appear on horseback. Towards the centre of the scene, a female figure wearing a *polos* and carrying a wreath in one hand grasps the tail of the horse on the right with her other hand. This is Helen, being led back to Sparta by her brothers.[21]

In the centre stands a large female figure wielding a spear and carrying a shield, while beneath and to the left stands a smaller female figure, grasping the arm of the figure brandishing the spear. The larger figure must represent the goddess Athena, or rather an armed statue of the goddess, an appropriate figure if the setting is Athens. The smaller figure, however, is problematic. Standing in the shadow of the statue, it calls to mind Kassandra, who sought refuge at the statue of Athena during the sack of Troy, but in the context of the recovery of Helen from Athens the figure is more likely to be Aithra.[22] A motif traditionally associated with one sack here appears transplanted into the other. Since the iconography of Kassandra, though soon to gain popularity throughout Greece, has not yet been firmly established here at the beginning of the seventh century, it is difficult to interpret this scene as an example of Ilioupersis iconography influencing iconography of the sack of Athens.[23] But the painter might easily have known the story of Kassandra, and the curious parallel remains a tantalizing link between the two myths.

[21] Identification of the scene as the rescue of Helen is supported by comparison with a contemporary proto-Korinthian aryballos; see n. 14 above.
[22] Ahlberg-Cornell (1992) 80–1, in fact, has suggested that the scene be identified as Kassandra at the statue of Athena. Elderkin (1936) 546 compares the scene with that on the chest of Kypselos, which also included Aithra.
[23] On the iconography of Kassandra see §12.2 below.

Closing Remarks

Beyond the one-dimensional plot sequence in which elements of the saga lock into place one after another, a network of resonating themes, motifs, and allusions winds the saga together into a complex and dynamic work of art. The preceding exploration of narrative correlations demonstrates that the cluster of Ilioupersis elements exerts a centripetal gravitational force within this galaxy of interconnected stories, its grip extending deep into episodes at both ends of the saga and beyond: Herakles' campaign against Laomedon; the invasion of the Dioskouroi into Attika; Paris' voyage to Sparta; the sacrifice of Iphigeneia; the capture of Thebe; Aineias' escape from Lyrnessos and the subsequent death of Troilos; the string of events in *Iliad* 20 to 24, including the escape of Aineias, the death of Hektor, and the ransoming of his corpse; the theft of the Palladion; the deaths of Aias and Neoptolemos; and the homecoming of Odysseus. Often the poets actively manipulated narrative correlations, using them to rupture the present and open corridors to the past and future, to make actions and characters grow larger against the monumental background of Troy's inevitable destruction. But even when the narrative bonds remain weak, no more than the copying of selected motifs, they nevertheless contribute genetic integrity to the system, allowing it to expand to enormous proportions while retaining unity of design among its varied but organically intertwined parts.

PART II

Tragic Images of the Ilioupersis

Introduction

The episodes of the Trojan saga supplied fifth-century Athenian tra-
gedians with narrative ingredients for a long list of dramas. Aischylos
composed approximately twenty plays based on Trojan myths, Soph-
okles more than thirty, and Euripides nearly a dozen.[1] The figures are
more impressive still when compared with the total number of plays
produced by each poet. The Trojan plays of Sophokles constituted
approximately one-quarter of his entire output, while for Aischylos
and Euripides the proportion is slightly lower, about one-fifth for each.[2]
The Ilioupersis—material drawn from the narrative span between
the implementation of the wooden horse and the final departure of
the Achaians—must have appeared frequently within this group.
While no specific dramatizations of Ilioupersis events are recorded
for Aischylos, Sophokles produced at least three Ilioupersis plays—
Laokoon, Aias Lokros, and *Polyxena*[3]—and Euripides produced two plays
closely related to the sack, both of which survive—*Hekabe* and *Troades*.
Moreover, the influence exerted by the Ilioupersis myth on the Athe-
nian stage certainly extended beyond the Ilioupersis dramas them-
selves into many, if not all, of the Trojan plays. Like the *Iliad*, which
contains within it the outlines and echoes of the entire saga, an Athe-
nian tragedy views a climactic moment within the background of a
wider narrative and, vice versa, offers a view of the larger story from
the perspective of a particular moment. Any play concerned with the

[1] These are inevitably rough estimates. Calculations based on the surviving titles
and fragments will naturally vary, since the subjects of several plays are not known
with certainty and since some titles may be no more than alternatives or duplicates of
others. In addition, numbers will vary according to the boundaries we set for the Tro-
jan cycle. Pearson, who includes in his calculations plays only loosely connected to
the Trojan War (e.g. the Elektra plays) produces higher counts. Knox (1979) 9 writes
that 'The Trojan War and its ramifications account for no less than 68 of the known
plays.'

[2] For Sophokles, Pearson (1917) p. xxxi counts 43 plays out of 113 as Trojan, i.e.
over 38%—a generous assessment. One-quarter is a more cautious estimate. Pearson
calculates 23% and 21% for Aischylos and Euripides respectively.

[3] See Ch. 10 below for a brief discussion of these plays.

Trojan War or its aftermath might readily include allusions to Troy's fall, as Sophokles' *Philoktetes*, for example, anticipates the Ilioupersis as the joint accomplishment of its heroes, and Euripides' *Andromache* repeatedly recalls the attack and ensuing enslavement.[4]

The following chapters explore several tragic images of the Ilioupersis. This is not an exhaustive analysis of the corpus, but rather a representative sampling of some of the most accessible examples. The fragments of lost Trojan plays, while they offer tantalizing glimpses of the conquest, discourage the kind of comprehensive analysis pursued here and therefore will not be treated at length. My first subject is Aischylos' portrayal of the Ilioupersis from the distant perspective of Argos in the *Agamemnon*. Next I observe several reflections of Ilioupersis motifs and themes in Euripides' *Andromache*. And finally I turn to a closer perspective on the suffering of the conquered in Euripides' *Troades*. The three chapters together offer general insights on how the tragedians further developed the mythic network constructed by the epic poets, and how they manipulated, enhanced, or altered the traditional components of the Ilioupersis for their own dramatic purposes.

Of only marginal relevance to the present study is the status of the Trojans with regard to the traditional polarity between Greeks and barbarians, the latter often regarded by the former as 'others' and tagged with a series of negative traits, including servility, savagery, and moral depravity. Fifth-century Trojans, like their Amazon and Ethiopian allies, sometimes fell on the barbarian side of the illusory racial divide, and their geographic origin and military opposition to the mythological Achaian alliance earned them occasional cultural associations with the contemporary Persian enemy, but there was rarely a simple one-to-one correlation between Trojans and the stereotypical barbarian. There is no Trojan equivalent to Euripides' Taurian Thoas or his Egyptian Theoklymenos, and in fact, when dramatists did expose the barbarian roots of the Trojans, it was often to challenge the simplistic stereotypes. The barbarian concubine in Euripides' *Andromache* displays a nobility far superior to her petulant Greek antagonist Hermione, and Greek acts of savage cruelty like the murder of Astyanax and the sacrifice of Polyxene demonstrate that barbarism is not confined to barbarians.[5]

[4] Taplin (1988) 76 discusses the anticipation of the Ilioupersis in the *Philoktetes*. Note in particular Herakles' warnings against sacrilege at lines 1440–4.

[5] Hall (1989) offers a comprehensive treatment of barbarians in Greek tragedy.

7

The Image of the Ilioupersis in Aischylos' *Agamemnon*

> Fortune rota volvitur
> > descendo minoratus;
> alter in altum tollitur;
> > nimis exaltatus
> rex sedet in vertice—
> > caveat ruinam!
> nam sub axe legimus
> > Hecubam reginam.
>
> (Carmina Burana)

Aischylos' *Oresteia* trilogy begins with the nostos of Agamemnon, with the ill-omened homecoming which follows the king's long-awaited victory over the Trojans. And as in the epic tradition of Troy's fall, where the Ilioupersis launches the Achaians on their disastrous homeward journeys, so too in Aischylos' *Agamemnon* the Ilioupersis opens the final chapter in the life of an Achaian hero. Over the first 800 lines of the play, while awaiting the imminent arrival of the victorious king on stage, we repeatedly hear reflections and recollections of his recent victory—from the chorus a memory of a distant omen, from Klytaimestra a provocative vision of distant events, a first eyewitness account from the messenger, and finally a report from the conqueror himself. Through these varied and sometimes contradictory recollections Aischylos projects a mysterious, haunting image of Troy's destruction into the drama of events at Argos.[1]

The very opening of the play first puts the Ilioupersis to work for dramatic effect, using the conquest as the spark of energy which awakens characters and plot to action. The watchman, stationed on the roof of the palace by the expectant Klytaimestra (10–11), lies vigilant in anticipation of a signal bringing news of Troy's capture

[1] Cf. the similar structure of the *Persai*, in which the royal court hears several reports of the distant defeat of the army and the king before the king himself returns.

(the ἁλώσιμον βάξιν—10). For a year he has watched the stars rise and set, and no sign from Troy has appeared. But today his labour ends as the long-awaited news of Troy's fall finally reaches Argos in the form of the beacon fire. With the arrival of that news the Argives can at last begin celebrations of thanksgiving, and Klytaimestra can at last set her trap in preparation for the return of her husband. The drama can begin.

Another dramatic element to which the Ilioupersis makes an indispensable contribution is the poignant and dramatic reversal of fortune suffered by Agamemnon. The king returns triumphantly after his recent victory over Troy, but the glorious homecoming pageant his success has earned him is soon succeeded by a dishonourable death at the hands of his wife and her lover. Although the persis itself lies beyond the formal boundaries of the drama, the repeated, extensive references to the recent conquest bring these successive events closer together and thereby increase the intensity of the reversal. Recollection of Agamemnon's victory elevates him to high levels of esteem and pride, thus making his subsequent fall all the greater. At one moment he is treading on the purple carpets of royalty as befits the conqueror of Troy, and at the next he lies dead in his own home, entangled in toils set for him by his own wife.

Among the major themes which subsequent dramatic events share with the Ilioupersis, one stands out immediately above the rest. Retribution plays a principal role in each play and unites the three independent works into a coherent trilogy. Klytaimestra murders Agamemnon in recompense for the murder of her daughter Iphigeneia (for example, *Ag.* 1412–20 and 1525–9), and Aigisthos assists her in order to avenge earlier offences against his father (for example, *Ag.* 1577–1611). This act of retribution then engenders another in the seseqent segment of the trilogy, where Orestes murders Klytaimestra and Aigisthos to avenge the murder of his father. Finally, after these two instalments of retribution the pattern threatens to continue in the third drama, as the Furies pursue Orestes to avenge the murder of his mother. The three plays form a tripartite chain of crime and punishment, each act responding to a former act which has engendered it. At the very beginning of this chain, the image of the Ilioupersis looms in the background of the *Agamemnon* as a fourth and truly monumental act of retribution. Paris abducted Helen ten years earlier, and in response Agamemnon led the Greek army to war against Troy. Now, on the eve of the opening of Aischylos' trilogy, the Greeks

have at last defeated and destroyed the city of their enemies. They have exacted retribution from the offenders, and the Ilioupersis is that retribution. More than simply the victory which launches the drama into motion, the Ilioupersis is itself an act of retribution which in turn sets into motion a series of such acts.

My purpose in the following pages is to explore in closer detail Aischylos' use of the Ilioupersis within the drama; to consider how the playwright builds an image of the sack piece by piece, and how he integrates that image into the poetry and plot of the play. Before I proceed further, however, one crucial point concerning the manner in which Aischylos depicts the Ilioupersis should be noted. Apart from a brief recollection of the ruse of the wooden horse (ἵππου νεοσσός— 825), Aischylos employs few precise references to specific elements of the Ilioupersis story. He offers no view of the murder of Priam, no acknowledgement of the act of Neoptolemos. Although the characters recognize that the war has been waged over Helen, Aischylos provides no report on her actual rescue. Even the herald, who proudly trumpets the victory to the whole of Argos, shares no tangible facts. The conquest took place far away across the Aegean, and the physical distance between Argos and Troy, between the location of the conquest and the location of the dramatic action, yields imprecision, ambiguity, and uncertainty. Despite this imprecision, however, and perhaps in part because of the resulting mystery, the Ilioupersis remains a powerful and influential image within the drama. Without telling us exactly what happened at Troy, the dramatist nevertheless evokes strong impressions of the conquest through the abstract means of metaphor and imagery. The common tradition of the Ilioupersis, though not adopted unequivocally, peers out through the vocabulary of the eyewitness reports and the general attitudes which the characters form toward the conquest. The Ilioupersis rests uneasily on the horizon, an ambiguous spectre whose immense influence is felt and acknowledged, but whose shape and contours cannot be fully discerned.

7.1 The Feast of the Eagles

We receive our first image of the Ilioupersis through a distant prophecy recalled by the chorus, Kalchas' interpretation of an omen which occurred long ago on the eve of the departure of the Greek fleet for

Troy (104–59). As the chorus recount the initial gathering of the Achaian army, they recall how two eagles devoured a pregnant hare together with its unborn young (113–20 and 135–6). Recognizing the two eagles as the Atreidai, Kalchas interpreted the feast on the pregnant hare as the capture of the city of Troy together with its riches. Just as the eagles hunted the hare, so the Atreidai will hunt and capture (ἀγρεῖ—126) the city of Priam.

The imagery is striking and highly appropriate to the Ilioupersis as traditionally represented by the poets. By referring to the hunted animal as 'offspring of the hare' (λαγίναν γένναν—119) instead of simply 'hare' (λαγώς), Aischylos underlines the animal's natural associations with fertility and procreation.[2] And as befits a symbol of fertility, Aischylos' hare is 'swollen with the burden of its womb' (ἐρικύμονα φέρματι—119). In eating this hare 'together with its unborn young' (αὐτότοκον πρὸ λόχου—136), the eagles kill the symbol of fertility and prevent procreation. The image thereby conveys a sense of eradication, utter extermination, which, while the passage contains no explicit references to specific events of the sack, corresponds well to the now-familiar traditions of the Ilioupersis. To appreciate the appropriateness of this image we need only recall the Achaian drive to wipe out the race of Priam completely (see Ch. 2). All the male members of Priam's household must die, even the young Astyanax, still only a child in his mother's arms. An epic passage sometimes compared with Aischylos' omen is the brutal threat which Agamemnon makes toward the Trojans in *Iliad* 6. There, in reprimanding his brother for leniency toward an enemy, Agamemnon declares his own ultimate goal of complete devastation for Troy, a devastation from which 'not even the male that a mother carries in the womb' is exempt (μηδ᾽ ὅν τινα γαστέρι μήτηρ | κοῦρον ἐόντα φέροι—Il. 6. 58–9).[3] Eating the hare together with its unborn young, Aischylos' eagles represent the fulfilment of Agamemnon's threat.

[2] Cf. Herodotos, 3. 108. 3: 'Because the hare is hunted by every wild beast and bird and by man, it reproduces abundantly; of all animals it alone can be impregnated again while pregnant; of the offspring in its belly one has fur, another is bare, another is just forming in the womb, and another is conceived.'

[3] See Dawson (1927) 213–14 and Garner (1990) 34, both of whom detect in Aischylos' omen an allusion to Agamemnon's boast in *Iliad* 6. In addition to the correspondence between the pregnancy of the hare and the Trojan children still in the womb, they draw attention also to the fact that the differing temperaments of the two sons of Atreus as noted by Kalchas—δύο λήμασι δισσούς (123)—reflect the difference exhibited in their treatment of the enemy in *Iliad* 6: the one brother is lenient, the other unrelenting.

The significance of Aischylos' omen within the drama is illuminated particularly well through a narratological analysis of the temporal framework. As news of the war's conclusion approaches Argos, the chorus looks back to the war's beginning, to the thousand ships launched against Troy to retrieve Helen—in narratological terms, an instance of analepsis. By means of this recollection Aischylos relates start to finish, shows us both ends of the war in relation to one another. A dramatic precedent may be found in the parodos of Aischylos' *Persai*, where, as we await news of the Persian king's campaign against Greece, the chorus recalls the initial gathering of forces and the outset of the expedition. That proud departure of the enormous army prepares for a dramatic contrast with the subsequent ignominious return of the defeated king.

In the parodos of *Agamemnon* the recollection of the war's beginning forms one half of a bipartite narrative frame; for while the chorus looks back to the beginning of the war, the omen which they recall simultaneously looks forward to the war's conclusion. In narratological terms, the analepsis contains within it a complementary prolepsis. Point *B* looks back to point *A*, which in turn looks forward to point *B*. The result is a telescoping of the war, as beginning and end are compressed together within the space of a few lines. The very similar portent narrated in *Iliad* 2 produces a comparable narrative loop: Odysseus recalls the omen of the snake and birds which occurred at the initial gathering of the fleet at Aulis, and that omen in turn anticipates the conclusion of the war. The epic poet has thereby drawn into a single book of the *Iliad* a frame for the entire war, a recollection of its now distant beginning and simultaneously a promise of its imminent conclusion.

This spanning of narrative distance through the omen—more than mere narratological play or display—assists the playwright in linking together events which, though widely separated in time, are of immediate relevance to one another. As Kalchas tells us, 'the signs are auspicious, but also disagreeable' (δεξιὰ μὲν κατάμομφα δὲ φάσματα—145). While his interpretation of the omen begins with the encouraging promise of Troy's capture, he also recognizes in the omen hints of less joyful events. Artemis, the seer perceives, is roused to anger by the eagles' feast (134–7) and will oppose the expedition by restraining the ships (147–9). Furthermore, he fears that the goddess will demand a sacrifice of appeasement, 'another sacrifice, unorthodox and inedible' (θυσίαν ἑτέραν ἄνομόν τιν' ἄδαιτον—150). These

very events foreseen by Kalchas through the omen emerge as fact
in the subsequent section of the parodos, where the chorus recalls
the unfavourable winds holding the fleet and Agamemnon's even-
tual agreement to offer his daughter Iphigeneia at the altar. The omen
and Kalchas' interpretation of it thus establish a causal link between
the eventual capture of Troy and the imminent sacrifice of Iphigeneia:
Artemis, angered by the predicted fall of Troy, demands in return
a sacrifice from Agamemnon. Other versions of the myth paint the
sacrifice simply as a prerequisite to the departure of the fleet from
Aulis.[4] Aischylos' omen, in contrast, which encompasses both sac-
rifice and Ilioupersis, presents the sacrifice as a prerequisite to the
Ilioupersis itself. The latter act necessitates the former.

Even before Kalchas' acute interpretation, the relationship between
the two events is already inherent in the omen itself, or rather in the
imagery and vocabulary with which Aischylos formulated the omen.[5]
The pregnant hare devoured by the eagles, as discussed above, cor-
responds thematically to traditional representations of the Ilioupersis
as an act of utter extermination: even the children of Troy must per-
ish. While applicable to the Trojans, however, the image resonates
suggestively with the present circumstances of the house of Argos;
for ironically, it is the offspring of Agamemnon himself, the child of
Klytaimestra, who will suffer as a result of the divine portent. The
ambiguously fertile symbolism conflates the fate of Iphigeneia with
the death of Troy's young. For a similar instance of multivalent im-
agery we may compare the eagles lamenting the loss of their chil-
dren at the opening of the parodos (49–59). Aischylos applies this
image initially with reference to the loss of Helen. But in choosing an
image of parents mourning stolen children, he chooses an image that
is equally, if not more readily, applicable to the subsequent loss of
Iphigeneia.[6] Although this dense conflation of symbolism confronts
the audience like a tangled riddle, clouding the past in mystery and
uncertainty, the motivation for the campaign and the stakes involved
actually emerge more clearly because of the symbolic overlap. In the
eagles' lament over the loss of their young, Aischylos asks whether

[4] Apollodoros, *Epit.* 3. 21 explains Artemis' demand with reasons unconnected with
the future capture of Troy: the goddess is angered either because Agamemnon has
boasted his superiority to her as a hunter or because he has failed to honour her with
sacrifice on a previous occasion.

[5] For the use of ambiguous or multivalent imagery in the *Oresteia*, as well as for
connected imagery, see in particular Lebeck (1971).

[6] Cf. also Knox (1952) on the multivalent image of the lion (*Ag.* 717–36).

the Atreidai will accept the loss of Helen or sacrifice Iphigeneia to re-trieve her; he asks us to weigh the two losses against each other. And similarly, the death of the pregnant hare asks whether Agamemnon will sacrifice Iphigeneia to purchase Troy's destruction.

Another point at which the Ilioupersis and Iphigeneia's sacri-fice overlap is in the word θυομένοισιν (136), used by Aischylos to describe the feast of the eagles. The birds, as Kalchas describes them, not only devour the hare; they 'sacrifice' it together with its young. The most immediate source of inspiration for the word is the immin-ent sacrifice of Iphigeneia; because Aischylos employs the omen to anticipate the sacrifice of Agamemnon's daughter, he portrays the feast of the eagles as a sacrifice.[7] But since the omen also looks bey-ond Iphigeneia to the capture of Troy, might we also hear in this word a hint of the sacrilegious nature of the capture, the disturbing 'sacrifice' of the hare evoking acts of sacrilege and desecration tradi-tionally found in accounts of Troy's destruction? A simpler interpreta-tion is conceivable: the hint of sacrifice applies only to Iphigeneia, the pregnant hare represents only Troy, and Aischylos simply rolled together these monosemantic symbols to produce a compound omen. But where the ingredients have been so closely blended that the fla-vours of each permeate the other, absolute demarcation of symbolism is neither desirable nor possible. The horror of Iphigeneia's unholy sacrifice is the first stain on the glory of the Ilioupersis.

To these two acts united through the omen and its imagery, Aischylos adds a third. In warning of the anger of Artemis, Kal-chas describes the resulting sacrifice as a 'builder of strife without fear of man' (νεικέων τέκτονα σύμφυτον, οὐ δεισήνορα—151-3). He is referring of course to the murder of Agamemnon. The sacrifice of Iphigeneia, as the present drama will soon reveal, engenders in Klytaimestra an anger which inspires her to murder her husband. She is the 'terrifying resurgent deceitful home-tender, mindful child-avenging wrath' that waits for Agamemnon's return (μίμνει γὰρ φοβερὰ παλίνορτος οἰκονόμος δολία, μνάμων μῆνις τεκνόποινος— 154-5). The omen and its interpretation thus encompass these three acts in a temporally looped chain of causality. The future Ilioupersis necessitates the preliminary sacrifice of Iphigeneia, which in turn leads to the murder of Agamemnon.

[7] Fraenkel (1950) ii. 82 explains, 'the expression increases the effect of the unholy deed, and at the same time prepares our minds for the sacrifice of Iphigeneia, the ἑτέρα θυσία (151).'

7.2 Ilioupersis and Nostos

Over the next thousand lines of Aischylos' *Agamemnon* the events foreseen by Kalchas in the parodos, the sack of Troy and the murder of Agamemnon, gradually unfold dramatically on the stage. The past prophecies of the seer provide a basic pattern for the subsequent development of the present drama, and when the parodos ends and Aischylos returns us to Argos and to the present, we find ourselves in the midst of Kalchas' long-range, programmatic predictions. The victory over Troy lies in the immediate past, Agamemnon's murder lies in the immediate future, and both events now begin to take shape side by side before us. As the death of Agamemnon moves ever closer, the echoes of the recent victory grow ever louder. As anticipation of the king's return increases, so does our picture of the destruction of Troy, evoked first in the imagination of Klytaimestra and the chorus, then through the eyewitness report of the herald, and finally through the report of Agamemnon, the conqueror himself. The Ilioupersis thus functions as a kind of expanding refrain in the background of Agamemnon's return to Argos.

The impression of the Ilioupersis which emerges from this series of invocations has two sides, two faces, the first a simple image of justice accomplished, the second an image of justice abused. From one perspective we observe that the Achaians have conquered and sacked Troy in response to offences committed by the Trojans, and that Zeus has sanctioned the Achaian army as his instrument of justice. Combined with this image, however, is an image of sacrilegious offence. While redressing the wrongs committed by the Trojans, the Achaians have themselves become perpetrators of wrongdoing. Although they capture Troy with the support and assistance of the gods, their sacrilegious disregard for the sanctity of Troy's temples rouses the anger of the gods against them. They have carelessly abused their role as deliverers of justice. As these two images compete with one another, Aischylos adds to the picture also a third relevant element, the theme of the retributive nostoi which follow the Ilioupersis. To punish the recent Greek offences, the gods send a storm of retribution which wrecks and scatters the fleet as the Greeks attempt to return to their homes. The Ilioupersis is thereby portrayed as the centre of a continuing sequence of retribution: the Greeks punish the Trojans, the gods punish the Greeks.

This pattern is already familiar to us from the epic tradition of the Ilioupersis, as it was undoubtedly familiar also to Aischylos' original audience. In the epic accounts the themes of victory, sacrilege, and retribution revolve around the goddess Athena, who first assists the Achaians, allowing them to capture Troy by means of the wooden horse, but is subsequently slighted by her allies. Lokrian Aias attacks Kassandra in the temple of Athena and is consequently drowned at sea in a storm of retribution sent by the goddess, and many of the Achaians who have failed to punish his sacrilege share his suffering.[8] This same familiar story-pattern underlies Aischylos' presentation of the Greek victory in *Agamemnon*. The dramatist refrains from refer- ring directly to specific characters or events, to Athena or to the crime of Aias, but through suggestive glimpses of the Ilioupersis he evokes the salient elements of this tradition and subtly colours the back- ground of his drama with the themes of sacrilege and retribution commonly associated with the conquest of Troy.

In the first episode of the drama Aischylos offers us our first sub- stantial glimpse of the Ilioupersis through Klytaimestra. After her stirring account of the beacons which brought to Argos the news of Troy's fall, Klytaimestra proceeds to present to the chorus an imagin- ary or visionary picture of the city in the hands of its new masters (320–50). Her picture is an odd mixture of triumph and apprehen- sion. For the chorus, anxious to hear news from Troy, Klytaimestra's report is a welcome affirmation of glorious victory, but the principal interests of Klytaimestra herself lie elsewhere. As she imagines the success of the Greeks, her thoughts are already pointing in another direction, towards the sacrilege of the conquerors and the disastrous storm awaiting them on the homeward journey; and this anticipa- tion of reversal darkens the tone of her entire speech.

Klytaimestra begins with a preliminary distinction between the subjugated Trojans and the victorious Greeks: they are like oil and vinegar, standing apart when poured into the same vessel (322–3). While the Greeks are celebrating their victory, the Trojan survivors, she imagines, are mourning for their dead, and the hungry are wan- dering the city by night (320–37). The Greeks have now exchanged their quarters for the former dwellings of their victims; 'they now lodge in the captured Trojan homes' (ἐν δ' αἰχμαλώτοις Τρωϊκοῖς οἰκήμασιν | ναίουσιν ἤδη—334–5). At first glance, this image of contrast

[8] The nostoi and the storm of retribution are discussed in greater detail above in §5.1.

between victims and victors seems a natural and innocent conclusion to draw from the news of victory, but as with so many words spoken by the devious queen, her vision of the Greek victory is tainted with irony and serves a double purpose. The picture of new-found comfort, while from one perspective an image of victory, is offered also as emotional preparation for the imminent reversal of fortune. By portraying the Greeks in comfort and splendour, Aischylos sets the scene for their mighty fall.

A closer reading of Klytaimestra's vision suggests, in fact, that the ultimate purpose of this passage is not to distinguish, but to assimilate the Greek victors to their former enemies. Those familiar with the Ilioupersis tradition may recognize that Klytaimestra's image of the victorious Greeks corresponds surprisingly closely to the traditional image of the Trojans on the eve of the Ilioupersis. Duped into believing themselves victorious by the ruse of the wooden horse, the Trojans dropped their defences, celebrated their supposed victory,[9] fell asleep, and were slaughtered by the Greeks.[10] Now the Greeks in turn, revelling in their own victory, allow themselves to 'sleep the entire night' in the houses of the Trojans 'with no guard, like fortunate men' (ὡς δ᾽ εὐδαίμονες | ἀφύλακτον εὑδήσουσι πᾶσαν εὐφρόνην —336–7). In effect, they duplicate the recent actions of the victims. Unexpected misfortune previously awaited the Trojans, and those who know the Ilioupersis tradition will already sense the unexpected misfortune now awaiting the Greeks. They are following in the footsteps of their victims, and their move into the homes of their former enemies is a symbolic first stage in the process of succession. Klytaimestra's preliminary contrast between Greeks and Trojans, between oil and vinegar, thus serves as an ironic façade, and the distinction she suggests is merely temporary. Greeks and Trojans, so very far apart for the moment, will soon be united in defeat.

As Klytaimestra continues her speech Aischylos makes the hints of imminent reversal more audible with an ominous warning against sacrilegious misconduct:

[9] *MI* arg. 22–3: 'and they celebrate as having won' (καὶ εὐωχοῦνται ὡς νενικηκότες).

[10] Although Proklos' summary of the *Iliou Persis* does not record that the Trojans went to sleep, Apollodoros gives more specific details in his account of the myth: 'and when night fell and sleep held all . . .' (ὡς δὲ ἐγένετο νὺξ καὶ πάντας ὕπνος κατεῖχεν . . . —*Epit.* 5. 19); and 'when they [the Achaians] perceived that the enemy were sleeping . . .' (ὡς δ᾽ ἐνόμισαν κοιμᾶσθαι τοὺς πολεμίους . . . —*Epit.* 5. 20). Cf. also Euripides, *Hek.* 914–23.

εἰ δ' εὐσεβοῦσι τοὺς πολισσούχους θεούς
τοὺς τῆς ἁλούσης γῆς θεῶν θ' ἱδρύματα,
οὔ τἄν ἑλόντες αὖθις ἀνθαλοῖεν ἄν.
ἔρως δὲ μή τις πρότερον ἐμπίπτῃ στρατῷ
πορθεῖν ἃ μὴ χρή, κέρδεσιν νικωμένους·
δεῖ γὰρ πρὸς οἴκους νοστίμου σωτηρίας,
κάμψαι διαύλου θάτερον κῶλον πάλιν.

If they reverence the divine guardians of the city,
those of the captured land, and the shrines of the gods,
then, capturing, they would not be captured in turn.
But let no premature desire strike the army
to destroy what it should not, conquered by greed;
for they need safety on the homeward return,
to turn back on the other leg of the course.

 (*Ag.* 338–44)

Here again Klytaimestra's words are double-edged. The effect of this
simple warning against sacrilege is in fact to invoke in the mind
of the audience the sacrilege traditionally associated with Troy's
capture. By having Klytaimestra deliver these words of caution,
warnings to the Greeks to honour the gods of the captured city and
their sanctuaries (338–9), the playwright recalls to us the traditional
Greek disregard for the sanctity of Troy's temples, the acts of sacrilege
memorialized by the epic poets.[11] When Klytaimestra warns against
the desire to plunder what is forbidden (342), Aischylos is reminding
us of the traditional lack of restraint exercised by the Greeks in cap-
turing Troy. Finally, for those familiar with the traditional sequence
of Ilioupersis and nostos, Klytaimestra's regard for 'safety on the
return' or 'safe return' (νόστιμος σωτηρία—343), will remind us that
many of the Greeks, in return for their actions at the sack, did not
survive the homeward journey.[12] The speech thus drafts a blueprint
for the ironic reversal of fortune presently under way. The Trojans
have received their final retribution in the capture of their city. But
now the Greeks, in destroying Troy, commit sacrilegious offences
and thereby call down divine retribution upon themselves. Like the
recently captured Trojans, the Greeks, Klytaimestra warns, may now
be 'captured in turn' (ἑλόντες αὖθις ἀνθαλοῖεν ἄν—340).

[11] See §2.1 and §2.2 for the murder of Priam, §3.1 and §5.1 for the attack on
Kassandra.
[12] The pattern of her thoughts here corresponds particularly closely to the story
of Lokrian Aias, who defiled the temple of Athena and was consequently deprived of
nostos by the storm of divine retribution.

Finally, towards the close of her speech, Klytaimestra gives us a hint of the retribution awaiting her husband Agamemnon, the principal reason for her interest in the victory over Troy. Although she does not mention Agamemnon here specifically in connection with the victory or with sacrilege, her soon-to-be victim remains in the forefront of her mind, and her closing lines neatly define his position within her scheme of nostos: 'And if the army should come without offence to the gods, | the pain of the dead could awaken' (θεοῖς δ' ἀναμπλάκητος εἰ μόλοι στρατός, | ἐγρήγορος τὸ πῆμα τῶν ὀλωλότων | γένοιτ' ἄν—*Ag.* 345–7).[13] The statement is prophetic. Agamemnon does in fact escape the storm of divine retribution at sea, the divine menace resulting from the recent transgressions at Troy, but he will return home only to find the grief of the dead Iphigeneia awakened in the form of his vengeful wife.

Like Klytaimestra's vision, the choral ode which follows it contains a complex and double-sided assessment of the Ilioupersis. The song begins with elation but ends in confusion and doubt, as the image of conquest is clouded by recollection of previous losses and fear of future reprisal.[14] At first overjoyed by Klytaimestra's news, the chorus sound proud praise for the capture of Troy as an illustration of divine justice. They imagine that Night has cast over Troy a giant net from which neither great nor small may escape—an appropriate complement to the earlier image of the pregnant hare, similarly symbolic of utter destruction. They imagine further that Zeus himself is allied with Night in the conquest. Zeus, the god of the guest–host bond, they reason, has brought about the fall of Troy (Δία τοι ξένιον μέγαν αἰδοῦμαι | τὸν τάδε πράξαντ'—362–3) because the deceptive Paris, in abducting Helen, abused the hospitality of Menelaos (ᾔσχυνε ξενίαν τράπεζαν—401–2). Whoever 'kicks the great altar of Justice' (λακτίσαντι μέγαν Δίκας | βωμὸν—383–4) must face the punishment of the gods, and the Trojans are no exception.

As the ode progresses, however, the initial exuberance of the chorus

[13] The continuation of line 347—εἰ πρόσπαια μὴ τύχοι κακά—produces a construction which has disturbed several editors. Fraenkel (1950) ii. 177–8 follows Headlam in looking for an alternative to ἐγρήγορος, and M. L. West (1990) posits a lacuna between lines 346 and 347 to allow for two independent conditional statements. Denniston and Page (1957) 100, on the other hand, interpret the text as it is transmitted; my translation and interpretation follow their explanation.

[14] For a summary of views on the structure of this ode see Fraenkel (1950) ii. 245–9. On the step-by-step development see in particular Wilamowitz-Moellendorf (1921) 185–6 and Kranz (1933) 159–60.

subsides and their thoughts turn to less commendable events of the war, to the dust of the countless men who have died on behalf of Helen and to the family grief resulting from these deaths. Instead of praising the Atreidai for their victory, the chorus dwells instead on the reproaches rising against them among the people (449–51). And as the ode approaches its conclusion the chorus expresses an unsettling fear of retribution yet to come: 'the slayers of many do not escape the vigilance of the gods' (τῶν πολυκτόνων γὰρ οὐκ | ἄσκοποι θεοί—461–2). These slayers of many are the Atreidai, the leaders responsible for the many past casualties of the war. The mood of the ode has thus undergone a reversal. Whereas at the beginning the chorus reflected upon the offences of the Trojans and the justice of Troy's capture, now they question that justice as they reflect instead upon the suffering which the Atreidai have caused. A general condemnation of the sack is audible in their own wish not to be sackers of cities (μήτ' εἴην πτολιπόρθης—472). The chorus has thereby returned to its original subject, the capture of Troy, but with an opposing attitude toward the capture. And in place of their initial eagerness for news of the victory, they now express a strong reluctance even to believe the ominous news of the beacon (475–88).

Having provoked our curiosity and suspicion through the insincere warnings of Klytaimestra and the anxious foreboding of the chorus, Aischylos next introduces the herald and offers us an eyewitness account of Troy's capture. His first speech takes the form of a eulogy to Agamemnon the sacker of cities, in which the herald, like the chorus before him, identifies the victory as a form of divine retribution. It is Paris who brought ruin upon Troy through his abduction of Helen (532–7). To punish Paris and the Trojans Agamemnon has razed the city of Troy with the 'mattock of Zeus, bringer of justice' (τοῦ δικηφόρου | Διὸς μακέλλῃ—525–6). Furthermore, in praise of Agamemnon's achievement the herald enthusiastically boasts of the magnitude and degree of the devastation: 'the altars and shrines of the gods are demolished | and every seed has been eradicated from the land' (βωμοὶ δ' ἄϊστοι καὶ θεῶν ἱδρύματα, | καὶ σπέρμα πάσης ἐξαπόλλυται χθονός—527–8).[15] Like the net in the first ode and the

[15] Various editors delete line 527 on the grounds that it does not fit with the surrounding agricultural imagery (525–6 and 528) and that such a blatantly sacrilegious statement would be inappropriate from the messenger. As it recalls line 811 of the *Persai*, editors suggest that it was originally a marginal note referring to that play. See Fraenkel (1950) ii. 266–7 for further discussion. I prefer to retain the line; for the

pregnant hare in the parodos, the image of Zeus' mattock and the now barren land vividly conveys the extent of the destruction. The extermination is comprehensive and final.

The words are bold, like the chorus's initial reaction to Klytaimestra's news of Troy's capture. As in the preceding choral ode, however, simple judgements mask a more complicated case, and beneath the herald's superficial claim of just retribution lies a grim picture of the war and its aftermath. Primed by the warnings of Klytaimestra and the concerns of the chorus, the audience will already perceive in the herald's boasting the darker side of the victory. Permeating his report is a general sense of overindulgence in punishment. In response to the original crime of Paris, the Greeks have exacted retribution from the entire city of Troy, and the Trojans have suffered much more than the offence warranted: 'the sons of Priam have payed double for the offence' (διπλᾶ δ' ἔτεισαν Πριαμίδαι θἀμάρτια—537). More damning is his claim that the Achaians have levelled Troy's altars and holy shrines (527), a claim so blatantly blasphemous in fact that some editors have wished to excise it from the text.[16] But this is precisely the image which Aischylos has prepared us to expect. The desecrated temples in the herald's report fulfil the riddling premonition of Klytaimestra, who only recently warned the Achaians to respect the temples of the gods (θεῶν ἱδρύματα—339). In effect, the herald unwittingly incriminates himself and the remainder of the Greek army.

Furthermore, the herald himself undergoes a sharp emotional reversal during the course of the scene, his initial elation turning to anxiety in the face of unwelcome and disturbing revelations. When eventually pressed by the chorus for news of Menelaos, he is forced to lay aside his previous pretensions to glory and reveal the vast naval disaster which succeeded the sack (615–60). With reluctance he reports that a fierce storm came upon the fleet by night, and that the rising sun of the next day revealed to the survivors a sea scattered with corpses (653–60). Even before the full disclosure of the calamity the chorus senses that a divine hand was at work behind it: 'Can you be saying that a storm came to the fleet through the anger of the

imagery need not be homogeneous, and the tone of sacrilege is not discordant with the agricultural metaphors. Although it may be considered a blasphemous statement, it is consistent with other less than pious statements of the messenger; cf. lines 567–73.

[16] See n. 15.

gods?' (δαιμόνων κότῳ—635). And the herald himself agrees with their suspicion, by admitting that the storm was 'not without divine wrath against the Achaians' (χειμῶν' Ἀχαιῶν οὐκ ἀμήνιτον θεοῖς—649). The herald thereby confirms the anticipation of divine retribution raised previously by Kytaimestra when she warned of the need for 'safety on the homeward journey' (343).[17] The sequence of crime and punishment foreseen by the queen has in fact occurred. The Achaians failed to respect the temples of the conquered city, and they have paid for their negligence in the storm of divine vengeance.

Finally, the herald's report ends with one more confirmation of Klytaimestra's warnings, as Aischylos gives further definition to the king's precarious position within the scheme of nostos. Contrasting the misfortune of the fleet with the survival of Agamemnon's ship, which escaped the storm unharmed, the herald attributes the escape to divine intervention, to 'some god, not man, who took hold of the rudder' and steered the ship safely through the danger (θεός τις, οὐκ ἄνθρωπος, οἴακος θιγών—661–6). While the herald interprets the escape as a divine miracle, the audience will realize that this stroke of fortune, instead of saving Agamemnon, has in fact steered him straight into the trap set by his wife. Although Aischylos never tells us so explicitly, this sequence of events suggests that Agamemnon's death be understood as an alternative form of punishment. Agamemnon escapes the storm only to meet a surrogate agent of retribution in the form of Klytaimestra.[18] Klytaimestra herself meanwhile, having delivered a speech of thanksgiving (587–614)—in reality thanking the gods for having left Agamemnon's punishment to her—has already departed to prepare the trap. The news of the herald has answered her previous expectations in every respect. As she warned in her own vision of the Ilioupersis, the suffering of the dead, of her daughter Iphigeneia, will soon awaken.

By the close of the second episode and the revelation of the storm of divine retribution, we recognize a general pattern underlying all of Aischylos' many invocations of the Ilioupersis. The initial elation

[17] Note also the echo of Klytaimestra's 'safety of return' when the chorus asks whether Menelaos 'has come back, *returned and saved*, with you' (εἰ νόστιμός τε καὶ σεσωμένος πάλιν | ἥκει σὺν ὑμῖν—618).

[18] Aischylos further underscores the irony of the sequence with the purple tapestries, perhaps a symbolic reminder of the sea. In having him walk on this fabric, the poet suggests that Agamemnon is metaphorically still at sea. Another comparison between the fate of Agamemnon and his former comrades is Kassandra's reference to Klytaimestra as Skylla (1232–4).

in the news of victory, the boasts of justice, and the pride of the victors consistently yield to sorrow and foreboding. Again and again, the initial image of success is deflated and the pendulum swings in the opposite direction. The first traces of this pattern are visible already in the play's prologue, in the speech of the watchman, whose joyous outbursts at the first sight of the beacon suddenly fall silent in the face of unnamed secrets concealed within the house (36–9). The pattern becomes fully operative with the feast of the eagles, interpreted first as a sign of victory, but subsequently as a warning of Iphigeneia's sacrifice and the retribution which that sacrifice will motivate—'signs auspicious, but also disagreeable' (δεξιὰ μὲν κατάμομφα δὲ φάσματα —145). Such an inversion underlies the entire first episode, in which Klytaimestra delivers the news of victory through an inspired account of the beacon chain, but subsequently stifles any joyful intoxication with a series of sobering reflections upon sacrilege and retribution. Klytaimestra is succeeded by the chorus, who first sing proudly of a just conquest but then revert to recollections of sorrow and ominous anticipation of future retribution. And the pattern recurs again in the speeches of the herald, whose joyful tidings of victory precede a painful revelation of the storm of retribution. Time and time again Aischylos exploits the Ilioupersis as a source of thematic and emotional reversal, as invocation of the victory repeatedly brings with it reflections of subsequent suffering and disaster.

The final and greatest swing of the Ilioupersis pendulum results in the death of Agamemnon. The preceding series of reversals, all initiated by the capture of Troy, reaches its climax in the long-awaited entrance of the king himself and the murder which follows shortly thereafter. Given the general prominence of the Ilioupersis, it is not surprising that Agamemnon, like the herald before him, should enter with the victory on his lips (810–29). The sentiments and the sequence of thought presented by the king are by now familiar. Like the chorus and the herald, the king conceives of the capture as an act of justice. In fact, in portraying the event to his fellow Argives, he paints an image of the highest possible form of justice, a court of law in which the gods themselves cast votes in favour of Troy's destruction (813–17). Agamemnon himself merely carries out their orders, serving as the human instrument of divine will. As the messenger has previously informed us, Agamemnon wields 'the mattock of Zeus, bringer of justice' (525–6).

Here again, however, behind the claims of justice lies an image of immoderation unflattering to the Greek victors. When Agamemnon

boasts that 'the Argive stinger has pulverized the city for the sake of a woman' (γυναικὸς οὕνεκα | πόλιν διημάθυνεν Ἀργεῖον δάκος— 823–4), he shows no appreciation for measure or balance in retribution. The statement parallels the herald's recent claim of double retribution, that the sons of Priam have paid the penalty twice (537). Agamemnon then proceeds to liken the army to a 'bloodthirsty lion', which 'leapt the walls' and 'lapped up its fill of royal blood' (827–8). Far from the picture of law and justice Agamemnon has just painted, his lion is an image of unbridled revenge comparable to Zeus' monstrous vision of Hera in *Iliad* 4, 'entering the gates and long walls of Troy and eating raw Priam and the sons of Priam' (34–5). Supporters of Agamemnon may argue that the victory entitles him to a few boasts, but in light of the previous warnings of sacrilege and divine retribution, Agamemnon's sense of justice seems at the least confused and imbalanced. His report raises once again the now-familiar theme of indulgence in excess and gives little cause for the celebration he requests.

In conjunction with the echoes of excess within this final account of the Ilioupersis, Aischylos raises further cause for concern in the curiously ominous greeting which introduces Agamemnon to the stage. The king's paean of victory follows in the wake of a lengthy *double entendre* from the chorus, who while hailing Agamemnon as 'Troy's destroyer' (Τροίας πτολίπορθε—783), simultaneously hint at the infidelity and deceit of his wife Klytaimestra (783–809). In the midst of their greeting Aischylos inserts a brief but disturbing reminder of Iphigeneia, as the chorus once again recall the ambiguously auspicious outset of the fleet (799–804), where Agamemnon maintained the army's spirit 'through sacrifice' (ἐκ θυσιῶν—803–4). They themselves, the chorus tell us, despite previous reservations, can now overlook that past tragedy in the face of the campaign's successful completion: 'I am favourable to those who have completed the labour well' (εὔφρων πόνον εὖ τελέσασιν ⟨ἐγώ⟩—806).[19] Behind their affirmation of loyalty, however, lies the suggestion of disloyalty elsewhere.[20] Klytaimestra, we know, has not forgotten the previous loss

[19] Editors are not in agreement over the reconstruction of this corrupted line, but the sentiment that satisfactory ends justify or at least outweigh questionable means is unmistakable, and the now favourable attitude of the chorus toward Agamemnon is obvious.

[20] Wilamowitz-Moellendorf's addition of ἐγώ to 806, adopted by Page, strengthens the implication of a contrast between the chorus—'I (at any rate)'—and some unspecified other, i.e. Klytaimestra.

and is soon to exact her revenge upon Agamemnon. In effect, this ill-omened recollection of Iphigeneia's sacrifice prepares us for the completion of the chain of retribution previously foreseen by Kalchas and presented to us in cryptic form in the parodos. Agamemnon performed the sacrifice long ago, he has recently captured Troy, and now step three, his own murder, is imminent. Aischylos thereby shades Agamemnon's introduction onto the stage with a tone of irony and apprehension, and as the conqueror proceeds to answer the chorus's greeting with a boastful account of the victory, his image of the Ilioupersis is already stained with the blood of that distant sacrifice and of his own approaching murder.

It is not necessary to review here the complex web of irony and deception behind Agamemnon's subsequent exchange with Klytaimestra, as his wife welcomes him back superficially as a victor, but in reality as an unwitting victim. One moment within the dialogue, however, is of particular relevance to the Ilioupersis theme: the brief but timely recollection of Priam immediately preceding Agamemnon's entry into the palace. Klytaimestra has spread purple tapestries on the ground before her husband in honour of his victory—'lest you should place your foot on the ground, my lord, destroyer of Ilios' (᾿Ιλίου πορθήτορα—906–7). When Agamemnon hesitates, Klytaimestra counters his reluctance with a question: 'What do you think Priam would have done, if he had achieved this?' (935). Certainly Priam would have walked on purple (936), and if the king of Troy could walk on purple, why not the king of Argos? Klytaimestra's arguments eventually succeed, and Agamemnon treads on the carpets. To the king this analogy may seem simple: in treading on the purple carpets he likens his power and prestige to the power and prestige formerly belonging to the king of Troy. As a figure associated with the Ilioupersis, however, Priam represents not merely power, but also power defeated, and the superficial comparison understood by Agamemnon carries with it this prophetic message of defeat. Like the Greek victors in Klytaimestra's vision, victors who take on a foreboding resemblance to their recent victims, Agamemnon too is portrayed in the image of his former enemy. In essence, he is walking in the footsteps of Priam and heading for a fall like that of his recently conquered rival.

After the departure of Agamemnon from the stage, the number of references to the Ilioupersis quickly decreases and the image of Troy soon recedes into the past.[21] The spirit of the Ilioupersis, however,

[21] See e.g. the brief remarks of Kassandra at lines 1287–9 and the chorus at 1335–7.

and the themes associated with the conquest remain active as the play reaches its dramatic climax with Klytaimestra's act of murder. Ironically, of all the characters in the play, Klytaimestra has shown the greatest understanding of the Greek excesses at Troy, of the army's fatal confusion between justice and vengeance. It was Klytaimestra who, upon receiving news of the victory, first recognized the potential for sacrilege. Yet she herself now indulges in just the type of behaviour she has condemned, and her vision of the Ilioupersis serves as a paradigm for her own actions.

Like the Greeks before her, Klytaimestra appeals to justice, interpreting the murder of Agamemnon as an act of warranted retribution, a payment in kind for the murder of her daughter (1412–20, 1431–3, 1525–9), but like them, she too allows her desire for retribution to lead her into excess. Immediately after performing her act of retribution, she appears in exultation before the chorus, and her boasting equals the recent boasting of her victim Agamemnon. She is now following in his footsteps, returning triumphant from her own victory. Like Agamemnon, who recently entered with elaborate thanks to the gods and claimed them as accomplices in the destruction, Klytaimestra too presents her conquest as an offering to the gods. She describes the murder in terms of a sacrifice, a fitting response to the sacrifice of her daughter Iphigeneia, and yet she fails to recognize the folly of this sacrilegious crime.[22] Furthermore, Klytaimestra also invites into her trap of retribution a second victim who is in no way implicated in the death of Iphigeneia. The Trojan princess Kassandra, of whom Klytaimestra speaks contemptuously as a 'side dish for my bed' (1447), serves in effect as a side dish not for the bed, but for the murderous wrath of the jealous queen.[23] In murdering her together with Agamemnon, Klytaimestra demonstrates that her act is governed not merely by retribution, but by a bitter and biting vengeance that drives its agent to cruel and violent extremes, the same force that recently drove the Greeks to unwarranted extremes in their destruction of Troy.

[22] For the theme of corrupted sacrifice in the *Oresteia* see Zeitlin (1965 and 1966). As perpetrators of illegitimate sacrifice, both Agamemnon and Klytaimestra may be compared with the lion which makes an unwanted offering to its masters (727–36); on the many potential applications of the lion imagery see Knox (1952).

[23] Aischylos complicates Klytaimestra's motivation by highlighting the wider sexual tensions between husband and wife. Klytaimestra attempts to justify the murder on the grounds of adultery (1438–43), and yet she ironically introduces this defence immediately after her first mention of her own adulterous relationship with Aigisthos (1436).

To underline the general thematic correlation between the Iliou-persis and the murder, Aischylos engineers a subtle metaphoric con-nection within Klytaimestra's first report on the deed.[24] To murder her husband she has entangled him in a robe which she subsequently describes to the chorus as a net: 'I surround him with an endless net, as for fish' (ἄπειρον ἀμφίβληστρον, ὥσπερ ἰχθύων, | περιστοχίζω —1382–3). The same image has been employed previously by Kassandra, who envisions the murderous wife herself in terms of a net: 'Is it some net (δίκτυόν τι) of Hades? | The wife is a snare (ἄρκυς), she who shares in | the murder' (1115–17). And Orestes will employ the metaphor again in reference to the robe in the following play (*Cho.* 997–1000). If we now glance back to the first choral ode of *Agamemnon*, we will recall that Aischylos began that ode with a very similar and very memorable image of a net, not in reference to Agamemnon's death, but in reference to the capture of Troy. After receiving news of the Greek victory, the chorus pictures Troy's capture in terms of a net cast over the city by Night, an all-encompassing net of slavery from which neither large nor small, old nor young, can escape (355–61). Like the net cast around Troy, a net which none of the Trojans can 'overleap' (ὑπερτελέσαι—359), Klytaimestra de-scribes her own plot as a net 'too high to jump' (ὕψος κρεῖσσον ἐκπηδήματος—1376). Aischylos has thereby associated the Iliou-persis with the murder at the level of metaphor. The use of the powerful net imagery in reference to the Ilioupersis anticipates the use of the same imagery in reference to the murder. The Greeks 'net' Troy, and Klytaimestra subsequently 'nets' Agamemnon.

Ultimately, the general themes encompassed in the image of the Ilioupersis extend in influence beyond the murder itself and into the two subsequent plays of the trilogy. Just as the excess of retribution carried out by the Greeks at Troy called forth the storm of divine retribution, so too Klytaimestra's sacrilegious and overindulgent act of retribution against Agamemnon will be answered with further retribution: the god Apollo will send her son Orestes to avenge the murder of Agamemnon. The prophetess Kassandra, who otherwise has surprisingly little to tell us of the Ilioupersis, nevertheless recog-nizes this grand design of successive retribution. Soon after she foresees

[24] On the robe/net imagery see in particular Lebeck (1971) 63–8 and cf. Conacher (1987) 17–18. As Lebeck points out (p. 65), the vocabulary in the relevant passages is polysemantic, including images of both fishing and hunting.

the future return of Orestes as avenger—'there will come another to assist us in retribution, | a matricide scion, avenger of the father' (1280–1)—she also thinks back upon the sequence of retribution that has recently befallen the Trojans and the Greeks: 'since first I saw the city of Ilios | faring as it fared, and those who took the city | end thus in the judgement of the gods . . .' (ἐπεὶ τὸ πρῶτον εἶδον Ἰλίου πόλιν | πράξασαν ὡς ἔπραξεν, οἳ δ' εἷλον πόλιν | οὕτως ἀπαλλάσσουσιν ἐν θεῶν κρίσει . . . —1287–9). Kassandra here perceives the paradigmatic function of the Ilioupersis. The Greeks visited retribution upon the Trojans and then met with retribution themselves. Likewise, Klytaimestra visits retribution on Agamemnon and will herself meet with retribution in the future. Like the Ilioupersis, Klytaimestra's act is only one in a series of acts, each to be answered by another. 'For the unholy act | engenders others to follow, | like to its own kind' (τὸ δυσσεβὲς γὰρ ἔργον | μετὰ μὲν πλείονα τίκτει, | σφετέρᾳ δ' εἰκότα γέννᾳ—758–60).

7.3 The Beacons

One Ilioupersis element of the *Agamemnon* remains to be discussed: the chain of beacons which first brings news of the Ilioupersis to Klytaimestra and ignites fires of thanksgiving on the altars of Argos, the chain which Klytaimestra describes at length and in rich detail in the first episode (281–316). In addition to their dramatic function in initiating the action of the drama, Aischylos has equipped his beacons with a highly symbolic function. For Klytaimestra and the Argives, of course, the signal represents the capture of Troy. She plainly tells the chorus that the fire is a 'symbol' (a τέκμαρ and a σύμβολον) sent from Troy by her husband (315–16). But the symbolism of the beacons reaches far beyond the prearranged code for announcing victory. The chain of fires stretching from Troy to Argos reflects metaphorically the chain of crime and retribution through which the events at Troy and Argos are linked, a chain which ultimately extends throughout the *Oresteia*. It is in part because of this deep symbolic correlation between the message-sending device and the pervasive theme of retribution that Aischylos has Klytaimestra follow the passage of the signal from beacon to beacon in such lavish detail. The sequence of beacons, each fire igniting the next, mirrors the dramatic progression of causally related events within the trilogy,

each ignited by the last—from the sack of Troy and the prerequisite sacrifice of Iphigeneia, to the death of Agamemnon, to the deaths of Klytaimestra and Aigisthos, and finally to the trial of Orestes. And as the principal agent of revenge in the *Agamemnon*, Klytaimestra is a most appropriate narrator for this metaphoric sequence of revenge. Despite, however, her privileged view on coming events and despite the confidence and verbal mastery exercised in her narration, her control over the forces of retribution is merely temporary. Although her speech guides the beacons to their finish-line in Argos, she lacks the power to terminate the signal of retribution with the death of Agamemnon, and she fails to appreciate fully the continuation of the chain as foreseen by Kassandra.

To reinforce the symbolism of the beacons Aischylos chooses to describe them with elements of vocabulary and imagery well suited to the theme of vengeance. One significant component, for example, is the motif of sleeping and waking. The fourth beacon station, Klytaimestra tells us, 'neither hesitates nor is foolishly conquered by sleep' (ὕπνῳ νικώμενος—290–1). Shortly thereafter the beacon of Messapion 'awakened' (ἤγειρεν) another beacon at Kithairon to receive the messenger-fire (299).[25] These metaphors, though brief, belong to a wide complex of sleep imagery which appears throughout the trilogy, frequently in conjunction with the theme of vengeance. In her vision of the victory Klytaimestra associates the punishment awaiting the Greeks with the 'awakened' suffering of the dead (346–7), while she imagines the Greeks themselves asleep in the houses of Troy with no guard (337). Vengeance wakes, and its victims sleep. In *Choephoroi* a premonition of vengeance comes to Klytaimestra as a dream while she sleeps (*Cho.* 32–41, 535–7), and Orestes and Elektra wake the ghost of their father for assistance in avenging his murder (*Cho.* 495). In *Eumenides* the ghost of Klytaimestra dramatically wakes the sleeping Erinyes to send them in pursuit of Orestes (*Eum.* 94–148). The sequence of 'awakening' in the beacon chain is part of this repeated image of vengeance waking.[26] Appropriately, the news the beacons bring to Argos at the opening of *Agamemnon* will greet Klytaimestra

[25] Conacher (1987) 16 similarly notes the association between vengeance and arousal in Klytaimestra's speech.

[26] For other passages in which Aischylos employs the motifs of sleep and waking see *Ag.* 14–15, 17, 274–5, 889–91. And cf. esp. line 912, where, as Klytaimestra invites Agamemnon to his bloody retribution, she describes herself as 'unconquered by sleep' (οὐχ ὕπνῳ νικωμένη), a phrase previously employed in reference to the beacons at 290–1.

as she wakes, 'rising from her bed' (εὐνῆς ἐπαντείλασαν—*Ag.* 26–7). One light rouses the next, until the final light rouses Klytaimestra and her vengeance.

Although Aischylos may be credited with invention of this chain —no such element is attested for earlier accounts of Agamemnon's nostos—his beacons were not completely without precedent, and I suggest that the playwright found some inspiration for them in the beacon-fire lit by Sinon prior to the capture of Troy. According to Proklos' summary of the *Iliou Persis*, after the Trojans have received the wooden horse into their city and have retired from their celebrations to sleep, Sinon lights a fire signalling the Greek fleet to return; they do so, and together with those who were hiding inside the horse they capture the city.[27] While the attention devoted to this beacon-fire within the epic tradition cannot be measured precisely without the poems themselves, the mere mention of the signal in Proklos' concise summary suggests that it was a well-known feature of the story.[28] An ambitious poet might easily have developed a memorable description of the signal fire, perhaps as a symbolic prelude to the greater fire to follow when the Greeks burn the city.[29]

Although there is insufficient evidence to argue that Aischylos is actually alluding to the beacon-fire of Sinon, that he is actually asking us to recall that beacon, it seems likely at least that the dramatist found some inspiration in the epic precedent. Like the Greek fleet, waiting for the signal from Troy, Klytaimestra too has been waiting for a signal. When the beacon-fire appears, the Greek fleet returns to Troy to take the city while the unsuspecting Trojans sleep, and at Argos Klytaimestra implements her plans to murder her unsuspecting husband. The beacon of the Ilioupersis is preparatory to the treacherous capture and destruction of Troy, while those of the *Agamemnon* are preparatory to the treacherous murder of the king.

[27] *IP* arg. 10–12: 'Sinon raises the torch-signal to the Achaians, having previously entered the city by pretence. And the men sailing from Tenedos and the men from the wooden horse attack the enemy' (καὶ Σίνων τοὺς πυρσοὺς ἀνίσχει τοῖς Ἀχαιοῖς, πρότερον εἰσεληλυθὼς προσποίητος. οἱ δὲ ἐκ Τενέδου προσπλεύσαντες καὶ οἱ ἐκ τοῦ δουρείου ἵππου ἐπιπίπτουσι τοῖς πολεμίοις).

[28] In addition, the story sparked a few variations. Apollodoros, perhaps following the *Mikra Ilias*, has Sinon light the beacon-signal from the tomb of Achilles (*Epit.* 5. 19). Vergil has Helen herself light a torch for the Greeks (*Aeneid* 6. 518–19).

[29] Proklos records the burning at the end of his *Iliou Persis* summary (lines 22–3), where it is followed only by the sacrifice of Polyxene. *Il.* 20. 316–17 (= 21. 375–6), which anticipates the burning of Troy, suggests that the burning may already have been an established feature in the earlier epic tradition. See also the conflagration at the close of Euripides' *Troades*.

7.4 The Image of the Ilioupersis in the Eumenides

The image of the Ilioupersis, though largely neglected in the second and third plays of the trilogy, re-emerges for a brief but significant appearance in the *Eumenides*. The final glimpse of the conquest arrives in conjunction with the timely return of Athena to Athens:

> πρόσωθεν ἐξήκουσα κληδόνος βοήν,
> ἀπὸ Σκαμάνδρου, γῆν καταφθατουμένη,
> ἣν δῆτ' Ἀχαιῶν ἄκτορές τε καὶ πρόμοι,
> τῶν αἰχμαλώτων χρημάτων λάχος μέγα,
> ἔνειμαν αὐτόπρεμνον ἐς τὸ πᾶν ἐμοί,
> ἐξαίρετον δώρημα Θησέως τόκοις.

> I heard a shout of invocation from afar,
> from the Skamandros, as I was appropriating the land
> which the leaders and chiefs of the Achaians,
> a great portion of the captured goods,
> assigned entirely and for ever to me,
> a choice gift to the sons of Theseus.

(*Eum.* 397–402)

Like the triumphant Agamemnon, Athena returns to her city after a military victory. Although she does not identify the conquered region as the kingdom of Priam, her mention of the river Skamandros and of the Achaian leaders places the victory squarely in the Troad and associates her arrival with the recent return of the Argive king.[30]

Despite the superficial resemblance between the entrances of the two conquerors, several elements of Athena's victory-speech contrast sharply with Agamemnon's previous boasts of victory. In his share of the spoils Agamemnon received the Trojan princess Kassandra as a 'choice flower from many goods' (πολλῶν χρημάτων ἐξαίρετον ἄνθος), 'a gift of the army to me' (στρατοῦ δώρημ' ἐμοί—*Ag.* 954–5). Athena too is honoured with a share of the spoils, which she describes with an echo of Agamemnon's vocabulary as her 'choice gift' (ἐξαίρετον δώρημα—*Eum.* 402). Athena's prize, however, is not a human captive, but the land gained through the conquest. While the Argive commander brought home a gift for himself, Athena has received a gift on behalf of the whole of Athens, present and future, a gift for the

[30] For a discussion of this passage and its relation to the Ilioupersis as represented in the *Agamemnon* see also Macleod (1982) 125.

sons of Theseus (*Eum.* 402). Her Trojan War is a joint venture, not a private vendetta or a source of personal gain, and in her capture of the city there is no place for Kassandra. Furthermore, instead of the utter destruction and extermination reported by Agamemnon's herald (*Ag.* 525–8 and 535–6), Athena intends to retain possession of the land for continued cultivation and settlement (*Eum.* 401). Desecration of temples (*Ag.* 527) plays no role within the new Ilioupersis, and in contrast to the sacrilegious acts suggested in the first play of the trilogy, the Greek chieftains in Athena's report have affirmed their piety by offering the first spoils of the war to her. Finally, in conjunction with this new image of conquest, Aischylos also promotes a positive image of the conqueror Agamemnon. Orestes remembers his father with pride as the leader with whom Athena shared victory over Troy (*Eum.* 457–8), and Athena makes no objection.[31] Soon Apollo too will recall Agamemnon's military leadership and even his piety, referring to him as 'the all reverent' (τοῦ παντοσέμνου— *Eum.* 637), nor will the Erinyes refute him.

This reversal might prompt us to question our previous conclusions about the Ilioupersis in the *Agamemnon*. Was our assessment of the sacrilege and divine retribution misguided? Rather than interpret the evidence introduced in the *Eumenides* as a call for a complete re-evaluation of the earlier play, I see the new Ilioupersis image as part of the comprehensive process of redefinition which takes place over the course of the trilogy. Since the murder of Agamemnon, Aischylos has developed the implementation of *díke* from the type of unbridled retaliation exemplified by the sack of Troy into a controlled form of punishment administered by the Areopagos in Athens.[32] In the *Eumenides* private revenge is superseded by public justice, and the vote of the lawcourt replaces the vengeance of the grieving mother and the dutiful son. Under this new code of justice the sack of an entire city is unacceptable as punishment for the abduction of one man's wife, and the traditional image of the Ilioupersis as it was presented in the *Agamemnon* has no place within the new system. So instead of the sacrilege and retribution envisioned by Klytaimestra, Aischylos now offers an alternative account of victory in the Troad, a version updated to accord with the revised code of justice. The trilogy thus presents two distinct Ilioupersis images, each corresponding

[31] Cf. Agamemnon's own claims at *Ag.* 810–13, that the gods were his partners in the sack. [32] On this development see e.g. Sommerstein (1989) 19–25.

to one of the two codes of justice. While the sack looms in the back-ground of the *Agamemnon* as a model of sacrilegious vengeance, that model becomes obsolete with the introduction of Athens' civic code, and rather than simply ignore Troy for the remainder of the trilogy, Aischylos chooses to re-form the myth and reintroduce it in a funda-mentally different shape. While a sceptical view of the accomplish-ments praised in the last play might classify this metamorphosis as an instance of ambiguity or dismiss it as self-contradiction, I prefer to see the two images working in conjunction with one another as a powerful illustration of the contrast between old and new.

8

Ilioupersis Paradigms in Euripides' *Andromache*

8.1 Introduction

Judged from the perspective of generations of critics, Euripides' *Andromache* would appear to be a bizarre play, a perplexing series of twists and turns which repeatedly raise and lower our emotions.[1] Such criticism certainly draws attention to the rapid pace and the density of events packed into this drama, but it will also naturally provoke defenders, who wish to find in Euripides a master craftsman of rhetorical argumentation, composing plots with a logic analogous to that of his agonistic characters.[2] I believe that a new analysis, sensitive to the perspective of the designing dramatist, will bring to light the exceedingly, perhaps excessively, rational structure upon which the drama rests. In the following pages I offer a partial outline of the logic of the drama, and at the same time I argue that the play's structure rests to a greater or lesser extent upon a set of fundamental paradigms borrowed from the Ilioupersis. Like Aischylos' *Agamemnon*, the play is set in the aftermath of the sack of Troy and abounds in Trojan recollections. Like Aischylos, Euripides was aware of the relevance of several Ilioupersis themes and motifs, and he employed these consciously as compositional paradigms, embedding them in the structure of his play.[3]

[1] For reviews of previous criticism, often negative, of the play's structure, see Aldrich (1961) 11–21 and Stevens (1971) 9–12.

[2] Aldrich (1961) 61–3 argues that the play's twists adhere to a single compositional principle: 'Each scene ends with a conflict which will be either complicated or resolved in the ensuing scene.' Burnett (1971) 130–1 attempts to explain the dramatic development as the result of a 'central experiment, that of role-changing'. While both proposals are useful, neither adequately describes the peculiarities of the play's structure.

[3] Aldrich (1961) 52, 69 and Stevens (1971) 13–15 begin to approach this direction by highlighting the importance of Troy as a recurrent image. Neither, however, focuses on the Ilioupersis or Euripides' use of Ilioupersis paradigms as patterning devices.

Let us begin with a preliminary glance at two parts of the play.[4] Our first object of analysis will consist of the prologue and episodes one to three. Here the lives of Andromache and her son are threatened by Hermione and her father Menelaos. The timely arrival of Peleus dissolves the threat and sends Menelaos back to Sparta with his murderous intentions unfulfilled. For the second component of our study we turn to the death of Neoptolemos in distant Delphi—introduced in episode four by Orestes, the architect of the deed (993–1008), and then confirmed in episode five, where the corpse of Neoptolemos is brought onto the stage and a messenger narrates the murder in detail. Although it is generally not fully recognized in critical studies of the play, Peleus' words of lament emphatically characterize the event not only as the loss of a grandson, but as the ruin of a family and a kingdom. The old king fears that after the deaths of Achilles and Neoptolemos no descendants remain to continue his royal line. But as Thetis will clarify in her epilogue, Peleus' line has not come to an end here precisely because he has rescued the child of Andromache earlier in the play. Andromache's son is now the last of the Aiakids (1246–7), and his descendants will rule over the Molossians from generation to generation (1247–9). It is through this engineered interplay of threatened discontinuity and ultimate continuity that these two blocks of the play are most fundamentally and logically linked.[5]

Since we have been scrutinizing the traditional Ilioupersis themes in the preceding chapters of this book, it is difficult not to perceive their influence here in the *Andromache*. The shifting balance between family continuity and family discontinuity is a principal concern of the Ilioupersis tradition, in which the fall of the city means in essence the death of Priam and the death of his sons. Astyanax, the last hope for the survival of the Priamids, is thrown from the towers of the city, and with that act the Achaians exterminate Priam's seed entirely. But while Priam, Hektor, and Astyanax fall victim to the Achaians, Anchises, Aineias, and Askanios survive the disaster that ruins their

[4] Friedrich (1953) 47 divides the play into two and calls it a 'diptych'. See Waldock (1951) 49–79 for a study of diptychs centred upon Sophokles' *Aias*. While I interpret the overall structure of the play as a triptych (cf. Stevens (1971) 5–9), in my initial analysis I shall, for the sake of clarity, temporarily ignore the significance of the suicide attempt and the rescue of Hermione in episode four, elements to which I shall return below.

[5] Kovacs (1980) 55, 60, and 76–8 is one of the few to stress the importance of family and dynasty for Andromache and Peleus.

cousins and escape to continue the race of Dardanos. In construct-
ing the plots of his *Andromache*, Euripides borrowed the patterns of
family continuity and discontinuity traditionally associated with the
Ilioupersis. Central to the first part of his drama is the Ilioupersis para-
digm of Andromache and Astyanax. Although distanced from her Tro-
jan background both temporally and geographically, Andromache
has been cast in a part which mimics her role at the Ilioupersis, as a
mother in danger of losing her son. And in the second part of the play
Euripides models the destruction of Peleus' entire family and king-
dom on the fall of Priam's family and kingdom at the Ilioupersis. Each
paradigm is a major patterning force, an essential tool, in fact, which
enables Euripides to bring the story of Phthia to the stage.

Before undertaking a more detailed analysis of this phenomenon,
I offer a preliminary warning against confusion between paradigm
and allusion in my initial discussion. When writing 'paradigm' I refer
specifically to a compositional tool, a patterning device. This tool can
contribute dramatic depth, and its employment can be perceived by
the spectators during presentation, but it is not *necessarily* something
that the spectators must register consciously. The term 'allusion',
in contrast, will be used to refer to something which the audience *is*
meant to perceive. While Euripides' play does contain allusions to the
Ilioupersis, they do not appear continuously from beginning to end.
Our primary goal is not to identify the allusions to the Ilioupersis, but
to observe Euripides' awareness of the Ilioupersis plots and to meas-
ure the influence which they have exerted on his composition. Only
once the mechanics of the paradigms have been sufficiently explored
can we assess what allusive force they may contain.

8.2 Andromache and her Child

The danger threatening Andromache and her child is the principal
subject of the programmatic prologue and the first three scenes of the
drama. Early in the prologue Andromache informs us that a dispute
has arisen between herself, the fertile concubine of Neoptolemos, and
Hermione, his barren wife. Hermione is jealous because Andromache
has given Neoptolemos a son while she herself has not yet succeeded
in this duty (26–38). This jealousy between wife and concubine
forms the background to their dramatic confrontation in the first
episode. The prologue informs us also that the jealousy of Hermione

is potentially deadly; that in the absence of Neoptolemos, Hermione villainously attributes her own infertility to the alleged sorcery of Andromache and plots with her father Menelaos to destroy her enemy (39–40); and that the child whom Andromache initially believes to be safely hidden in another city has since been discovered by Menelaos, who intends to kill him (68–9). This set of facts leads to the action of the second episode: the arrival of Menelaos with the child, the agon between Andromache and Menelaos, and Andromache's futile self-sacrifice for the life of her son. In addition, the initial exchange between Andromache and the servant introduces us to Peleus, the only remaining hope for the rescue of mother and child (79–91). The servant departs to fetch the king in the prologue, and the call is answered by his arrival in episode three, where he takes up the defence of Andromache and the child in opposition to Menelaos' sustained demands for their death. While Euripides weaves several other themes and arguments into the dialogue of the first three episodes, this brief schematization of the action demonstrates that mother and child remain central concerns throughout.

The evidence for a mythic tradition behind the dangers facing Andromache and her child in Phthia is thin. It had long been known that Andromache fell to Neoptolemos as his concubine. From prior tradition Euripides knew also that Andromache married Helenos after the death of Neoptolemos,[6] and earlier poets and mythographers may already have credited Andromache with a child.[7] While, however, the mythic subject-matter was familiar to Euripides' audience, the dramatic poses in the *Andromache* were entirely new. Hermione's deadly jealousy, Menelaos' march to Phthia, their intent to murder mother and child, these are compositional inventions of Euripides, devices with which he transformed myth into tragedy. To bring Andromache and the son of Neoptolemos to the stage, Euripides had to add to their pre-existing mythic roles a new dramatic situation, life-threatening circumstances ripe for heightened passions.[8] That they both merely survive the death of Neoptolemos was in itself not

[6] Euripides' cursory mention of Helenos in the epilogue (1245) acknowledges a preexisting tradition. On the various traditions concerning the fate of Helenos after the Ilioupersis, see Frazer (1921) ii. 250–1, discussing Apollodoros, *Epit.* 6. 12–13.

[7] See Stevens (1971) 3.

[8] With regard to the danger facing Andromache and her son, Friedrich (1953) 59 offers an illuminating assessment of Euripides' use of 'the almost'—*das Beinahe*—as a dramatic tool.

sufficiently tragic. Thus the dramatist exposes them to the jealousy of Hermione and the villainous brutality of Menelaos, has Andromache offer herself as a sacrifice for the safety of her son, and gives to the child a desperate plea for life.

A principal tool in this generic metamorphosis is the Ilioupersis paradigm of Andromache and Astyanax. The image of the mother and her only child, repeatedly at the heart of the arguments in Euripides' play, derives from the pre-existing tradition of Andromache and her previous child Astyanax, who was taken from her and murdered by the Greeks after the capture of Troy. As a parallel we may compare Polydoros in Euripides' *Hekabe*, a second Trojan prince created in imitation of Astyanax. Like his nephew Astyanax, Polydoros is the last surviving member of the Trojan royal family, the final but illusory hope for a revival of Troy. In *Andromache* Euripides has again created a character in imitation of Astyanax, this time a second child for Andromache herself.

Two passages best illuminate the connection between Astyanax and Andromache's second son. At the very opening of the play Andromache reviews several salient details of her past life: her marriage into the royal family of Priam (1–4), the death of her husband Hektor (8–9), and the loss of her child Astyanax at the sack of Troy (9–11). With this initial recollection Euripides tacitly acknowledges the Astyanax paradigm as the source of his 'new' plot. The swift disclosure of Andromache's present predicament in the remainder of the prologue juxtaposes present with past, and through this juxtaposition Euripides implicitly discloses that he has forged the bond between Andromache and her new child (26–8) in imitation of her traditional role as the loving mother of Astyanax. Like Astyanax, the new child is again left unprotected by the absence of his father (49–55, 74–6), and the plot of murder against him threatens to double Andromache's past loss.[9] Furthermore, Euripides draws attention to

[9] While not addressing the subject of Ilioupersis paradigms directly, Friedrich (1953) 58 conjectures that Euripides adapted this plot from that of a previous play, in which Astyanax remained hidden in the citadel of Troy until Odysseus forced Andromache to reveal the child's presence. In support of his theory he cites parallel plots in Accius and Seneca. If true, the proposal would mean that Euripides was constructing a very close connection between Andromache's past and present situations. Friedrich's theory is attractive, but we have no firm proof to defend it, and we might just as easily argue the reverse, that it was Accius or Seneca or some other later dramatist who, noting the similarities between Astyanax and Andromache's second son, reinterpreted the tradition of Astyanax on the model of Euripides' *Andromache*.

the analogy between present and past through the vocabulary of Andromache's initial reminiscences. She recalls that she was given to Hektor to be a 'child-bearer' (δάμαρ δοθεῖσα παιδοποιὸς Ἕκτορι— 4), and she remembers Astyanax not just as her son, but as 'the child I bore to my husband' (παῖδά θ' ὃν τίκτω πόσει—9). Now she functions again as child-bearer, this time for Neoptolemos: 'I bear a male child for this house' (δόμοις τοῖσδ' ἄρσεν' ἐντίκτω κόρον—24). Ironically, it is precisely this role as child-bearer that has led to her present misfortune, by arousing the jealousy of the infertile Hermione, the would-be child-bearer.

It may strike us as unusual that, despite the bold introduction of Astyanax at the opening, Euripides fails to mention him anywhere in the remainder of the play. With the early reference to Astyanax we may contrast, for example, several of Andromache's subsequent recollections of Troy, recollections from which Astyanax is noticeably absent. At the end of the prologue Andromache again reflects upon her past, first briefly in iambics (96–9) and then at length in elegiacs (103–12). Hektor, Troy, and her own slavery remain in her thoughts here, but the child Astyanax has disappeared. Andromache enumerates her past misfortunes a third time in the second episode (394–405), and though the passage provides a perfect context for allusion to her first son, she neglects him once again. In addition, in all of these passages subsequent to the opening, Andromache's role as 'child-bearer' to Hektor is ignored, and instead she is simply considered Hektor's wife.

This repeated reticence over Astyanax may in part be due to Euripides' wish to avoid a negative characterization of Neoptolemos, popularly branded as the murderer of Astyanax. Euripides refuses to recall the child's murder in order not to tarnish the hero's reputation or to jeopardize our sympathy towards him, just as he avoids any needless recollections of Neoptolemos' role in the murder of Priam. In addition, the reticence tells us something about Euripides' poetic techniques and priorities. The play is not first and foremost intended as a study in allusion. While employing Astyanax as a paradigm for plot construction, Euripides prefers not to belabour a connection with ponderous references. Astyanax and the Ilioupersis are sources of inspiration, but Euripides is writing his own play and feels himself free to leave Astyanax in the past, or rather to leave him out of the past. Anticipating later developments in the play, we may even relate the absence of Astyanax to the growing importance of the present child.

As we will soon observe, Euripides seeks not just to mimic Astyanax, but to supplant him.

In another illustrative passage, the 'murder' scene which opens the third episode, Astyanax appears in spirit but not in name, functioning again as a paradigm rather than a subject of allusion. Fearing Andromache and her child as threats to the status of his daughter, Menelaos will use any possible argument to justify their deaths. Accordingly, he revives an argument used previously to advocate the death of Astyanax after the capture of Troy, namely that it would be unwise to allow the son of the great Hektor to survive.[10] As Menelaos prepares to murder mother and child in the *Andromache*, he defends his actions on similar grounds, ignoring the actual paternity of the child and treating him instead as if he were a son of Hektor. He identifies both Andromache and her son as Trojan enemies, 'from an enemy citadel' (καὶ γὰρ ἀπ᾽ ἐχθρῶν | ἥκετε πύργων—515–16), and then declares that 'it is great folly to let enemies born from enemies live, when it is possible to kill them and remove fear from one's house' (519–22).[11] Just as Astyanax, the last surviving male of the Trojan ruling dynasty, previously presented a threat of retaliation to the Greeks if allowed to live, so now, according to Menelaos' wicked logic, this second child of Andromache is an enemy and a threat.[12]

As if to assist Menelaos' skewed interpretation of events, Euripides further invokes the Trojan background in the lines following this denunciation. Here Andromache calls upon her husband for assistance (ὦ πόσις πόσις—523), not Neoptolemos, the child's actual father, but her former husband Hektor, 'son of Priam' (Πριάμου παῖ—525). The scene then reaches a climax with another reference to the capture of Troy and to the enslavement of Andromache, upon which

[10] Euripides attributes the argument to Odysseus at *Tro.* 723 (λέξας ἀρίστου παῖδα μὴ τρέφειν πατρὸς . . .). The brief presentation of the argument here suggests its previous familiarity among the audience, and it is likely that Odysseus employed the same argument in the epic *Iliou Persis*, as Proklos' summary of that poem attributes the murder to Odysseus (cf. §3.2).

[11] Murray prints the lines thus: καὶ γὰρ ἀνοία | μεγάλη λείπειν ἐχθροὺς ἐχθρῶν, | ἐξὸν κτείνειν | καὶ φόβον οἴκων ἀφελέσθαι. While editors generally explain the somewhat troubling ἐχθροὺς ἐχθρῶν as 'enemies born from enemies', as I have translated it, Wilamowitz proposed the replacement of ἐχθροὺς with σκύμνους, 'pups' (recorded in Murray's apparatus). Either way, the words point specifically to the younger generation, strengthening the resemblance between Menelaos' argument and that employed against Astyanax.

[12] Cf. *Hek.* 1136–44, where Euripides puts the same argument into the mouth of another villain, Polymestor, as a defence for the murder of another Astyanax double, Polydoros.

grounds Menelaos seeks to justify his intentions to murder the child (540–4). With the exception of only a few phrases (the mention of Phthia at 507 and Hermione at 519), the interaction between Menelaos, Andromache, and child is entirely consistent with the previous dispute over Astyanax.

The arrival of Peleus on the heels of this near-murder overturns the Astyanax paradigm. The threat of death is pushed to its limit, but death itself is averted, and unlike his predecessor, this child will survive thanks to the timely intervention of his great-grandfather Peleus. In the ensuing debate between Menelaos and Peleus, the villain again employs his slippery logic, treating the child less as a son of Neoptolemos than as a son of Hektor. In his eyes Andromache is still a barbarian enemy (647–54), still a member of the hated family of Priamids (655–6), and is still bearing enemies to the Greeks (659). Menelaos therefore justifies his actions on the basis of anticipated future retaliation (προνοίᾳ τῇ τε σῇ κἀμῇ—660–1). The Astyanax-based arguments, however, have no effect on King Peleus, who in fact threatens to do just as Menelaos fears, to raise the child in Phthia as an enemy to the Spartans (723–4). Through this rescue and promise of a powerful future, the new child achieves a position that once belonged to Astyanax before his hopes for future rule were cut short by the fall of Troy. With the new child the previous damage is redressed, the paradigm reversed.

At the very same moment that the new child sheds the trappings of Astyanax, Euripides engineers a complementary reversal of Ilioupersis precedent for the child's mother, releasing her from the bonds of servitude which have held her since the fall of Troy. The first three episodes of the drama present an Andromache heavily burdened by the yoke of slavery. Formerly given to Hektor as his childbearing wife (4), after the fall of her city she was 'given to Neoptolemos as the prize of the spear, | chosen from the Trojan plunder' (τῷ νησιώτῃ Νεοπτολέμῳ δορὸς γέρας | δοθεῖσα λείας Τρωϊκῆς ἐξαίρετον—14–15; compare 12–13). The fall of Troy meant for her a transition from wife to concubine, replacing the marriage veil with a veil of slavery: 'I was led from the marriage-chamber to the shore of the sea, my head wrapped in hateful slavery' (δουλοσύναν στυγεράν ἀμφιβαλοῦσα κάρᾳ—109–10).[13] Her station as slave is defined further

[13] Seaford (1987) 130 also observes the distorted marriage imagery and detects here an inversion of the custom whereby the departing bride removes the veil instead of putting it on.

through her relationship with Hermione, who at her entrance in scene one is quick to point out the tremendous contrast between herself and the inferior woman. The queen enters with head and body adorned in gold and embroidery, wedding gifts from Menelaos, part of the dowry which establishes her rights as wife (147–53). Andromache, who wears instead the veil of slavery, she haughtily addresses as 'slave, woman won by the spear' (σὺ δ᾽ οὖσα δούλη καὶ δορίκτητος γυνὴ—155). As Erbse has argued, however, Andromache's slavery is an external circumstance discordant with the true nobility of her character.[14] The servant who converses with her in the prologue, for example, another of the Trojan captives, still recognizes this fellow slave as her mistress and continues to treat her with the respect due to a princess: 'Mistress (δέσποινα), I do not shun calling you by this title, | since in your home too I thought it right, when we dwelled in the plain of Troy . . .' (*Andr.* 56–8).

The theme of Andromache's servitude reaches a climactic resolution in scene three, where the physical bonds with which Menelaos has recently bound his victim function dramatically as a point of contention between Menelaos and Peleus. The shackling device has caught Peleus' attention already at his first speech (555–6), and immediately after Andromache pleads her case, he orders that matters proceed no further before her bonds are loosed (577–8). But Menelaos resists Peleus' order with the assertion that he, not Peleus, has a greater claim over Andromache, because he 'took her captive from Troy' (εἷλόν νιν αἰχμάλωτον ἐκ Τροίας ἐγώ—583). With this exchange Euripides expands the mere physical restraint into a symbolic token of Andromache's status as slave and a reminder of her initial enslavement at the fall of Troy. She is bound now because she was bound at Troy; she is a slave now because she was enslaved at Troy.

After the ensuing debate the bonds return once more to prominence at the end of the scene, where Peleus again attempts to loose them, this time confident that none will prevent him (715–22). Here, while struggling to undo the fetters, Peleus calls for the assistance of Andromache's son, simultaneously declaring his intention to raise this child as an enemy to Menelaos: 'come here to my embrace, child, | untie with me the bonds of your mother; in Phthia I | will rear you

[14] See esp. Erbse (1966) 281–2 on Andromache's slavery, the contrast between Andromache as captive and Hermione as free, and the contrast between Andromache's virtuous nature and servile station.

to be a great foe against them' (*Andr.* 722–4). The result of this call to the child is a visual tableau which symbolically reflects the new-found unity of the Phthian family. The old king and his newly recognized grandson join together to release the bonds of Andromache, in other words, to release her from the slavery that began with the capture of Troy. Her previous shift in status, the transition from princess to slave that occurred at the Ilioupersis, is now symbolically reversed, and at the same time Peleus overturns the Astyanax paradigm by rescuing Andromache's son and accepting him into the royal family. It is an inverted Ilioupersis.

8.3 Troy and Phthia

For the moment let us turn from the happy resolution of conflict in part one of the drama to the darker plot of part two. To perceive the Ilioupersis paradigms at work in this section, we must first observe how the tragic elements of the plot revolve around the three successive generations of Aiakids—Neoptolemos, Achilles, and Peleus. Although Achilles survives only in memory and Neoptolemos' major activities take place elsewhere, the deaths of these two heroes are indispensable components of the tragedy. The murder of Neoptolemos, while geographically distant from the staged setting, is reported in Phthia with a detailed speech of eighty-one lines, after which the dead body itself is transported onto the stage and greeted with prolonged lamentation.[15] Achilles is less prominent, but Euripides repeatedly brings his death to our attention in conjunction with the death of Neoptolemos. As Andromache informs us in the prologue, Neoptolemos' reasons for visiting Delphi, the eventual site of his own death, revolve around the death of his father. Previously Neoptolemos went to Delphi to charge the god with responsibility for slaying Achilles, and now he has journeyed there once again, this time to atone for his previous insult (49–55).[16] It is during these endeavours, first

[15] To display the corpse on stage necessitated a few swift logistic manœuvres, since 5th-c. Greeks knew that Neoptolemos' grave was situated in Delphi, not in Phthia. The body that arrives from Delphi in scene five, we are told in the epilogue, will promptly be returned to Delphi for burial (1239–42 and 1263–4). Obviously it was of great concern to Euripides that the corpse be present for mourning on stage.

[16] The double visit seems to be an innovation upon previous accounts involving only a single visit. Sophokles' *Hermione*, perhaps produced prior to Euripides'

blaming the god for his father's murder and then retracting the blame, that Neoptolemos himself falls victim. The resulting irony is neatly anticipated by Orestes: 'bitterly will he demand penalty for the murder of his father | from lord Phoibos' (πικρῶς δὲ πατρὸς φόνιον αἰτήσει δίκην | ἄνακτα Φοῖβον—1002–3). The 'penalty for murder', expressed with words which translate literally as 'bloody penalty', is to be his own death. Euripides again associates the fates of father and son in the messenger's dramatically charged account of Neoptolemos' death. When asked to state the purpose of his visit to Apollo's precinct, Neoptolemos announces his intent to make peace with the god: 'I once demanded | him to pay the penalty for the blood of my father' (ἤτησα γὰρ | πατρός ποτ' αὐτὸν αἵματος δοῦναι δίκην—1107–8). But no sooner has this recollection of his father's death escaped his lips than his present intentions are misinterpreted and Neoptolemos is murdered.[17] Father and son are united in death.

Peleus is the third element in the trio, a grandfather devastated by the loss of both son and grandson. When the chorus first warn him of the threat from Orestes, they emphasize the ties of blood by referring to Neoptolemos as 'the son of your son' (σῷ γε παιδὸς παιδὶ—1063). And the same designation, 'son's son', is repeated by the messenger only a few lines later when he informs Peleus of Neoptolemos' death (οὐκ ἔστι σοι παῖς παιδός—1073). The phrase may sound like a simple circumlocution for 'grandson', but against the background of family deaths the innocent words assume a deeper significance. By linking Neoptolemos to Peleus as 'the son of the son', Euripides sustains our awareness of the three generations involved. Once again before the messenger's account of the murder Euripides repeats the expression, this time placing it in the mouth of Peleus,

Andromache, probably included only one visit; the murder takes place when Neoptolemos attempts to charge the god for Achilles' death; see Radt (1977) 192. By including two visits, Euripides maintains the emphatic associations between the deaths of father and son, and at the same time presents Neoptolemos as a sympathetic hero, slain not while confronting the god aggressively, but instead while honouring him. Note also that the play nowhere alludes to the sacrilegious murder of Priam and that, unlike Pindar, Euripides draws no correlation between that act and Neoptolemos' death at the altar of Delphi (see §5.1 above). We might also cite the barrenness of Hermione as a reason for the second visit. Euripides, however, does not make this logical connection explicit.

[17] Stevens (1971) 232, following the scholiast on line 1139, associates the mysterious 'Trojan leap' (τὸ Τρωικὸν πήδημα) with Achilles' initial leap from ship to shore in the Troad, and notes the appropriateness of the similarity between the actions of father and son. This added connection between Achilles and Neoptolemos is attractive, but the action to which the phrase refers remains uncertain.

who accentuates the loss by pointing out that each son was an only son: 'How did he die, the only son of my only son?' (πῶς δ' οἴχεταί μοι παῖς μόνου παιδὸς μόνος;—1083).[18]

After the messenger has delivered his account of the murder, Peleus explodes into lament, revealing the full emotional impact of the recent events and their further significance for the trio. Again Euripides pairs the death of Neoptolemos with the death of Achilles, as Peleus recalls with regret Neoptolemos' charge against the god, that Apollo's 'bloody archery' slew his father (τοξοσύνᾳ φονίῳ πατρός—1194–6). And while Peleus laments strictly over the corpse of Neoptolemos, the deaths of both father and son contribute to his misery: 'Phoibos robbed me of both children' (διπλῶν τέκνων | μ' ἐστέρησ' ὁ Φοῖβος—1212–13). The present tragedy, as Peleus interprets it, is not merely the loss of one descendant, but rather the double loss of son and grandson, and the consequent dissolution of an entire family. The playwright paints the old man not simply as a grief-stricken father, but as a lonely patriarch whose line of descent has been permanently interrupted. Achilles fell previously, and now in the death of Neoptolemos, son of his son, Peleus perceives that his lineage is no more (οὐκέτι μοι γένος—1177).

To magnify the calamity even further Euripides also includes in Peleus' lamentation several references to his kingdom, drawing attention to the fact that, beyond the walls of the single household, the recent misfortune has fundamentally shattered the ruling hierarchy of Phthia. With his first outburst of emotion Peleus calls upon the polis to witness his undoing: 'Thessalian polis, we are undone, we are dead' (ὦ πόλι Θεσσαλία, διολώλαμεν, | οἰχόμεθα—1176). The marriage of Neoptolemos and Hermione, Peleus claims, has 'destroyed this house and my polis' (1186–7). The recipient of his cries here is not merely the chorus of attendant women, but Peleus' city and kingdom, all of which are struck by the loss. The king's final response to the tragedy is to let fall the sceptre, the symbol of his ruling power, and to sink to the ground with it: 'polis, polis, you are no more, | away with this sceptre' (οὐκέτ' εἶ πόλις, πόλις, | σκῆπτρά τ' ἐρρέτω τάδε—1222–3). With the end of the family line, so too the dynastic rule of Peleus and his descendants in Thessaly has come to an end,

[18] Cf. also the simple phrase 'son of Achilles' (παῖδ' Ἀχιλλέως) at 1069, another traditional and common paternal designation of a son, but one which in this context reinforces the bonds of family connecting the three generations.

and the fall of the kingdom is captured visually in the fall of the sceptre to the ground.[19]

To claim that the fall of Troy was in the forefront of the audience's mind throughout this final lamentation would require stretching the evidence and the imagination. But that the dramatic presentation of the events incorporates themes traditionally associated with the Ilioupersis is difficult to ignore. Having previously brought Andromache to the stage by replicating her misfortunes at Troy, Euripides brings King Peleus to the stage through imitation of King Priam, the paradigmatic patriarch who witnesses the deaths of his sons and the dissolution of his entire family at the Ilioupersis.[20] With the destruction of lineage and polis in Peleus' lament, Euripides mimics the precedent set by Troy, a city emptied of its rulers.

As in part one of the drama, audible allusions are few, but Euripides does suggest a powerful thematic connection between Phthia and Troy in the fourth choral ode, where he juxtaposes the Trojan War with the subsequent disasters in Greece.[21] The chorus begins with an address to Apollo and Poseidon, who built the walls of Troy but later abandoned their work to the ravages of war (1009–18). In the second stanza the chorus remembers the fighting (1019–21) and its destructive results for Troy: 'The kings descended of Ilos are dead and gone, and no longer on the altars of Troy does fire shine for the gods with fragrant smoke' (ἀπὸ δὲ φθίμενοι βεβᾶσιν | Ἰλιάδαι βασιλῆες | οὐδ' ἔτι πῦρ ἐπιβώμιον ἐν Τροί- | ᾳ θεοῖσιν λέλαμ- | πεν καπνῷ θυώδει—1022–6). Having thus addressed Troy and its fall, the poet turns next to subsequent events in Greece. The fall of Troy is succeeded by the fall of its conqueror Agamemnon, whose death leaves misery for his children in its wake (1027–36).[22] The view of Greece then expands in the final stanza with a reflection on the suffering of the

[19] The sceptre of kingship is mentioned already in the prologue (22–3). Peleus envisions himself falling (to the ground) in line 1225. See Stevens (1971) 241 on the generally excised phrases ἐπὶ γαῖαν (1223) and πρὸς γᾶν (1225). Taplin (1977) 124–5 prefers to follow Hermann and to retain the questioned words thus: σκῆπτρα τάδ' ἐρρέτω 'πὶ γᾶν (1223) and γᾷ πίτνοντά μ' ὄψει (1225). Either way, the fall of the sceptre is an indispensable visual device.

[20] Cf. also the portrayal of Priam in *Iliad* 22 and 24; see §2.1 above. Priam, in fact, compares himself with Peleus at *Il.* 24. 486–506.

[21] Euripides here follows a tradition witnessed previously at Aischylos, *Ag.* 355–487; see §7.2.

[22] Stevens (1971) 216, discussing βεβᾶσι of line 1023 and βέβακε of line 1027, notes, 'The repetition stresses the identical fate that overtook both victor and vanquished.'

Greek women who lost their children and husbands (1037–41). Finally, the chorus ends by drawing the previous subjects together and juxtaposing Greece and Troy in misfortune:

> οὐχὶ σοὶ μόνᾳ
> δύσφρονες ἐνέπεσον, οὐ φίλοισι, λῦπαι·
> νόσον Ἑλλὰς ἔτλα, νόσον· διέβα δὲ Φρυγῶν
> καὶ πρὸς εὐκάρπους γύας
> σκηπτὸς σταλάσσων Δαναΐδαις φόνον.

(*Andr.* 1041–6)

These difficult lines may be loosely translated as follows: 'Not to you alone fell sorrowful grief, not just to your kin; Hellas too bore sickness. The storm passed from Phrygia [i.e. Troy] to our own fertile fields, raining blood upon the Danaids.'[23]

The position of this ode within the dramatic unfolding of events in Phthia is crucial. At the close of the preceding episode Orestes has announced his plot against Neoptolemos, and in the subsequent episode news of the plot will reach Peleus. Thus the death of Neoptolemos provides the primary dramatic context for the ode, and from this collocation we may infer that the death of Neoptolemos is an effect of the 'storm' (σκηπτός) of line 1046, the storm which brought ruin from Troy to Greece. Like the murder of Agamemnon, the murder of Neoptolemos numbers among the Greek disasters complementary to the fall of Troy. Just as 'the kings descended of Ilos are dead and gone' (1022–3), so too, with the death of Neoptolemos, the royal descendants of Aiakos are no more.

The comparison would be significantly sharpened if, as several scholars have argued, Andromache, a witness to both disasters, is present on stage as a silent observer during the final episode. Thetis' deictic reference to 'this child' (παῖδα τόνδε) in line 1246 suggests that at least Andromache's child is present during the epilogue, and scholars have found a stage direction for Andromache herself in the 'you' (σοί) of line 1041. Although the referent of this word is not specified by name, Andromache is a likely candidate.[24] An address

[23] I follow the text as printed by Diggle, who accepts Campbell's emendation of Δαναΐδαις in line 1046. The meaning of σοί in line 1041 will be discussed below.

[24] Kamerbeek (1942) 63 proposes that σοί be understood to refer to Andromache, and Erbse (1966) 294 agrees. Aldrich (1961) 87 n. 14 instead follows the scholiast in understanding σοί to refer simply to Troy. Stevens (1971) 218–19 is indecisive

to her would follow naturally upon the sorrows of the Greek women
(1037–41), the sense of the sequence being: '[We] Greek women lost
sons and husbands. You [Andromache] are not the only one to have
lost friends and family. Hellas suffered too.' Furthermore, lines 1039–
41, 'wives left their homes for another mate' (ἄλοχοι δ' | ἐξέλειπον
οἴκους | πρὸς ἄλλον εὐνάτορ'), while spoken in reference to Greek
women, is particularly relevant as an introduction to the parallel
situation of Andromache, who has left the house of Hektor and en-
tered the house of Neoptolemos. The *philoi* of line 1042 may then be
understood as Andromache's Trojan family—Hektor, Astyanax, and
so on—and the sense of the passage becomes 'You and your family
are not the only ones to have suffered; Greece has suffered too.' Thus,
as the ode introduces an analogy between the fall of the house of
Priam and the present extermination of the house of Peleus, the
silent presence of Andromache on stage in the following scene under-
lines that analogy by reflecting the past visually. From the cast of
characters featured at the close of *Iliad* 24, Priam and Hektor have
been replaced with Peleus and Neoptolemos, while Andromache re-
mains to witness a second dissolution of family and kingdom.[25]

A final link between the complementary disasters on opposite
sides of the Aegean is the common agent, Apollo, to whom Euripides
affords a prominent role in the ode. The chorus begins by identifying
the god, together with Poseidon, as builder of Troy (1009) and asks
'what anger' led them to abandon their city to the ravages of war
(τίνος οὕνεκ'... ὀργᾶς—1014). The second stanza associates the
gods with the fighting, imagining them harnessing chariots (ὄχους
ἐζεύξατε—1019–20) and holding 'deadly contests, devoid of victory'
(φονίους ἀνδρῶν ἀμίλλας ἔθετ' ἀστεφάνους—1020–1). Apollo ap-
pears again in the third stanza, here as the god of vengeance direct-
ing the affairs of the house of Agamemnon, and the chorus recalls
with disbelief his instructions of matricide (1033–6). This prominence
afforded to Apollo within the ode complements his appearance in the
surrounding episodes, where he is repeatedly blamed for the present

but leans towards Andromache, suggesting that she enters towards the end of the
ode with Peleus as a non-speaking character. Steidle (1968) 118–21 argues against
Andromache and in favour of Hermione, but I do not find his reasons convincing.

[25] Kamerbeek (1942) 64 and Erbse (1966) 295 interpret the silence of Andromache
as condemnation of Neoptolemos, destroyer of Troy and consequently her enemy. But
if this was Euripides' intent, it seems odd that the rest of the play does not offer expli-
citly negative references to Neoptolemos' past actions at Troy.

misfortune of Phthia. At the close of scene four Orestes claims that
the god will have a hand in the murder of Neoptolemos (999–1008),
the messenger ends his report of the murder by rebuking Apollo for
being mindful of 'old quarrels' (1164–5), and Peleus identifies the
god as murderer in his lament over the corpse (1211–12; compare
also the chorus at 1203). Finally, the god's association with the
murder of Neoptolemos is to be memorialized in the hero's burial
place, which will be located according to Thetis' instructions at the
Pythian hearth as a disgraceful reminder of the crime ($\Delta\epsilon\lambda\phi o\hat{\iota}\varsigma$
$\ddot{o}\nu\epsilon\iota\delta o\varsigma$—1240–1). The builder of Troy did not, as the chorus think,
simply abandon the city (1009–18), but visited the house of Peleus
with a complementary misfortune.

8.4 Thematic Unity

To appreciate fully the function of the Ilioupersis paradigms employed
in the earlier and latter parts of the drama, we must view them in
combination with one another rather than simply as two events
in a sequence. The principal and most obvious connection between
the two plots lies in the themes of family continuity and family dis-
continuity. The death of Neoptolemos reported in the later segment
threatens to end Peleus' line of descent; but on the contrary, because
Peleus has preserved Andromache's son in part one, he has in fact
rescued his line of descent from extermination. A literary critic might
detect a flaw here. By the beginning of Peleus' lament we already
know that his line of descent has survived the calamity, and because
his laments are delivered against the background of the rescue in
part one, they will appear illogical, superfluous. The *Andromache*, how-
ever, was not composed purely according to constraints of linearity.
Euripides has constructed the play not just as a poetic narrative,
but also as an Archaic artist would construct a bipartite narrative
painting, overstepping Lessing's distinction between temporal lin-
earity in literary narrative and temporal simultaneity in visual nar-
rative. The visual critic, unimpeded by linear bias, will appreciate in
the *Andromache* the extraordinary degree of balance, symmetry, and
unity. The death of Neoptolemos offers a sorrowful contrast to the for-
tunate rescue of his child. Viewed from the opposite perspective, the
significance of the initial rescue is fully revealed only after the later
catastrophe has been experienced.

The epilogue, wherein all the family sorrow is suddenly and mira-
culously purged from the stage, brings the two plots face to face.
Here at last the *dea ex machina* illuminates for the audience the for-
tunate connection between the rescue of the child in part one and
the deaths of part two. At the opening of her speech Thetis recalls the
death of Achilles, the child she bore to Peleus (1235–7). Next she
addresses the death of Neoptolemos, the son of her son (1238–42).
Finally, she foresees a brighter future for the child of Neoptolemos
and Andromache, whom she recognizes to be 'the only survivor
of the descendants of Aiakos' (τῶν ἀπ' Αἰακοῦ μόνον | λελειμμένον
δή—1246–7). Together with Andromache, the child is to accom-
pany Helenos to Molossia, where he and his descendants, one after
another, will rule as kings (βασιλέα δ' ἐκ τοῦδε χρὴ | ἄλλον δι'
ἄλλου διαπερᾶν Μολοσσίας | εὐδαιμονοῦντας—1247–9).[26] At the end
of these instructions Thetis gives a single, all-encompassing reason
for her declarations: the royal line of descent must not be overturned.

> οὐ γὰρ ὧδ' ἀνάστατον
> γένος γενέσθαι δεῖ τὸ σὸν κἀμὸν, γέρον,
> Τροίας τε· καὶ γὰρ θεοῖσι κἀκείνης μέλει,
> καίπερ πεσούσης Παλλάδος προθυμίᾳ.

> the lineage must not
> be overturned thus, yours and mine, old man,
> and Troy's; for the gods care for it too,
> even though it fell by the will of Pallas.

> (*Andr.* 1249–52)

The 'thus' (ὧδε) of line 1249 brings into clearer focus the calamity
that has struck the house of Peleus through the deaths which Thetis
has just enumerated. In these lines she is telling Peleus that although
they have lost their son Achilles (1235–7), and although their grand-
son Neoptolemos has recently died (1238–42), the dynasty will not
come to an end 'thus', with *their* deaths, as Peleus previously feared.
Instead the child of Andromache, whom Peleus rescued from near-
death in part one of the play, will continue the line.

[26] The connection between Neoptolemos and the Molossians existed prior to
Euripides' *Andromache*; see Pindar, *Paian* 2. 109 and *Nemean* 7. 56–9. But for dra-
matic purposes Euripides leaves the connection unstated before Thetis' revelation. For
the name 'Molottos', not employed in the *Andromache*, see Stevens (1971) 94.
D. S. Robertson (1923) gives the nameless child some contemporary historical import-
ance by associating him with the 5th-c. Molossian prince Tharpys.

Euripides strengthens the impact of this grand resolution through the physical arrangement of grandfather, grandson, and great-grandson on the stage. Thetis points verbally to each of them in turn, beginning with Neoptolemos, 'this son of Achilles' (τόνδ' Ἀχιλλέως γόνον—1239), and her use of the paternal designation tells us that she is pointing both to Neoptolemos and to his father Achilles. Next she points to the son of Neoptolemos, 'this child' (παῖδα τόνδε—1246), labelled as the last of the Aiakids, and finally she turns back to the old man, 'and you' (σὲ δ'. . .—1253), to inform him of his own salvation. As illuminated by Thetis, this final spectacle of three generations neatly complements the visual tableau that ended the third episode. There we saw old man and young child joined physically in a common action. Here in the epilogue the previous juxtaposition of great-grandfather and great-grandson is complemented by the addition of a third figure, the corpse of the intervening generation. Euripides thereby reinterprets one tableau with another. The visual alliance between oldest and youngest at last acquires its true symbolic meaning of salvation for the family, both despite and because of the intervening death of Neoptolemos.[27]

While illuminating the thematic interaction of parts one and two of the drama, Thetis also acknowledges Euripides' ultimate source for the play's principal themes. The brief mention of Troy in the final two lines of Thetis' genealogical declarations (1251–2) finally anchors the Ilioupersis paradigms firmly in place. Andromache's child represents the salvation not only of Peleus' line, but also of her former family, the house that fell at the Ilioupersis.[28] Although a reader with a distaste for mythological manipulation might wish to ignore or excise the lines, the reference should come as no surprise after the extensive interplay of Trojan themes and characters throughout the play. The drama of family continuity and family discontinuity which

[27] The visual correlation is further enhanced by the figure of Thetis. The goddess's statue looms large throughout scenes one to three (e.g. line 246: ὁρᾷς ἄγαλμα Θέτιδος ἐς σ᾽ ἀποβλέπον;) and is reflected by the physical manifestation of the goddess herself in the epilogue. The drama that began at the sanctuary of Thetis is now at last resolved by her intervention.

[28] The child was not really a Trojan, because Andromache herself was originally not from Troy but from Thebe; see line 1. The survival of her child perpetuates the line of Eetion rather than the line of Priam. But this technicality did not prevent Euripides from associating the child with both Phthia and Troy. The mention of Helenos (1245) as Andromache's next husband might also have motivated the reference to Troy, but his lineage will not technically continue through her son.

we have been watching for the past few hours, while it applies first and foremost to Phthia, has its roots in the tragedy of Troy, and Euripides openly acknowledges those roots here. Just as he recognized the precedent of Astyanax at the play's opening, so he draws attention to the source of his plots once again at the play's conclusion, as Thetis, the mouthpiece of the dramatist, explicitly recognizes the overlap between the fates of the two families and the two kingdoms.

8.5 Hermione and Orestes

In our bipartite analysis of the play thus far, episode four has been overlooked as a kind of hinge between two wings of a diptych, Hermione's actions sealing the events of part one, and Orestes introducing the developments of part two. After the rescue and rehabilitation of Andromache at the end of episode three, Hermione in episode four recognizes defeat and admits her errors. Orestes, in turn, in recalling to her his argument with Neoptolemos and his consequent plans for murder, provides narrative background for the subsequent episode. At the same time, the action of the episode neatly isolates itself from the surrounding drama. Orestes arrives on the stage in Phthia fresh from his intrigues in Delphi, and he conveniently removes Hermione from the stage before events in Phthia take a new turn. The interaction of these two characters thus provides a logical, self-contained transition from parts one to two.

To give proper credit to the scene, however, we must admit that Euripides has amplified this transition between parts one and two into a drama in its own right—a highly complex and contrived drama—and it would be more correct to analyse the full play as a composite of three plots, as a connected trilogy in miniature. Rather than allowing the princess simply to await the arrival of Orestes in silence and inactivity, Euripides opens the scene with a nurse declaring news of Hermione's attempted suicide. After this powerful introduction, Hermione arrives on stage dreading the return of her husband, who she is sure will put her to death as punishment for her recent wickedness. In effect, Euripides has reversed the roles of Hermione and Andromache, as the princess, her life now endangered, finds herself in a situation analogous to that of the slave in the first

two episodes.[29] Furthermore, while linking the action thematically with the preceding episode, the dramatic opening of episode four also primes the audience for a powerful surprise. Already at the end of episode three Euripides has planted in his audience the expectation that Neoptolemos will soon return, since Menelaos departed with the stated intention of returning to face Neoptolemos in the future (737–9). Hermione's subsequent behaviour in episode four strengthens that expectation and leads the audience to anticipate a conflict between the wicked wife and her angered husband. But this preparation deliberately misleads us, and instead of the expected Neoptolemos, we are treated to the surprise arrival of Orestes. The character whose entrance we were led to anticipate does finally arrive in scene five, but as a corpse, not as an angry husband. Thus, rather than interpose this episode as mere transition, Euripides crafts it into a complex array of emotion and surprise.

The contrived complexities of this scene, due in part to intended correlations with the surrounding episodes, have grown also out of an attempt to mimic the figure of Helen in that of her daughter Hermione. In the preceding and subsequent sections of the play Euripides has relied heavily on Ilioupersis paradigms, and here again in the intervening section the playwright has turned to Trojan material to enhance the action. That Euripides had Helen in mind behind the characterization of Hermione is witnessed in several comparisons drawn between mother and daughter.[30] Andromache advises Hermione not to exceed her mother in 'love of men' (φιλανδρία—229–30). 'Wise daughters', she warns, 'should shun the ways of wicked mothers' (230–1). Rebuking Menelaos, Peleus declares that he previously advised his grandson against marrying the daughter of an evil woman, 'for they carry | the faults of their mothers' (ἐκφέρουσι γὰρ | μητρῷ' ὀνείδη—619–23). Early in the play Andromache recalls Helen's 'marriage' with Paris as the cause of Troy's downfall:

'Ιλίῳ αἰπεινᾷ Πάρις οὐ γάμον ἀλλά τιν' ἄταν
ἀγάγετ' εὐναίαν ἐς θαλάμους Ἑλέναν.

[29] Kamerbeek (1942) 61 discusses the parallels between Andromache and Hermione. Cf. also Burnett (1971) 146–7.

[30] Kamerbeek (1942) 54–6 discusses the parallels between Helen and Hermione and concludes that Euripides employed Helen as a model when creating Hermione. To my knowledge, however, no one has previously discussed the specific similarities between Euripides' Hermione and the Helen of the Ilioupersis, to be explained below.

ἃς ἕνεκ᾽, ὦ Τροία, δορὶ καὶ πυρὶ δηϊάλωτον
εἷλέ σ᾽ ὁ χιλιόναυς Ἑλλάδος ὠκὺς Ἄρης . . .

To lofty Ilios Paris brought not marriage, but some power of ruin,
when he brought Helen wedded into the bride-chamber.

Because of her the swift thousand-shipped warrior of Hellas
took you captive, Troy, with spear and fire . . .

(Andr. 103–6)

Later in the play Peleus recognizes another unfortunate marriage,
that of Hermione to Neoptolemos, as the source of his own ruin, the
marriage 'which utterly destroyed this house and my city' (ὦ γάμος,
ὦ γάμος, ὃς τάδε δώματα | καὶ πόλιν ὤλεσας ὤλεσας ἀμάν—
1186–7; compare also 1189–92). The ill-omened union of Helen and
Paris is resurrected in the marriage of Hermione and Neoptolemos,
and like her mother, Hermione has brought destruction to an entire
family and an entire city.[31]

Within this background of broad parallelism the departure of
Hermione in episode four exhibits particularly strong similarities
with Helen's departure from Troy at the Ilioupersis. According to the
epic Ilioupersis tradition, Menelaos' original intent is to murder Helen,
but he experiences a change of heart and permits her to live.[32] Euri-
pides reminds us of that episode in the debate between Peleus and
Menelaos, where Peleus rebukes his opponent for his lack of resolve
against his wife's seductions (627–31). Included in the recollection
are two salient elements of the tradition—Helen exposes her body in
an attempt to dispel Menelaos' anger, and Menelaos casts aside his
sword. Their reunion is recollected again at 685–6, where Menelaos
responds to Peleus' accusation, citing temperance rather than weak-
ness as his motivation. This image of Helen's recovery from Troy,

[31] A lengthier analysis of Hermione's participation in the interplay of themes
revolving around family continuation might incorporate further discussion of her bar-
renness. The threat to the family inherent in her failure to produce an heir anticip-
ates the disaster which her marriage eventually brings to the stage in scene five, the
discontinuation of lineage as lamented by Peleus. The union of Helen and Paris also
failed to produce offspring, a fact potentially reflective of the discontinuity which it
inflicted on the ruling line of Troy.

[32] Evidence for this tradition of Helen's rescue is provided by Aristophanes,
Lysistrata 155 and an accompanying scholion (*MI* fr. 19). Aristophanes writes that
'Menelaos, seeing the breast of naked Helen, threw away the sword' (ὁ γῶν Μενέλαος
τᾶς Ἑλένας τὰ μᾶλα πα | γυμνᾶς παραϊδὼν ἐξέβαλ᾽ οἶῶ τὸ ξίφος). The scholion
states that the same account is found in the works of Ibykos, in the *Mikra Ilias*, and
in Euripides (ἡ ἱστορία παρὰ Ἰβύκῳ· τὰ δὲ αὐτὰ καὶ Λέσχης ὁ Πυρραῖος ἐν τῇ
μικρᾷ Ἰλιάδι· καὶ Εὐριπίδης). For the iconographic evidence see §12.3 below.

employed by the litigants in their verbal arguments, suggested to Euripides a rough outline for the dramatic staging of Hermione's rescue from Phthia. The Menelaos of the Ilioupersis provides a model for Orestes, the man incensed by the loss of a woman who rightfully belongs to him (966–81). While the family of Peleus and the city of Phthia rest on the edge of destruction, Orestes enters the city to recover his wife and to redress the crimes of his enemy Neoptolemos (see especially 1001). Amidst the turmoil, the baneful Hermione departs unscathed from the ruined city, just as her baneful mother escaped unscathed from Troy. The foiled anticipation of Hermione's death—anticipation so strong at the opening of the episode, yet cast utterly aside with the arrival of Orestes—reflects the successive possibilities of death and rescue which previously faced Helen, first the object of Menelaos' animosity, then the object of his desire. Of course, in engineering this similarity, Euripides has divided the role of the violent then docile Menelaos between Neoptolemos, whose anger Hermione only imagines, and Orestes. Thus there is no one-to-one correlation of male characters. But the thematic correlation uniting Helen and Hermione remains obvious in the repeated transition from death to rescue. Mother and daughter both escape the threat of death and survive the marriages which bring destruction to Troy and Phthia.

8.6 Conclusions

In staging the fortunes of the family of Peleus, Euripides re-enacts the fortunes of the family of Priam. The Ilioupersis offered the playwright a series of paradigms with which he could shape the myth of the Peleids into a drama, paradigms which were, in fact, already tangentially related to the fortunes of the Peleids through their renowned involvement in the war against Troy and the ultimate conquest of the city. The first step for the dramatist was simply to set the play in Phthia, and once the setting was established the paradigms of the Ilioupersis fell easily into place for each segment of the connected trilogy. In part one Euripides gives Andromache a son modelled on her previous child Astyanax and likens the threats facing this mother and child to the threats which faced Andromache and Astyanax at the Ilioupersis. Like his Trojan brother, the child becomes the object of a shifting struggle between family continuity and discontinuity.

In part two Euripides assigns Hermione a role analogous to the role played by her mother in the destruction of Troy: the woman sought by two men, the woman whose marriage brings ruin to a family. Finally Peleus, the central character of part three, develops on the model of Priam, the patriarch and king who witnesses the dissolution of his family and his kingdom.[33]

Euripides did not write every word of the play with the Ilioupersis in his mind, he did not restrict himself to Trojan models in embellishing the plot, and he did not overburden the play with allusions to the Ilioupersis. Nevertheless, the extensive interplay of Ilioupersis paradigms must ultimately have reached Euripides' audience with allusive force. The introductory reference to Astyanax serves as an announcement, an invitation to compare present with past. Although this invitation is muted, the message is advertised again with the juxtaposition of Troy and Greece in the fourth choral ode, and it returns once more with Thetis' reference to Troy at the play's conclusion. With the aid of these explicit connections, the Ilioupersis patterns saturating the play could scarcely have escaped the audience altogether. Hearing these Trojan notes resonating within the present drama, the audience will appreciate the epic dimension which the Ilioupersis contributes to the tragedy and may at the same time recognize the limit of the correlations, that Phthia is not Troy, and that the Ilioupersis paradigm of ruin and extermination is overcome in the rescue of Andromache's child and the divinely ordained continuation of Peleid lineage.

[33] As such, Peleus may be compared also with Hekabe in *Troades*; see §9.2.

9

Euripides' *Troades*

9.1 Introduction

From dramas which incorporate Ilioupersis themes we turn to a dramatization of the Ilioupersis itself, or as close to such as any Athenian playwright could come. Set in the immediate aftermath of the capture, as the captive women await departure and the city awaits final destruction, Euripides' *Troades* presents a panorama of lamented suffering comparable in scope to an epic Ilioupersis. Without dramatizing the traditional highlights of the capture itself—an impossibility on the Athenian stage—Euripides nevertheless reproduced the composite spirit of the epic accounts by including a wide cast of characters engaged in a varied sequence of complementary actions. In his earlier *Hekabe* he had combined the sacrifice of Polyxene with the death of Polydoros and the revenge of Hekabe to produce a similar powerful aggregate of events bordering on the fall of Troy. Now going several steps further, Euripides synthesized the fates of Hekabe, Kassandra, Andromache, Helen, and Astyanax—five notable Ilioupersis figures—into a single dramatic presentation. This synthesis has resulted in an ambitious and unusual play, one sometimes criticized as a miscellany, a parade of suffering. But Euripides is guilty only of adopting a less canonical approach to dramatic presentation, an approach more akin to the practices of the visual artists of his day. As A. Burnett has described it, the work is like a panelled screen.[1] Instead of a single tableau Euripides presents a series of images, each bound to and balanced by its neighbours. The following general analysis of this composite construction forms a conclusion to the preceding study of poetic Ilioupersis images, while also offering an introductory parallel to the techniques employed by Archaic artists in their attempts to capture the diversity of the Ilioupersis visually, the subject of the subsequent chapters.

[1] See Burnett (1977) 292.

9.2 Form and Meaning

True to its title, Euripides' *Troades* narrates the Ilioupersis from the perspective of the Trojan women. With few exceptions the cast consists primarily of the captive women of Troy, the Trojans who saw and suffered all, who watched while the men of their city were slain, and who now wait uneasily while the Greek victors make preparations to lead them away from Troy into slavery. In addition to the chorus, from whom the play derives its name, Euripides includes Hekabe, Kassandra, Andromache, and Helen. The last of these, 'Helen of Troy', though not Trojan by descent, may certainly claim Trojan citizenship as a ten-year resident. The only major Trojan captive widely known in the previous tradition but not featured on stage is Polyxene. Her inclusion would have strained the limits of the cast, and Euripides has consequently left her aside, but not without at least a few recollections of her recent sacrifice (260–70, 622–9). Focusing on these women poised at the shore of the Aegean, the play explores the momentous transitions they suffer at the city's fall, transitions from free-born woman to slave, from wife to concubine. The Greek captors, on the other hand, though their actions and decisions influence the course of events, and though their own impending reversal of fortune is triumphantly announced by Athena in the prologue, have been relegated to the background. Talthybios is little more than a conveyor of information. Menelaos appears only briefly and is given little to say. We hear about the Greek chieftains more than we see them, and any report of their activity becomes significant only through its effects on the Trojan captives on stage before us.

The common thread binding together this cast of Trojan women, and indeed the primary focal point of the play, is the Trojan matriarch Hekabe. While others come and go from the stage, Hekabe remains before our eyes continuously from beginning to end and retains a position of centrality throughout. She is already visible in the prologue while the other captives are still concealed within the tent. Poseidon's invitation to the audience to look upon her (εἴ τις εἰσορᾶν θέλει, | πάρεστιν—36–7) anticipates her prominence in the drama to come. It is Hekabe's initial dirge (98–152) that dramatically motivates the entrance of the chorus (153). In the ensuing scene the herald Talthybios recognizes Hekabe as chief among the captives and addresses himself primarily to her. She is present and involved at the entries and exits of Kassandra, Andromache, and Helen; she performs

the final duties of burial for Astyanax; and her exit from the stage marks the end of the play. While the spotlight shifts on occasion to other characters, each time it swings back to the deposed queen, and she is never far from the audience's eye. Like the lonely principal of the *Prometheus Bound*, she remains fixed on the stage from beginning to end, host to a succession of temporary visitors and a multitude of sorrows.[2]

The list of losses Hekabe recounts upon the departure of Kassandra (474–99) conveniently defines her present status and her role in the drama. The many sons she bore she has now buried (474–80), and she watched as their father Priam was murdered before her very eyes (481–3). The daughters she raised are now being taken away from her, condemned to a fate far different from the noble marriages she had planned (484–8), and Hekabe too will soon be taken into slavery (489–99). She is, in short, the matriarch of the disintegrating royal family of Troy, the mother who watches as her family dissolves before her eyes.

The speech is an unmistakable adaptation of Priam's Ilioupersis vision in *Iliad* 22, where he pictures the slaying of his sons, the enslavement of his daughters, and finally his own ignominious death (*Il.* 22. 59–76).[3] Like Priam, Hekabe draws attention to her role as eyewitness to the disintegration. She 'saw' her sons fall (479). She witnessed Priam's murder 'with her own eyes' ($\tau o \hat{\iota} \sigma \delta \epsilon$ δ' εἶδον ὄμμασιν | αὐτὴ ... —*Tro.* 482; compare *Il.* 22. 61). Like Priam's vision, Hekabe's speech concludes with a glimpse of the speaker's own fate as the crowning insult, and both speakers underscore the shame in such disrespectful behaviour toward the elderly (*Tro.* 491 and *Il.* 22. 66–76). In addition, the two speeches are motivated by analogous dramatic stimuli. Priam discloses his vision as a final plea to his son Hektor, and Hekabe delivers her speech in response to the loss of her daughter Kassandra. In adapting this design from the *Iliad*, Euripides has granted Hekabe the epic role previously granted to her husband.

[2] Burnett (1977) 291, while comparing the play with the *Prometheus Bound*, likens Prometheus not to Hekabe, but to the three transient captives, Kassandra, Andromache, and Helen: 'The action of the play thus has a formal likeness to that of *Prometheus Vinctus*, except that here the single figure of the vanquished giant has been splintered to become three female mortals, to whom a chorus of other women adhere.' I prefer instead to liken Hekabe to Prometheus and to interpret her continuous prominence and centrality as a major force of unity in the drama.

[3] The passage is discussed above in §2.1.

In the absence of the patriarch, Euripides centres the drama of undo-
ing on the matriarch.

The chorus of captive women accompanying Hekabe complement
her individual perspective with the wider perspective of the many Tro-
jan families stricken by the war. Analogous to the chorus of captive
women in Euripides' earlier *Hekabe*, these are the unnamed women
of Troy who share a common burden, who, like Hekabe, have lost
husbands and sons and now await enslavement and departure from
their homeland. In the ode following scene one they supplement
Hekabe's poignant speech of family dissolution with their own more
comprehensive account of the sack, recalling how all the Trojans,
young and old (527–8), the entire race of the Phrygians (531), wel-
comed the wooden horse into the city. They remember participating
in joint celebrations at the temple of Artemis (ἐμελπόμην χοροῖσι—
554–5) and recall in generalized terms how at the attack infants clung
to their mothers (557–9), and how the Phrygians succumbed to Hellas
(566–7). Their continuous presence throughout the play alerts us
to the universal suffering behind the few more infamous individual
cases.[4]

The action of the *Troades* is in essence a dramatization of the last
phases of Hekabe's dissolution speech, the last phases of the Ilioupersis.
The chorus discuss their imminent enslavement and departure at
length in the parodos, and their anxiety and curiosity prepare the
stage for the ensuing farewell scenes, in which one by one the women
of the royal family are led away into slavery. After Talthybios an-
nounces a programmatic schedule of enslavements in scene one (235–
91), there follows a trio of departures: Kassandra leaves with the
herald in scene one, Andromache enters and exits in scene two,
and Helen in scene three. While not causally linked in terms of plot,
the three departures form a logical progression clearly defined by
the involvement of Hekabe in each. Hekabe's first farewell is to her
daughter; next is Andromache, daughter-in-law; and third comes
a daughter-in-law of a different type, Helen. Euripides may have
derived some inspiration for this hierarchy of family ties from

[4] Compare this vision with the choral account of the sack at *Hekabe* 905–53. Both
accounts are narrated from the perspective of the Trojan women, but in the *Hekabe*
passage Euripides places less emphasis on the communal nature of the disaster and
greater emphasis on the individual, domestic sphere. Compare this generalized view of
the Ilioupersis also with the impression conveyed by the generic scenes of murder and
enslavement on the Mykonos pithos, discussed in Ch. 11.

Iliad 6, where Hektor meets successively with Hekabe, Helen, and Andromache—with his mother, his sister-in-law, and finally his wife. A similar sequence appears at the close of *Iliad* 24, where the same three women deliver successive laments over his corpse. Like the progressions in the *Iliad*, the progression of farewells between the ever-present Hekabe and her three transient visitors generates unity within the composite drama while also allowing for controlled development of theme and action.

Although Kassandra dominates the first scene with her lively marriage-song and her prophecies of misfortune for the Greeks, Hekabe nevertheless remains prominently involved, and her interaction with Kassandra is of vital importance to the scene's overall impact on the audience. The frenetic bridal song to which Kassandra enters, wedding torches in hand, while it mocks her less-than-matrimonial union with Agamemnon, also likens her forced farewell to the momentous separation of bride from family. Twice during the wedding song Kassandra addresses her mother directly, the second time inviting her to join in celebrating the marriage (315–17 and 332–7). Hekabe, on the other hand, is unwilling to sustain the painful masquerade. She responds to the song with bitter sorrow (343–7), calms her daughter, and removes from her the torches (348). Hekabe is again the recipient of Kassandra's next speech, a prediction of Agamemnon's coming punishment and an enumeration of benefits brought to Troy by the war—words which Kassandra directs toward her grieving mother as consolation (353, 394, 403–5). And Kassandra's subsequent prophecies concerning Odysseus (424–43) arise in response to the news that Hekabe is to become Odysseus' slave (421–3). Hekabe thus functions both as interlocutor and as stimulus for Kassandra's revelations.

Euripides complements this interaction between mother and daughter with a barrier of miscommunication between them. For the audience Kassandra's prophecies serve as a reminder of the familiar tales of disastrous nostos, a theme already invoked by Athena and Poseidon in the prologue. For the other characters in the play, in contrast, Kassandra's words carry no validity, since the prophetess is cursed with the inability to make her prophecies believed. The revelations shock Talthybios, but he dismisses them as madness (417–19). Although directed toward Hekabe, Kassandra's prophecies of retribution fall on deaf ears, and Hekabe fails to share in her daughter's

vision.[5] An insurmountable difference in sentiment separates mother from daughter, and Kassandra's intended consolation brings only more pain. The impact of Kassandra's farewell is pointed out by the chorus, who turn back from watching the departure to find Hekabe fallen to the ground in despair (462–5). While the prophetess exits with an image of herself triumphant ($\nu\iota\kappa\eta\phi\acute{o}\rho\varsigma$—460), Hekabe is left lamenting her own slavery, and in response to her daughter's enumeration of Troy's blessings (365–99), she enumerates her family's misfortunes (474–99). The scene thus belongs not to Kassandra alone, but to both Kassandra and Hekabe, daughter and mother at their poignant final farewell.

A greater mutual understanding governs the relationship between Hekabe and her daughter-in-law Andromache, who share in each other's grief and commiserate with one another profusely. The scene begins not with a song from the new arrival alone, as in the Kassandra episode, but with a duet shared between the two principals, a sustained sequence of quick lyric and dactylic exchanges underlining the empathy between the two women (577–96). The rapid shifts from one singer to the other, each completing the thoughts of her associate, mark a consonance of mind. The lyrics and dactyls are then followed by an iambic exchange, distichomythia, in which each woman discloses recent misfortunes to the other (608–33). As in the previous scene, the interaction between Hekabe and the transient captive continues throughout, but here with a greater degree of common understanding.

The two women are most closely allied in their roles as mothers. Having previously lost her sons, Hekabe has now been robbed also of her daughters: Kassandra, who only recently departed from the stage, and Polyxene, whose recent death is revealed by Andromache (622–3). During the course of the present scene Andromache in turn is robbed of her own child by the well-timed intervention of Talthybios, bringing the order of execution from the Greek assembly. In fact, it is just as Hekabe begins to console Andromache with hopes for the future of Astyanax that Talthybios arrives to conduct her child to his death (697–711). Euripides in effect assimilates Andromache to Hekabe by successively separating both from their children. The

[5] Hekabe has previously informed us of her daughter's madness at lines 168–73, where she in fact expresses a wish not to see her daughter.

two women who began the scene with such mutual understanding now share an even greater bond of suffering in the mutual loss of offspring. The scene closes with Hekabe, robbed already of her own children, now participating also in Andromache's maternal grief and lamenting the loss of her grandchild: 'child, son of my labouring son, we are unjustly robbed of your soul, | *your mother and I*' (ὦ τέκνον, ὦ παῖ παιδὸς μογεροῦ, συλώμεθα σὴν ψυχὴν ἀδίκως | μήτηρ κἀγώ—790-2).

By delicately manipulating these shared elements of maternal devotion and loss, Euripides succeeds in sealing the encounter within a frame of death and burial. The conversation between Hekabe and Andromache begins with news of Polyxene's sacrifice, and it leads eventually to the announcement of Astyanax's imminent death. The first child has been slain before the scene begins, and the second is to be slain after the scene ends. Furthermore, Euripides exploits this frame of burial to intensify the interaction between the two mothers by contriving an exchange of maternal duties for the dead children. In the absence of Andromache, Hekabe will later perform the burial rites for Astyanax. Andromache, in turn, in the absence of Hekabe has already performed last rites for Polyxene: 'I saw her myself, and descending from this carriage, | I hid her in robes and mourned over the corpse' (εἶδόν νιν αὐτή, κἀποβᾶσα τῶνδ' ὄχων | ἔκρυψα πέπλοις κἀπεκοψάμην νεκρόν—626-7). Each mother buries the child of the other.

While Hekabe's continued presence and interaction provide a principal force of continuity between the appearances of Kassandra and Andromache, the two scenes are also closely linked by the common theme of marriage. Kassandra, though still unwed, dwells at length on her coming 'marriage' to Agamemnon. Euripides announces the subject with visual splendour in the wedding torches which herald her entrance (298-303, 319-24), and he sets the theme to music in her energetic bridal song. Andromache too is surrounded by tokens of marriage. Soon to be allied with Neoptolemos, she continues to identify herself in relation to her deceased husband Hektor, whose son (Ἕκτορος ἶνις—571) and whose weapons (Ἕκτορος ὅπλοις—576) accompany her in her cart. Her journey from Troy to the ships marks the forced transition from one marriage to the next, and the cart that carries her to Neoptolemos might easily have conveyed to the audience a distorted image of the vehicle that traditionally transported the Greek bride from her parents' home to the home of her

husband.[6] As she walks down this inescapable aisle, her speech explores the bitter reversal uniting her with the family that slew her first husband (657–60) and forcing her to betray her previous conjugal loyalties (661–4). While she still struggles to reconcile herself emotionally to the shift, the announcement of her son's impending execution cruelly severs her physical ties to the past marriage.

The prevalence of the marriage theme in these two episodes unites them also, of course, with the ensuing appearance of Helen, whose ambiguous marital status—wife or adulteress—fuels the fire of debate in the third farewell scene. Exploiting the cohesive function of this theme, Euripides projects Helen and her disastrous marriages back into both preceding bridal scenes. Kassandra, anticipating her influence in the death of Agamemnon, represents herself as a second Helen: 'Marrying me, he will find a marriage more ill-fated than Helen's' (Ἑλένης γαμεῖ με δυστυχέστερον γάμον—357). Just as Helen's marriage to Paris has led Agamemnon to destroy Troy, so Kassandra's marriage, she claims, will 'destroy in turn' the house of Agamemnon (ἀντιπορθήσω δόμους—359).[7] Andromache, in contrast to Kassandra, describes her marital behaviour as opposite to that of Helen. As wife of Hektor, she conducted herself with absolute propriety, in accord with every rule governing the correct behaviour of wives (643–56). She forms, in effect, the perfect antithesis to Helen, who is soon to be attacked by Hekabe as a wanton adulteress.[8] Maintaining her fidelity to Hektor in the face of her imminent union with Neoptolemos, Andromache condemns the woman who forgets her first husband and loves another (667–72)—implicit condemnation of Helen, who allegedly abandoned Menelaos in favour of Paris and will soon return to Menelaos with equal ease. Finally, distraught by the loss of Astyanax, Andromache casts blame for the present misfortunes on Helen directly (766–73); and upon Andromache's departure from the stage the chorus too cites Helen as the cause of Troy's misfortune: 'Wretched Troy, you lost thousands | because of one

[6] Seaford (1987) 130 also suggests the likeness to the bridal vehicle and points out that, whereas the bride would normally ride beside the groom, Andromache is accompanied instead by the weapons of her former husband.

[7] See also Hekabe's reference to Helen's marriage in the speech following Kassandra's exit (498–9).

[8] Friedrich (1953) 62 points out that Andromache and Helen are implicitly contrasted already in the *Iliad*, just as their Trojan husbands are contrasted. He also compares this scene of *Troades* with the agon between Andromache and Hermione, daughter of Helen, in Euripides' *Andromache*.

woman and a hateful marriage' (τάλαινα Τροία, μυρίους ἀπώλεσας | μιᾶς γυναικὸς καὶ λέχους στυγνοῦ χάριν—780–1). Euripides thus defines the characters of the three women in terms of one another, and Helen, the last of the trio, serves as a measuring stick for her two predecessors.

In devising the encounter between Helen and Hekabe, Euripides drew inspiration from a long-familiar element of the Ilioupersis myth. A tradition extending back to the early lyric poets, and perhaps originating in the epic, records that during the capture of Troy Menelaos pursues Helen with drawn sword, intending to kill her.[9] At the sight of her naked body, which Helen seems to have deliberately exposed to her husband, Menelaos abandons his violent intentions and lets the sword drop. The story was a favourite among fifth-century vase-painters, who captured Menelaos' emotional transformation visually by depicting the sword in mid-fall (compare §12.3). Euripides himself alludes to the episode briefly at *Andromache* 627–31, where Peleus, recalling Menelaos' behaviour at the capture of Troy, rebukes the Spartan king for having succumbed to Helen's seduction and not having killed her: 'when you saw her breast, throwing away the sword, | you accepted a kiss' (ὡς ἐσεῖδες μαστόν, ἐκβαλὼν ξίφος | φίλημ' ἐδέξω—*Andr.* 629–30).

Euripides in his *Troades* follows the antecedent tradition in representing the reunion between husband and wife as a matter of life or death for Helen. In his entrance speech Menelaos informs us that the Greeks have granted him a choice, 'to kill her or, if I wish, to take her back to Argive land' (κτανεῖν ἐμοί νιν ἔδοσαν, εἴτε μὴ κτανὼν | θέλοιμ' ἄγεσθαι πάλιν ἐς Ἀργείαν χθόνα—874–5). At the same time, the dramatist has radically altered the setting and the form of Helen's ordeal. First, in order to bring the episode within the temporal and spatial compass of the play, Euripides has postponed the meeting until the aftermath of the sack and has included Helen among the captive women. Poseidon has drawn the audience's attention to this innovation already in the prologue (34–5). Second, whereas according to the more common version Menelaos' intent to murder is subverted by Helen's visual beauty, Euripides dramatizes the deliberation over life and death verbally, as a dialogue. By having Hekabe warn Menelaos not to look upon Helen (ὁρᾶν δὲ τήνδε φεῦγε, μή σ' ἕλῃ πόθῳ—891), Euripides winks at the popular tradition, according to

[9] See Ch. 8 n. 32 for discussion of *MI* fr. 19.

which the sight of Helen's exposed body softened Menelaos' heart. That possibility is soon rejected, however, and Helen chooses to defend herself not with her body, but 'with words' (ἔξεστιν οὖν πρὸς ταῦτ' ἀμείψασθαι λόγῳ;—903). For this the dramatist is likely to have derived some inspiration from preceding poets, particularly Ibykos. A scholion on Euripides' *Andromache* 631 records that a poem of Ibykos located the scene of reconciliation within the temple of Aphrodite, and implies that Helen subdued Menelaos' anger not through visual exposure of her body, but through verbal persuasion (διαλέγεται τῷ Μενελάῳ—Ibykos, fr. 296). The encounter between Menelaos and Helen in Euripides' *Troades* is a further development of this idea.

Euripides' third and most significant alteration to the popular tale is the introduction of a third character, Hekabe. Initially, as Menelaos arrives on stage, Euripides invokes the traditional paradigm of reunion between Helen and her estranged husband. Menelaos announces that he has come to retrieve his wife, and he orders his men to drag her out of the tent by her hair (880–2). Before Helen has emerged from the tent, however, the dramatist interjects Hekabe into the confrontation (884–94), and Menelaos converses with this third participant even before he speaks with his wife. Once Helen appears, husband and wife are allowed a brief exchange of words (895–904) but are soon separated by another interruption from Hekabe, who proposes a debate between Helen and herself (906–10). The proposal effectively relegates Menelaos to the sidelines, and instead of the traditional reunion between Helen and Menelaos, we witness a confrontation between the two women. The result neatly harmonizes with the overall scheme of the play: Hekabe retains her position of centrality, she again interacts with a younger woman connected with the royal house, and the Greek warriors remain on the fringes of the action.

Hekabe's final encounter with Helen forms an emotional climax to the past exchanges, and unlike the earlier scenes, which presented a given situation as a fact, introduces a conflict as yet unresolved. Menelaos' introductory announcement that the Greeks have granted him a choice regarding Helen's life (874–5) contrasts with the dogmatic attitude of Talthybios, who in the previous scene announced the execution of Astyanax as a *fait accompli* and thereafter stifled any objections from Andromache with a stern warning of even harsher penalties (725–39). Helen, condemned in her absence in preceding

scenes, is now granted the opportunity to present a defence which will leave her audience less confident of her guilt. And Hekabe, who has previously exercised no control over the course of events, has found no means of preventing the loss of Kassandra or the taking of Astyanax, is now granted power to inflict harm upon her greatest adversary. The grief and lamentation that filled her former speeches give way here to an overwhelming desire for vengeance. Sympathy and compassion for Kassandra and Andromache yield to hatred for Helen, and the Hekabe of the *Troades* grows to resemble the vengeful main character of Euripides' earlier *Hekabe*.[10]

The burial of Astyanax provides a fitting coda to Hekabe's trio of farewells. The women of the royal household, women who might have born successors to the royal Trojan line, have departed with their new masters, and the last of the Trojan children is now murdered and buried. This death is the final, conclusive stage in the dissolution of Hekabe's family, as well as insurance against the possible resurgence of the Priamids in the future (see 723, 1160–1). In terms of plot the scene is most closely allied with scene two; the burial resumes and concludes the story which began with the parting of Astyanax from his mother Andromache. Helen's departure in scene three separates the two chapters of the Astyanax plot with a heated rhetorical exchange, and as A. Burnett has observed, the insertion twists the vengeful expectations of the Trojan queen back upon herself: Hekabe attempts to secure the execution of Helen in scene three and is handed instead the corpse of Astyanax in scene four.[11] At the same time, the death of the child serves as a prelude to the catastrophic destruction of the entire city. His fall from the towers (πύργων δίσκημα πικρόν—1121)[12] functions as symbolic affirmation of the end of Troy and prefigures the fall of the towers themselves in the final moments of the play.[13]

[10] See Lloyd (1984) and (1992) 99–112 for detailed discussion of the arguments employed in the agon. [11] See Burnett (1977) 292 and 296.

[12] The hurling of the child from the towers is mentioned also at 725, 774, 1134, and 1172–3.

[13] For the physical fall of the city see 1319: 'Soon you will fall nameless to the earth' (τάχ᾽ ἐς φίλαν γᾶν πεσεῖσθ᾽ ἀνώνυμοι), and 1325: ꞌΗΕΚ. Did you hear? ϹΗΟ. The crash of the citadel' (Ἐκ. ἐμάθετ᾽, ἐκλύετε; Χο. Περγάμων ⟨γε⟩ κτύπον). See also the reference to Troy falling at 1160–1 and Hekabe's wish to fall to her death at 506–9. To the Athenian audience, which could look back to see their own acropolis opposite the flames and smoke engulfing Troy, the drama must have presented a frightening image of war's perilous consequences.

By reintroducing Hektor's shield, previously featured on Andromache's cart, as a makeshift casket for the hero's infant son (1141–2), Euripides ties the scene more securely to the preceding drama and ties the fate of Astyanax more securely to the career of Hektor.[14] Following his epic predecessors, Euripides defines the child and his death in terms of his eminent father (compare §3.2), and he reinforces that relationship visually with the father's magnificent shield. Like the shining helmet which frightens the infant in *Iliad* 6, this piece of armour links Hektor and Astyanax with battle and death. Attention to the shield's originally intended function underlines the poignant irony of the son's lethal inheritance: the device which once protected Hektor has failed (1194–5), and the device which safeguarded the life of Astyanax will now shield him only in death.

Euripides has gone to some length to ensure that Hekabe, and not Andromache, buries the child—the grandmother and not the mother. Talthybios must explain the unusual circumstances with a rather lengthy announcement: news of trouble in Phthia has arrived, Neoptolemos has been forced to depart quickly and has taken Andromache with him, she has entrusted her child's burial to Hekabe and has left behind the shield of Hektor in place of a casket (1123–46). To end with the burial and at the same time to preserve the unity and rhythm of the play, this contrivance is indispensable. Over the course of the three central scenes of departure Hekabe's involvement has been continuous, and the burial of the child now allows her a final moment in the spotlight. The reappearance of Andromache, apart from upsetting the unity of the central trio of departures, would also impair the crescendo leading to Hekabe's final laments.

While preserving the balance of the whole, Euripides also gains from the contrivance a poignant juxtaposition of grandmother and grandchild, oldest and youngest generations side by side, together with a memory of the intervening generation in the shield of Hektor. The mother who buried her many sons and witnessed the murder of her husband Priam, who has bid farewell to her many daughters (474–88), now buries her grandson as well, the very last male member of her family. This burial arrangement aptly captures the enormous scale of the disaster and the span of generations involved. It is interesting to note that Euripides is here reflecting a theme which had long been traditional in Ilioupersis iconography. For more than

[14] See Poole (1976) 266 for discussion of the shield as a 'relic' of the heroic past.

a century the painters of Athens had regularly depicted the murder of Astyanax together with the murder of Priam in a single scene, thereby juxtaposing the oldest and youngest generations of the Trojan ruling family (compare §12.1). Euripides has engineered a similar juxtaposition, but replaced the patriarch with the matriarch.

The burial of Astyanax is the last in a long series of Ilioupersis events to which Hekabe bears witness, and is followed only by the burning of the city and the departure of Hekabe herself from the stage. While the many captive women have come and gone, lamenting their own fates and the loss of their families, the presence of Hekabe has provided the indispensable focal point for the parade. The sorrows of the royal family and of the entire nation converge upon her, and she in turn serves as our window upon the multifaceted depiction of ruin before her. With this chain of unhappy encounters between Hekabe and the departing Trojan women, anomalous as it is in comparison with dramas limited to a smaller number of principal characters, Euripides succeeds masterfully in translating the monumental scale and composite nature of the Ilioupersis myth from the epic poems to the Athenian stage.

9.3 Past and Future

Like his epic predecessors and dramatic colleagues, Euripides was well aware of the pivotal position of the Ilioupersis within the Trojan saga, and through a series of references to external events he anchored the action of his Ilioupersis drama within that wider narrative. Poseidon's introductory recollection of building the city walls together with Apollo (4–7) neatly complements the fall of these walls at the close of the drama. In her opening lament Hekabe looks back to the coming of the Greek ships in search of Helen (122–33), the same ships in which she herself is soon to be transported away from Troy. Memories of the war's origins—the judgement of Paris, Helen's abduction—contribute to the debate between Hekabe and Helen. The recollections bring Troy's past back into our thoughts, remind us of the ten years that have led up to this drama, and convey with greater impact the enormity of the present destruction. The play itself is a momentous climax. Within the capture of this city and the enslavement of its women lie the conclusion to a protracted war and the collapse of an entire civilization.

The second choral ode is particularly rich in memories of previous generations. Its first two verses recall the campaign of Herakles and Telamon as a parallel to the present defeat (799–819),[15] and the subsequent references to Ganymede (820–46) and Tithonos (847–57) point a finger of reproach at the gods who have now abandoned the city they once cherished.[16] In the past Zeus' love for Ganymede helped rebuild Troy: 'Eros, Eros, who once came to the Dardanian halls | on behalf of the lords of heaven, | how high you built Troy's walls then, | forming a bond of marriage with the gods' (840–4).[17] Now, in contrast, the walls are to be levelled with no possibility of rebuilding. The song is particularly effective in its position immediately after the removal of Astyanax from the stage. Hekabe previously perceived in this child the hope for a new generation of Trojans who might rebuild the city of Ilios (καὶ πόλις γένοιτ᾽ ἔτι—702–5); but Talthybios has contradicted her hopes, and the child's impending death confirms that Troy's destruction will be complete. This time, not even the love of Zeus for Ganymede or of Eos for Tithonos will preserve and resurrect the city. Unlike those beautiful princes, the gods abandon Troy's last prince to death at the hands of the Greeks.

In addition to the retrospective allusions contained within the *Troades*, the two previous plays of the trilogy, *Alexandros* and *Palamedes*, would also have presented the original audience with a more comprehensive view of Troy's past.[18] The first play told the story of Paris' reunion with his family, the second concerned the intrigues of Odysseus against his rival Palamedes, and the fall of the city in *Troades* provided a monumental conclusion to the sequence.[19] The

[15] For Herakles' campaign against Troy see §6.1.

[16] Burnett (1977) 302–4, in a comprehensive though sometimes strained interpretation of the ode and its position within the drama, points out that while the chorus recalls Ganymede and Tithonos to reproach the gods for undeserved abandonment, the reminiscences of Laomedon, notorious for his impiety, undermine their arguments.

[17] Given the arrangement of topics in the ode—Herakles' campaign (799–819), Zeus' love for Ganymede (820–39), the past (re)building of Troy (840–4)—Euripides seems to be following a tradition according to which Zeus' love for Ganymede encouraged the god to preserve and rebuild Troy after the earlier sack. As Burnett (1977) 302 observes, in opposition to the Iliadic tradition which records Ganymede as a son of Tros, Euripides delays his birth for two generations and makes him a son of Laomedon instead (Λαομεδόντιε παῖ—821), thereby placing him closer to the earlier Trojan war.

[18] See Snell (1937) for the fragments of the *Alexandros*. For discussion of the lost plays see Koniaris (1973), Lee (1976) pp. x–xv, Lesky (1983) 282–83, Scodel (1980), and Webster (1967) 165–81.

[19] The trilogy was followed by a fourth, less closely related play, the *Sisyphos*.

extent to which Euripides deliberately interrelated the three plays cannot be determined.[20] Certainly the common subject-matter, the saga of Troy, contributed a degree of coherence to the series, but specific thematic continuity is less easily assessed. There are obvious points of potential correspondence between the *Alexandros* and the *Troades*. The former depicted the reunion of a family with the acceptance of Paris into the royal house, and the latter in turn represented the final stages of family disintegration, the ultimate result of Paris' ill-omened return.[21] Hekabe played a major role in the first play, as she does in the third. But how and whether the themes of the *Palamedes* might have related to those of the other plays is less clear,[22] and it must be admitted that, while we may consider the three plays together as a connected trilogy, the continuity was perhaps less controlled and less sustained than that in Aischylos' *Oresteia*.[23]

Less numerous than the recollections of the past, the allusions to future events within the *Troades* are nevertheless equally memorable. Before the action of the play begins, Poseidon and Athena plot together to wreck the Greek fleet, and as they anticipate their lethal concoction of wind, fire, and sea, they seem already to revel in the deaths of the Greek victors (75–97). In scene one, Kassandra eagerly envisions Agamemnon's ignominious death at the hands of Klytaimestra (356–64 and 446–50) and enthusiastically reviews the catalogue of perils to confront Odysseus on his voyage home (424–43). While nothing in these passages will come as a surprise to the audience, the allusions nevertheless serve to remind us that the present drama is one chapter within the continuing story. As we watch the enslavement of the Trojan women, we are asked to remember as well the disasters yet to be faced by their Greek captors.[24] Euripides contrives a more cunning allusion to the future in Menelaos' final stated intention to execute Helen upon their return to Greece

[20] Reacting against scholars who have sought to explain the play's irregular format through its position within the trilogy, Koniaris (1973) argues against assuming any deliberate connections between the plays. Scodel (1980) responds to Koniaris's arguments with a search for intricate potential links.

[21] Webster (1967) 165 observes the concern with the family in both plays.

[22] The numerous references to Odysseus in *Troades* (277–91, 421–44, 721–2, 1224–5, 1285–6), stimulated by his status as new master to Hekabe, might be understood as an attempt on the part of the dramatist to reinforce continuity with the *Palamedes*.

[23] Cf. Lesky (1983) 283 for a similar, neutral assessment of the trilogy's unity.

[24] Euripides displays a similar fondness for glimpses into the bleak future at the close of his *Hekabe*, where Polymestor reveals the suffering which awaits his tormentors.

(1036–41). Together with Hekabe's anxious doubts that his resolve will survive the journey home (1049 and 1051), this threat will naturally provoke in the audience some attempt at reconciliation with the familiar Odyssean tradition of the couple's subsequent conjugal life in Sparta.

Some of these future references are of a distinctly erudite or academic nature, in that Euripides employs them to direct our attention not only to a traditional tale, but to specific works of specific poets. His Kassandra acts in unmistakable imitation of her Aischylean predecessor when, for example, she casts aside her priestly insignia prior to her exit (*Tro.* 451–4, *Ag.* 1264–72).[25] Euripides thereby acknowledges his fellow-dramatist with a quote that a learned audience was certain to recognize, and accordingly, Kassandra's repeated predictions of Agamemnon's death recall not only the myth, but Aischylos' specific dramatization of that myth. More deliberately allusive to particular poets than were his predecessors, Euripides anchors his story within the saga while simultaneously attempting to anchor his poetry within the canon.[26]

The dramatic significance of the predictions is difficult to gauge. It is sometimes argued that the reminders of the Greek nostoi are intended to counterbalance the present suffering of the Trojans.[27] According to this view, the positioning of Athena's conversation with Poseidon at the opening of the play conditions our reception of the coming acts of the Greeks; while the Greeks inflict such terrible pain on the Trojans, we have as consolation at least the promise of justice, the knowledge that the victors themselves will soon suffer in turn. Similarly with Kassandra's prophecies, Agamemnon, the conqueror who takes Kassandra as his concubine, will face punishment upon his return to Argos; and Odysseus, the arch-villain who advocates the death of Astyanax (282–8, 721, 1224–5), will suffer even more than his Trojan enemies (432–3). The anticipation of those later chapters reminds us of the traditional double peripeteia of the Ilioupersis. As Aischylos had long since dramatized in his *Agamemnon*, the Greek victors will themselves be vanquished.

[25] Cf. also Hekabe's remarks at 256–8. For a recent comparison between the Kassandras of Aischylos and Euripides see Garner (1990) 165–7.

[26] Cf. the speech delivered by Hekabe in response to Kassandra's departure—as has been discussed above, an unmistakable replication of Priam's farewell speech to Hektor in *Iliad* 22.

[27] Halleran (1985) 92–3, Lee (1976) 16, and Scodel (1980) 65–7.

The correlation between the staged events and the predictions of future disaster, however, is not a simple example of crime and punishment. The first half of the prologue, in which Poseidon introduces the captive women, is the true prologue to the ensuing drama. The second part of the prologue, in which Athena arrives and the two divinities plot the downfall of the Greeks, introduces a story which lies beyond the formal bounds of the drama and is largely alien to it.[28] The Greeks themselves, the victims of the anticipated storm, are distant from the play. We do not see the actions of Agamemnon, Aias, or Odysseus, and the anticipation of their suffering carries little dramatic significance for us. Furthermore, after the prophecies of Kassandra in scene one there is no suspenseful anticipation of disaster, no unmistakable resounding echo of the storm in the last moments of the play.

We observe instead the interminable suffering of the Trojan women, who themselves derive no benefit from the planned punishment. Athena wins Poseidon's confidence by telling him that she wishes to raise the fallen spirits of the Trojans (τοὺς μὲν πρὶν ἐχθροὺς Τρῶας εὐφρᾶναι θέλω—65), but we see few signs of any comfort or consolation during the play. The reason for Athena's anger and for her apparent change of sides is not the suffering of the Trojans, but Aias' assault on her sanctuary and the failure of the Greeks to punish him (69–71). That dispute involves only gods and Greeks, and is external to the ensuing drama of the Trojan women. Even Poseidon, apparently sympathetic to the Trojans, relates the coming retribution specifically to the desecration of Troy's sanctuaries (95–7). Thus the correlation between the promised storm of the prologue and the ensuing events of the play is imprecise, incomplete. The gods inform us not that the Trojans will receive compensation, but that this futile and destructive war ends with neither side truly victorious.

Kassandra's visions generate a similar discord with the surrounding drama. While promising retaliation and compensation, Kassandra's words are irreparably weakened by the restriction placed on her prophecy. She is the only human character granted knowledge of future events, and yet she cannot share that knowledge with those around her, not even with her mother. Her inability to communicate her privileged information underlines the division between the current suffering of the Trojans and the predicted suffering of the

[28] See Halleran (1985) 92–3 for analysis of the duplicitous structure of the prologue.

Greeks. The future is another chapter: retribution for wrongs, but not alleviation of the present distress. Even for the audience, though we know she speaks the truth, Kassandra's prophecies are hollow and devoid of comfort. Revealing as much about Kassandra herself as they tell us about the Greeks, they demonstrate that like Aischylos' prophetess, Euripides' Kassandra thirsts greedily for vengeance. She takes delight in anticipating her own role in Agamemnon's downfall and even numbers herself among the Furies (457). Like Hekabe in her pursuit of retribution against Helen, she is driven by misfortune to seek relief through the adversity of her enemies. Euripides' allusions to future retribution thereby offer more than a simplistic lesson in tit-for-tat justice. They balance the narrative with anticipation of compensatory suffering, but the justice foreseen remains hidden from the Trojan women. It is a justice in which suffering mortals will find no solace.

10

The Lost Ilioupersis Dramas of Sophokles

In addition to Euripides' *Hekabe* and monumental *Troades*, several other dramas incorporating Ilioupersis material were composed for the Athenian stage. No record of such plays survives for Aischylos, who was perhaps dissuaded by the composite nature and unwieldy magnitude of the myth. Sophokles, however, managed to extract at least three dramas from the Ilioupersis tradition: *Laokoon*, *Aias Lokros*, and *Polyxene*.[1] Evidence exists also for an anonymous Ilioupersis drama which treated the Trojan captives and was perhaps centred upon the fate of Andromache.[2]

Sophokles' *Laokoon*, as the title and the few remaining fragments suggest, was set immediately prior to the city's capture and focused on Laokoon's unheeded warning of danger and the subsequent death of the priest and his children.[3] The messenger-report on the departure of Aineias and his family, as preserved in fragment 373, suggests that Sophokles followed the epic tradition according to which Aineias perceived in Laokoon's death an omen of impending disaster (ἐπὶ δὲ τῷ τέρατι δυσφορήσαντες οἱ περὶ τὸν Αἰνείαν ὑπεξῆλθον εἰς τὴν Ἴδην—IP arg. 8–9).[4] Given these few indications, it seems likely that the drama relied heavily on the city's imminent fall as a source of suspense, that Laokoon's death was interpreted as a divine warning, and that the cautious retreat of Aineias contrasted with the general Trojan oblivion concerning the coming disaster.[5] While the

[1] Evidence is slim for the other four plays which Pearson (1917) p. xxxi optimistically classified as Ilioupersis dramas. The *Antenoridai* is thought by some to be the same as *Laokoon*, by others to be the same as *Helenes Apaitesis*. The subject of the *Priamos* is unknown. *Aichmalotides* probably treated the captives Briseis and Chryseis, not the Trojan captives. *Lakainai*, on the other hand, which treated Odysseus' spying mission or the theft of the Palladion, though not listed by Pearson, might also be considered an Ilioupersis drama. For each see Radt's (1977) edition of the fragments.

[2] See fr. 644 in Kannicht and Snell (1981) 211–13.

[3] See Radt (1977) 330–4 for the fragments. Robert (1881) 192–212 discusses the early evidence for the Laokoon myth, including the fragments of Sophokles' *Laokoon*.

[4] The omen is discussed above in Ch. 4.

[5] Frr. 370, 374, and 375 suggest the Trojans' false impression of victory.

actual taking of the city may have stood beyond the play's temporal bounds, Sophokles sought to capture dramatically the traditional, ironic blend of presumed victory and unexpected defeat, celebration in the midst of imminent ruin—a reversal inherent already in the epic narratives of the Ilioupersis.

One of two Sophokles plays set in the immediate aftermath of the sack, the *Aias Lokros* revolved around the notorious attack upon Kassandra and Athena's consequent wrath.[6] According to Proklos' *Iliou Persis* summary Aias' crime roused the anger of his fellow Achaians, but he evaded stoning by seeking refuge at the altar of the offended goddess (*IP* arg. 15–18). Adapting this sequence for the stage, Sophokles presented the conflict between Aias and the Achaians as a trial at which Aias pleaded his innocence. The play seems to have touched upon the fate of Antenor's family, perhaps because Theano, Antenor's wife, served as priestess in the temple where the assault took place (frr. 10e and 11). Athena herself appeared at some point, perhaps to deliver a warning of retaliation, and the dramatized events must have anticipated the imminent wreck of the Achaian fleet, traditionally a direct consequence of Aias' crime and the Achaians' failure to punish him adequately.

While little remains of Sophokles' *Polyxene*, comparison with Seneca's *Troades* suggests the possibility of a dispute among the Achaians over the sacrifice of the Trojan princess, a dispute involving Achilles' demand for the sacrifice and Agamemnon's reluctance to grant the ghost's demands.[7] If so, Sophokles might have borrowed motifs from their dispute over Briseis in the *Iliad* or from the sacrifice of Iphigeneia, which involves a similarly reluctant Agamemnon. The fragments, though too few to offer a fully reliable guide, suggest that here again Sophokles anticipated the disastrous nostoi. The quarrel between Menelaos and Agamemnon attested by fr. 522 is probably an adaptation of the quarrel narrated in the epic *Nostoi*, where it formed an ominous introduction to the tales of Greek adversities (*Nost.* arg. 3–4). The ghost of Achilles may have predicted future events here as he had done previously in the epic *Nostoi*: 'And as Agamemnon and his followers sail away the ghost

[6] For the fragments see Radt (1977) 102–23 and Haslam (1976) on P.Oxy. 3151.

[7] See Radt (1977) 403–7 for the fragments and Calder (1966) for an attempted reconstruction. Calder (pp. 34–7, 44, 48) discusses the dispute. Cf. Euripides, *Hek.* 116–28 for a similar dispute over the sacrifice.

of Achilles appears and attempts to restrain them by predicting what will befall them' (τῶν δὲ περὶ τὸν Ἀγαμέμνονα ἀποπλεόντων Ἀχιλλέως εἴδωλον ἐπιφανὲν πειρᾶται διακωλύειν προλέγον τὰ συμβησόμενα—Nost. arg. 9–11).[8]

[8] Frr. 526 and 528 perhaps refer to events predicted by Achilles, in particular to the dangers awaiting Agamemnon and Diomedes; see Radt (1977) 407.

PART III

Ilioupersis Iconography

Introduction

In this section we turn from the verbal to the visual manifestations of the Ilioupersis. While the poets were drawing upon the vast corpus of heroic myth to produce epic, lyric, and tragic verse, contemporary artists and artisans were employing the same body of material in a variety of plastic and painted forms. Although the beginning stages of mythological representation in Greek art are obscured by the paucity of surviving evidence, the Ilioupersis seems to have been an early favourite. The oldest known image of the wooden horse is found incised on a bronze pin dated to the late eighth century BC, placing the Ilioupersis among the first of all recognizable myths to appear in Greek art.[1] Another remarkable example dates to the mid-seventh century: a pithos from Mykonos decorated in relief with multiple scenes of the sack, among them the wooden horse and the reunion of Helen and Menelaos (Cat. no. 2*).[2] By far the richest vein of Ilioupersis representations is that found among the extensive corpus of Attic black-and red-figure pottery. Three scenes in particular—the recovery of Helen, the murder of Priam, and Aias' attack upon Kassandra—became favourites of the Athenian vase-painters, who reproduced them repeatedly and continuously from the mid-sixth to the mid-fifth century.

The vast quantity of Ilioupersis artwork has been subjected to frequent study during the past few decades.[3] The material has been classified, the iconographic traditions of the various episodes have been outlined, and relationships between the visual and poetic traditions have been charted. One extraordinary aspect of Ilioupersis iconography, however, has attracted far less attention: the practice

[1] BM 3205, Sadurska (1986) no. 22.

[2] See Ch. 11 and the Catalogue for details.

[3] Moret (1975) provides general information on the iconography of the Ilioupersis in his preliminary chapters, i. 53–60. Studies of specific episodes are cited in the notes below.

of combining two or more episodes within a single work of art. Like the labours of Herakles and the deeds of Theseus, the cluster of well-known and easily recognizable Ilioupersis episodes provided artists with an ideal subject for composite visual narratives. Among monumental representations of Troy's capture it seems to have been standard practice to include several episodes. Notable examples are the north metopes of the Parthenon and Polygnotos' wall-painting in the Knidian Lesche at Delphi. On a smaller scale, painted vases lent themselves readily to combinations. The two decorated panels of an amphora, for example, which in common practice housed two mythological scenes of no necessary relation to one another, could be united into a harmonious pair if filled with two complementary Ilioupersis scenes.

Although to manufacture an 'Ilioupersis' out of individual Ilioupersis episodes required no more than positioning a few traditional iconic patterns side by side, Greek artists learned at an early stage that a composite picture could be more than the sum of its parts. For many the art of combination meant exploration and manipulation of relationships among the scenes combined. The temporal sequence of the narrative, for example, might influence the relative arrangement of individual scenes. More commonly the blending of juxtaposed scenes involved the artful manipulation of shared themes and motifs. By fostering a visual dialogue based on reiteration or contrast between neighbouring scenes, artists could set into relief the principal concerns of the individual episodes and extrapolate from them a compelling composite narrative. Two scenes representing acts of sacrilege, for example, when set side by side, convey the theme of sacrilege with greater intensity than would either scene alone. While adherence to iconographic tradition kept the pace of innovation in check, their attempts to assimilate or balance juxtaposed scenes frequently led artists to enhance the standard iconography with additional figures and new designs. Combination of Ilioupersis scenes thus amplified artistic impulses toward creative adaptation and development.

In the following pages I analyse several instances of Ilioupersis combination, directing the discussion primarily but not exclusively around black- and red-figure Attic vases, as these are the most numerous and the best-preserved examples. The combinations to be considered range from simple juxtapositions of only two scenes to elaborate mixtures of five and nine. While this study could be extended into the fourth

century and beyond, the late fifth century provides a convenient stopping-point, since vase-painting was taking new directions with westward expansion, and iconographic conventions were shifting rapidly.[4]

[4] See Moret (1975) for Ilioupersis representations in Italian vase-painting, and see Cat. nos. 33–5 for Italian examples of Ilioupersis combination.

11

The Mykonos Ilioupersis Pithos

One of the earliest surviving examples of Ilioupersis scenes in com-
bination is also one of the most spectacular: a large terracotta pithos
found on the island of Mykonos and dated to the second quarter of
the seventh century BC (Cat. no. 2*—Figs. 2(a) and (b)).[1] This vessel,
one of a family of large pithoi manufactured in the seventh century
and decorated in relief with mythological subjects, stands out among
its siblings, indeed among all contemporary Greek representations
of myth, for the scope and elaborate detail with which it relates the
story of Troy's fall.[2] The neck of one side of the pithos is occupied
by the wooden horse, filled with seven warriors and surrounded by
seven more. Below the horse three horizontal rows of panels spanning
the vessel's upper body feature the enslavement of Trojan women
and the murder of their children. The two sections, neck and body,
together comprise a sequential narrative couplet. The upper panel
narrates an early stage of the attack, while the lower group follows
with later chapters of the same story. This progression may be de-
scribed with more precision as preparation and execution, the ruse
of the horse above forming a prelude to the murder and enslavement
below.[3]

The neck panel of the pithos is dominated by the horse, repres-
ented in profile and facing right (Fig. 2(b)). The artist has identi-
fied this figure specifically as the wooden horse of Troy by attaching
wheels to its hoofs and perforating its back and neck with a series of

[1] Athens, Myk. 67. The pithos was discovered in 1961 and published by M. Ervin
in *AD* 18 (1963), hereafter referred to as Ervin (1963). The same author discusses the
vessel again in *AJA* 80 (1976) under the name M. Ervin Caskey, hereafter referred to
as M. E. Caskey (1976). The pithos measures 1.34 m. in height, and M. E. Caskey (p.
28) dates the pithos to the second quarter of the seventh century. Ahlberg-Cornell
(1982) 77–85 describes the scenes decorating the pithos and provides useful illustra-
tions. See the Catalogue and the notes below for further bibliography.

[2] For a general survey of the group see M. E. Caskey (1976), and for a list of mytho-
logical subjects see ibid. 32–3.

[3] Cf. Hurwit (1985) 173–6 for discussion of the visual narrative on the neck and
body of the pithos.

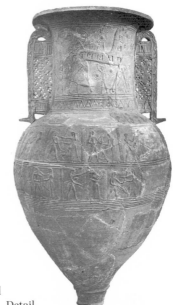

2(a) *right* Relief pithos from
Mykonos, Cat. no. 2. The wooden
horse, Greeks capture Trojan women
and children. (Courtesy, Archaeological
Receipts Fund, Athens.) 2(b) *below* Detail.

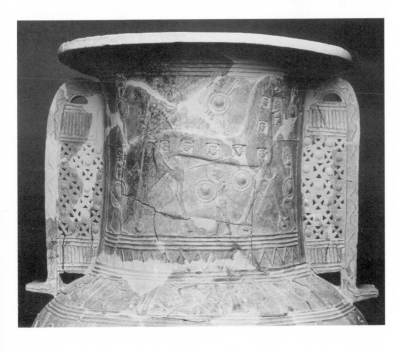

window-like openings.[4] The wheels denote the means by which the Trojans drew the horse into their city, and the openings, in addition to offering the viewer a glimpse of the Greeks inside, represent the hatches through which they entered and emerged from the statue.[5] Rather than an isolated experiment in wooden-horse design, this creature appears to have belonged to an established visual tradition, as both wheels and windows were witnessed once before, a half-century earlier, on a bronze fibula of the late Geometric period.[6] Further evidence for a tradition appears on a fragment of a relief pithos from Tenos, contemporary with its neighbour from Mykonos.[7] Although this shard preserves only the lower portion of the horse's front legs, the wheels are a sufficient indication that this animal is another wooden horse. The existence of this tradition at such an early date, when mythological representation in Greece was still in its infancy, naturally suggests that the myth of the Ilioupersis was prevalent on the mainland and the islands by this time. The horse may also owe its early iconographic popularity in part to the widespread general popularity of horses in art of the mid- and late Geometric period, horses which were easily transformed into wooden horses by the few simple adjustments observed on the fibula and the pithoi.[8] Furthermore, in an art which did not yet employ the aid of inscriptions to identify its subjects, a horse with wheels was a conveniently unambiguous subject, one sure to be greeted with immediate recognition from its viewers.

[4] Differences in decorative detail between the neck and body suggest that two or more artists may have worked in collaboration to produce the relief work on this vessel. Thus the word 'artist' as I employ it here should be understood to include the possibility of multiple artists. M. E. Caskey (1976) 28–9, however, judges all the decoration on this vase to be the work of a single artist.

[5] While the basic significance of the wheels is clear—the horse is mobile—the origin of the wheels is not clear. At Vergil, *Aeneid* 2. 235–6 it is the Trojans who supply rollers or wheels for the horse. At Quintus Smyrnaeus, 12. 424–7, and Tryphiodoros, 100, Epeios equips the horse with wheels. For discussion of the practical likelihood of each option see Austin's (1964) note on *Aeneid* 2. 236. The wheels on the Mykonos horse neither support nor contradict either of the poetic traditions.

[6] BM 3205, Sadurska (1986) no. 22. [7] Ibid. no. 24.

[8] The popular horse form also lent itself to early images of monsters. Cf. the equine representations of the Minotaur on relief pithos BS 617 in the Basle Antikenmuseum, M. E. Caskey (1976) 28–9 and fig. 22; of Medusa on relief pithos CA 795 in the Louvre, M. E. Caskey (1976) 28 and pl. 3, fig. 14; of a monster fighting a god (Typhon and Zeus?) on a bronze figurine, New York MMA 17.190.2072, Schefold (1966) pl. 4a; and of a similar monster on a proto-Korinthian lekythos, Boston MFA inv. no. 6508. For discussion of the last two see in particular Buschor (1934).

The horse on the Mykonos pithos, unlike its ancestor on the Geo-
metric fibula, which stands unaccompanied, provides an architec-
tural setting for a military operation. The artist includes in the panel
not only the horse, but also the company of Greek soldiers who rode
the horse to victory over Troy. The seven windows on the neck and
body of the statue reveal the heads of seven Achaian warriors lodged
inside, while outside stand seven more warriors, three on the ground
below and four in the panel's upper register. A Korinthian artist dec-
orating a small aryballos in the mid-sixth century, perhaps conver-
sant with the tradition witnessed on the pithos, again surrounded
the horse with warriors, making it the setting for a miniature scene
of battle between Greeks and Trojans.[9] But the positions and gestures
of the figures on the pithos suggest earlier moments, probably the
emergence from the horse.[10] Four of the seven warriors still within
the horse pass pieces of armour through the hatches in preparation
for their descent. Those surrounding the horse have just emerged,
and with the exception of one who still carries his helmet by his side,
they have armed themselves for the imminent attack on the Trojans.
While six of them carry their spears at rest beside them, the war-
rior prominently positioned beneath the horse's belly brandishes his
weapon above his head, as if about to engage in combat.[11] Together,
the several moments conflated within this parade of evolving figures

[9] Paris Cab. Méd. 186, Sadurska (1986) no. 17. The panel on this aryballos is divided
into four registers by three horizontal lines, and each register contains scenes of com-
bat. The lines on the aryballos are unlikely to indicate physical elevation. The combat
on the upper line extends not only to the back of the horse, but also to the shoulder of
the panther, the animal immediately to the right of the horse in the miniature animal
frieze. Similarly for the pithos, as Ervin (1963) 46 remarks, although the baseline divid-
ing the upper and lower registers, placed approximately level with the height of the
horse's back, might be interpreted as the wall of Troy or some other elevated surface,
it probably carries no intended indication of physical height. The four warriors in the
upper register need not be understood as walking above the horse. Rather they are posi-
tioned here to fill the available picture space.

[10] This is to me the most likely interpretation, but since comparative evidence is
rare at this early stage of narrative art, and iconographic conventions are only par-
tially understood, certainty is impossible.

[11] Schefold (1966) 46, in contrast, suggests that the two warriors at the lower right,
both facing left while the others face right, are Trojans attempting to repel the Greek
invaders. Cf. the Korinthian aryballos (n. 9 above), where the horse forms a back-
ground for several images of combat between Greeks and Trojans. The warrior be-
neath the horse, standing alone with his spear raised, might also recall Vergil's Laokoon,
who thrusts a spear into the belly of the horse. As Laokoon, however, is entirely absent
from Archaic art elsewhere and his role in the early epic is obscure, his appearance
here is unlikely. I offer my own interpretation of the figure below.

spell the launch of the sinister Achaian attack, a controlled but aggressive advance from the lair.[12]

The narration continues in the rows of panels stretching across the upper body of the vessel (Fig. 2(*a*)).[13] Most of these scenes are composed according to a single pattern: a warrior armed with a sword stands on one side, usually the left, confronting a woman who stands opposite. Having already slain the Trojan men, the Greeks are now enslaving their mothers, wives, and daughters. In several of these panels warrior and woman are accompanied by a third figure, a small male child, appearing in various locations with various poses. One warrior, sword drawn, grasps the woman by her hair, while she tries to protect the child which she holds in her arms (met. 16).[14] In another panel the child stands behind the warrior, who draws his sword as he turns to the child, while the mother reaches out to avert the attack (met. 15).[15] Some scenes depict a more advanced stage of confrontation. One of the warriors impales a child on his sword (met. 14); a child in another panel has already received two wounds (met. 8); and the warrior in a third scene, swinging a child by the foot, appears to dash his head against the ground (met. 17).

This conglomeration of panels exposes an operation of mass enslavement and extermination. Repetition with variation is this artist's means of conveying proportion, of capturing the monumental scale of the assault and the carnage within the limited space on the pithos. The gruesome result is reminiscent of Priam's vision of the Ilioupersis in *Iliad* 22, where he foresees in generalized terms the death of his sons, the enslavement of his daughters and daughters-in-law, and the murder of their children (22. 62–5; compare §2.1). But the massacre on the pithos need not be limited to a single family, and the multiplication of scenes may be read as an attempt to represent all the women and children of the city. Like the Achaians of epic poetry,

[12] Hurwit (1985) 174 offers a broader interpretation, seeing here even more phases of the operation: Greeks entering the horse, Greeks within the horse, and Greeks emerging from the horse. On the practice of narrative compression in Greek art see in particular Snodgrass (1982).

[13] The uppermost of these rows, shorter in height than the two below it, stretches across what might technically be termed the shoulder of the pithos, but since there is no major differentiation between this and the rows below, I refer to all three rows of panels together as the body panels.

[14] I refer to each 'metope' according to Ervin's numeration.

[15] This child has already received a sword wound, to be read as an indication of the eventual outcome of the struggle rather than as a narrative error.

the warriors on the pithos are determined to eradicate the entire race of Trojans, and all the male children must die, even the sons still in the womb, as Agamemnon coldly threatens in *Iliad* 6. The profusion of violence against the helpless in these scenes suggests that the Greek artist looked upon the Ilioupersis not necessarily with pride or patriotism, but with a degree of horror, and while this particular manner of combining children and grieving mothers is not repeated in later works, the themes of brutality and suffering conveyed so poignantly on the pithos recur continuously in the visual tradition from this point on.

Among the generic scenes of confrontation, the artist has distinguished one as the reunion of Helen and Menelaos (met. 7). Her more elaborate clothing, a large shawl or himation draped around her body and head, separates Helen from the other female figures on the vessel.[16] Menelaos stands opposite, grasping his wife by the wrist with one hand and holding his sword in the other. For Helen, the capture means a potentially lethal confrontation with Menelaos, and the gestures of the figures on the pithos recall the poetic tradition according to which the betrayed husband initially intends to murder his wife but is subdued at the sight of her beauty.[17] The drawn sword, pointed threateningly toward Helen, indicates Menelaos' violent intentions. The placement of Helen's hands on the upper folds of her himation, a feature to be adopted also in the sixth-century iconography of the scene, suggests that she is removing her clothing to reveal her face or body, to expose her beauty to her husband and thereby settle his anger.

Helen owes her inclusion on the pithos to her role as a principal motivating factor behind the war and the destruction of Troy. Ten years earlier the Greeks sailed against Troy to retrieve her, and now the ruse of the wooden horse, pictured just above, has enabled them to accomplish their original task. This monumental achievement, however, casts a long and bitter shadow over the pithos. A viewer's initial glance at the body of the vessel reveals not Helen, but the slaughter of the children prominently displayed in the more central panels. Only later, as our eyes roam from side to side, will we meet Helen, situated two panels to the left of the centre. While the scene itself looks forward to reconciliation and to the couple's less turbulent

[16] Ervin (1963) 48 interprets the three layers of clothing as peplos, himation, and shawl. [17] See Ch. 8 n. 32 for discussion of *MI* fr. 19.

future as known from *Odyssey* 4, the viewer cannot ignore the uneasy tension between this and the bleak picture of carnage and enslavement painted in the surrounding panels, a tension comparable to that which Euripides was later to develop around the same figure in his *Troades*. Recognizing her here in the midst of misfortune, we are forced to ask again why so many must suffer for the sake of a single woman.

Another candidate for individual identification is the panel in which a merciless Greek swings a Trojan child by the foot as his mother watches (met. 17). The image is reminiscent of poetic accounts of the murder of Astyanax, who according to the epic *Mikra Ilias* was hurled by the foot from the walls of Troy (*MI* fr. 21. 3–5; compare §3.2). If the epic image was widespread in the mid-seventh century, then for artist and viewer of the pithos the position of the child in metope 17 may have suggested Neoptolemos and Astyanax.[18] But while the association is tempting, several factors urge caution and ultimately outweigh the arguments for individual identification. At this early stage in Greek narrative art, when comparative examples are few[19] and the popularity or existence of the Astyanax story in poetry is not firmly attested, it is difficult to determine whether the artist has actually intended to depict a known tale of Astyanax or has instead simply adapted a generic formula which later became associated with the individual.[20] Here, amidst numerous repetitions of the warrior–woman–child combination, the proposed 'Astyanax' panel may be only another anonymous variation of the theme. Moreover, specific identification of Astyanax lends little to an interpretation of the aggregate composition. The identification of Helen carries meaning because she is an individual and because her fate contrasts sharply with that of the Trojan women. In the case of the children, on the other hand, it is not the single murder of Astyanax the individual,

[18] Ervin (1963) 60 (and again M. E. Caskey (1976) 32) sees here Astyanax. In discussing the panels, Schefold (1966) 46–7 draws no distinction between this panel and the others.

[19] Another possible early representation of Astyanax is found on a fragment of proto-Attic pottery, Athens Agora Museum P10201a, second half of the 8th c., Touchefeu (1984) no. 26. A man holds a smaller figure upright by the leg in the presence of two other figures, at least one of whom is female. The proto-Attic example is a small fragment; context might confirm or refute its association with Astyanax. Carter (1972) 50 ff. argues against the specific association of this fragment with Astyanax. Schefold (1966) 27 cautiously interprets the scene as the murder of Astyanax.

[20] Astyanax poses a similar problem at *Il*. 24. 734–6. Is Andromache's vision of her son's death an allusion to a known poetic tradition, or is the vision first invented here and then established in the Ilioupersis tradition? See §3.2 above.

but rather the collective infanticide that stirs the artist. Were there only one scene of murder on the pithos, the choice of Astyanax would be more attractive, but here the story of Astyanax could be viewed as a source of inspiration in the background of any or all of the murder panels.

On the far right of the middle row of panels stands a lone female figure, gazing on the events to the left in horror (met. 13). As in the Helen scene, where the difference in clothing suggests individuality, it is tempting to recognize a specific character in this isolated figure, and Kassandra, as suggested by M. E. Caskey, is a compelling possibility.[21] The prophetess who has previously foreseen the destruction of the city and attempted in vain to warn her kinsfolk now watches as her prophecies are realized. The case for Kassandra is stronger than that for Astyanax, but comparative evidence again fails to confirm an identification. Aias' attack upon Kassandra will provide the subject-material for dozens of paintings in the sixth and fifth centuries, but the figure on the Mykonos pithos bears no resemblance to that tradition. Like the potential Astyanax, she may be another generic Trojan.

Finally, we turn to the most perplexing figure on the vase, featured prominently in the central panel of the topmost row (met. 2B, see Fig. 2(*b*)).[22] In contrast to the other panels on the body, which contain two or three smaller figures, this panel is filled entirely by the single, massive figure of a dead or dying warrior, bleeding from the neck, eyes closed, and perhaps still falling to the ground. With his knees bent beneath him, his head and upper body bent forward, the figure spans the entire height and length of the panel. He carries two spears, which extend across the panel diagonally from corner to corner, filling the space not covered by the warrior himself. In conjunction with his size, the figure's shield, helmet, and spears differentiate him from the other warriors in the body panels, who are armed only with swords. In this respect the figure closely resembles the men on the neck panel above, who are similarly equipped with shields, helmets, and spears.

Two identifications have been proposed. J. Christiansen interprets the figure as the Trojan prince Deiphobos, who was slain by Menelaos

[21] Ervin (1963) 62.
[22] The fragment was recovered after the rest of the vessel and was published separately by J. Christiansen in 1974. M. E. Caskey (1976) 36 numbers the metope 2B.

in the most celebrated battle of the night.[23] Since his death is preliminary to the reunion of Helen with Menelaos in the literary accounts,[24] the placement of Deiphobos in this panel would complement the Helen–Menelaos panel below and to the left, as Christiansen points out. A closer juxtaposition of the two panels, however, would have strengthened the argument.[25] A second proposal, that of M. E. Caskey, identifies the dying warrior as Echion, whom Apollodoros records as the first Greek to have descended from the wooden horse (*Epit.* 5. 20).[26] Unlike the other warriors, who descended safely by means of a rope, Echion leapt to the ground and died from the fall—one of the very few, if not the only, Greek casualty of the night. Like Echion, the dying warrior on the pithos appears not to have participated in any fighting. His sword is still in its scabbard, and his right arm is not inside his shield, but around it. Further possible arguments in favour of Caskey's proposal are the warrior's proportions and his armour, which associate him with the figures in the neck panel rather than those in the body panels, as if this character had literally fallen from the horse above into the body panel below. Arguments against Echion, on the other hand, include his infrequent appearance in the surviving classical evidence—only in Apollodoros—and his comparatively minor role within the story, a role unlikely to have earned him so prominent a position on the pithos.[27]

Both of these identifications have their strong and weak points, but without utterly rejecting or embracing either, I propose a third alternative. The most telling aspects of the mysterious figure are his unusual stature and equipment, which, as previously observed,

[23] Readers of Danish may consult Christiansen's (1974) arguments. A summary of his arguments in French is provided on pp. 19–20 of his article. M. E. Caskey (1976) 36–7 reviews his arguments in preparation for her own reinterpretation.

[24] *IP* arg. 14–15: 'Menelaos finds Helen and leads her to the ships, after having slain Deiphobos.'

[25] M. E. Caskey (1976) 37 protests also that no Trojan could be positioned so prominently on the vase. The overall composition, however, indicates no specific bias toward the Greeks. As in the later iconographic tradition, the Greeks are not necessarily represented favourably here. Furthermore, even if the artist were biased toward the Greeks, the figure of a dead Trojan would not detract from the image of Greek victory.

[26] M. E. Caskey (1976) 36–7. Hurwit (1985) 175 follows Caskey cautiously.

[27] In an attempt to compensate for Echion's minimal role, M. E. Caskey (1976) 37 proposes a parallel with Protesilaos' leap from the Achaian ships at the beginning of the war. Perhaps it was fated that the first warrior to leave the horse would die, or that the Greeks would be victorious if this warrior were to die. Echion's death may therefore have been a sacrifice for the success of the mission, an act which might reasonably earn him a prominent place on the pithos.

associate him more closely with the warriors on the neck of the pithos than with those on its body. If, therefore, we attempt to read the figure in the context of the scene above, we might, with Caskey, settle for Echion. But we can equip him with a much more integral role if we interpret him as a complement to the solitary fighting warrior beneath the belly of the horse. The dead man in the upper row of body panels is the defeated opponent of the victorious warrior who stands directly above him. The two figures form a pair, each acquiring its narrative significance through its relationship with the other. Perhaps, as Christiansen suggests, the fallen warrior represents Deiphobos, which would make his opponent Menelaos. But the figures need not be specific, and a generic confrontation will impart a greater force of cohesion to the work as a whole.

The image of combat between a Greek and a Trojan supplies a logical middle step in the narrative progression initiated in the upper scene. The Greeks have entered Troy by means of the wooden horse, depicted on the neck of the pithos. After emerging from the horse, they murder the men of the city—a process encapsulated in the image of the victorious Greek and the dead Trojan below him. Finally they recover Helen and enslave the Trojan women, the subjects of the remaining panels on the body of the pithos. The middle step, in fact, leads directly to the third component of the action, the death of the Trojan warrior rendering the women and children defenceless against the onslaught of the Greeks. Although it would seem an irregular and somewhat misleading practice to separate victor and vanquished into different panels, here the separation actually serves to unite the two physically distinct components of the visual narrative. Straddling the neck and body of the pithos, the pair forges a link between the first stage of the narrative above and the final stage below.[28] The power of this clever conjunction, however, is never fully unleashed, and the one dead Trojan is carefully confined within a strictly limited space. The essence of the Ilioupersis here is not battle, but defeat, slaughter, and enslavement. The artist passes over combat itself in favour of a single image of combat completed, and the Greek standing victorious over his vanquished foe quickly abandons the corpse on his way to the easy prey waiting below.

[28] The physical placement of one warrior above the other might also reflect the hierarchy between victor and vanquished—an iconographic convention more common in art of the Near East.

12

Iconography of the Ilioupersis in Attic Vase-Painting

After the Mykonos pithos a hundred years passes before a recognizable tradition of Ilioupersis iconography develops and we again witness an interest in the juxtaposition of Ilioupersis scenes. In the first half of the sixth century BC—among the now greater quantities of surviving pictorial evidence, particularly the extensive corpus of Attic painted vases—we see the emergence of several Ilioupersis scenes among the most popular mythological icons. In addition to Helen's reunion with Menelaos, witnessed previously on the Mykonos pithos, the murder of Priam and the attack on Kassandra now acquire standard, easily recognizable iconographies, and each maintains its popularity in the record of Athenian painted vases from the mid-sixth to the mid-fifth century. Aineias, though not represented so frequently as the others, also acquires a distinctive iconography on black-figure vases of the late sixth century and continues to appear occasionally in red-figure works. Before progressing to the Ilioupersis combinations produced during this period, I first review these most commonly found scenes individually, observing the regular composition of each, the themes expressed, and the evolution of the iconography over time.

12.1 Priam and Astyanax

The first subject is itself a combination. In apparent contradiction to the poetic tradition, which places the murder of Priam and the murder of Astyanax at separate times and separate locations, Archaic artists regularly depict the two events together as a single unit (for example, Cat. nos. 4*, 16*, 18*, and 25).[1] Neoptolemos is shown

[1] For a general study of black- and red-figure examples of the composition see Wiencke (1954). For the murder of Astyanax see also Touchefeu (1984) and for the combination of Priam and Astyanax see also Dugas (1960) and Himmelman-Wildschütz (1967) 76–7.

advancing upon Priam, who has taken refuge at the altar of Zeus, and at the same time he holds Astyanax by the heel and appears to be hurling the child towards the old man. The image of Neoptolemos attacking Priam corresponds to the myth as narrated in the epic *Iliou Persis*, which places the king's murder at the altar of Zeus Herkeios (*IP* arg. 13–14).[2] The image of Neoptolemos hurling Astyanax recalls the *Mikra Ilias*, according to which the warrior hurls the child from the wall of Troy (*MI* fr. 21).[3] In the visual tradition, however, the time and location of the latter murder were altered, and the murder of Astyanax was transplanted into the scene of Priam's murder. The two most notable deeds of Neoptolemos were thereby superimposed and a powerful new image was born. Instead of hurling the child from the wall of the city, as he does in the *Mikra Ilias*, Neoptolemos now appears to hurl him towards Priam. Although the two episodes may have been introduced into Greek art as independent representations, early iconographic evidence is rare and inconclusive.[4] In Attic vase-painting Priam's murder is occasionally represented without the inclusion of Astyanax, but the combination is the norm, and Astyanax has no standardized iconography of his own without Priam.

This uncommon visual compound of two events recorded independently in the poetic narratives is sometimes thought to have been inspired or facilitated by a similar visual composition popular in the early and mid-sixth century, the murder of the child Troilos at the altar of Thymbraean Apollo.[5] Several vase-paintings feature Achilles at the altar hurling the child Troilos, or a piece of him, towards a group of advancing Trojans. Priam sometimes joins the composition,

[2] The early poetic accounts of Priam's death are discussed at the beginning of §2.1 above.

[3] For the early poetic accounts of the death of Astyanax see §3.2 above. Morris (1995) suggests that the images (and legend) of Astyanax originated in or were stimulated by Near-Eastern representations of the practice of sacrificing children in times of crisis.

[4] Some would identify Astyanax among the scenes of murder on the Mykonos pithos. That several of the scenes on the pithos, however, follow a similar pattern suggests a generic type rather than a specific incident. See Ch. 11. The murder of Priam is sometimes identified on a relief pithos of the 7th c., Boston MFA 99.505, but the image is poorly preserved and the identification disputed; see M. E. Caskey (1976) 34–6. The murder of the seated figure depicted in the pedimental relief sculpture of the temple of Artemis on Kerkyra has also been identified as the murder of Priam (e.g. Wiencke (1954) 291–2), but again with uncertainty.

[5] Dugas (1960) 70–2 discusses the similarities and the relevant paintings in greater detail. For the iconography of Troilos see Kossatz-Deissmann (1981) nos. 206–388 and esp. nos. 359–66.

as if pleading for the return of his son or mourning his death. Since this combination of warrior, small child, and Priam is closely analogous to the combination of Neoptolemos, Astyanax, and Priam in scenes of the Ilioupersis, it appears that the painters have drawn upon the former as a model in the construction of the latter. The hurling of Troilos provided a pattern for the hurling of Astyanax, and the appearance of Priam and an altar of Apollo in scenes of Troilos' death translated into the image of Priam at the altar of Zeus Herkeios in representations of the death of Astyanax. The deaths of Priam and Astyanax were thus merged on the model of Priam and Troilos.[6]

Priam is generally more prominent in the composition than Astyanax (for example, Cat. nos. 4* and 16*). In the standard iconography Priam lies or sits motionless at the altar while Neoptolemos advances or attacks, generally from the left. The king is usually clothed in robes befitting an old man but is occasionally represented naked, perhaps an indication of his vulnerability before the young warrior (Cat. no. 11).[7] In some early black-figure depictions his body lies already dead across the altar (Cat. no. 4*), but this image of life expired soon recedes in favour of the intense moment of confrontation just prior to the king's death, as he looks up at his murderer or raises an arm toward him. By the third quarter of the sixth century Priam appears seated upright, receiving his attacker with a gesture of supplication, and this suspenseful depiction of the initial stages of the attack becomes the norm for succeeding painters. While the ageing king sometimes assumes a more animated pose of resistance, he is never equipped with weapons and never offers any threat to the young warrior.

Priam is frequently accompanied by two or three female figures, rarely explicitly identified, but presumably to be understood as members of his family, his wife, daughters, and daughters-in-law (Cat. nos. 4* and 5). They look upon the act in horror with arms raised to

[6] This is a simplified sketch of a complicated and poorly understood process. The precise steps towards the creation of the Priam-Astyanax combination cannot be unravelled. Although some form of influence from the Troilos iconography seems likely, it is uncertain whether the Priam-Astyanax combination represents a deliberate borrowing and reshaping of iconography or is simply the result of a fortuitous mistake. Dugas (1960) 71–2 takes the latter view and believes that the artists originally responsible for the Priam-Astyanax combination simply confused the Ilioupersis iconography with that of Troilos. Childs (1991) 35–6 argues instead that artists were aware of the similarities.

[7] Compare also the black-figure lekythos Syracuse 21894, *Para*. 201, Touchefeu (1981) no. 7, Wiencke (1954) fig. 4.

their heads, or they entreat Neoptolemos with extended arms to spare the king. In earlier depictions where Priam lies dead or horizontal across the altar, the female figures appear to deliver a lament over him. The image is thus at once a scene of murder and a scene of farewell to the corpse, the altar serving as a bier and the female figures as the mourners.[8]

The religious themes so prominent in the poetic tradition of the episode have not gone unnoticed among the artists. Without exception the scene is depicted at the altar of Zeus Herkeios.[9] Having sought the protection of the sanctuary, Priam extends an arm towards the chin of Neoptolemos, an appeal to the young warrior to respect his protected status as a suppliant upon a sacred spot. Several artists highlight the religious significance of the crime by drawing the viewer's attention to the altar. On two cups of Onesimos, for example, an inscription identifies the altar as belonging to Zeus. The altar on the earlier cup is labelled *ΔΙΟΣ HIEPO[N]*, 'the shrine of Zeus' (Cat. no. 15),[10] and that on the second carries the more specific inscription *HEPKEIΩ*, 'of [Zeus] Herkeios' (Cat. no. 16*).[11] Other artists have stressed the anomaly of human bloodshed at the altar by staining it with the blood of past animal sacrifices (Cat. nos. 12 and 23).[12] On a late black-figure amphora belonging to the Leagros Group it is the blood of Priam himself which stains the altar,[13] and the Kleophrades Painter juxtaposes bloodstains on the altar with blood pouring forth from the wounds of Priam and Astyanax (Cat. no. 23). The scene of murder is thus depicted as a distortion of customary religious rites. Since Priam himself is slain where we should instead expect animal sacrifice, his death may be termed a corrupted sacrifice.[14] In addition, the traces of blood sacrifice on the altar reflect with visual irony the familiar poetic lament over the city abandoned

[8] Wiencke (1954) 295 points out the theme of lament.

[9] A notable feature of the story already in its epic renderings, the altar would have been a particularly potent image in late Archaic and Classical Athens, where the altar of Zeus Herkeios still served as a focal point of the home; see Aristotle, *Ath. Pol.* 55.

[10] On the inscription see §13.5 n. 42.

[11] As Williams (1991) 51 explains, the symbol *Ω* represents the genitive singular ending.

[12] See Simon (1981) 105 on the Vivenzio Hydria: 'Die Blutspuren an dem Altar bezeugen, daß der Gott hier regelmäßig Opfer empfing. Aber Umsonst.' As Simon implies, the blood on the altar conveys a sense of divine abandonment; not even Priam's previous devotion to the gods can save him.

[13] London B 241, *ABV* 373.175, Wiencke (1954) fig. 16.

[14] I borrow the term 'corrupted sacrifice' from Zeitlin (1965).

by its gods: despite reverence shown to Zeus in the past, Priam is left to die at the very spot where he previously offered sacrifices to the god.

In the fifth century the Niobid Painter adds another religious element to the scene. On both a kalyx-krater now in Ferrara (Cat. no. 24) and a volute-krater in Bologna (Cat. no. 25), a young woman flees from the sacred precinct and carries with her two phialai, religious vessels commonly used in libations. Perhaps she is attempting to remove the religious instruments from the scene of pollution. Or perhaps her hurried departure, libation vessels still in hand, indicates that Neoptolemos' attack has interrupted a ceremony.

The child Astyanax usually appears small and naked. In one of the earliest known depictions of the scene, on a black-figure lekythos from Gela, Neoptolemos holds the child upside down by the foot directly over the corpse of Priam, while with his other hand he runs a sword through the child's body.[15] In most depictions, however, Neoptolemos holds Astyanax instead as he would a raised sword, above and behind his head, and he swings the child, still alive, like a weapon towards Priam and the altar. A sword sometimes appears at Neoptolemos' feet, as if the warrior has dropped the weapon and grasped the child instead (Cat. no. 16*). Through this gruesome substitution the artists complement the visual fusion of the two episodes with dramatic interaction. Instead of simply evoking the external Ilioupersis episode in which the child is hurled from the walls of Troy, the raised figure of Astyanax now plays an integral part in Priam's murder. Although he is much smaller than his grandfather, and sometimes hovers on the periphery of the painting, the artists frequently enhance the child's visibility by endowing him with a frontal face, an uncommon phenomenon in vase-painting as a whole, and a feature certain to earn prolonged attention from the spectator (Cat. nos. 15, 16*, 23, and 27*). With his gaze thus turned towards us, Astyanax appears to stare out of the figured plane, as if appealing for sympathy.

The juxtaposition of Priam and Astyanax expresses with double intensity traditional Ilioupersis themes found in the poetic accounts. In the deaths of Priam and Astyanax, Troy loses its ruling line, both the king of the city and the heir to the throne. As Poseidon states at *Iliad* 20. 293–308, the race of Priam, now hateful to Zeus, is fated to extermination, and the artists capture that theme of genocide

[15] Syracuse 21894, *c*.560 BC, *Para.* 201, Touchefeu (1984) no. 7, Wiencke (1954) fig. 4.

visually in the combination of grandfather and grandson, the oldest generation and the youngest destroyed together. A few painters include also an adult male warrior lying dead on the ground near the altar, thereby representing the death of three generations at once (Cat. nos. 15, 16*, and 23).[16] Another contribution to this theme is the invariable presence of the altar, anchoring the destruction of the family at the physical centre of the household.

The combination also delivers a defamatory indictment against the character of Neoptolemos. In this, by far the most popular image of Neoptolemos in Greek art, rather than heroize him as the warrior who led the Achaians to victory over Eurypylos, the artists have chosen instead to immortalize him as a bloodthirsty murderer. The simultaneous slaughter of an old man and a child, two defenceless victims, reveals an unrivalled capacity for brutality. At the same time, the transfer of Astyanax to the altar scene amplifies the tones of religious condemnation already distinct in the Priam scene by itself. As the painters attach the murder of the child, elsewhere unconnected with altars or sanctuaries, to the sacrilegious murder of the old king, Neoptolemos appears to commit two acts of desecration at once.

This image of an altar defiled, the climax of Neoptolemos' activity at the Ilioupersis, carries within it faint memories of two other episodes, one in the past and one in the future, both connected by narrative ties with the present moment and sharing its fascination with religious transgression. As discussed above, the Priam-Astyanax combination displays similarities with the iconography of Troilos' murder, and representations of the latter episode are thought to have facilitated the development of the former. While explicable simply in terms of mechanical, visual patterning, the correlation between the model and its issue also points towards the unusually close relationship shared by father and son in the poetic tradition. Epic bards developed an extensive series of narrative parallels between Neoptolemos and Achilles, and the artists appear to have followed suit.[17] While the Neoptolemos of the *Mikra Ilias* inherits his father's arms and with them engages in battles which mimic those of his father, the Neoptolemos of the vase-painters inherits his father's iconography, violating the sanctuary of Zeus as his father had violated the sanctuary of Apollo.

[16] Williams (1991) 51 observes that Onesimos (Cat. no. 16*) represents the death of three generations at once. See also Childs (1991) 35–6.

[17] The narrative relationship between Neoptolemos and Achilles in the poetic tradition is discussed above in §2.2.

Sacrilege follows sacrilege in successive generations. That the artist who first shaped the Astyanax scene was conscious of its significant resemblance to the Achilles scene cannot be proved or disproved, and it is possible that the image may have arisen simply by chance, or even through misinterpretation of the iconography of Achilles. But the early artists and their public, immersed in the traditions of Troy and familiar with the network of associations woven by the poets, would naturally have perceived significance in this visual correlation, and the original popularity of the Priam-Astyanax combination may be due in part to its powerful reminiscence of the father's parallel sacrilege.

The other episode evoked by the image of Neoptolemos' crime, though not equally in all representations, is the hero's death at Delphi, the divine retribution that answers his act of sacrilege.[18] On an early red-figure cup attributed to Oltos, a palm tree appears immediately to the left of the altar where Priam has taken refuge (Cat. no. 11), and although rare in depictions of Priam's death, the tree appears also on the Vivenzio Hydria of the Kleophrades Painter, here again to the left of the altar as Neoptolemos attacks from the right (Cat. no. 23).[19] The palm tree, commonly associated with the worship of Apollo, might suggest to the viewer that the murder is located at an altar of this god, one of Troy's most loyal patron deities. Since this interpretation, however, is adamantly opposed by the canonical literary and pictorial tradition which identifies the altar as that of Zeus Herkeios, instead of actually designating the location of the murder, the tree must be intended rather to remind the viewer of Apollo and his altar. Like the pose of Neoptolemos, it may have been borrowed from the iconography of the death of Troilos, where it frequently appears in conjunction with the god's altar at Thymbra.[20] But while

[18] For the poetic evidence of Neoptolemos' death in Delphi see §5.1 above.

[19] Sourvinou-Inwood (1991) 100–1 suggests instead that the tree on the Vivenzio Hydria belongs to the Kassandra scene and that its appearance here is motivated by her association with Apollo.

[20] Wiencke (1954) 303, in discussing the Vivenzio Hydria, notes the borrowing but does not detect allusion and instead interprets the tree as a symbol of nature's lamentation. For the palm tree in scenes of Troilos' death see a black-figure lekythos, Kopenhagen Nat. Mus. Chr. VIII 383, 500–490 BC, Kossatz-Deissmann (1981) no. 361; a red-figure cup by Makron, Palermo, *c.*490 BC, *ARV* 480.2, Kossatz-Deissmann (1981) no. 368; and a red-figure cup by Onesimos, Perugia 89, *ARV* 320.8, *Para.* 359, Kossatz-Deissmann (1981) no. 370 and Boardman (1975) fig. 232 (two palm trees, one next to the altar). Cf. also Kossatz-Deissmann (1981) no. 376, shield-bands from the late 7th c., with Achilles, Troilos, the altar, and a laurel tree.

reflecting that previous act of sacrilege, the tree will also trigger anticipation of the retribution awaiting Neoptolemos at Apollo's altar in Delphi. The magnificent Ilioupersis cup of the Brygos Painter (Cat. no. 19*), roughly contemporary with the Kleophrades Painter's hydria, includes an analogous device conveying the same message, an enormous tripod rising ominously behind the altar of Zeus Herkeios. The palm tree and the tripod, neither of which belongs at this location or at this temporal point in the story of Neoptolemos, stand out as imported symbols of Apollo, and as such they complement the present scene of confrontation between the hero and his Trojan victims with a warning allusion to the future encounter between the hero and the god.[21]

12.2 Kassandra

Black- and red-figure depictions of Aias' attack upon Kassandra correspond closely to the known poetic accounts, according to which Aias attacks Kassandra within the sanctuary of Athena and pulls her away from the statue of the goddess.[22] The composition traditionally consists of three principal figures: Aias, Kassandra, and the image of Athena (for example, Cat. nos. 4*, 6, 7, 16*, and 23). In the centre is Kassandra, usually naked or only partially clothed, running towards or crouching before the statue of Athena, which stands to one side, usually the right. Aias advances from the opposite side with his sword drawn and held at waist height, while with his other hand he grasps Kassandra's hair, arm, or cloak in an attempt to wrest her from the statue. Spectators occasionally appear to either side.[23]

One of the two most prominent themes of the composition is sacrilege. Like her father Priam, Kassandra has taken refuge at the sanctuary of a divinity, and like Priam, she occasionally extends her

[21] Cf. the raven sometimes found in depictions of Troilos' murder at the fountain, explained by Carpenter (1991) 18 as a sign of Achilles' own eventual death at the hands of Apollo.

[22] For the iconography of Kassandra see Davreux (1942), Touchefeu (1981), and most recently Connelly (1993). A concise summary of the development of the Kassandra tradition in black- and red-figure vase-painting is given by Beazley in Caskey and Beazley (1963) 64–5. The poetic accounts of the episode are discussed above in §3.1.

[23] This pattern may have been derived from an earlier, non-Attic tradition. It is found on a bronze shield-band of the early 6th c., Olympia B 1801, Touchefeu (1981) no. 48. Surviving examples, however, trace the history of the iconography no earlier.

arm towards her attacker in a gesture of supplication, as her father extends his arm toward Neoptolemos. Aias ignores her plea despite the sanctity of the location, thereby committing an act of sacrilege. A second major peculiarity of the composition is the sexual nature of the attack, indicated by Kassandra's striking state of whole or partial nudity in most black- and red-figure depictions. The consistently repeated exposure of her body stands out as a clear violation of the norms of contemporary Greek art, according to which no women except hetairai regularly appear completely nude. The artists remember Kassandra as the victim of attempted rape and symbolize Aias' intent visually by means of nudity.[24]

Over the course of the sixth and fifth centuries the figures of Kassandra and Athena undergo several changes, while that of Aias remains relatively constant. In earlier depictions Kassandra is dwarfed by the warrior and the statue. She crouches beneath them with bent knees and is sometimes barely half their height. Occasionally the artists compress Kassandra's flight to the statue and her supplication there into a single scene by depicting her in the *Knielauf* position, her bent knees indicating rapid motion (Cat. no. 6). On red-figure vases the small, child-like Kassandra of the black-figure tradition is transformed into a young woman.[25] On the Vivenzio Hydria of the Kleophrades Painter, for example, although she still crouches beside the statue and therefore still appears small in relation to the other figures, her body is painted with greater weight than in earlier depictions and her stature is in fact proportional to that of the statue and of her attacker (Cat. no. 23). Later in the fifth century she sometimes stands beside the statue, level with her attacker (Cat. no. 25).

Black-figure artists cast the statue in the pose of Athena *promachos*, striding forward in profile, one hand holding a spear raised for combat, the other supporting a large round shield often turned to the viewer to reveal the decoration on its face (Cat. no. 6). The much smaller figure of Kassandra appears beneath the shield, her head sometimes hidden behind it, as if the statue represented the goddess herself, shielding Kassandra from her attacker. In fact, the figures of Aias and Athena, balanced on either side of the tiny Kassandra, each with weapon poised, appear to confront one another as if engaged

[24] On the nudity of Kassandra see Beazley in Caskey and Beazley (1963) 64 and Touchefeu (1981) 351. Cf. 5th-c. representations of centaurs abducting Lapith women, whose clothing is torn in the struggle.

[25] See Touchefeu (1981) 350 on this transformation.

in battle. This combative arrangement highlights the sacrilegious nature of Aias' crime: he not only attacks Kassandra, but dares also to attack the holy image of Athena. The goddess's anger is visible in the pose of her statue, and although she does not physically interfere at the present moment, the martial stance of the *promachos* hints at the retribution which Athena will later exact from her enemy.[26] Like the presence of the tripod or the palm tree in scenes of Priam's murder, here the statue itself anticipates the divine vengeance to follow.[27]

As the figure of Kassandra grows in size and importance, the statue of Athena gradually sheds its illusion of action and begins to appear more like an inanimate object.[28] Late black-figure and early red-figure artists raise it onto a base or pedestal (Cat. nos. 7, 8, 16*, and 23), and as the fifth century progresses the profile is replaced by a frontal representation. The lifeless statue grows increasingly detached from the surrounding human figures, the suggestion of a confrontation between Aias and the goddess disappears, and the void is filled only with a growing sense of abandonment. The motionless pose of the statue, leaving the now-prominent figure of Kassandra utterly defenceless against her attacker, reminds us that not even the sanctuaries of the gods will deliver the Trojans from the Greeks—a sentiment felt also in scenes of Priam's murder. A few late fifth-century artists reintroduce the goddess as an independent figure appearing beside her statue (Cat. nos. 30 and 31). In one such painting she extends an arm towards the conflict, but pity for the mortal Kassandra is not necessarily to be read in the gesture. Rather, like the indignant Athena in the prologue of Euripides' *Troades*, the goddess perceives the transgression as a personal offence against herself. Her gesture indicates awareness of the violation and, like the stance of the *promachos* in earlier depictions, points to the consequent punishment that she will inflict upon Aias.[29]

Unfortunately not imitated in any surviving vase-paintings, one

[26] The composition has led some scholars, e.g. Touchefeu (1981) 339, to believe that the figure of Athena represents not the statue, but the goddess herself. But the literary tradition and the red-figure depictions argue otherwise. Beazley in Caskey and Beazley (1963) 64 states unequivocally that 'the figure of Athena always depicts a statue'.

[27] See §5.1 for the poetic tradition of Aias' nostos. Compare Alkaios, fr. S262, where the crime and its punishment are narrated together in rapid succession.

[28] Cf. Connelly (1993) 114–16 on the transformation of the statue.

[29] The inclusion of the goddess in these paintings may have been motivated by her appearance in Sophokles' *Aias Lokros*.

of the most striking representations of this sacrilege was that in-
cluded by Polygnotos in his Ilioupersis painting at Delphi. According
to Pausanias, who describes the entire painting in detail, Polygnotos
chose to depict not the attack itself, but its aftermath (10. 26. 3).[30] A
group of Greek chieftains angered by Aias' crime has gathered to pun-
ish him, and he now ironically takes refuge at the altar of Athena.
Sitting on the ground nearby, Kassandra still clutches the statue,
which has been overturned in the struggle.[31] Although the moment
of attack has passed, the toppled statue, the sacred image of the god-
dess desecrated, preserves a powerful reminder of the crime. The
concern of the Greek warriors, of course, lies not with the maiden,
but with the offended deity and her offender, whose sacrilege has
reserved for him and many of his colleagues a sandy grave at the
floor of the Aegean.

12.3 Helen

Helen and Menelaos appear together in two popular black-figure
Ilioupersis scenes.[32] The first of these appears in the second quarter of
the sixth century and follows the tradition first witnessed a century
earlier on the Mykonos pithos, where the reunion of Menelaos and
Helen offers an ambiguous contrast to the many images of slaugh-
ter and enslavement (Cat. no. 2*).[33] As on the Mykonos pithos, hus-
band and wife face one another again in the sixth-century tradition
(for example, Cat. no. 5). Often grasping Helen by her himation with
one hand, Menelaos raises his sword in the other, while Helen holds
aside the himation to reveal her face beneath. The gestures anticip-
ate Menelaos' change of heart as recorded in the poetic tradition,
the transition from anger to desire effected by Helen's beauty.[34] One

[30] This work will be considered in greater detail at §14.1. The painting is dated
roughly to the mid-5th c. BC. Cf. also Polygnotos' painting of the same event in the
Stoa Poikile in Athens, Pausanias, 1. 15. 2.

[31] The displacement of the statue is recorded at *IP* arg. 16 (συνεφέλκεται τὸ τῆς
Ἀθηνᾶς ξόανον).

[32] The most complete surveys of the iconography of Helen are those of L. Kahil.
The first appeared as a monograph in 1955 and the second as an article in *LIMC*
vol. iv (1988). For the iconography of Helen's reunion with Menelaos see Kahil (1988)
537–52.

[33] The image was also depicted on the chest of Kypselos (*c.*550 BC), according
to Pausanias, 5. 18. 3. For black-figure examples see Kahil (1988) section IX.B,
nos. 210–24. [34] The poetic evidence for this tradition is discussed §8.5 above.

black-figure artist has developed the theme further by exposing also a portion of Helen's upper body within the folds of her clothing.[35] As in the early poetic tradition, it is not merely Helen's face, but her naked body (τᾶς Ἑλένας τὰ μᾶλα πᾳ γυνμᾶς—Aristophanes, *Lysistrata* 155) which will produce the sudden change of emotions within Menelaos.

A second group of black-figure paintings recalls the narration of events found in Proklos' summary of the *Iliou Persis*: 'Menelaos finds Helen and takes her to the ships after having slain Deiphobos' (*IP* arg. 14–15). In the corresponding visual tradition, which may more properly be categorized as recovery than reunion, Menelaos grasps Helen with one hand and marches her forward.[36] Although the scene lacks the dramatic immediacy of their initial confrontation, the artists continue to exploit the emotional interaction between husband and wife. While leading Helen forward, Menelaos regularly turns his head back to look upon her, and as in the scenes of reunion, he often points his drawn sword menacingly in the direction of his wife, an indication that the estranged couple have not yet been fully reconciled. Helen's pose also recalls the reunion scene, one hand holding back her himation to display her beauty to her angered husband. In fact, the combination of these gestures and the couple's forward movement conveys to the viewer both stages of the narrative together, reunion and recovery compressed into one scene.[37]

The black-figure recovery iconography is adopted in a few early red-figure paintings but soon disappears from the repertoire (Cat. no. 11). The reunion, in contrast, remains popular throughout the fifth century and attracts several additions and variations. Menelaos' dropped sword, a powerful feature of the poetic tradition, first appears in the iconography on a cup painted by Onesimos and dated to approximately 490 BC (Cat. no. 16*). Helen lowers herself before her husband with hands outstretched in a plea of mercy. Menelaos,

[35] Athens National Museum 20813, Kahil (1988) no. 211.

[36] See Kahil (1988) sections 1–3 of IX.C and sections 1–2 of IX.D for several dozen examples.

[37] There remains uncertainty in the identification of some scenes in this group. Only a few examples, one of which is a red-figure plate of Oltos (Odessa, Mus. O.577, *ARV* 67.137, Kahil (1988) no. 310), carry inscriptions identifying Helen and Menelaos. The close similarities to the reunion iconography support the identification of most other examples. A few examples listed in Kahil's category D, however, where the warrior does not hold his sword unsheathed, closely resemble a pattern employed for Polyxene and might represent her instead of Helen.

still advancing upon Helen but already overcome by her beauty, has dropped his weapon, and it is now falling to the ground below. Instead of hinting at the future change of heart as did the black-figure artists, Onesimos has chosen to depict the very moment of transition, anger yielding to desire as the sword falls from the warrior's grasp. The motif is repeated throughout the century.[38]

Two other popular red-figure additions first witnessed on the Onesimos cup are Aphrodite, standing directly behind Helen, and Eros, the small winged boy hovering between Helen and Menelaos. Like the sword, these innovations too may have been influenced by a poetic tradition, perhaps the poetry of Ibykos, who locates the scene within the temple of Aphrodite (fr. 296). Although Aphrodite and Eros do not intercede physically in the confrontation between husband and wife, as divine embodiments of beauty and desire they provide Helen with at least symbolic assistance. And their presence suggests further that in addition to Helen's human charms, supernatural forces have a hand in securing a peaceful reunion.

As in the black-figure tradition, Helen frequently lifts part of her clothing from her face to reveal herself to Menelaos. A few painters underline the power of Helen's physical beauty with a new method not available to their black-figure predecessors. With a thin line of fine glaze Onesimos reveals the profile of Helen's lower body beneath her clothing, as if it were transparent (Cat. no. 16*),[39] and following Onesimos' lead, Makron exposes to the attacker a full frontal view of Helen's body beneath a similarly diaphanous garment (Cat. no. 18*). With this subtly suggestive outlining technique the artists represent not what is actually visible to the unaided eye, but what Menelaos perceives as he looks upon his wife, the physical object that converts his murderous rage into sexual desire.

While Helen and Menelaos appear to be stationary in the earlier representations, several red-figure artists animate the scene by putting the characters in motion. On his Boston skyphos Makron paints Helen in the process of turning away from Menelaos, her right foot already pointed away from her husband and the heel of the other foot lifted from the ground as she begins to flee (Cat. no. 18*). The position of Menelaos' right foot, heel lifted, indicates that he too is in motion.[40]

[38] For the dropped sword see Kahil (1988) nos. 260–77 and p. 559.

[39] For further discussion of the use of this technique on Onesimos' cup see §13.5.

[40] Cf. the similar arrangement of the feet of Helen and Menelaos on another cup painted by Makron, Cat. no. 17.

In other paintings the motion is more advanced, and the reunion is transformed into a scene of flight and pursuit, in which Menelaos, his sword already cast aside, chases Helen with outstretched arms. In place of his sword, Menelaos is sometimes equipped with two long spears, weapons borrowed from the Athenian ephebe featured in contemporary representations of youthful erotic chase.[41]

Helen's flight occasionally takes the scene into a temple or sanctuary, sometimes that of Aphrodite, in agreement with Ibykos' account of the reunion. More commonly the temple belongs to Apollo, as is indicated by a small statue of the god, bow in hand, and/or by the figure of the god himself (Cat. no. 24). In the latter half of the fifth century Helen's sanctuary scene is repeatedly influenced by the traditional iconography of Kassandra, who similarly took refuge within a temple. One depiction has Helen in the process of losing her clothing as she approaches the altar.[42] In place of the deliberate exposure of her body or the suggestive glimpses through her clothing observed earlier, here we see Helen's nudity assimilated to that of Kassandra, traditionally represented either naked or partially exposed. On occasion Helen is found at the statue of Athena, another apparent borrowing from the iconography of the Trojan princess.[43] One perplexing vase shows a woman clinging to the statue of Apollo, just as Kassandra clings to the statue of Athena, while a warrior pulls his victim away from the statue by the hair.[44] Is this Kassandra, priestess of Apollo, here taking refuge at his altar instead of Athena's? Or is this Helen and Menelaos in the temple of Apollo, assuming the poses of Kassandra and Aias? While we might be tempted to judge such mixing of iconography to be the result of ignorance or accidental confusion on the part of the artist, the interaction between these two very well-known sets of iconography appears to be less accident than deliberate experimentation. Not bound always to follow the standard version of a myth, the artists decided to enliven the story of Helen with details of

[41] On scenes of erotic pursuit see Sourvinou-Inwood (1991) 58–98.

[42] Red-figure bell-krater, Toledo Mus. of Art 67.154, *c.*440–430 BC, Kahil (1988) no. 274; Helen's right side is exposed from shoulder to foot. Compare this with the death of Kassandra on side A of a cup by the Marlay Painter (Cat. no. 32*), discussed in §14.2 below. Here Kassandra is similarly exposed, not fully, but along her right side from shoulder to foot.

[43] Red-figure oinochoe, Vat. 16535 (H525), *ARV* 1173, *Para.* 460, Heimarmene Painter, Kahil (1988) no. 272 *bis*.

[44] Red-figure neck-amphora, London BM E336, *ARV* 1010.4, *BA* 153, the Dwarf Painter, *c.*440 BC, Kahil (1988) no. 358.

Kassandra's iconography, thereby assimilating the fates of the two women visually. As in Euripides' *Troades*, where Helen exits with the threat of execution still hanging over her head, these paintings once again postpone the expected reconciliation.

12.4 Other Ilioupersis Subjects

In addition to this core of the three most popular episodes, the moving image of the dutiful Aineias carrying his ageing father out of Troy, perhaps inspired by early epic poetry, joins the repertoire of the Athenian painters in the late sixth century.[45] While it enjoyed its greatest popularity among black-figure artists, it is also found on several red-figure vases of the fifth century. Anchises is pictured hoisted onto his son's back or held at his side in a crouched and awkward position. The unusual composition of one man carried by another clearly posed difficulty for the painters, who rarely achieved an altogether convincing image of father and son. Aineias sometimes leans his upper body forward to accommodate his father, while providing further support with one or both arms. He is dressed as a warrior, wearing helmet and greaves, and sometimes carries a shield, enhancing his characterization as protector. A staff often held in the hands of Anchises implies that his lame, ageing body would be unable to make the journey without his son's assistance.[46] While Aineias advances, his gaze fixed before him, Anchises often turns his head back towards the opposite direction—perhaps a nervous glance to the rear, or more likely, an emotional, departing look upon his former home.[47]

[45] For the iconography of Aineias see Canciani (1981). The early poetic accounts of Aineias' escape are discussed in Ch. 4 above. For the image of Aineias carrying Anchises cf. Sophokles, *Laokoon* fr. 373.

[46] According to the poets, Anchises' physical disability was not merely an infirmity of old age, but divine punishment sent via thunderbolt from Zeus for divulging the secret of his union with Aphrodite. The tradition is alluded to already at lines 281–90 of the *Homeric Hymn to Aphrodite* and in Sophokles' *Laokoon* fr. 373 (Radt).

[47] Canciani (1981) 395 suggests that Anchises looks back to guard against attack from the rear. The iconography does not indicate at precisely what time Aineias left Troy—whether the artists conceived of the episode as occurring before the attack, in agreement with the epic *Iliou Persis*, or whether they followed an alternative tradition, placing the event during the night battle. Since Aineias and his occasional male companions, though armed, do not engage in fighting, either time is possibile. The juxtapositions of the Aineias scene with other episodes of the attack, to be discussed below, cannot be interpreted as evidence of narrative simultaneity, since the conventions of

Father and son are often accompanied by other members of the household, generally by Aineias' wife or son, sometimes both.[48]

Other Ilioupersis figures occasionally represented in Attic vase-paintings include Antenor and his wife Theano, Aithra and her grandsons, and Polyxene. Since these characters are less common, they will not be treated here, but as they become relevant in the discussions below. One surprising absence should also be addressed. Despite its earlier popularity and its occasional appearance in monumental works of the fifth century, the wooden horse enjoys no enduring tradition of its own in Attic vase-painting.[49] In a medium which adopted the human body as its primary standard of proportion, and in which large, architectural objects were generally excluded or represented only in synecdoche, there was little room for the monumental and unwieldy horse of Troy. It does appear once on a fragment dated to the mid-sixth century, which shows the Greeks descending from the statue.[50] In the early fifth century a few red-figure vases feature Athena together with a statue of a horse, perhaps a model of the wooden horse of Troy.[51] And two fragments from the end of the fifth century feature warriors emerging from a hatch in the horse's back.[52] These three groups, however, while interesting in themselves, provide little evidence for a coherent tradition, and in none of the surviving representations is the horse juxtaposed with other Ilioupersis scenes.

visual narrative allowed scenes chronologically distant from one another to be set side by side, and even permitted various temporal stages of a narrative to be denoted simultaneously within a single scene.

[48] Attempts to identify Aphrodite among Aineias' retinue have been hindered by a lack of inscriptions.

[49] For the known representations of the horse see Sadurska (1986) and Sparkes (1971).

[50] Black-figure vase fragment, Berlin Staatl. Mus. F1723, *ABV* 314, *Para.* 136, 560–550 BC, Sadurska (1986) no. 18. Only one leg of the horse survives, and the entire statue may not have been included in the painting. The artist's attention appears focused on the warriors and their physical exertion as they descend, rather than on the horse itself. Contrast this with the roughly contemporary depiction on the Korinthian aryballos, Sadurska (1986) no. 17.

[51] Red-figure cup, Munich Antikensammlung 2650 (J.400), *ARV* 401.2, *c.*490 BC, Sadurska (1986) no. 1; and red-figure cup, Florence Mus. Arch. V57, *ARV* 838.30, Sabouroff Painter, *Para.* 423, Sadurska (1986) no. 2. Cf. also the red-figure oinochoe Berlin 2415, *ARV* 776.1 and 1669, *Para.* 416, *BA* 288; Athena models a horse in clay.

[52] Red-figure krater fr., Heidelberg Univ., Sadurska (1986) no. 19; and red-figure kalyx-krater fragment, Würzburg Wagner Mus. H4695, Sadurska (1986) no. 20.

13

Ilioupersis Combinations in Attic Vase-Painting

13.1 A Survey of Examples

While the great majority of black- and red-figure Ilioupersis repres-
entations are not found in combination with other Ilioupersis scenes,
examples survive in sufficient numbers to indicate that combination
was practised with relative frequency. In the following pages I sur-
vey the known examples, and although the small pool of data makes
the search for trends and development precarious, I attempt some
categorization of the vases in terms of date, shape, and manner of
combination.

The first Attic painter whose experiments in this area survive is
Lydos. On a fragmentary amphora belonging to the earlier part of
his career, he has painted the rape of Kassandra and the murders of
Priam and Astyanax side by side within the same panel (Cat. no. 4*).
On a slightly later amphora, Lydos again joined two Ilioupersis scenes
within a single panel, this time pairing the murders of Priam and
Astyanax with the recovery of Helen (Cat. no. 5). In both cases the
two scenes are placed side by side with no visual barrier separating
them, but each remains a distinct, individual dramatic unit, and the
combination has motivated no apparent deviations from the stand-
ard iconographies found elsewhere. The Priam and Astyanax scene
is placed to the right on both vases and with its larger cast of char-
acters slightly outweighs its neighbour to the left. The existence of
two related examples by the same artist, each displaying the same phe-
nomenon but with variation in the choice of scenes, suggests that
Lydos may have experimented with Ilioupersis composites repeatedly
during the course of his career. These two vases may have belonged
to an early wave of interest in visual combinations, as demonstrated
most spectacularly by the François Vase, with its alternative method
of combining semirelated mythological episodes. Apart from the two
amphorae, however, further contemporary evidence for the treatment
of Ilioupersis scenes in combination is lacking.

When next we see black-figure Ilioupersis combination, the manner of combination has changed: the episodes are no longer placed side by side within the same panel. Although Lydos had found in the single amphora panel a space suitable to the juxtaposition of scenes, other artists may have avoided the practice because of the unusual visual balance it produces. Whereas painters typically decorate the large panels of amphorae and related shapes with a single event, which often allows them to order figures symmetrically about the centre, the combination of two scenes within this space necessitates a bipartite arrangement lacking a single, central focal point. The popularity of back-to-back Ilioupersis scenes was limited by this aesthetic constraint, and rather than risk sacrificing traditional compositional symmetry as Lydos had done, subsequent black-figure painters began instead to place Ilioupersis scenes on opposing panels.[1]

A black-figure column-krater produced in the third quarter of the sixth century features Aias attacking Kassandra on one side, while on the opposite side Helen is reunited with Menelaos (Cat. no. 6). Each panel is an exercise in bilateral symmetry. Kassandra, planted at the centre of her scene, is flanked by the opposed pair of Athena and Aias, and beyond this nucleus of three a pair of spectators standing to the left balances two spectators to the right. Likewise, Helen stands at the centre of her scene and is surrounded by two armed men, Menelaos to her right and an unidentified warrior to her left. At either end of the panel stands a spectator, and although the artist has differentiated them in terms of age, these lateral figures are near-reflections of each other.

The same manner of combination is found on a neck-amphora dated to *c.*520 BC, which features the murder of Priam on one side and the attack upon Kassandra on the other (Cat. no. 7). But here while carefully maintaining bilateral balance within each composition, the artist has also deliberately balanced the two compositions against each other. Both consist of three figures, with the victim sandwiched between the other two. The statue of Athena stands to

[1] Note that Lydos himself avoids the loss of bilateral symmetry by subordinating one scene to the other. On his Paris amphora (Cat. no. 4*) he places Neoptolemos at the geometric centre of the composition; the scene to the left of Neoptolemos (Aias, Kassandra, and the statue) is balanced by the remaining figures in Neoptolemos' scene (Priam and the two female figures). Similarly, on his Berlin amphora (Cat. no. 5) Neoptolemos and Priam form the centre of the composition, and the two female figures in this death-scene balance the figures of Menelaos and Helen to the left.

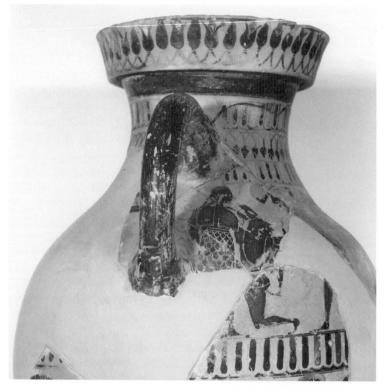

3(*a*) Attic black-figure amphora, Lydos, Cat. no. 4. Aias attacks
Kassandra. (Courtesy, Musée du Louvre.)

the right of Kassandra, and its visual analogue on the opposite side
is the female figure standing to the right of Priam, probably Hekabe
or one of Priam's daughters. The large base upon which Athena's
statue stands, though witnessed elsewhere, is not a common feature
of the iconography and may have been included here to complement
the altar of Zeus opposite. Aias attacks from the left, his sword held
at his right side and his left arm stretched out to hold Kassandra, and
Neoptolemos attacks Priam from the same direction with the very
same pose. Astyanax, traditionally shown in conjunction with Priam,
has been omitted, as his inclusion would upset the one-to-one corre-
spondence. In fact, only one major difference distinguishes the two
warriors: Aias wears a cloak draped over his right shoulder and left
arm, and Neoptolemos does not. The artist, evidently fond of visual

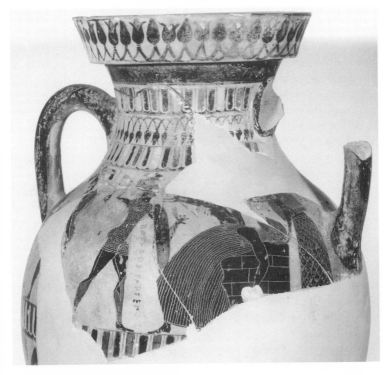

3(*b*) Neoptolemos murders Priam. (Courtesy, Musée du Louvre.)

harmony, perhaps added this single inconsistency to the figure of
Aias to counterbalance the aegis carried by Athena's statue.

A final method of black-figure Ilioupersis combination is preserved
on a hydria of the Priam Painter, one of a circle of artists known as the
Leagros Group, active at the end of the sixth century and renowned
for their iconographic innovations (Cat. no. 8*—Fig. 4).[2] Because of
its unusual nature, this example requires a relatively detailed discus-
sion, in order to justify its classification as an Ilioupersis combination.
The Priam Painter has depicted Aias attempting to wrest Kassandra
from the statue of Athena in the presence of five spectators. In other
representations of the assault on Kassandra, the spectators, if pres-
ent, are usually selected from generic categories—women, youths, or

[2] See Schauenburg (1964) for another discussion of the iconography.

warriors—but the spectators in this painting all appear to be identi-
fiable figures of the Ilioupersis tradition. To the left stands a warrior
carrying an old man on his shoulders, an image which can only rep-
resent Aineias and Anchises. Counterbalancing this pair, a group of
three figures watches from the other side: a boy sitting on the should-
ers of a woman, and behind them an old man. Inscriptions are lacking,
but given the context of the Ilioupersis, these three are probably in-
tended to represent Astyanax, his mother Andromache, and his grand-
father Priam.[3]

Instead of simply juxtaposing episodes, as the previously observed
artists have done, the Priam Painter has complemented the repres-
entation of a single episode with characters usually found in separ-
ate episodes. The image of Aineias and Anchises, son carrying father,
recalls their escape from Troy, but here they are not actually in the
process of departing.[4] Likewise, Priam and Astyanax, better known
in Ilioupersis representations as victims of Neoptolemos, are not under
attack in this painting. The artist has extracted these characters from
their more familiar environments and introduced them as passive spec-
tators into the Kassandra scene, where as relatives of the victim they
contribute a new dimension of pathos. The elevation of Anchises and
Astyanax, probably motivated by the need for mobility in a time of
crisis, also puts them in positions ideal for viewing the crime, just
as parents today sometimes lift children onto their shoulders to give
them a better view. Although Aineias too witnesses the crime, we
need not chastize him for failing to intervene on behalf of his cousin,
because the scene is not intended as a literal representation of dramatic
reality. The imported figures are confined to the sidelines, and while
Anchises may extend an arm in a gesture of sorrow, they cannot actu-
ally cross the narrative gap separating them from the present action.
Rather than assistance, they offer pity, and their helpless glances to-
wards the crime anticipate a similar emotional response from the
vase's external viewers.

At the same time, these imported elements retain inevitable links
with their traditional habitats and thereby function as allusions to

[3] Identification of the child and woman instead as a son and wife of Aineias
would be problematic, since this would leave the old man behind them out of place.
Schauenburg (1964) 61 also notes this possibility but prefers to identify them as
Andromache and Astyanax.

[4] This representation of Anchises on Aineias' shoulders differs from the more famil-
iar pattern which places Anchises on his son's back.

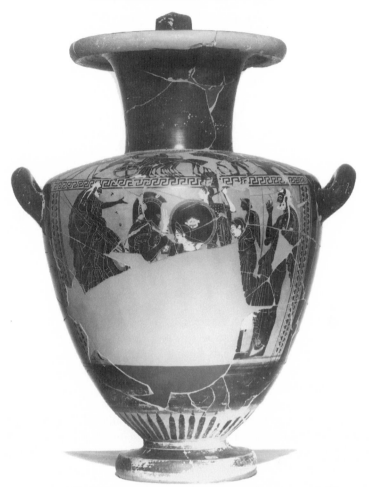

4. Attic black-figure hydria, the Priam Painter, Cat. no. 8. Aias attacks
Kassandra, various Trojans. (Courtesy, Monumenti Musei e Gallerie
Pontificie.)

those external events. It is difficult to view Priam and Astyanax in
this context without anticipating their imminent deaths, regularly
combined by the painters into a single scene. Although they appear
here as passive spectators, the viewer knows that they will soon join
Kassandra in her suffering. Aineias and Anchises, on the other hand,

can look forward instead to escape and survival. While the image of father and son is deliberately mirrored in the image of Astyanax mounted on his mother's shoulders, the fates of the two parties diverge, and their physical separation in the two wings of the painting reflects the contrast between the predicted continuation of Anchises' lineage and the extermination of the Priamids.

Although this was not the first time that an artist had surrounded Kassandra and Aias with specific spectators, a glance at one of the Priam Painter's predecessors quickly distinguishes the startling degree of innovation practised by the later artist. On a Group E amphora dated to the middle of the sixth century, Polyxene and a young boy labelled Antilochos exit to the left of Aias and Kassandra, and a young Trojan warrior named Skamandrophilos leaves the scene at the right.[5] Despite obvious similarities with the Priam Painter's vase, this cast does not truly represent or imply a combination of episodes. Two of the three flanking characters are extemporaneous creations, not recognizable actors drawn from related episodes, and although Polyxene does carry an independent story of her own, there is little stimulus here to direct the viewer's thoughts towards her sacrifice. The poses of departure suggest that the three figures are present at the scene of attack, not suspended at a fantastic vantage-point on the sidelines, and no complex thematic interaction binds the central drama and the wings. While the painting on the amphora remains primarily a representation of Aias' assault on Kassandra, the Priam Painter's work demands to be read instead as an Ilioupersis.[6]

In the last few decades of the sixth century, as black-figure painting declines in popularity, a new tradition of Ilioupersis combination arises in conjunction with the introduction of the red-figure technique

[5] Black-figure amphora, Berlin F1698, *ABV* 136.54, *BA* 37, *c.*550 BC, Touchefeu (1981) no. 18.

[6] The *mélange* of elements on this vase may be compared with another painting executed by the same artist on a black-figure hydria (Cat. no. 9). The composition appears to be a conglomeration of elements from various episodes of the Trojan war. The scene on the body is interpreted as either the murder of Troilos by Achilles or the murder of Astyanax by Neoptolemos. Above this scene, on the shoulder of the vase, the artist has painted the wall of Troy, and among the figures here a warrior raises a drinking-horn—perhaps a Trojan celebrating the supposed departure of the Greeks on the eve of the sack, or a Greek celebrating the capture of the city. Childs (1991) 35–6, who identifies the scene below as the death of Troilos, draws attention to a tradition that made the child's death a necessary prerequisite for the Ilioupersis and proposes that the composition as a whole be understood as 'a complex amalgam of events that led up to the destruction of Troy'.

and particularly with the growth of the cup-painting industry. I have collected nearly twenty red-figure examples spanning the late Archaic and early Classical periods (Cat. nos. 11, 12, 13, 14, 15, 16*, 17, 19*, 20, 21, 22*, 23, 24, 25, 26, 27*, 28, 29, and 30). Although still small in comparison with the total number of representations of individual Ilioupersis scenes, the number of combinations now far exceeds the preceding black-figure examples. Their more regular distribution from the late sixth century to the second quarter of the fifth century suggests a continuous, sustained interest in the practice. While the combination of Ilioupersis scenes remained a specialized manner of decoration, it nevertheless occurred repeatedly and with relative regularity.

The red-figure cup-painters employed two regular methods of combination, each well suited to the geometry of their vases. Like Lydos, the cup-painters again juxtapose scenes side by side, but without seriously risking a compromise in compositional balance. The long, narrow panels on the two exterior sides of the kylix provide ample space for the juxtaposition of two scenes without crowding, and on the earliest surviving example Oltos fits three Ilioupersis scenes into a single panel (Cat. no. 11).[7] The desire for an even distribution of figures generally overrides the concern with bilateral symmetry observed among the amphora-painters, and combinations of related scenes provide an effective means of filling the space from one handle to the other. Though side by side and sometimes slightly overlapping, scenes juxtaposed in this manner generally retain their narrative independence, as on the earlier amphorae of Lydos. The traditional iconography of each is maintained, and the mixing of elements practised by the Priam Painter is rare. In addition to juxtaposing scenes in one exterior panel, painters commonly distribute them among two or three of the cup's painted zones. Except in the case of the very large display pieces, the kylix was meant to be handled by its users, and in turning the kylix repeatedly the viewer could easily observe narrative relationships among the exterior surfaces and the tondo. One of the better-known examples of this method is the Ilioupersis cup of the Brygos Painter, a three-faced collage of familiar and less familiar elements from the

[7] The three scenes are the recovery of Helen, the murder of Priam, and the rape of Kassandra. See Wescoat (1987) 58–61 for further discussion of the cup's iconography. The same three scenes are similarly combined in a single panel on Akropolis 212 (Cat. no. 12).

sack (Cat. no. 19*).[8] Finally, an extremely large cup decorated by Onesimos forms a hybrid class of its own (Cat. no. 16*).[9] Instead of distributing Ilioupersis scenes on the cup's exterior panels, Onesimos fits eight of them on the corresponding interior surface surrounding the tondo and ties the composition together with a ninth scene, the murder of Priam and Astyanax, in the tondo itself.

Though the cup-painters dominate the field early in the century, they were not the only artists experimenting with Ilioupersis combination. Like the interior kylix-zone decorated by Onesimos, the shoulder of a hydria provided a painter with a space ideal for the juxtaposition of scenes, a long strip interrupted at only one point by a handle. The Vivenzio Hydria of the Kleophrades Painter, one of the most elaborate and most widely known of Ilioupersis works, features five scenes positioned side by side (Cat. no. 23).[10] The artist has actually stretched the figured zone over the shoulder and onto the smooth shoulder-joint and upper body of the vase, thereby endowing the figures with greater height than the shoulder alone would allow. In contrast to the scenes in Onesimos' interior kylix-zone, which radiate outward from a central, circular ground-plane, the scenes on the hydria rise from a wide ground-plane at the body to a much narrower circle at the neck, and this conical surface encourages compact, triangular compositions. A related but less elaborate example survives on a now fragmentary hydria painted by Polygnotos around the middle of the century. The similarly elongated shoulder-zone of this vase includes both Aias attacking Kassandra and Menelaos pursuing Helen (Cat. no. 29).[11]

A final group of Ilioupersis combinations is formed by several red-figure kraters belonging to the second quarter of the fifth century. Three are the work of the Niobid Painter (Cat. nos. 24, 25, and 26), one was painted by the Altamura Painter (Cat. no. 27*), and one by the Tyszkiewicz Painter (Cat. no. 28).[12] While cup-painters like the

[8] See §13.3 for a detailed treatment of the Brygos Painter's cup.

[9] See §13.5 for a detailed treatment of Onesimos' cup.

[10] See §13.4 for a detailed treatment of the Vivenzio Hydria.

[11] Only the Helen scene is fully visible, but the incomplete figure with arm outstretched to the left must be Aias attempting to wrest Kassandra from the statue.

[12] Another example might be observed on a fragmentary krater of Polygnotos (Cat. no. 30). Only the upper portion of one side of the vase remains. The scene pictured is the attack on Kassandra, and Athena herself is present in addition to the statue. Matheson (1986) 101 n. 2 records that the fragmentary inscription *MENE*[. . .] appears to the right of the head of Athena and tentatively suggests that Menelaos

Brygos Painter often inject a sense of grandeur into their miniature Ilioupersis scenes, and the shoulder of the Vivenzio Hydria allows its figures substantial height, the characters on these large kraters attain the most monumental proportions possible among the vase shapes, their massive bodies extending across the entire height of the figured zone. The distribution of scenes varies, as each side of the krater can house either one scene or two. On two of the Niobid Painter's kraters the magnificent Priam scene fills one side completely, while two scenes are juxtaposed on the opposite side (Cat. nos. 24 and 25). Decorative borders below the handles of one of these vases separate obverse from reverse (Cat. no. 25) and yield two distinct panels, as on a much earlier black-figure column-krater (Cat. no. 6). On the other no formal division exists between obverse and reverse, and the decorated zone continues around the entire circumference without interruption (Cat. no. 24). The effect here may be compared to that of the Vivenzio Hydria, where several scenes are represented side by side, with the Priam scene at the centre.

13.2 Kassandra, Priam, and Astyanax

Having surveyed the range of Ilioupersis combinations in the late Archaic and early Classical periods, I next proceed to a closer analysis of the mechanics of combination in a small number of examples, each a combination of the rape of Kassandra and the murder of Priam (and Astyanax). How do different artists fit the same two scenes together? Visual dynamics and thematic correlations are generally among the first elements to be considered in analysing relationships among scenes. Balance, symmetry, and rhythm stood regularly in the forefront of a painter's mind, and co-operative interplay between shape and meaning have often fused two originally independent episodes into an indissoluble composite. While exploring the internal dynamics of composition, it is instructive also to compare a combined scene with earlier, later, or more prevalent representations of the same episode, in order to gauge the effect of combination on the balance of tradition and innovation. To what extent do artists manipulate or alter the received iconography of individual scenes when

stood to the right, although she admits that his presence would be unusual in this scene. Perhaps Menelaos and Helen were both depicted together with Aias and Kassandra, i.e. another juxtaposition of Ilioupersis scenes.

painting them in combination? What novel elements might an art-
ist introduce to bind two scenes more closely together? And how are
the traditional themes of individual scenes enhanced or modified in
combination?

The earliest vase of the series is one of Lydos' two Ilioupersis com-
binations (Cat. no. 4*—Figs. 3(*a*) and (*b*)). At the far left of the scene,
Kassandra crouches beside the statue of Athena while Aias advances
with raised sword from her right. Next to Aias, Neoptolemos, facing
right, holds the tiny body of Astyanax by the foot and prepares to
hurl the child against Priam, whose body already lies sprawled across
an altar at the right end of the composition. Two female figures stand
near the altar opposite Neoptolemos and beg him for mercy.[13] The
Kassandra and Priam scenes are distinguished from one another
by the position of the two warriors, back to back. But the panel as a
whole is arranged according to a tripartite rather than bipartite struc-
ture, with Neoptolemos in the centre and Kassandra and Priam bal-
anced on either side.

The common narrative context of the two episodes provides an
obvious connection between them, and after the preceding survey
of sixth- and fifth-century Ilioupersis images, this relatively straight-
forward combination may offer few surprises. For the inexperienced
viewer of the mid-sixth century, however, unaccustomed to amphora
panels containing more than one scene, the image will present at
least an initial challenge. One might at first be tempted to read the
proximity of the two scenes—no formal border separates them—as
an indication of dramatic physical contiguity, but tradition tells us
that while Priam was slain at the altar of Zeus in his palace, Kassandra
took refuge at the statue of Athena in the goddess's temple. Since both
altar and statue are present here to identify the distinct locations, the
painting cannot be viewed as a simple snapshot of a single location,
but must instead be understood as a more complicated and compelling
collage of images. By bringing the scenes so closely together, Lydos
is in effect inviting his contemporaries to observe the two together as

[13] For a very similar, contemporary representation of Priam's death cf. the black-
figure pyxis Berlin 3988, Wiencke (1954) fig. 7. On the pyxis the body of Priam is
similarly sprawled across the altar, and a female figure pleads for mercy. Most striking
is the similarity in the depiction of Neoptolemos' shield. In both cases it is represented
in profile, and a serpent-head protome rises toward Neoptolemos' enemies. The two
artists are following the same pattern or perhaps using a well-known monumental
representation as a model.

a unit and explore the motives behind the pairing. The artist who produced the Mykonos pithos no doubt also expected the viewer to observe the interaction among scenes, but Lydos intensifies the provocative force of the juxtaposition by removing the icons from their frames and combining them within the one panel.

Confronted by the novel ensemble, we should immediately perceive the familial links shared between the two scenes. The juxtaposition of Priam and Astyanax, already standard in the iconography, symbolizes the end of the ruling family, grandfather and grandson dying simultaneously. The two female figures near Priam also belong to his family. Similar unnamed spectators appear in numerous versions of this scene and in varying numbers, and while their identification can rarely be determined precisely, they are presumably members of his household. In this case the female figures probably represent Andromache, pleading with outstretched arms for the life of her son Astyanax, and Hekabe, touching her husband's head with one hand and pleading for his life with the other. Kassandra too belongs to that family, and her presence on the opposite side of the panel adds another dimension to our view of the family suffering. Priam and his grandson are murdered while immediately to their left Aias attacks Priam's daughter. We see not two, but three members of the same family suffering at the hands of the Achaians.

The other obvious bond between the two components is the common theme of sacrilege. Aias attacks Kassandra at the statue of Athena, and Neoptolemos murders Priam (and Astyanax) at the altar of Zeus. These events stand out among the Ilioupersis episodes as the two notorious offences against the gods, and by placing them side by side Lydos conveys the theme of sacrilege with twice the intensity. We see the two criminals standing back to back, with the two suppliants shrunk before them at the two desecrated sanctuaries, and recalling the family tie between the suppliants, we might also recognize the parallel family tie between the two offended divinities, Zeus and his virgin daughter Athena. The composition is not merely an Ilioupersis, but an image of the sacrileges committed at the Ilioupersis.

While appreciating these connections between the scenes, we should not overlook the fact that Lydos has employed few specific internal mechanisms to reinforce the connections. Apart from selecting and juxtaposing the images, the painter has done little else to underline the thematic connections between the scenes. Lydos must have recognized Kassandra and Priam as father and daughter, he must

also have perceived both scenes as acts of sacrilege, and he probably
expected the viewers to appreciate these links. But while providing
the material, he relies on the viewer to assemble the pieces and to
produce an interpretation.

An alternative method of combination pairs the same two episodes
on a black-figure neck amphora of a few decades later (Cat. no. 7).
Here each scene occupies one side of the vase, and the viewer is there-
fore deprived of the interpretative advantage of observing them side
by side. But in the absence of visual simultaneity, the extreme visual
symmetry between the two compositions (observed above in §13.1)
serves as a guiding stimulus, encouraging us to turn repeatedly from
one scene to its companion. The large base supporting the statue of
Athena, not a regular element of the iconography, forms a visual
counterpart to the altar of Priam in the scene opposite. The resulting
bond of reflection between statue and altar, each indicative of a sanc-
tuary, leads the viewer to the common denominator of sacrilege. Like-
wise, prompted by their reflective poses to compare Neoptolemos and
Aias, we will quickly recognize the heroes as a pair of sacrilegious
offenders and might also cast our thoughts forward to the divine
retribution awaiting them both.

Lydos' innovative juxtaposition finds another successor among a
group of Ilioupersis scenes on the exterior of a fragmentary red-figure
cup of the late sixth century (Cat. no. 12). Although only a portion
of the two scenes remains, the surviving fragments reveal the gen-
eral scheme of the composition. On one fragment Kassandra sits awk-
wardly at the foot of Athena's statue, with her body oriented towards
the right and her head turned back to the left. She must be looking at
Aias, and she probably raises an arm towards him in supplication.[14]
Immediately to the right of Athena's statue a small portion of a blood-
stained altar is visible, and although little else remains of the altar
scene, one fragment, on which is preserved part of Astyanax and
below him the leg of an advancing warrior, confirms that this is the
altar of Zeus Herkeios and that Neoptolemos was depicted advancing
upon Priam from the right. These are the same two scenes combined
by Lydos, but a simple rearrangement of the figures produces a very
different visual bond between the two sides. The statue of Athena
and the altar of Zeus, the two symbols designating the sanctuaries,
are now positioned adjacent to one another, and the base of Athena's

[14] See §12.2 above for the customary iconography of Kassandra.

statue actually touches the altar. The physical proximity of these religious symbols, the two holy objects desecrated during the sack, forms an axis of sacrilege which draws the two episodes together around it. From here the theme of sacrilege advances laterally to the two victims joining the statue-altar combination. By the end of the sixth century Priam and Kassandra were regularly depicted extending an arm towards their attackers, and if holding that pose here, they would form a tightly reflective pair, a double image of supplication disregarded. The attackers advancing towards their victims and towards the sanctuaries close the frame on either end and press the two scenes together with their centripetal movement. Of course, this reconstruction relies on a degree of speculation, but it is clear that by inverting the order of figures observed on the Lydos amphora and making a few other small alterations, a painter could join the Kassandra and Priam scenes into an extremely cohesive pair.

The Ilioupersis krater of the Altamura Painter, dated to the second quarter of the fifth century, contains an even bolder synthesis of the Kassandra and Priam scenes (Cat. no. 27*—Fig. 5(a)).[15] The ordering of the characters here repeats that in Lydos' composition exactly: Kassandra and Aias are positioned to the left, Neoptolemos (with Astyanax) and Priam to the right. Instead of forming a tripartite or bipartite panel, however, the Altamura Painter has woven the two scenes into a single, compact unit. The massive figures, positioned much closer together than those of Lydos, leave no space dividing one scene from the other. The warriors again stand back to back, but here they overlap and recede slightly into the background before the prominent figures of Kassandra and Priam. Remarkably, the painter shifts attention away from the relationships between the attackers and their suppliant victims, and invents a form of dramatic interaction between the two victims. While Aias and Neoptolemos direct their vision towards their victims, Kassandra and Priam look not towards the warriors, as is standard, but instead towards each other, as if the two events were actually occurring side by side. And their hands, traditionally extended in supplication towards their attackers, here reach out towards one another.[16] The painter has thereby merged

[15] Beazley discusses the vase in Caskey and Beazley (1963) 61–5.

[16] Beazley, ibid. 62, accustomed to the traditional representations of these scenes in isolation, does not seem to recognize the interaction in their gestures, and in explaining the position of Kassandra's arm, he notes only that Aias has pulled it away from the statue.

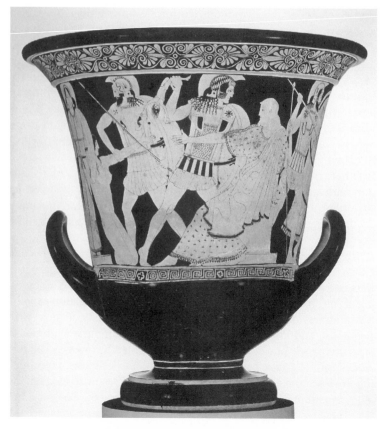

5(*a*) Attic red-figure krater, the Altamura Painter, Cat. no. 27. Side A:
Kassandra, Aias, Astyanax, Neoptolemos, and Priam. (William Francis
Warden Fund; Courtesy, Museum of Fine Arts, Boston.)

two traditionally independent narrative scenes into a quasi-dramatic
unit of extreme pathos, as each victim becomes a spectator of the
other's misfortune.[17] The final element of cohesion is the tiny figure
of Astyanax, suspended upside-down in the upper centre of the paint-
ing. His extended arms appear to reach towards the outstretched

[17] This scene need not be explained as a representation of a lost poetic narrative
which placed the attacks on Kassandra and Priam at the same location. It is an evocat-
ive amalgamation created by the painter.

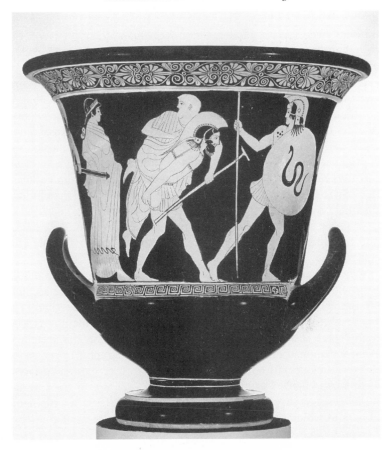

5(*b*) Side B: the family of Aineias escapes from Troy.

hands of the other two victims, and while father and daughter look towards one another, the child's traditional frontal face emits an unanswered plea for help to the viewer.

The decoration continues above the handle to the right of Priam with a duel between a Trojan and a Greek, which leads to the opposite side of the vase and another well-known episode from the Ilioupersis (Fig. 5(*b*)). In the centre of the scene a bearded Aineias advances to the right carrying his ageing father on his back. Before them a younger warrior, probably the son of Aineias, leads the way, while a female figure, probably Aineias' wife, follows behind

the hero and his father. The successful departure of this family—husband, wife, son, and father—counterbalances the grim events in the painting opposite, where father, daughter, and grandson fall victim to the invaders. Epic accounts of the Ilioupersis contrasted the survival of Anchises' family with the destruction of the family of Priam (see Ch. 4), and the Altamura Painter has captured that traditional antithesis visually by pairing the dissolution and the escape on opposite sides of the same vase. Like the interlocking stares of Kassandra and Priam, which draw their episodes together with an illusion of contiguous dramatic action, Anchises' retrospective glance bridges the physical distance between the two sides of the krater and guides the viewer to observe the complementary departure and dissolution together. As Aineias carries him from Troy, Anchises looks back beyond his immediate scene to the suffering of Priam, Astyanax, and Kassandra, misfortunes from which he and his own family are spared.[18]

A final example in this series of Priam–Kassandra combinations is provided by the Telephos Painter on a cup dated to the second quarter of the fifth century (Cat. no. 22*). In contrast to the Altamura Painter, who introduced bold innovations while still maintaining a high degree of fidelity to standard Ilioupersis patterns, the Telephos Painter demonstrates a distinct interest in iconographic novelties in the three Ilioupersis episodes decorating the three figured surfaces of this cup. Side B features Kassandra and Aias not in their traditional poses as suppliant and sacrilegious attacker, but in a moment of pursuit which has not yet brought them to the statue (Fig. 6(*b*)). Kassandra flees to the left, turning her head back to Aias, who pursues from the centre of the composition. Despite the departure from the more common iconography, the victim is clearly recognizable from her semi-naked state, the cloak flung around her shoulders hardly sufficient to cover her body. Her outstretched arms suggest that her destination is the statue of Athena,[19] but the statue itself is absent from the scene, and the sacred precinct of the goddess is instead represented by a column situated between the victim and her assailant.[20]

[18] Cf. Anchises' role as spectator in the Priam Painter's depiction of the attack on Kassandra (Cat. no. 8*).

[19] Cf. her pose on a roughly contemporary red-figure volute-krater of the Niobid Painter (Cat. no. 25).

[20] For the column cf. the red-figure oinochoe Oslo OK 10.155, successor of the Niobid Painter, *c*.450, Touchefeu (1981) no. 65.

The pose of Aias has also undergone a radical alteration. In contrast to the solid, attacking warrior found in most depictions, here he is an extremely lively figure, practically dancing his way towards Kassandra, and instead of menacing her with raised sword, he now holds a spear by his side—a pose closely associated with tne iconography of erotic pursuit.[21] To the right of Aias the painter has framed the composition with another energetic figure, a woman fleeing in the direction opposite to Kassandra's flight.

In the Priam scene on side A the Telephos Painter demonstrates greater allegiance to his predecessors, but here too he has attempted to enliven the composition by agitating the figures (Fig. 6(*a*)). Priam sits at the altar of Zeus as usual, but here recoils at the sight of Neoptolemos bearing down upon him. In the absence of Astyanax, Neoptolemos wields a spear which, pointed menacingly towards Priam, accentuates his forward lunge. The victim extends one arm toward his attacker, not in the standard gesture of supplication, but with palm forward, as if to arrest the warrior's violent advance. To Priam's right a woman flees from the scene, her right hand mimicking the gesture of the old man, and with both arms outstretched, she closely resembles the fleeing figure in the Kassandra scene opposite. In contrast to the stationary mourning and supplicating women found in earlier representations of the story, the moving figure contributes to the general tone of emergency in this unusually energetic depiction.[22]

A unique scene occupies the cup's interior (Fig. 6(*c*)). A man with a cloak draped over his left arm runs rapidly to the right while looking back, perhaps toward pursuers beyond the picture frame. A young boy sits on the man's shoulders and clings to his head. He wears a red band in his hair, a serpentine bracelet on his right wrist, and a similar ornament on his right leg. The singularity of this composition makes identification difficult, but several arguments point convincingly towards an attempted rescue of the prince Astyanax.[23] First, the related subjects of the two exterior scenes, though not

[21] On erotic pursuits and the distinction between swords and spears see Sourvinou-Inwood (1991) 29–57, 'Menace and Pursuit: Differentiation and the Creation of Meaning'.

[22] Women flee from the scene also on the kraters of the Niobid Painter (Cat. nos. 24 and 25).

[23] Other possibilities include Orestes and the paidagogos, tentatively suggested by Beazley at *ABV* 817. Askanios might also be considered.

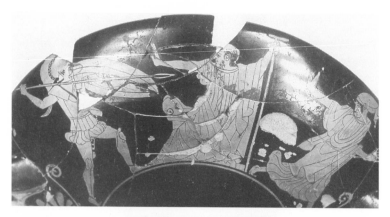

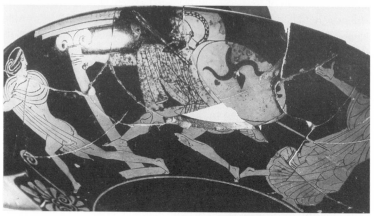

6(a) (top) Attic red-figure
cup, the Telephos Painter,
Cat. no. 22. Side A:
Neoptolemos attacks Priam.
(Courtesy, Hermitage Museum.)
6(b) (above) Side B: Aias pursues
Kassandra. 6(c) (right) Interior:
Astyanax?

necessitating a third Ilioupersis scene in the tondo, make it a likely choice. Next, the cloak draped over the man's left arm is paralleled in other representations of Trojans caught unprepared by the surprise attack of the Greeks and therefore suggests an Ilioupersis context.[24] Finally, in addition to the ornaments on his wrist and leg, another compelling reason for the identification of the child as Astyanax is his striking frontal face, rare in vase-painting as a whole, but common for Astyanax.[25] The painter has removed the child from his regular position within the Priam scene and has situated him instead at an earlier moment, before his capture and death at the hands of Neoptolemos.[26]

Although the three scenes do not display the tight psychological unity of the Altamura Painter's Kassandra–Priam combination, the artist has nevertheless succeeded in uniting them within a coherent complex of common motifs. The evenly spaced arrangement of Neoptolemos, Priam, and the fleeing woman on side A is counterbalanced by the similarly symmetric arrangement of Kassandra, Aias, and the fleeing woman on side B. In addition to the geometric reflections, the two external compositions share a mood of agitated suspense. Priam leans back and resists as Neoptolemos strides toward him, Kassandra is dislodged from her traditional stationary position at the statue and spurred to flight, and the fleeing woman enhances the sense of movement in both scenes. Finally, the attempted rescue of Astyanax in the tondo draws upon elements in both of the exterior scenes. Side A might be recognized as the source for the subject of the interior scene, since instead of appearing in his customary position in the hands of Neoptolemos, the child has been transplanted into a scene of his own. The manner of depiction in the tondo, on the other hand, was influenced more by the scene on side B. Like Kassandra, running into the temple instead of stationed at the statue, Astyanax is still in flight from his Greek assailants.

The preceding examples offer a sufficient demonstration of the

[24] Cf. the Trojans on side B of the Brygos Painter's Ilioupersis cup (Cat. no. 19*) and in scene NE of Onesimos' Getty Ilioupersis (Cat. no. 16*), discussed in §13.5 below. The beard of the man is unusual but parallels the beard of Priam on side A.

[25] The frontal face is discussed in §12.1 above.

[26] For other instances of innovation with Astyanax cf. the figure of the child seated on the shoulders of his mother on the Priam Painter's hydria (Cat. no. 8*), the flight of Astyanax on side B of the Brygos Painter's Ilioupersis cup (Cat. no. 19*), and the child lying in Priam's lap on the Vivenzio Hydria (Cat. no. 23).

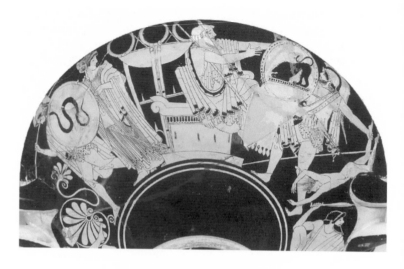

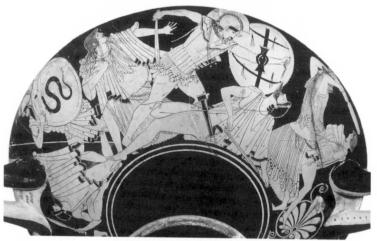

7(a) (*top*) Attic red-figure cup, the Brygos Painter, Cat. no. 19. Side A:
Polyxene led away to her death, Neoptolemos murders Priam and
Astyanax. (Courtesy, Musée du Louvre.)
7(b) (*below*) Side B: conflict between Greeks and Trojans.

variety of compositional devices employed by Athenian artists in combining the Kassandra and Priam episodes. All of them join the scenes with an eye to visual symmetry, and the visual correlation often underlies an explicit thematic correlation, as for example in the juxtaposition of statue and altar on the Akropolis fragments. Lydos, however, leaves the thematic possibilities unstated. The Telephos Painter uses action rather than theme as a linking factor. In several of the examples the traditional iconography of the individual scenes is maintained with little significant alteration, but the Altamura Painter subtly adapts customary poses to create dramatic interaction between Kassandra and Priam, and the Telephos Painter departs radically from the traditional iconography of both Kassandra and Astyanax to depict them in flight. This variety is evidence of a living and developing tradition. From generation to generation, the painters do not simply recopy the scenes, but like the poets who continually revise the myth verbally, they constantly reconsider the relationships among the various aspects of the story and reshape the received iconography accordingly.

13.3 The Louvre Ilioupersis Cup of the Brygos Painter

From combinations of two or three Ilioupersis scenes, we turn next to a selection of even more elaborate examples. The first of these vases, in order of increasing complexity, is the Louvre Ilioupersis cup of the Brygos Painter (Cat. no. 19*). At the centre of one exterior side a well-armed Greek warrior towers above his dying Trojan victim, who is armed only with a sword (Fig. 7(b)). To the left a woman flees, and beyond her another victorious Greek slays another disadvantaged Trojan. To the right of the centre, in contrast to the fleeing woman opposite, Andromache lunges forward swinging a large pestle against the Greek warrior, while her son Astyanax, here much older than usual, escapes behind her to the right. The boy's flight, however, prolongs his life only briefly, and on the opposite exterior side we see him in his more familiar death-scene (Fig. 7(a)). Here, in place of Andromache swinging her impromptu weapon behind her head and preparing to strike the Greek warrior, Neoptolemos now swings Astyanax behind his head and prepares to fling the boy against Priam, who sits at the altar of Zeus in an agitated pose, arms outstretched.

Turning to the warrior and female figure to the left of Priam and the altar, the viewer might initially think of Menelaos and Helen,

since this couple recalls the earlier, black-figure recovery, but inscriptions reveal them to be Polyxene and Akamas. Among Attic vase-paintings the gruesome sacrifice of Polyxene survives only on a Tyrrhenian amphora by the Timiades Painter: three Greek warriors hold Polyxene above a mound while Neoptolemos slits her throat (Cat. no. 3).[27] In the later sixth century a less violent evocation of the episode appears on a black-figure vase of the Leagros Group: a Greek warrior leads Polyxene by the hand towards the tomb of Achilles (Cat. no. 10).[28] While the painter has avoided the unsightly details of the slaughter by depicting the moment prior to it, the imminent sacrifice will not escape the viewer's imagination, and the resulting disjunction between the picture perceived and the anticipated act produces a dramatic tension comparable to that in the popular depictions of Aias preparing for his imminent suicide. The Brygos Painter adopts this prospective image and raises the suspense even higher by setting Polyxene next to the murder of Priam. As the accompanying Greek warrior leads her away, Polyxene turns her head to look back upon the murder of her father and sees simultaneously a reflection of the fate awaiting her at the tomb of Achilles.[29]

Although the warrior himself is not physically present at the Ilioupersis, the ghostly figure waiting to receive Polyxene at his tomb exerts an invisible unifying force among all the exterior scenes on the Brygos Painter's cup. Hektor, the absent link between Priam, Astyanax, and Andromache—his father, son, and wife—died at the hands of Achilles not long before the present events; and in the absence of Achilles, Neoptolemos now continues his father's assault on Hektor's family.[30] After slaying here the orphaned child of his father's greatest Trojan opponent, he will soon enslave the widow. The inclusion of Polyxene, while reminding us that the dead warrior will not be forgotten in the division of spoils, reminds us also of the lineage of the warrior in the adjacent scene and thereby reinforces the correlation between the present episodes and the antecedent victory of Achilles.

[27] For the poetic tradition of the sacrifice see §3.3 above.

[28] The same scene appears on a red-figure cup by Makron, Louvre G 153, *ARV* 460.14 and 481, *BA* 244; see Beazley (1954).

[29] See Schefold (1975) 37 for a similar discussion of the Priam–Polyxene juxtaposition.

[30] For the epic treatment of the Achilles–Neoptolemos succession see §2.2. Recall also that Neoptolemos has inherited the iconography of his father; see §12.1.

Memories of the departed hero linger also in the curiously isolated scene on the cup's interior, where the young Briseis pours wine for the ageing Phoinix. The wrath of Achilles in the *Iliad* began with the loss of his concubine Briseis, the prize he had formerly won at the capture of Lyrnessos. Phoinix, Achilles' mentor, is remembered particularly for the magnificent plea he delivered to his ward in *Iliad* 9, and the poets record also that he accompanied Odysseus to Skyros to enlist Achilles' son into the Achaian army (Sophokles, *Philoktetes* 343–4 and Apollodoros, *Epit.* 5. 11). Paired on the cup's interior in the calm and temporally indefinite poses of server and served, the two characters rest on an ambiguous border between past relationships with Achilles and present allegiance to his son—apparently descending into the story of Neoptolemos, but still retaining a degree of separation from their new leader. The ageing Phoinix appears on one other vase in an Ilioupersis context, the singular representation of the sacrifice of Polyxene on the black-figure Tyrrhenian amphora mentioned above (Cat. no. 3). There he turns his back towards the horrible act as if to indicate his disapproval, and his detached appearance in the tondo of the Brygos Painter's cup may likewise be meant to distance him from the brutal acts represented and anticipated on the exterior panels. Briseis is a dutiful but constrained member of the Peleid household. Like the suffering Andromache on the cup's exterior, she too once suffered the fall of her city and the loss of her husband, and she now lives the life of servitude that awaits the widowed Trojan princess.

13.4 *The Vivenzio Hydria of the Kleophrades Painter*

The Kleophrades Painter's Vivenzio Hydria displays five Ilioupersis scenes side by side in the long and relatively tall zone stretched across its shoulder (Cat. no. 23).[31] From left to right the five scenes are: (1) the departure of Aineias' family, (2) Aias' violation of Kassandra, (3) the murder of Priam and Astyanax, (4) a conflict involving a Greek warrior and a Trojan woman wielding a pestle, and (5) the rescue of Aithra. The arrangement of episodes follows a rough chronological progression from left to right. In contrast to the later Vergilian version

[31] The iconography on the vase is discussed briefly by Beazley (1974) 6–7 and in more detail by Schefold (1975) 37–8 and Boardman (1976).

of the story, the Archaic *Iliou Persis* placed Aineias' escape prior to and not during the sack proper (*IP* arg. 8–9). He and his family leave Troy in response to and directly after the omen of Laokoon, and scene 1 on the Vivenzio Hydria may therefore represent a moment prior to the attack on the city.[32] Scenes 2 and 3, the assaults on Kassandra and Priam, occur during the attack, and scene 4, although not precisely identifiable, clearly belongs with the preceding two as part of the conflict. The rescue of Aithra in scene 5, in contrast, represents a stage of the narrative after the attack.[33]

More stimulating than this left-to-right chronological progression, however, is the symmetric interplay of shape and theme converging on the centre of the chain. At the core of the composition lies the familiar combination of Priam and Astyanax, symbolizing the fall of the city and the end of its ruling dynasty. The unusual placement of the child's body—usually suspended by the foot behind the head of Neoptolemos, but here already strewn across Priam's lap—tightens the bond of kinship between grandfather and grandson. The Trojan warrior lying dead at the feet of Neoptolemos, perhaps another member of Priam's family, fills the generation gap between the child and the old man, and by including him, the painter captures the deaths of three successive generations simultaneously.[34]

While the murder of these male figures occupies the centre, the two flanking scenes both feature a Greek warrior clashing with a woman of the royal household—Kassandra and Aias at the statue of Athena to the left (scene 2), a soldier and a woman wielding an enormous pestle to the right (scene 4). The unspecified pestle-wielder might be read as Priam's wife Hekabe, but Andromache would provide a more apt complement to Kassandra—a daughter on one side of Priam balanced by a daughter-in-law on the other.[35] Kassandra is tied closely to her father by the common theme of sacrilege, the statue of the virgin goddess Athena paralleling the altar of father Zeus, and their scenes are linked further by the two warriors lying at the feet of the

[32] See Ch. 4 for the poetic traditions of Aineias' departure.

[33] See *IP* arg. 21–2 and *MI* fr. 20. Cf. also Quintus Smyrnaeus, who relates the rescue of Aithra at the end of his account of the attack (13. 496–543). For the relatively infrequent occurrences of this scene in Greek art see Kron (1981).

[34] Together with the fallen Trojan below Aias, this figure indicates also that combat has recently taken place.

[35] Cf. side B of the Brygos Painter's Ilioupersis cup (Cat. no. 19*), where Astyanax flees while Andromache swings a pestle at a Greek.

two attackers, and by the two similarly posed, grief-stricken women, one sitting at the base of the palm tree behind the altar, facing left, and the other sitting opposite, half hidden behind the statue.[36] While the pairing of these two scenes accentuates the desecration of religious sanctuaries, the pairing of Priam with the pestle-swinger of scene 4 underscores the penetration of the household. The pestle is a domestic utensil, here enlisted as a weapon in a desperate situation, and like the neighbouring altar of Zeus Herkeios, it indicates that the Greeks have violated the domestic sphere, both the physical structure of the palace and the family that lives within it. As the male Trojan lies dead beneath Neoptolemos, even the women of the palace now join in the defence of their home. To add a final element of cohesion to this family cluster, the painter has structured the two flanking scenes (2 and 4) according to a single pattern. In each, a standing figure towers above a crouching figure; only the genders of the participants are reversed. The pose of the kneeling Greek warrior in scene 4 closely resembles that of Kassandra in scene 2, and the shield which he holds out against the pestle-swinger serves as a visual analogue to the shield of Athena, under which Kassandra seeks protection from Aias.

The kinship theme reaches a surprisingly gentle conclusion in the Aineias and Aithra scenes at the edges of the composition (nos. 1 and 5). To the far left (scene 1) we witness a family escaping, as Aineias departs Troy with his father on his back and his young son before him—the traditional antithesis to the fall of the Priamids. And to the far right (scene 5), where Aithra's grandsons rescue and release her from servitude, we see a family reunited. As with scenes 2 and 4, the Kleophrades Painter balances these two endpoints against one another with visual reflections. While Aineias' small son Askanios stands under the shield of his father at the left edge of scene 1, a complementary shield bounds the Aithra scene, and beneath it sits a small girl, not an identifiable character of the tradition, but an innovation designed specifically to parallel the figure of Askanios opposite. Although both of these peaceful lateral scenes offer a glimpse of optimism, with the assistance of retrospective glances from Anchises and Astyanax, they also point us back again to the contrasting violence of the centre. To the left the old man Anchises and his young grandson Askanios are rescued by Aineias, and to the right the old

[36] The palm tree is discussed in the final paragraph of §12.1.

woman Aithra is rescued together with a young girl, but between them Neoptolemos brutally murders the ageing king and the young grandson sprawled helpless before him.

13.5 *The Onesimos Ilioupersis Cup in Malibu*

Even more elaborate than the combination on the Vivenzio Hydria is Onesimos' arrangement of nine Ilioupersis scenes on the interior of a large red-figure kylix dated to the early fifth century (Cat. no. 16*— Figs. 8(*a*)–(*c*)).[37] While in the previously observed examples scenes are either distributed among two or more surfaces or juxtaposed in a linear manner, side by side, the interior of the Onesimos cup presents much greater geometric complexity. In the tondo Onesimos has depicted the murder of Priam, and in the surrounding circular zone he has distributed eight further scenes.[38] As the choice and positioning of a scene within the circular (or octagonal) zone are influenced by its thematic relation both to the neighbouring scenes and to the scene opposite, the outer scenes together form a network of parallels and contrasts, and the tondo provides a unifying focus in the centre. For example, the ageing king Priam, pictured in the tondo, extends an arm in supplication to Neoptolemos; in the scene to the right (east) an elderly woman, Theano, extends an arm in supplication to a Greek warrior; and in the scene directly opposite (west), another elderly woman, Aithra, holds a similar pose.[39] The alignment of these scenes along a single axis and the visual similarities shared among them lead the viewer to consider them together as a group and to explore each in relation to the others. Doing so, we will immediately notice that the theme of supplication is of particular interest to the artist,

[37] In a recent article on the cup Williams (1991) has discussed the iconography of each of these scenes individually. In the following pages I hope to complement Williams's observations by drawing attention to the visual and thematic interaction among the nine scenes when viewed in combination. The observations in this section were originally published in similar form in Anderson (1995).

[38] The cup is unusually large. Williams (1991) 47 records its diameter as 46.5 cm. This rarely employed scheme of cup-decoration is particularly well suited to the simultaneous presentation of multiple, thematically related scenes. Cf. the arrangement of the deeds of Theseus on a large red-figure cup of the Penthesilea Painter, Ferrara 44885 (T 18C VP), *ARV* 882.35 and 1673, *Para.* 428, *BA* 301.

[39] For clarity I will refer to the surrounding scenes using compass directions.

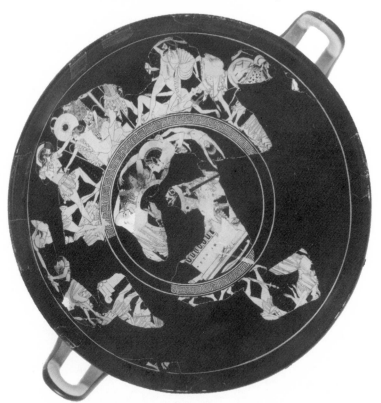

8(*a*) Attic red-figure cup, Onesimos, Cat. no. 16. Ilioupersis scenes.
(Collection of the J. Paul Getty Museum, Malibu, California.)

and we might next proceed to examine the significance of Priam's
futile supplication of Neoptolemos in contrast to the successful sup-
plication in the lateral scenes. Similar parallels unite all nine scenes
into a symmetric web of connected images and ideas, inviting the
viewer to examine and to interpret.[40]

The death of Priam in the tondo, as the central and the largest
scene, provides the natural beginning for an analysis of the decora-
tion. The basic structure of the scene is traditional. Priam has taken
refuge at the altar of Zeus Herkeios, and Neoptolemos prepares to

[40] The exterior scenes, which do not exhibit such tight thematic links with the
interior scenes, will be discussed separately in §14.2 below.

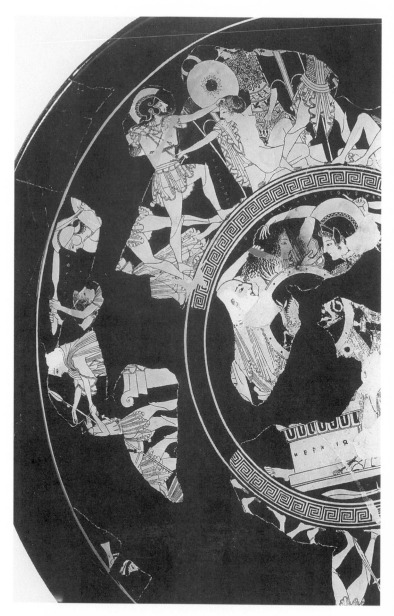

8(b) Attic red-figure, cup, Onesimos. Detail.

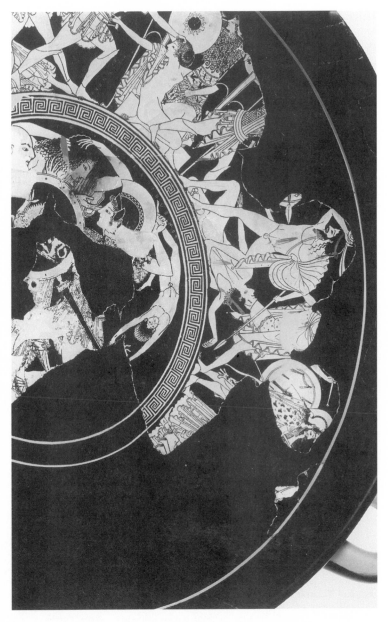

8(c) Attic red-figure, cup, Onesimos. Detail.

strike him with the body of the child Astyanax.[41] On the ground behind the altar lies the body of a dying Trojan, Deiphobos, son of Priam and the second of Helen's Trojan husbands.[42] Thus we witness the deaths of three generations—old king, warrior, and young child—as on the Vivenzio Hydria.[43] The entire ruling dynasty is exterminated at the sack.

In the background, positioned pictorially between Priam and Neoptolemos, is another member of the royal family, Polyxene (identified by an inscription).[44] Her appearance as a horrified spectator heightens our own sense of horror as we observe the scene. In addition, the figure carries with it a subtle allusion to a future moment in the story, when, according to the poetic tradition, the Greeks will sacrifice Polyxene at the tomb of Achilles. While the Brygos Painter pairs Priam's murder with Polyxene's departure for the tomb, Onesimos achieves a similar effect by introducing Polyxene alone into the Priam scene and placing her face to face with her future murderer. Seeing her here as a spectator to the murder of her father, the viewer will recall that Polyxene herself is soon to fall victim to a similar fate, to be slain by the same agent. The allusion to that abhorrent human sacrifice adds an even darker dimension to the sacrilegious murder of Priam, as it suggests that Priam's death at the altar be understood not only as violation of a suppliant, but also as a corrupt form of sacrifice.

Turning from the tondo to the scene directly above (north), we observe the suffering of another of Priam's beautiful and unfortunate daughters, Kassandra. As observed previously, the traditional

[41] Onesimos uses a very similar composition to decorate the tondo of a slightly earlier cup, only fragments of which now remain (Cat. no. 15). The cup is treated by Stenico (1953) and Speier (1954), and for the most recent reconstruction of the fragments and the attribution to Onesimos, see Williams (1976).

[42] The figure is labelled $\Delta]AI\Phi ONO\Sigma$. Williams (1991) 51 suggests that 'Onesimos might perhaps have made a slight slip and written Daïphonos instead of Daïphobos.' The name Daïphonos might also be an alternative to Daïphobos (or Deiphobos). Cf. the tondo of Onesimos' earlier Ilioupersis cup, which includes a dying Trojan warrior in the same position (Cat. no. 15). Three inscriptions appear on and below the altar on that cup: $\Delta IO\Sigma$ above the moulding, $HIEPO[$ in the middle, and $\ldots]NO\Sigma$ retrograde below the base. Speier (1954) 114 reads these inscriptions together as $\Delta IO\Sigma$ $HIEPO[N]$ $[TEME]NO\Sigma$. I suggest instead the possibility of two separate inscriptions: $\Delta IO\Sigma$ $HIEPO[N]$ for the location and $\ldots]NO\Sigma$ for the name of the fallen warrior. It is normal for an inscription to originate near the head of a figure, and therefore this inscription is retrograde. The figure is probably $[\Delta AI\Phi O]NO\Sigma$ as on the Getty vase. [43] Cf. Williams (1991) 51.

[44] A similar female figure appears in the tondo of Onesimos' earlier Ilioupersis cup. Although she is not identified with an inscription, comparison with the Getty cup suggests that she is Polyxene, as Williams (1991) 50 notes.

iconography of Kassandra shares several visual and thematic similarities with that of Priam, and the two scenes are juxtaposed on several vases. On Onesimos' cup both Kassandra and Priam extend an arm toward their attackers in a desperate but unsuccessful plea for mercy. Parallel to the altar of Zeus in the tondo, which is here highlighted by the unusual addition of the inscription *HEPKEIΩ* ('of [Zeus] Herkeios'), the statue of Athena provides a striking symbol of the divine in the Kassandra scene.[45] Onesimos has drawn further attention to the sanctity of the location by framing the statue with two enormous tripods. In both scenes the religious sanctuary is clearly identified, the sacrilege manifest. By aligning these two scenes along the same axis and with the same orientation, Onesimos highlights the theme of sacrilege as one of the principal concerns of the overall composition.

The Kassandra scene and the tondo are complemented by a third scene (south) positioned along the same axis, but with the opposite orientation. Menelaos rushes towards Helen with the intent to murder her, but at the sight of her beauty his anger subsides and he drops his sword. Onesimos has developed the relationships between this scene and the two above, particularly the Kassandra scene, through a number of visual similarities. Priam and Kassandra each extend one arm towards the attacking Greek, and Helen in the scene below extends both arms towards the advancing figure of Menelaos. Kassandra and Helen are further associated in their posture and clothing. Kassandra cowers in fear of Aias, and Helen crouches before Menelaos. With only a cloak hanging over her shoulder, most of Kassandra's body is exposed; and although Helen is clothed, Onesimos paints a distinct outline of her lower body beneath the thin chiton.[46] Even the general composition of the two scenes is curiously reflective. Aias attacks from one side of Kassandra, and the statue of Athena stands on the other. Likewise, Menelaos advances on one side of Helen while a female figure, probably representing the goddess Aphrodite, stands on the other.[47]

[45] The only other known example of an inscription on this altar in the Priam scene occurs on Onesimos' earlier Ilioupersis cup (Cat. no. 15); see n. 42.

[46] Since transparent clothing is found on the Getty vase also on the figures of Akamas, Demophon (west), and the pestle-swinger (NW), the technique cannot be considered unusual. Nevertheless, the painter did have the choice of whether or not to reveal Helen's body, and his decision to do so provides a parallel with the Kassandra scene.

[47] See Williams (1991) 56 for the suggested identification of this figure as Aphrodite. For assimilation between the iconography of Helen and Kassandra elsewhere see the end of §12.3 above.

Onesimos' purpose in creating such balance among the three scenes of this axis exceeds simple aesthetic delight in visual symmetry; for, by including multiple visual parallels, the artist is able to highlight individual elements and thereby to sharpen thematic distinctions. While observing the iconographic similarities, the sensitive viewer will simultaneously be struck by the contrast in dramatic content. Helen, Priam, and Kassandra are all suppliants, but Helen's plea for mercy is successful, while those of Priam and Kassandra are not. Helen receives support against Menelaos' attack both from the goddess Aphrodite and from a small Eros, but Kassandra's divine companion is only a statue. Unlike Menelaos, who has dropped his sword upon seeing Helen, Aias still wields his weapon (not surviving) without regard for Kassandra's desperate plea. While Helen's beauty mollifies, Kassandra's beauty incites. A similar tension exists between the Helen scene and the tondo. The small, naked body of Astyanax suspended in the air parallels visually the small, naked figure of Eros below.[48] But while the figure of Eros is symbolic of restraint, the figure of Astyanax is employed to heighten the theme of violence, the child actually functioning as a weapon in the hands of Neoptolemos.

The scenes located on the oblique axes (that is, the four scenes immediately adjacent to the Kassandra and Helen scenes) involve fighting between Greeks and Trojans. Directly to the left of the rape of Kassandra, a Trojan woman, one knee already pressed to the ground, swings a large pestle against an attacking Greek warrior (NW).[49] In the oblique scene to the left of this (SW), a Trojan woman holding an axe prepares to assist in a struggle between two figures, no longer identifiable.[50] On the opposite side of the cup's interior, immediately to the right of the Kassandra scene, a fully armed Greek warrior attacks a Trojan armed only with a sword, and naked except for a cloak; another naked Trojan already lies dying on the ground below (NE).

[48] I am grateful to Oliver Taplin for pointing out this parallel.

[49] The remains of an inscription suggest that this figure may be Hekabe. Williams (1991) 54, noting that the figure appears too young to be Hekabe, suggests instead Klymene, a slave of Helen whose name appears at *Il.* 3. 144. Because of the figure's active resistance I would more readily identify her as a Trojan belonging to the royal house. For other armed women in Ilioupersis scenes cf. the Ilioupersis cup of the Brygos Painter (Cat. no. 19*) and the Vivenzio Hydria of the Kleophrades Painter (Cat. no. 23). Note also the presence of another pestle in the tondo of the Getty cup, pointed out by Williams (1991) 51–2.

[50] The fragmentary inscription suggests that the woman is Andromache, as is noted by Williams (1991) 56.

The fourth oblique scene (SE) is missing, but it is likely that another scene of male combat originally balanced that to its left (NE).[51] The result would then be four scenes of fighting arranged symmetrically around the tondo—two scenes featuring Trojan women set opposite two scenes involving only men.[52]

While the symmetry of this arrangement links the fight scenes visually—each lies along an oblique axis—they are also related by a common qualitative element. None of the three surviving scenes represents a true combat, a battle between two equally opposed warriors. Rather, they are distortions of normal combat. Although traditional in depictions of the sack of Troy, women bearing weapons, especially impromptu, household utensils like pestles, do not properly belong in combat with fully armed men. And like his female counterparts, the fighting Trojan male (NE) is not adequately equipped to ward off the Greek advance. The cloak thrown over his shoulder alludes to the surprise attack of the enemy. Either he was woken from sleep and had time to grab only this garment, or he was wearing it while celebrating the supposed departure of the Greek army.[53] He is unprepared and offers no serious threat to his heavily armed opponent.[54] Together these three scenes highlight the inequality of the fighting during the sack. Furthermore, they offer an interpretative context for the adjacent scenes along the vertical axis (north–south).

[51] Williams (ibid.) suggests that the space 'was probably filled by a fight scene'.

[52] This arrangement is reminiscent of Onesimos' earlier Ilioupersis cup (Cat. no. 15). On one side of the exterior are two pairs of fighting men; on the other are two groups, each consisting of a Trojan woman fleeing from a Greek warrior. As on the Getty cup, scenes of male combat are balanced against groups composed of warriors and women.

[53] Cf. the cloaks worn by the Trojan men on the Brygos Painter's Ilioupersis cup (Cat. no. 19*). Men in scenes of feasting and celebration often wear similar cloaks. See e.g. a cup by Douris, Cab. Méd. 542, *ARV* 438.133 and 1653, *Para.* 375, *BA* 239, Arias (1962) pl. 148; a skyphos by the Brygos Painter, Louvre G 156, *ARV* 380.172 and 1649, *Para.* 366, *BA* 227, Simon (1981) pls. 151–3; and a cup by the same, Würzburg 479, *ARV* 372.32 and 1649, *Para.* 366 and 367, *BA* 225, Simon (1981) pls. 154–6.

[54] Male nudity can convey a wide range of meaning in Greek art, and in scenes of combat it may be employed simply as a heroic convention. In the context of the sack of Troy, however, the iconographic contrast between naked and fully armed appears to represent an imbalance between the Achaians and Trojans, an imbalance that was probably traditionally recorded in poetic accounts of the Ilioupersis; see Apollodoros, *Epit.* 5. 20 for the Achaian assault on the sleeping Trojans. For the theme of unequal combat compare *Il.* 22. 124–5, where Hektor says of Achilles, 'He will slay me naked, | like a woman, when I take off my arms' (κτενέει δέ με γυμνὸν ἐόντα | αὔτως ὥς τε γυναῖκα, ἐπεί κ' ἀπὸ τεύχεα δύω).

Like the Trojan men and women in the fight scenes, Kassandra, Priam, and Astyanax are defenceless victims, and although the attack of Menelaos is ultimately averted, Helen too belongs in this category. Here the sack is represented less as a glorious military victory than as a slaughter of the helpless.

Two scenes remain to be explored. Near the handle to the left of the tondo, Aithra, mother of Theseus and slave to Helen, is rescued by her grandsons Akamas and Demophon (west).[55] Directly opposite is another scene of rescue: Odysseus spares the Trojan Antenor and his wife Theano (east).[56] Like the Kassandra and Helen scenes on the vertical axis, the Aithra and Antenor scenes are intended to complement each other and the tondo which lies between them. In each scene along the horizontal axis an elderly figure raises an arm in a gesture of supplication towards a Greek warrior—Aithra to her grandsons, Priam to Neoptolemos, and Theano to Odysseus. Another visual link between the scenes is formed by the use of added white for the hair of the elderly characters. In addition, both the meeting of Aithra with her grandsons and the murder of Priam are located at an altar.[57] In essence the three scenes share the same subject: an elderly figure supplicates a warrior. But as in the vertical axis, one of the three scenes along the horizontal axis stands in contrast to the other two. The success of supplication in the lateral scenes is the antithesis of Priam's failure in the tondo, and in contrast to the turbulent movement in the centre, the lateral figures are still, the scenes peaceful. The thematic opposition of kinship groups observed on the Altamura Painter's Ilioupersis krater and on the Vivenzio Hydria of the Kleophrades Painter is operative here too. While Aithra is reunited with her family and Antenor's family is spared, Priam and his family are brutally attacked by the Greeks.

[55] Cf. Aithra on the Vivenzio Hydria (Cat. no. 23), discussed in §13.4 above.

[56] For identification of the scene see Williams (1991) 55–6, and for Antenor see M. I. Davies (1981), esp. p. 812 for the literary sources and p. 813 for the rescue at Troy. Pausanias, 10. 27. 3–4 records the rescue of Antenor as depicted in the wall-painting of Polygnotos in the Knidian Lesche at Delphi. The skin hung over Odysseus' shoulder in this scene, as Williams suggests, must be the skin which Odysseus hangs before Antenor's house as a sign to the Achaians not to attack. See also Sophokles, *Aias Lokros* fr. 11 (Radt) and Strabo, 13. 1. 53.

[57] We might furthermore suspect that the Antenor scene also took place at some type of sanctuary, perhaps the temple of Athena, since Theano is her priestess. The literary sources, however, place Antenor in his home at the time of the sack; see Pausanias, 10. 27. 3.

The juxtaposition of the Aithra, Priam, and Antenor scenes should also prompt the viewer to reflect on the roots of the war and the reasons behind Troy's ultimate destruction. As Pausanias recognized (10. 26. 7–8) in his discussion of Polygnotos' Ilioupersis painting in Delphi, the rescue of Antenor's family is motivated by his past support of the Achaian cause. When Menelaos and Odysseus came to Troy as ambassadors seeking the release of Helen, they were hosted by Antenor, who not only entertained his guests hospitably, but also foiled a Trojan plot to murder them.[58] In the *Iliad* Antenor is represented as an opponent of hostilities and an advocate of returning Helen to Menelaos.[59] It is because he sympathized with the Greeks, protected Menelaos and Odysseus, and opposed the abduction that he and his family are spared at the sack.

The rescue of Aithra is also to be associated with support of the Achaian cause. Her slavery began before the Trojan War, when the Dioskouroi rescued Helen from her previous abductor, Theseus.[60] In response to Theseus' act Helen's brothers sacked the city where she was held and, in addition to recovering Helen, also enslaved Theseus' mother Aithra. Later, when Paris abducted Helen, Aithra went to Troy as Helen's slave, and this second abduction gave the family of Theseus a chance to make amends for the previous error. Akamas and Demophon, the sons of Theseus, take part in the campaign against Troy, and in return for their services Aithra is freed from slavery when the city is taken—the scene depicted here by Onesimos. The story of Aithra can thus function both as a warning of the retribution which follows abduction—she was enslaved as a result of her son's aggression against Helen—and as an example of the rewards that follow the campaign against abduction—she is freed as a consequence of her grandsons' participation in Helen's rescue. The cloud of slavery still evident here casts its shadow also into the scenes immediately adjacent to Aithra (NW and SW). The present fate of the Trojan women in these scenes, soon to be taken captive by their Greek adversaries, parallels Aithra's past suffering and contrasts with her

[58] See *Il.* 3. 205–8 for Antenor as host. For the plot see *Il.* 11. 138–42 and Apollodoros, *Epit.* 3. 28–9. Antenor's hospitality and protection of the ambassadors probably formed part of the *Kypria*. See also Bakchylides, poem 15 for the reception of the embassy by Antenor and Theano.

[59] See *Il.* 7. 344–78, where Antenor urges that Helen be returned, Paris refuses, and Priam tacitly sides with his son.

[60] The poetic sources of the myth are discussed above in §6.2.

present release.[61] With the fall of Troy the yoke of servitude now passes from Aithra to her Trojan neighbours.

By flanking the tondo with two scenes of virtue rewarded, Onesimos suggests that we detect an element of punishment at work in Priam's death. While the lateral scenes express advocacy of the Greek cause and reward for opposition to abduction, the devastating results of Helen's abduction naturally fall upon Priam, who as leader of the Trojans must ultimately accept responsibility for failing to return her to the Greeks. Though sacrilegious and excessively brutal, Priam's death is a consequence of his actions. Trojan culpability extends also to the figure of Deiphobos, who lies dying behind the altar of Zeus in the tondo. Even after the death of Paris the Trojans refused to return Helen to the Greeks and instead married her to another of Priam's sons, Deiphobos. Onesimos joins the death of this second Trojan adulterer to the murder of Priam because Deiphobos, like his father, refused to recognize the legitimacy of the Greek claim upon Helen. His inclusion here complements the opposition between Antenor, spared because of his sympathy to the Greek cause, and Priam, whose death is motivated by his unwillingness to return Helen. Meanwhile Helen herself, the reason for the struggle which has led to this disaster, is depicted immediately below, at last reunited with her rightful husband.

The overall picture formed by these scenes is one of horror and brutality transgressing the norms of warfare. The Greeks abuse and slaughter defenceless Trojans and at the same time violate the sanctuaries of the gods.[62] Two instances of mercy, however, stand out in opposition to the scenes of violence and ask us to review the motivation behind the surrounding events. The rescue of Aithra and the sparing of Antenor suggest at least a sense of legitimacy in the Greek attempt to recover Helen. Noting the thematic contrast between these scenes and the tondo, the viewer cannot ignore the fact that the suffering of Priam and his family originates with the past errors of the Trojans themselves. The Greek victory is excessively severe, but the Trojan side is far from blameless.

[61] This relationship between the Aithra scene and those adjacent to it would suggest that a similar relationship once connected the Antenor scene with its neighbours, but the lack of one adjacent scene and the obscurity of the other make even speculation difficult.

[62] Cf. Williams (1991) 61 on the intensity of the brutality and sacrilege. I would, however, disagree with Williams's interpretation of the cup as a 'Greek celebration of the Greek defeat at Troy'.

The extensive visual and thematic symmetry which has led to this interpretation of the work can only be the result of a degree of deliberate arrangement and construction. In part, the artist achieves interaction among scenes by manipulating inherited iconographic patterns—for example, the altar in the Priam scene and the analogous statue in the Kassandra scene, and the similar gestures of father and daughter. Other parallels, however, seem to have required more radical innovations. The appearance of Aphrodite and Eros (south), figures which occur in no previous surviving examples of the recovery scene, may have been motivated by the artist's wish to create doublets with Astyanax (tondo) and with the statue of Athena (north) in the scenes above. Similarly, the rescues of Aithra and Antenor, not found in art before this cup,[63] may have been introduced specifically to contrast with the fate of Priam. In short, we must credit Onesimos with a deep appreciation for the significance of the images represented and with a remarkable ability not only to transmit tradition, but to shape and even to supplement it according to his own designs.

[63] Attempts have been made to identify Aithra's rescue in black-figure vase-paintings, but the identification is doubtful; see Kron (1981) nos. 59–65. Apart from the Onesimos cup, the earliest certain representation of the scene appears on a red-figure kalyx-krater decorated by Myson, BM E 458, *ARV* 239.16, *Para.* 349, *BA* 201, Kron (1981) no. 66. The krater is dated to between 500 and 490 BC and is therefore contemporary with the Onesimos cup.

14

Further Directions

14.1 Monumental Works

The fact that many of the Ilioupersis combinations on vase-paintings display deliberate and logical organization and interaction among scenes suggests that these features were to be found also on monumental representations. One tantalizing example is the series of Ilioupersis metopes on the north side of the Parthenon. Although the linear alignment of temple metopes does not facilitate the complexity of associations observed in Onesimos' octagonal arrangement, the Kleophrades Painter provides a sophisticated precedent for interactive adjacent scenes, and some comparable system of connections is likely to have governed the choice and structure of the adjacent temple metopes. The amazonomachy and centauromachy metopes running along other sides of the temple, since they feature less specific mythological moments and fewer identifiable characters, may have been arranged primarily according to visual concerns with balance and symmetry, but the Ilioupersis metopes would seem to have demanded a more deliberate, narrative ordering, whether following temporal or thematic progressions. Unfortunately, however, the poor preservation of the metopes themselves and the confusion over their original order permit little more than speculation about the composite scheme.[1] Furthermore, in the absence of a clear dialogue among the Ilioupersis metopes themselves, their position within the overall iconographic scheme of the temple remains obscure. Should the capture

[1] See Brommer (1967), esp. 210–21, for the most detailed study of the remains. Metopes 24 and 25 have been identified as the reunion of Helen and Menelaos, and metope 28 features the escape of Aineias. The series seems to be bounded by Helios in metope 1 and Selene in metope 29, and the latter's appearance perhaps indicates the nocturnal setting of the attack. Metopes 30–2 may depict an assembly of the gods. The subjects of the other metopes cannot be determined with any certainty, and while it is possible that the entire series was devoted to the Ilioupersis, some of the metopes may have represented earlier chapters of the war.

be read in conjunction with the battles against centaurs and Amazons as a glorious victory for the Greeks and the sons of Theseus? Or did the myth veil a subtle warning for the Athenians themselves, a reminder that the divine patroness could abandon the people who worshipped her if they allowed personal ambition to cloud their judgement.

A more accessible example from the mid-fifth century is Polygnotos' Ilioupersis wall-painting in the Knidian Lesche at Delphi, a work which although itself now lost, is described in detail in the tenth book of Pausanias' traveller's guide to Greece (10. 25–7).[2] While Polygnotos filled one part of the building with the catalogue of shades seen by Odysseus on his journey to the underworld (10. 28–31), he decorated the walls adjacent and/or opposite with a work of equal magnitude, a panoramic view of the Trojan conquest analogous in scale to Euripides' dramatic presentation of the disaster in *Troades*. Set primarily in the immediate aftermath of the victory, the Ilioupersis painting features a parade of characters, Greek and Trojan, distributed among scenes extending from the Trojan citadel to the Greek camp. Most of these scenes are densely detailed and highly innovative products, true to the spirit of the traditional narrative but only minimally, if at all, dependent on the standard iconographic patterns employed by the vase-painters. It is therefore fortunate that Polygnotos chose to label his characters—a practice common in vase-painting—thereby avoiding considerable potential confusion for Pausanias and his readers.

The Ilioupersis scenes covered an enormous rectangular surface, longer in width than in height, perhaps extending across two or even three of the building's four walls. Though positioned side by side and above and below one another, the scenes seem not to have been formally isolated within individual borders and may have overlapped or

[2] In his commentary on Pausanias, Frazer (1889) v. 356–72 offers general archaeological background, discusses many of the painting's complexities, and surveys the relevant scholarly work of the 19th c., including Carl Robert's elaborate reconstruction. See M. Robertson (1975) 247–53 for a more contemporary discussion of the date, medium, style, and position of the painting within the building, together with a detailed and sensitive analysis of the composition. Schefold (1975) 36–8 offers a concise discussion of the painting's structure. The most recent reconstruction is that of Stansbury-O'Donnell (1989). The work is generally dated to the second quarter of the 5th c., and the accompanying elegiac couplet of Simonides (10. 27. 4) argues for a date before 467 BC, the year of the poet's death. The segment of the painting devoted to Aias' crime resembles Polygnotos' painting in the Stoa Poikile at Athens, which according to Pausanias' description (1. 15. 2) also contained Trojan captives and Greeks assembled to punish Aias.

blended at the edges. In fact, it is impossible to subdivide the panel
into fully distinct scenes, and it is sometimes more accurate to speak
instead in terms of fields, each consisting of several characters clus-
tered in groups with a common setting. This arrangement no doubt
promoted the kind of multiple interaction observed on Onesimos'
Ilioupersis cup, as each character and each field could interact with
several neighbours. While the many images contributing to this im-
mense collage are not intended to harmonize fully within a single,
uniform perspectival frame of reference, Polygnotos effects some car-
tographic consistency by clustering the Achaian camp and ships on
the left and features of the city at the centre and the right. Tempor-
ally, most of the images belong to the aftermath of the capture, and
hence Pausanias refers to the composition as 'Troy taken' (10. 25.
2). The fact that no character appears more than once, at least in the
guidebook, gives an impression of simultaneity despite a few notice-
able temporal advances.

Pausanias chose to conduct his reader through the dense field
of characters from one end of the panel to the other, but given
the carefully planned bilateral symmetry of the whole, the painting's
centre offers an equally, if not more, convenient point of departure
for a systematic compositional analysis.[3] In the upper centre is an
image of the city wall, above which appears the head of the wooden
horse, a small reminder of the ruse by which the city fell (10. 26. 2).
Also in this area of the painting is Kassandra, sitting at the statue of
Athena, while Aias now takes refuge at the goddess's altar from a
group of Greeks angered by his crime (10. 26. 3). In the lower centre
of the panel Neoptolemos alone among the Greek warriors still fights
against the Trojans. As Pausanias notes, the painting is situated near
the tomb of the hero and is apparently intended to honour his accom-
plishments (10. 26. 4).

In ceramic painting, Aias and Neoptolemos are frequently paired
as sacrilegious warriors, the one violating the sanctuary of Athena
and the other the altar of Zeus Herkeios. Polygnotos repeats the tradi-
tional pairing, juxtaposing these two Greeks at the horizontal centre

[3] Pausanias does not specify whether his description begins at the left or the right.
Robert reconstructed the painting with Helen and the Achaian ships, the first field
discussed by Pausanias, at the right. But here I follow M. Robertson (1975) 247–8,
who argues that the 'Troy taken' met the underworld painting at the middle of the
north wall, and suggests that the water at the Trojan coast on the left edge of the
former met the water of Acheron at the right edge of the underworld painting.

of his composition, but in both cases he departs significantly from the iconography customarily employed by the vase-painters. Aias he places in the precinct of Athena, as usual, but instead of choosing the moment of attack, Polygnotos has shifted the primary temporal focus to the aftermath of the crime. While Kassandra still clings to the overturned statue—an image reminiscent of her standard pose on vases—Polygnotos has now moved Aias to the altar and introduced a group of Greek chieftains, gathered, it seems, in judgement of the alleged crime, to hear either Aias' oath of innocence or some promise of restitution.[4] Kassandra, of course, falls not to Aias but to Agamemnon in the division of Trojan spoils, and the inclusion of the latter here among the group of Achaian witnesses either represents or anticipates his claim to the Trojan captive. The effect of Polygnotos' alterations is uncertain, but they would seem to draw greater attention to Aias' crime, rather than excuse it. Although the understood condemnation from the group of Greek leaders may appear to isolate Aias and his act from the others, the scene is more likely to recall a tradition deriving from the *Nostoi*, whereby the storm of retaliation strikes the entire army because the chieftains failed to administer adequate punishment for Aias' crime (§5.1). By shifting the temporal setting forward and introducing the group of Greeks into the story, Polygnotos anticipates not just Aias' individual retribution, but the epidemic consequences of his crime—a fitting innovation for a painting of epic proportions.

In his representation of Neoptolemos, Polygnotos makes an even more radical departure from the ceramic tradition, abandoning the iconic image of the warrior murdering Priam together with Astyanax in favour of a less imbalanced confrontation.[5] No longer branded as the villain who butchers a defenceless old man, hurls his infant grandson to his death, and simultaneously desecrates the altar of

[4] M. Robertson (1967) reads here also a ritual of purification as a prerequisite to Aias' release. He conjectures that the term κλίνη ('couch'—10. 26. 2), describing a location where four of the Trojan captives are situated, is a corruption from κρήνη ('spring'), and that Epeios is not hurling the Trojan wall to the ground, as Pausanias imaginatively but falsely inferred (10. 26. 2), but is carrying water to the scene of purification from this nearby spring. Robertson's interpretation, though boldly dependent on a possible interpretive error of Pausanias and a textual uncertainty, is nevertheless compelling in that it ties together several seemingly independent pictorial elements into a coherent narrative.

[5] Astyanax is still with his mother among the Trojan captives to the right, leaving the relationship between him and Neoptolemos ambiguous (10. 25. 9).

Zeus, Polygnotos' Neoptolemos has just slain Elasos and now strikes Astynoos, who has fallen to his knees and begs in vain for mercy (10. 26. 4). Although Pausanias fails to record the age or equipment of these Trojans, given the description of Trojan corpses still wearing their armour in chapter 27, Neoptolemos' two opponents are most likely soldiers equipped for combat, not defenceless elders or children. Although Astynoos, like the suppliant Priam, appeals for mercy from his enemy, the religious component of the appeal is absent here, and Neoptolemos' rejection of the grovelling Trojan, reminiscent of Achilles' dismissal of Lykaon in *Iliad* 21, implies that the time for apologies and excuses is past.

The ostensible effect of this departure from the iconographic standard is to remove the censure attached to Neoptolemos in his more familiar environment and to reduce the viewer's sympathy with the victims. Just beyond this heroic image, however, Polygnotos plants a potential reminder of Neoptolemos' less glorious encounter with Priam. Not far from the warrior (Pausanias gives no indication of direction or distance, but moves immediately from Neoptolemos to this feature) Polygnotos positioned an altar with a corselet lying on it and a child clinging to it. Beyond the altar stands Laodike, a daughter of Priam; next to her Medousa, another princess, clings to a water-basin resting on a pedestal; and an old woman or eunuch (Pausanias does not know which) holds a naked child (10. 26. 5–9). Laodike, Pausanias tells us, is the wife of Helikaon and daughter-in-law of Antenor, and since Odysseus demonstrates his goodwill toward the Antenoridai and rescues the wounded Helikaon during the night battle in the *Mikra Ilias*, Pausanias concludes that Laodike herself must also have been spared (10. 26. 7–8). If we group her together with the altar, the combination of elements might allude to a successful supplication, to be followed later by a reunion between Laodike and the remainder of her husband's family, situated at the far right of the painting. The presence of Helikaon would strengthen Pausanias' argument, but he is absent from the description, and the presence of Medousa and the others complicates the suggestion of Laodike's release. While, however, the grouping of the altar, Laodike, and the other figures remains uncertain, the altar voices an unmistakable comment on the adjacent Neoptolemos scene. Given the contemporary popularity of the iconic image of Priam's death, the placement of an altar next to Neoptolemos can hardly fail to recall that familiar episode. The proximity of Priam's daughters helps

trigger the allusion, and the corpse itself lies somewhere to the right, although its distance from the altar cannot be determined.[6] Certainly Polygnotos could have tempered or avoided this suggestion, had he wished, simply by distancing the altar from Neoptolemos, but he preferred instead to paint an enigmatic portrait of the local hero, honouring his martial success without ignoring entirely the extremes to which his belligerent spirit carries him. Just as, in the scene directly above, the sacrilege of Aias remains manifest in the toppled statue of the goddess although the moment of the crime itself has passed, so too a trace of sacrilege lingers beside Neoptolemos, even though the warrior now engages in a different conflict.

To the right of the central cluster of scenes, Polygnotos devoted a considerable segment of the panel to the corpses of slain Trojans, stacked or strewn about on several planes (10. 27. 1–3). Pausanias lists ten by name, and for all but a few he is able to cite poetic accounts which identify the Greek adversary before whom the Trojan fell. As the recently deposed king of Troy, Priam naturally appears among the dead, and he is accompanied by a son, Axion. The more surprising inclusion of a body labelled 'Laomedon', belonging either to the former king of Troy now dislodged from his tomb or to a younger namesake, perhaps contributes a third generation of the same family (10. 27. 3). While the other corpses still lie on the ground, Polygnotos has drawn special attention to this one by having two Greeks, Sinon and Anchialos, carry it off ($\dot{\epsilon}\kappa\kappa o\mu\acute{\iota}\zeta o\nu\tau\epsilon\varsigma$), and M. Robertson sees here an allusion to the legend that Troy would not fall while King Laomedon rested safely in his tomb.[7] Since Laomedon was notorious for his deceitful dealings with both gods and Greeks, his inclusion here among the defeated simultaneously calls into question the Trojan ethics which precipitated the war.[8] And for those who know that

[6] Without indicating his own assent or dissent, Frazer (1889) v. 368 records a fascinating conjecture of Carl Robert, accounting for both Laodike and the corselet: 'Prof. C. Robert suggests that we are to suppose this corselet to have been brought by Laodice, daughter of Priam (*Il.* vi. 252), to her father Priam at the altar where he had taken refuge, and that before Priam could put it on he was murdered by Neoptolemos (*Die Iliupersis des Polygnot*, p. 64).'

[7] M. Robertson (1970) points to evidence preserved in Plautus' *Bacchides* and Servius' commentary on the *Aeneid* for the legend that regarded the tomb of Laomedon, situated in the lintel of the Skaian gates, as a source of security for the city, analogous to the Palladion. The Trojans perhaps forfeited that security when they damaged the gate to accommodate the entrance of the wooden horse.

[8] Stansbury-O'Donnell (1989) 213 makes Laomedon and Helen the visual focal points of the two wings of the composition, and reads both as symbols of 'Trojan misdeeds'.

Priam's father died at the hands of Herakles, the prominent corpse also bridges this and the antecedent Greek campaign against Troy, both of which ended in desolation for the city and death for the king (§6.1). In addition to the royal family, Polygnotos completes the group with several other Trojan nobles, as well as the foreign ally Koroibos, who recently joined the Trojan ranks with hopes of winning Kassandra as his bride (10. 27. 1). Recalling his unsuccessful suit, the viewer will feel the dissonance between Priam's original plans for his daughter and the unwelcome proposals of Aias and Agamemnon alluded to in the neighbouring scene at the sanctuary of Athena.

In exposing to his audience this startling array of corpses, Polygnotos focuses attention on the achievement rather than the process of achieving. He has forgone the thrill of suspense, the impatience of soldiers waiting nervously within the wooden horse, the anticipation of ambush, and even the mild uncertainty of combat, and offers instead an image of utter finality. The king's headless and nameless trunk left lying on the seashore in *Aeneid* 2 paints a similar picture of irreversible, irreparable termination. As in the underworld scenes opposite, action is past, and the present is a world of quiet and stillness. Laomedon perhaps adds a hint of Trojan dishonour, and the cluster of dead bodies advertises an immense failure antithetic to the adjacent success of Neoptolemos, but at the same time it is hard to imagine the field of corpses without a sense of lament over Troy's passing.

Balancing the corpses stacked to the right of Aias and Neoptolemos is a group of female captives to the left of the centre—Pausanias names eleven—distributed among several horizontal registers, as are their male counterparts opposite (10. 25. 9–26. 2).[9] Polygnotos has thus arranged the central scenes of the panel as a triptych, with an implied chronological progression from centre to wings, from action to the results of action. The figure of Kassandra provides one of several possible unifying factors, attaching to the corpse of her suitor Koroibos to the left and simultaneously sharing the plight of her fellow-captives to the right. Also significant in the structure of the central triad is the artist's decision to isolate the group of captives from the corpses. The battles of the night, reflected in the conflict between Neoptolemos

[9] In addition to this cluster of captives to the right of the centre, Pausanias mentions a few others who do not seem to have been joined pictorially to this group: Laodike, Medousa, and an old woman or eunuch with a child (10. 26. 7–9). These figures, as discussed above, may be on the opposite side of Neoptolemos and near to the slain Trojans, but their position is uncertain.

and the two Trojans, have severed the women from their Trojan kinsmen both figuratively and literally. With their husbands, brothers, and fathers slain, their former families destroyed, the women are now transferred into the hands of the Greek victors. The actual distribution of spoils, however, is yet to take place, and the captives remain momentarily in limbo, herded together as at the opening of Euripides' *Troades*. Physically Polygnotos situates them between the city and the ships, between one life and the next, and temporally he positions them in a thin channel of calm bordered by storms, for Polyxene still resides among the group and Astyanax still clings to his mother's breast. Pausanias does not neglect to remind us that the Greeks will soon sacrifice Polyxene at the tomb of Achilles (10. 25. 10) and hurl Astyanax from the tower (10. 25. 9).

To the left of the captives is the seaside camp of the Achaians, some of whom are shown tending wounds received in the fighting of the previous night (10. 25. 5–6). Most of the activity here, however, appears to be centred upon the crew of Menelaos and upon Helen, the ultimate goal of the campaign against Troy, at last retrieved and ready to return to Sparta. With the central Aias scene Polygnotos has already cast a shadow of apprehension over the homeward journey ahead; and here too, while Menelaos' crew make preparations for departure, Polygnotos paints a stormy future in the figure of Phrontis, stationed prominently on the deck with two boat-poles. As Pausanias recalls, the loss of this steersman at Cape Sounion in *Odyssey* 3 marked a change of fortune that cast Menelaos and his ship all the way to Egypt before allowing them a safe return to Sparta (10. 25. 2). Nearby sits Helen, with one servant stationed at her side and another at her feet—a substantial departure from standard ceramic iconography, which prefers to picture her in conjunction with Menelaos, and often suggests a less than blissful reunion (10. 25. 4). A group of three women glancing toward her, Briseis among them, may bring to mind the fame of her beauty. The proximity of the downcast Helenos, the Trojan prince and prophet who betrayed the secrets of his city's preservation, perhaps alludes to his alleged infatuation with Helen (see Apollodoros, *Epit.* 8. 9). The herald Eurybates is also present, as Pausanias explains, to seek Helen's permission for the release of the slave Aithra, pictured nearby together with her grandson Demophon (10. 25. 4 and 7–8). The respect thus conferred upon Helen leaves little doubt that she has been reconciled with her husband, and Pausanias seems not to have detected any embarrassing questions

pertaining to her fidelity. These final left-hand scenes neatly coun-
terbalance the clusters of captive Trojans just to the right. As on
Onesimos' elaborate Ilioupersis cup, the release of Aithra is intro-
duced as an emotional antidote in the midst of enslavement; and the
treatment of the Trojan women is again countered with inversion in
the rescue of Helen, a juxtaposition explored as early as the Mykonos
pithos.

Offsetting the activity at Menelaos' ship is another scene of depar-
ture at the far end of the panel. Beyond the piles of Trojan corpses,
the family of Antenor pack their belongings in preparation to leave
the fallen city, though with notably less enthusiasm than their Greek
counterparts opposite (10. 27. 3–4). A panther skin hangs above the
entrance to their home, a sign placed by Odysseus, Pausanias tells
us, instructing the Greeks to spare the household. Odysseus has in-
tervened presumably because of Antenor's past sympathy with the
Greek claim to Helen, and because the family once rescued Odysseus
and Menelaos when a Trojan plot threatened their lives (see §13.5,
end). The victorious Greek now returns the favour. As on Onesimos'
Ilioupersis cup, Antenor's conciliatory policy toward the Greeks exem-
plifies the alternative, the route not taken by the rest of the Trojans,
whose corpses now litter the ground nearby. And the tension between
reward and punishment created in this juxtaposition of Antenor and
the corpses reflects the contrast in the opposite wing of the composi-
tion between the slavery of the Trojan captives and the freedom now
granted to Helen and Aithra.

Although Pausanias' guidebook cannot reveal all of the detailed
complexities of Polygnotos' mural, it has allowed a fairly comprehens-
ive analysis of the overall configuration of scenes as well as glimpses
at several compositional devices welding individual units together.
The work as a whole appears to be structured according to a *CBABC*
pattern.[10] The captured citadel and the last moments of the fighting
occupy the centre of the panel, where Polygnotos awards particular
prominence to the local hero Neoptolemos. To the left and right are
the conquered Trojans, dead warriors and captive women. Finally,
at either end are preparations for future journeys, the continuation
of the saga. A smooth temporal and thematic progression leads the
viewer from the centre to the sides, while the companion fields to the
left and right of the centre neatly mirror each other. As on the Vivenzio

[10] Schefold (1975) 37–8 offers an illuminating comparison of the five-part arrange-
ment of Polygnotos' painting and the five-scene composition on the Vivenzio Hydria.

Hydria and Onesimos' Ilioupersis cup, various thematic correspond-
ences enhance the overall symmetry by interlocking neighbouring
pieces. In the painting itself we might expect to find figures linked
also by the type of geometric patterning and reflection employed by
the Kleophrades Painter, as well as by chromatic similarities com-
pelling the eye to associate one scene with another.

How closely Polygnotos intended to pair his 'Troy taken' with the
complementary underworld adventure of Odysseus is a matter of
some speculation, since a comprehensive, one-to-one correlation be-
tween the two paintings is not apparent in Pausanias' record. Both
scenes share a partial mood of melancholy stillness, corpses and cap-
tive women populating one picture and lifeless shades the other. The
companion piece also supplements the narrative of the Ilioupersis
with a subsequent chapter in the same campaign, as the departure
from the coast of Troy led many of the Greeks directly to the shore of
Hades, and a few characters of Polygnotos' Ilioupersis actually re-
appear in his underworld. Beyond specific thematic ties, however, it
is the sheer abundance of subjects contained within these two epic
chapters which most readily unites them into a formally compatible
pair. As *Odyssey* 11 demonstrates, the underworld offers a potentially
endless series of encounters for a visiting hero, and the poet must ulti-
mately induce dread to compel Odysseus' withdrawal from the over-
whelming number of fascinating shades. Warriors who died at Troy,
preceding generations of heroes, a catalogue of female shades, and
several infamous criminals receiving their merited punishments make
Polygnotos' underworld a fitting companion in scale and grandeur
to the Ilioupersis mural opposite, and the alliance between the two
works reminds us that the Ilioupersis too forms a kind of catalogue,
allowing the artist unusual room for display, while at the same time
necessitating creative cohesive manœuvres.

14.2 Combination of Ilioupersis and Other Trojan Scenes

Polygnotos' juxtaposition of Troy and the underworld is just one ex-
ample of the wider phenomenon of combination between Ilioupersis
scenes and other segments of the Trojan story. Like the Archaic poets,
who employed the Ilioupersis as a magnetic focal point within the
Trojan saga and repeatedly bonded events of the sack with preced-
ing and following episodes, the artists too appreciated the potential
for coalition between the Ilioupersis and the broader story of Troy.

The external narrative can sometimes be felt even within individual Ilioupersis scenes. The black-figure confrontation of Aias with Athena, for example, anticipates her ensuing anger and his imminent death, and the rescue of Antenor carries with it the memory of his past kindness to the Greeks. Actual combinations with relevant, external Trojan scenes, however, are rarer than combinations of Ilioupersis scenes alone, and as Polygnotos' work in Delphi demonstrates, the bonds are often weaker.

In addition to the nine scenes on its interior, Onesimos' Ilioupersis cup features two more Trojan scenes on the exterior, on one side the taking of Briseis from Achilles, and on the other the battle between Telamonian Aias and Hektor (Cat. no. 16).[11] Given the web of interaction uniting the interior scenes, it is tempting to look for similar correspondences with the exterior scenes and to incorporate them into a comprehensive interpretation of the entire decorative scheme. Both exterior panels contain episodes of the Trojan War, both episodes are chronologically earlier than the capture of the city, and both stories are narrated in the *Iliad*. The Briseis episode suggests a weak analogy to the series of events revolving around Helen on the interior, since the unjustified appropriation of each of these two women has disastrous consequences for the party of the offender. The Briseis scene thus echoes the critical attitude toward Helen's abduction voiced in the east–west axis of the interior, where clemency and reward for the pro-Achaian families of Antenor and Theseus throw into relief the interposed punishment of Priam and his son Deiphobos. The battle between Aias and Hektor, on the other hand, can best be allied with the interior via polarity rather than analogy. As one of the Iliad's few formal heroic duels between champions of relatively comparable stature and ability, it calls into question the heavy imbalance in the many interior conflicts, where fully armed Greek warriors ambush poorly armed Trojan men, together with Trojan women, the ageing king, and his infant grandchild. In conjunction with this transformation in the conduct of warfare, the viewer might also recognize that the heroes Hektor and Aias, like Achilles and Patroklos opposite, will not live to participate in the brutal conflict that accompanies the city's fall. Thus, while one exterior scene generates potential antipathy towards the original Trojan act of aggression, the other counterbalances that sentiment by disparaging the conduct of the victorious Greeks.

[11] For illustrations see Williams (1991) figs. 8k–n.

This dialogue of comparison and contrast between interior and exterior, however, is far less audible than that shared among the interior scenes alone. The channels of communication here are muffled, and the exterior resists complete integration into a federated narrative. While the Ilioupersis scenes rely heavily on pronounced reiteration of shapes and gestures in combination with shared themes, no such visual reflections direct interaction beween interior and exterior, and while we can extract dialogues between the Iliadic and Ilioupersis episodes, the same dialogues do not operate between the two exterior scenes themselves. It is safest to sum up the vase as a whole as slices from the Trojan cycle, a tightly knit Ilioupersis ensemble on the interior and two loosely related, earlier episodes on the exterior.[12] The search for further unity remains an exercise open to the viewer, but it is not a project which Onesimos took pains to promote, and in fact, the artist may have deliberately avoided stronger correlations with the exterior in order not to upset the delicate balance within.

In contrast to Onesimos, who relegated two Iliadic scenes to the periphery of a large Ilioupersis collage, the vase-painter Makron has established a lively exchange of shape and theme between a single Ilioupersis episode and a single external episode paired on opposite sides of a skyphos (Cat. no. 18*). Paris, accompanied by Aineias, removes Helen from the home of Menelaos on one side of the cup (Fig. 9(a)). Like a bride following a bridegroom, she proceeds with downcast head as he leads, her wrist grasped by his hand. Aphrodite is present to fulfil her promise to Paris, and together with a winged Eros she adds a note of eroticism to the encounter. Peitho, persuasion deified, stands by at the right to urge Helen forward. A small boy, possibly a child of Helen by Menelaos, stands inconspicuous under the right handle and raises an arm towards the departing company. The other side of the skyphos contains an inherently complementary scene, the reunion of the abductee with her former spouse (Fig. 9(b)). As Menelaos begins to draw his sword to exact vengeance, Helen lifts her cloak, and her beauty, implied by the outline of her body beneath her diaphanous clothing, arrests the murderous anger of the approaching warrior. Aphrodite stands behind Helen to ensure a non-violent reunion between husband and wife. The presence of Chryseis and Chryses to the left perhaps suggests that the scene takes

[12] Cf. the notoriously puzzling concoction of scenes on the François Vase. Common threads appear, but a single unifying strand is absent.

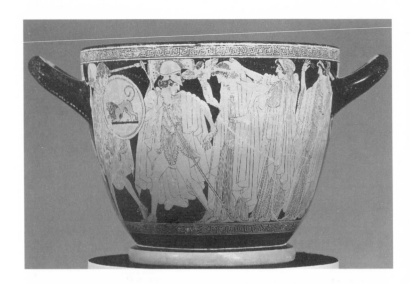

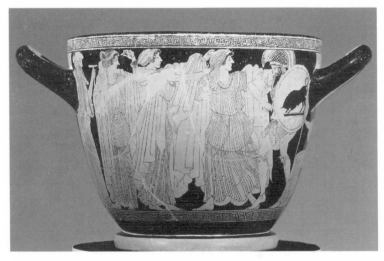

9(*a*) (*top*) Attic red-figure cup-skyphos, Makron, Cat. no. 18. Side A:
Paris abducts Helen. (Francis Bartlett Donation; courtesy, Museum of Fine
Arts, Boston.)
9(*b*) (*below*) Side B: Menelaos recovers Helen.

place within the sanctuary of Apollo, and to the far right, Priam observes the scene from his seat under the handle.

The narrative continuity between the two paintings is immediately obvious. Paris abducts Helen from her Spartan home, but Menelaos ultimately retrieves her from the captured city of his enemy. On the skyphos we see the beginning and the end of the Trojan conflict, cause and effect, back to back. Moreover, the painter has built the two scenes upon a common compositional format—a similar cast of characters arranged in similar positions. In the abduction scene Aphrodite raises her hands to Helen's head, to remove Helen's cloak or to veil (or unveil) the face of the bride,[13] and Makron mirrors this pose on the opposite side, where the same goddess again extends her arms around Helen's head, this time to reveal Helen's beauty to her angered husband. Paris and his companion gaze back upon Helen in admiration as they lead her away, and Menelaos directs an analogous, piercing glance towards the captivating body of his wife. On one side the desire aroused by Helen's appearance leads to her abduction, and on the other that desire saves her life. Although the cup's two handles formally divide the two episodes from one another, the figure of Priam situated under the handle to the right of the reunion can be read as a transitional link between the two sides. With his back turned toward Paris, he seems to condemn the abduction, and his prospective glance toward the reunion anticipates the ultimate effects of his son's reckless behaviour.[14]

This calculated juxtaposition arouses a particular interest in the character and culpability of Helen, the central object of attention on both sides. While Menelaos has already discarded his sword in many red-figure reunion scenes, this Menelaos is still drawing the weapon from its sheath—a gesture which, despite his obvious distraction, advocates judgement over pure forgiveness. Chryseis and Chryses, otherwise unknown in the context of the Ilioupersis, should remind the viewer of this maiden's forced abduction, of its devastating

[13] Simon (1981) 120 suggests the veiling of the bride.

[14] M. Robertson (1995), noticing that a calm Priam is out of place in an Ilioupersis context, tentatively suggests that instead of the couple's final reunion, the painting represents an earlier encounter, one that took place during the embassy of Menelaos and Odysseus to Troy. Given the lack of strong comparative evidence, however, and the carefully crafted complementarity between the cup's two sides, I prefer to identify the scene as the Ilioupersis reunion and read Priam as a liminal spectator rather than a real participant. Cf. the array of spectators on the Priam Painter's Kassandra hydria (Cat. no. 8*) discussed above in §13.1.

consequences for the Greek army at the opening of the *Iliad*, and of her subsequent return to her father. Her inclusion here seems to be asking whether we can categorize these two women together as passive victims of male aggression. And the inscriptions identifying her and her father as 'Kriseis' and 'Kriseus', rather than simple misspellings, perhaps pun on the base 'kris-', making the priest and his daughter 'judges' of Helen's trial. Priam's attitude is ambiguous. The abduction leads to the capture of his city and to his murder, but like the gentle father-figure of the *teichoskopia* in *Iliad* 3, he may still feel compassion for his beautiful daughter-in-law.[15]

The atmosphere of judgement at Helen's reunion with Menelaos points inevitably to the scene opposite, to the circumstances surrounding her initial departure from Menelaos' house. Was this a case of abduction or of elopement? Is Makron's Aphrodite, whose outstretched hands seem to direct Helen's movements, akin to the controlling and menacing goddess of *Iliad* 3? Can Helen present a Gorgianic defence, ascribing her actions to insurmountable divine compulsion? Or do Eros and Peitho instead imply that Helen has weakened in the face of erotic persuasion? Although no one is present to prevent the abduction, Helen herself shows no signs of resistance, and the downcast head of the timid bride carries a hint of shame at the betrayal of Menelaos. More damning is the inclusion of the small boy at the far right, perhaps accusing Helen, as Alkaios (fr. 283) had done, of abandoning her own child.[16] Despite the multitude of evidence, however, Makron has not painted unequivocal grounds for acquittal or conviction. While different viewers may judge the matter differently, the complexity of the case and the array of conflicting questions it provokes fuels continued fascination with the vase and its ambiguous heroine.

We turn finally to Helen's occasional Trojan counterpart, Kassandra, and to a vase which combines her ordeal at the hands of Aias with her subsequent death at the home of her second Greek admirer (Cat. no. 32*). On one exterior side of a large kylix dated to the second half of the fifth century, the Marlay Painter depicts Kassandra in flight towards the statue of Athena, while Aias pursues with drawn sword from the left (Fig. 10(a)). Although Kassandra is better clothed

[15] Cf. Simon (1981) 121.

[16] Kahil (1988) no. 166 identifies the unlabelled child tentatively as Helen's son Nikostratos.

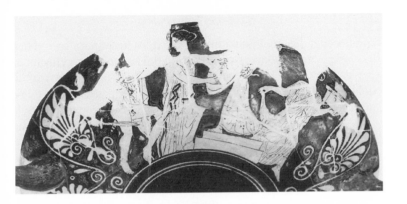

10(a) (top)
Attic red-figure
cup, the Marlay
Painter, Cat. no. 32.
Side A: Aias attacks
Kassandra. (Fotografia
del Museo Archeologico
Nazionale di Ferrara.)
10(b) (above) Side B:
youth pursues maiden.
10(c) (right) Interior:
Klytaimestra murders Kassandra.

than is usual, her traditional nudity is echoed in the exposure of her right side from shoulder to foot. Beyond the statue a second woman flees, carrying with her two small containers. Like the priestess in the Niobid Painter's depictions of Priam's death (Cat. nos. 24 and 25), she removes religious implements from the scene of sacrilege.

On the left side of the opposite exterior surface a beardless male figure, carrying a spear and wearing a cloak and traveller's hat, pursues a female figure fleeing towards the right (Fig. 10(*b*)). Before her stands a bearded man, whose head is turned towards a second female figure approaching from the right, her outstretched arms indicating some anxiety over the nearby pursuit. Identifications are problematic. A victorious Menelaos recovering his wayward wife in the presence of two concerned divinities would continue the Ilioupersis narrative with a familiar complement to the more violent encounter of Aias and Kassandra opposite, but the iconography does not readily support such a reading. Instead the painter has given us a less specific scene of erotic pursuit with a strong implication of imminent conjugal union between the eager youth and the as-yet untamed bride.[17] The youth in this and similar pursuit scenes, regularly equipped with petasos, chlamys, and two spears, is often thought to be Theseus, the ideal Athenian ephebe.[18] The maiden may sometimes be construed as Helen, but given the number of mythological heroines associated with Theseus and the general absence of inscriptions in such scenes, absolute identification is impossible.[19] The iconography places less emphasis on a specific mythological incident than on the ritualized marital chase. The stationary bearded man and the agitated woman to the right are the stereotypical parents of the frightened bride. While the mother exhibits obvious concern for her daughter's welfare, the father refuses to interfere in the ceremony that will transfer the girl from his house to the house of her husband.[20]

[17] Sourvinou-Inwood (1991) provides a detailed and sensitive treatment of the iconography of erotic pursuit. Ch. 2.1, 'Menace and Pursuit: Differentiation and the Creation of Meaning', pp. 29–57, and ch. 2.2, 'A Series of Erotic Pursuits: Images and Meanings', pp. 58–98, are of particular relevance to the pursuit on the Marlay Painter's cup.

[18] Cf. Sourvinou-Inwood (1991) 40: 'for both Athenian artists and viewers the elements "youth", combined with "chlamys, petasos, and spear(s)" made up the sign "ephebe" and/or "Theseus as ephebe".'

[19] Sourvinou-Inwood (1991) 64 considers the complex Eriboia/Periboia/Phereboia as the best candidate, if a choice must be made.

[20] For further discussion of the marriage implication in the pursuit scene and the association of marriage with abduction, see Sourvinou-Inwood (1991) 64–8.

Despite the lack of a pronounced mythological correlation between the two exterior scenes, the painter clearly intended them as a pair, each reflecting the other in shape and subject. From left to right in both, a male figure pursues a female figure, his hand grasping her shoulder, and she flees in vain towards a perceived source of protection, the inanimate statue on one side and the inactive father on the other. Completing each scene is a second female figure, distressed in both cases, one fleeing and the other drawing closer to the conflict. Reflection, of course, as observed above in Ilioupersis combinations, should prompt the viewer to scrutinize closely the relationship between paired scenes, and closer scrutiny of this reflective pair reveals a serious polarity contained within the superficial resemblance. While both sides of the cup feature an act of male aggression against a female target, the aggression on one side is tempered by the implication of socially sanctioned marriage. Though reluctant, the maiden must wed, and the father assents to the union despite the mother's concern. On the opposite side, however, a bearded adult replaces the young lover, and while the ephebe's spear rests at ease in his arm, its tip pointed to the rear, Aias has drawn his sword and holds it at his side ready for attack.[21] The statue of the virgin goddess is hardly an equivalent substitute for Kassandra's absent father, and although the goddess herself fails to intervene, the statue's adversarial pose warns already of the penalty soon to be exacted for this crime. The marriage pursuit here degenerates into a vicious and sacrilegious rape. A few alternative interpretations of the reflection might be wagered in opposition. A viewer sensing the brutality of the assault on Kassandra might impute a tone of condemnation also to the semi-mythological domestication opposite; or vice versa, Aias' action, mitigated in light of the companion scene, might be viewed as a mock prelude to marriage. But such interpretations would, to my mind, undervalue the critical differences and violate the iconographic integrity of the individual scenes.

[21] While not contrasting these two paintings specifically, Sourvinou-Inwood (1991) 29–57 argues persuasively for a generally valid distinction of meaning in Attic iconography between the spears held inactive by the side of an ephebe and a drawn sword in similar scenes, the former denoting erotic pursuit and the latter serious attack. Eroticism is not necessarily excluded by the sword, as the Kassandra scene demonstrates, but the weapon carries with it also a level of violence not present with the relaxed spears. Sourvinou-Inwood (pp. 36–8) discusses various positions in which the ephebe holds the spears, all lacking a sense of martial hostility.

Kassandra's story continues on the cup's tondo with a comple-
mentary scene of sacrilege previously unknown among the repertoire
of the vase-painters, its stimulus no doubt originating in Aischylos'
Agamemnon (Fig. 10(c)).[22] To the right Kassandra crouches awk-
wardly at the foundation of an altar underneath a laurel tree, both
features partially eclipsed by the frame of the tondo. Her feet and
legs push her toward the altar and away from danger, while she turns
her head and upper body to the left and extends one arm in supplica-
tion towards her attacker. Klytaimestra lunges forward from the left
wielding an axe above her head with both hands, and unlike the altar
and tree opposite, the axe and her right foot both overlap the decor-
ative frame, making her violent aggression appear to surge beyond
the confines of the picture. Kassandra's exposed right breast recalls
her traditional nudity in Ilioupersis scenes, as displayed in modified
form on the cup's exterior, but the significance of her exposure has
here been transformed in conjunction with the nature of the crime.
While her body once aroused the sexual aggression of Aias, it now
fuels the jealousy of the Aischylean Klytaimestra, who vents her rage
not only on her estranged husband, but also on the beautiful concu-
bine brought home to share the wife's bed.[23] Another point of affinity
with Aischylos is the theme of sacrifice, unmistakably implied by the
altar setting and by the ceremonial double-headed axe prominently
displayed in the hands of the attacker at the top of the field.[24] As in
some depictions of Priam's murder, blood staining the altar indicates
previous animal sacrifice, the regular cult practice to be contrasted
with the perverse abnormality of the present human slaughter.[25] The
tripod frozen in mid-fall, overturned in the violent confrontation, con-
demns Klytaimestra's blatant disregard for the sanctity of the location,
and like the occasional symbols of Apollo in Ilioupersis crime scenes

[22] For another likely instance of Aischylean influence on a painter see Vermeule
(1966) on the Boston Oresteia krater, esp. pp. 6–7. On the opposing sides of this vase
the painter pairs the death of Agamemnon, dramatized in Aischylos' *Agamemnon*, with
the death of Aigisthos, dramatized in the *Choephoroi*.

[23] Aischylos' Klytaimestra voices her indignation toward the concubine at *Ag.*
1438–46.

[24] For the theme of corrupted sacrifice in *Agamemnon* see in particular Zeitlin
(1965). Connelly (1993) 122, discussing the relationship between the play and the
vase, draws attention to *Ag.* 1277–8: 'in place of the paternal altar waits a chopping-
block, | warm and bloodied from a previous slaughter' (βωμοῦ πατρῴου δ᾽ ἀντ᾽ ἐπίξηνον
μένει, | θερμῷ κοπείσης φοίνιον προσφάγματι).

[25] Connelly (ibid.) points out also that Klytaimestra 'is dressed as one who sacrifices,
with himation slung apron fashion across her waist'.

(for example, Cat. nos. 11, 16*, and 23), the tripod and the laurel anticipate the punishment that will eventually overtake the offender at the hands of Apollo's agent Orestes.

Together the three scenes form a progression of intensifying violence directed against young women: on the exterior an erotic pursuit degenerates into a hostile sexual attack, and a sacrificial murder terminates the series in the tondo. The spear held gently in the ephebe's arm gives way first to the sword held in readiness at Aias' side and finally to the sacrificial axe which is soon to end Kassandra's life. A sequence that begins with male aggressors reaches a shocking climax with a female agent of violence reminiscent of the man-like Klytaimestra of Aischylos' *Agamemnon*. Although the repeated victimization in a sacrilegious setting seems designed to evoke sympathy for Kassandra, if we read the symbols of Apollo surrounding her death in light of the questions regarding virginity posed in the exterior scenes, we might recall the duplicitous sexual game Kassandra once played with the god, gaining for herself his gift of prophecy, but refusing to yield her virginity in return. Thus, while we may pity the object of Klytaimestra's savage and sacrilegious attack, the painting also allows us to detect a faint but disturbing dissonance between Kassandra's previous betrayal of Apollo and her present plea for salvation at his altar.[26]

[26] Aischylos acknowledges Kassandra's betrayal at *Ag.* 1202–8.

Appendix

Comparison of Editorial Numeration for Relevant Fragments

Bernabé frr.	Davies frr.
Kypria	
13	12
14	11
19	inc. loc. 4
21	16
28	22
34	27
Mikra Ilias	
12	13
13	14
15	16
16	test. 7 and fr. 17
19	19
21	20
24 (inc. op.)	4
Iliou Persis	
1	fr. dub.
5	3
6	4

Bibliography

Ahlberg-Cornell, G. (1992), *Myth and Epos in Early Greek Art: Representation and Interpretation* (Studies in Mediterranean Archaeology, 100; Jonsered).

Aldrich, K. M. (1961), *The* Andromache *of Euripides, University of Nebraska Studies*, NS 25 (Lincoln, Nebr.).

Allen, T. W., and Monro, D. B. (1917, 1919, 1920, and 1920), *Homeri Opera*, vols. iii², iv², i³, and ii³ (Oxford).

Andersen, Ø. (1977), 'Odysseus and the Wooden Horse', *Symbolae Osloenses*, 52: 5–18.

Anderson, M. J. (1995), 'Onesimos and the Interpretation of Ilioupersis Iconography', *JHS* 115: 130–5.

Arias, P. E. (1962), *A History of Greek Vase Painting* (London), trans. and rev. B. B. Shefton, photos M. Hirmer.

—— (1963), *Storia della ceramica di età arcaica, classica ed ellenistica e della pittura di età arcaica e classica* (*Enciclopedia classica*, xi. *Archeologia e storia dell'arte greca*; Turin).

Aurigemma, S. (1960–5), *La necropoli di Spina in Valle Trebba* (Rome).

Austin, R. G. (1964), *Aeneidos Liber Secundus* (Oxford).

Beazley, J. D. (1947), *Etruscan Vase-Painting* (Oxford).

—— (1954), 'A Cup by Hieron and Makron', *Bulletin van der Vereeniging tot Bevorderung der Kennis van de Antieke Beschaving*, 29: 12–15.

—— (1974), *The Kleophrades Painter* (Mainz), a revised translation of *Der Kleophrades-Maler* (Berlin, 1933).

Bernabé, A. (1987), *Poetae Epici Graeci: Testimonia et Fragmenta*, vol. i (Leipzig).

Bethe, E. (1922), *Homer, Dichtung und Sage, ii. Odyssee, Kyklos, Zeitbestimmung* (Leipzig), reprinted in 1929 with different pagination.

Bielefeld, E. (1952), *Zur griechischen Vasenmalerei des 6. bis 4. Jahrhunderts vor Christus* (Halle).

Boardman, J. (1974), *Athenian Black Figure Vases* (London).

—— (1975), *Athenian Red Figure Vases: The Archaic Period* (London).

—— (1976), 'The Kleophrades Painter at Troy', *AK* 19: 3–18.

—— (1990), 'Herakles', part V.A in *LIMC* v (Zurich and Munich), 111–13.

Brommer, F. (1967), *Die Metopen des Parthenon* (Mainz).

Burkert, W. (1983), *Homo Necans*, trans. P. Bing (Berkeley).

Burnett, A. P. (1971), *Catastrophe Survived: Euripides' Plays of Mixed Reversal* (Oxford).

—— (1977), '*Trojan Women* and the Ganymede Ode', *YCS* 25: 291–316.

Buschor, E. (1934), 'Kentauren', *AJA* 38: 128–32.

Calder, W. M. III (1966), 'A Reconstruction of Sophocles' *Polyxena*', *GRBS* 7: 31–56.

Canciani, F. (1981), 'Aineias', *LIMC* i (Zurich and Munich), 381–96.

Carpenter, T. H. (1991), *Art and Myth in Ancient Greece* (London).

Carter, J. (1972), 'The Beginning of Narrative Art in the Greek Geometric Period', *BSA* 67: 25–58.

Caskey, L. D., and Beazley, J. D. (1963), *Attic Vase Paintings in the Museum of Fine Arts, Boston*, vol. iii (Boston).

Caskey, M. E. (1976), 'Notes on Relief Pithoi of the Tenian-Boiotian Group', *AJA* 80: 19–41.

Childs, W. P. (1991), 'A New Representation of a City on an Attic Red-figured Kylix', *Greek Vases in the J. Paul Getty Museum*, v: 27–40.

Christiansen, J. (1974), 'Et skår fra Mykonos', *Meddelelser fra Ny Carlsberg Glyptotek*, 31: 7–21.

Clay, J. S. (1983), *The Wrath of Athena: Gods and Men in the Odyssey* (Princeton).

Conacher, D. J. (1987), *Aeschylus' Oresteia: A Literary Commentary* (Toronto).

Connelly, J. B. (1993), 'Narrative and Image in Attic Vase Painting: Ajax and Kassandra at the Trojan Palladion', in P. J. Holliday (ed.), *Narrative and Event in Ancient Art* (Cambridge), 88–129.

Davies, M. (1988), *Epicorum Graecorum Fragmenta* (Göttingen).

—— (1989*a*), 'The Date of the Epic Cycle', *Glotta*, 67: 89–100.

—— (1989*b*), *The Epic Cycle* (Bristol).

—— (1991) (*post* D. L. Page), *Poetarum Melicorum Graecorum Fragmenta*, vol. i (Göttingen).

Davies, M. I. (1981), 'Antenor I', *LIMC* i (Zurich and Munich), 811–15.

Davreux, J. (1942), *La Légende de la prophétesse Cassandre d'après les textes et les monuments* (Paris).

Dawson, H. S. (1927), 'On *Agamemnon* 108–120', *CR* 41: 213–14.

de Jong, I. J. F. (1989), *Narrators and Focalizers: The Presentation of the Story in the Iliad* (Amsterdam).

Demargne, P. (1984), 'Athena', *LIMC* ii (Zurich and Munich), 955–1044.

Denniston, J. D., and Page, D. (1957), *Aeschylus: Agamemnon* (Oxford).

Diggle, J. (1981 and 1984), *Euripidis Fabulae*, vols. ii and i (Oxford).

Dugas, C. (1960), 'Tradition littéraire et tradition graphique dans l'antiquité grecque', in H. Metzger (ed.), *Recueil Charles Dugas* (Paris), 59–74, reprinted from *L'Antiquité classique*, 6 (1937), 5–26.

Edwards, M. W. (1987), *Homer, Poet of the Iliad* (Baltimore).

—— (1991), *The Iliad: A Commentary*, vol. v (Cambridge).

Elderkin, G. W. (1934), 'The Dioscuri on an Early Protocorinthian Aryballos', *AJA* 38: 543–6.

Erbse, H. (1966), 'Euripides' "Andromache"', *Hermes*, 94: 276–97.

Ervin, M. (1963), 'A Relief Pithos from Mykonos', *Archaiologikon Deltion*, 18: 37–75.

Faraone, Christopher A. (1992), *Talismans and Trojan Horses: Guardian Status in Ancient Greek Myth and Ritual* (New York and Oxford).

Fehling, D. (1989), 'Die ursprüngliche Troja-Geschichte, oder: Interpretationen zur Troja-Geschichte', *WJA* NS 15: 7–16.

—— (1991), *Die ursprüngliche Geschichte vom Fall Trojas, oder: Interpretationen zur Troja-Geschichte* (Innsbruck).

Fenik, B. (1968), *Typical Battle Scenes in the Iliad*, Hermes Einzelschriften, 21 (Wiesbaden).

Fontenrose, J. (1960), *The Cult and Myth of Pyrros at Delphi* (University of California Publications in Classical Archaeology, 4.3; Berkeley), 191–266.

Fowler, R. L. (1979), 'Reconstructing the Cologne Alcaeus', *ZPE* 33: 17–28.

Fraenkel, E. (1950), *Agamemnon* (Oxford).

Frazer, J. G. (1889) (ed. and trans.), *Pausanias's Description of Greece* (London and New York).

—— (1921) (ed. and trans.), *Apollodorus: The Library* (Cambridge, Mass., and London).

Friedrich, W. H. (1953), *Euripides und Diphilos* (Munich).

Froning, H. (1986), 'Chryse I', *LIMC* iii (Zurich and Munich), 279–81.

Gantz, T. (1993), *Early Greek Myth: A Guide to Literary and Artistic Sources* (Baltimore and London).

Garner, R. (1990), *From Homer to Tragedy: The Art of Allusion in Greek Poetry* (London and New York).

Ghali-Kahil, L. (1955), *Les Enlèvements et les retours d'Hélène dans les textes et les documents figurés* (Paris).

Graf, F. (1993), *Greek Mythology* (Baltimore and London).

Griffin, J. (1977), 'The Epic Cycle and the Uniqueness of Homer', *JHS* 97: 39–53.

—— (1980), *Homer on Life and Death* (Oxford).

Hall, E. (1989), *Inventing the Barbarian* (Oxford).

Halleran, M. R. (1985), *Stagecraft in Euripides* (Totowa, NJ).

Haslam, M. W. (1976), 'Sophocles, Αἴας Λοκρός (and other plays?)', *The Oxyrhynchus Papyri*, xliv, no. 3151, pp. 1–26.

Herter, H. (1936), 'Theseus der Jonier', *RhM* 85: 177–239.

Heubeck, A., and Hoekstra, A. (1989), *A Commentary on Homer's Odyssey*, vol. ii (Oxford).

——, West, S., and Hainsworth, J. B. (1988), *A Commentary on Homer's Odyssey*, vol. i (Oxford).

Himmelmann-Wildschütz, N. (1967), *Erzählung und Figur in der archaischen Kunst* (Akademie der Wissenschaften und der Literatur, Mainz).

Horsfall, N. M. (1979), 'Stesichorus at Bovillae?', *JHS* 99: 26–48.

Hurwit, J. M. (1985), *The Art and Culture of Early Greece, 1100–480 BC* (Ithaca, NY).

Huxley, G. L. (1969), *Greek Epic Poetry* (Cambridge, Mass.).

Kahil, L. (1988), 'Helene', *LIMC* iv (Zurich and Munich), 498–563.

Kakridis, J. Th. (1971), *Homer Revisited* (Lund).

Kamerbeek, J. C. (1942), 'L'Andromaque d'Euripide', *Mnemosyne*, NS 11: 47–67.

Kannicht, R., and Snell, B. (1981), *Tragicorum Graecorum Fragmenta*, ii. *Fragmenta adespota* (Göttingen).

Kirk, G. S. (1985), *The Iliad: A Commentary*, vol. i (Cambridge).

Knox, B. M. W. (1952), 'The Lion in the House', *CP* 47: 17–25.

—— (1979), *Word and Action: Essays on the Ancient Theatre* (Baltimore and London).

Koenen, L. (1981), 'Alkaios: P. Köln II 59 and P.Oxy. XXI 2303', *ZPE* 44: 183–4.

Koniaris, G. L. (1973), '*Alexander, Palamedes, Troades, Sisyphus*. A Connected Tetralogy? A Connected Trilogy', *HSCP* 77: 85–124.

Kossatz-Deissmann, A. (1981), 'Achilleus', *LIMC* i (Zurich and Munich), 37–200.

Kovacs, P. D. (1980), *The Andromache of Euripides: An Interpretation* (Ann Arbor).

Kranz, W. (1933), *Stasimon* (Berlin).

Kron, U. (1981), 'Aithra I', *LIMC* i (Zurich and Munich), 420–31.

Kullmann, W. (1960), *Die Quellen der Ilias (Troischer Sagenkreis)*, Hermes Einzelschriften, 14 (Wiesbaden).

—— (1991), 'Ergebnisse der motivgeschichtlichen Forschung in Homer (Neoanalyse)', in J. Latacz (ed.), *Zweihundert Jahre Homer-Forschung, Rückblick und Ausblick* (Stuttgart and Leipzig), 425–55.

Langlotz, E. (1933), *Die antiken Vasen von der Akropolis zu Athen* (Berlin).

Lebeck, A. (1971), *The Oresteia: A Study in Language and Structure* (Washington).

Lee, K. H. (1976), *Euripides' Troades* (Basingstoke).

Lesky, A. (1983), *Greek Tragic Poetry*, trans. M. Dillon (New Haven and London).

Lloyd, M. (1984), 'The Helen Scene in Euripides' *Troades*', *CQ* 34: 203–13.

—— (1992), *The Agon in Euripides* (Oxford).

Macleod, C. W. (1982), *Homer, Iliad, Book XXIV* (Cambridge).

—— (1982), 'Politics and the *Oresteia*', *JHS* 102: 124–44, reprinted in id., *Collected Essays* (Oxford 1983).

Maehler, H. (1975 and 1987) (*post* B. Snell), *Pindari Carmina*, vols. ii and i (Leipzig).

Matheson, S. B. (1986), 'Polygnotos: An *Iliupersis* Scene at the Getty Museum', *Greek Vases in the J. Paul Getty Museum*, iii (Malibu, Calif.), 101–14.

Monro, D. B. (1901), *Homer's Odyssey, Books XIII–XXIV* (Oxford).

Moret, J.-M. (1975), *L'Iliupersis dans la céramique Italiote* (Geneva).

Morris, S. P. (1995), 'The Sacrifice of Astyanax: Near Eastern Contributions to the Siege of Troy', in J. B. Carter and S. P. Morris (eds.), *The Ages of Homer: A Tribute to Emily Townsend Vermeule* (Austin, Tex.), 221–45.

Murray, G. (1902, 1913, and 1913), *Euripidis Fabulae*, vols. i, ii³, and iii² (Oxford).

Nagy, G. (1979), *The Best of the Achaians: Concepts of the Hero in Archaic Greek Poetry* (Baltimore and London).

—— (1992), 'Homeric Questions', *TAPA* 122: 17–60.

Nobile, C. S. (1968–9), 'Il Pittore di Telefo', *Studi miscellanei*, 14.

Ohly, D. (1986), *Glyptothek München: Griechische und römische Skulpturen* (6th edn.; Munich).

Page, D. L. (1962), *Poetae Melici Graeci* (Oxford).

—— (1968), *Lyrica Graeca Selecta* (Oxford).

—— (1972), *Aeschyli Septem Quae Supersunt Tragoediae* (Oxford).

Pearson, A. C. (1917), *The Fragments of Sophocles*, edited, with additional notes from the papers of Sir R. C. Jebb and Dr W. G. Headlam (Cambridge).

Poole, A. (1976), 'Total Disaster: Euripides' *The Trojan Women*', *Arion*, 3: 257–87.

Prag, A. N. J. W. (1985), *The Oresteia: Iconographic and Narrative Traditions* (Warminster and Chicago).

Radt, S. (1977), *Tragicorum Graecorum Fragmenta*, iv. *Sophocles* (Göttingen).

—— (1985), *Tragicorum Graecorum Fragmenta*, iii. *Aeschylus* (Göttingen).

Richardson, N. J. (1993), *The Iliad: A Commentary*, vol. vi (Cambridge).

Robert, C. (1881), *Bild und Lied* (Berlin).

Robertson, D. S. (1923), 'Euripides and Tharpys', *CR* 37: 58–60.

Robertson, M. (1949), review of J. D. Beazley, *Etruscan Vase Painting* (Oxford, 1947), in *JHS* 69: 93–4.

—— (1967), 'Conjectures in Polygnotus' Troy', *ABSA* 62: 5–12.

—— (1970), 'Laomedon's Corpse, Laomedon's Tomb', *GRBS* 11: 23–6.

—— (1995), 'Menelaos and Helen in Troy', in J. B. Carter and S. P. Morris (eds.), *The Ages of Homer: A Tribute to Emily Townsend Vermeule* (Austin, Tex.), 431–6.

Sadurska, A. (1964), *Les Tables iliaques* (Warsaw).

—— (1986), 'Equus Troianus', *LIMC* iii (Zurich and Munich), 813–17.

Schauenburg, K. (1964), 'Iliupersis auf einer Hydria des Priamosmalers', *RM* 71: 60–70.

Schefold, K. (1966), *Myth and Legend in Early Greek Art* (London), trans. of *Frühgriechische Sagenbilder* (Munich, 1966).

—— (1975), *Wort und Bild: Studien zur Gegenwart der Antike* (Basle).

Scodel, R. (1980), *The Trojan Trilogy of Euripides*, Hypomnemata, 60 (Göttingen).

Seaford, R. (1987), 'The Tragic Wedding', *JHS* 107: 106–30.

Segal, C. (1971), *The Theme of the Mutilation of the Corpse in the Iliad* (Leiden).

Simon, E. (1981), *Die griechischen Vasen* (Munich).

Smith, P. M. (1981), 'Aineiadai as Patrons of *Iliad* XX', *HSCP* 85: 17–58.

Snell, B. (1937), *Euripides' Alexandros und andere Strassburger Papyri*, Hermes Einzelschriften, 5 (Berlin), 1–68.

Snodgrass, A. M. (1982), 'Narration and Allusion in Archaic Greek Art', The Eleventh J. L. Myres Memorial Lecture, delivered at New College Oxford, 29 May 1981 (London).

Sommerstein, A. H. (1989), *Aeschylus: Eumenides* (Cambridge).

Sourvinou-Inwood, Ch. (1991), *'Reading' Greek Culture: Texts and Images, Rituals and Myths* (Oxford).

Sparkes, B. A. (1971), 'The Trojan Horse in Classical Art', *Greece and Rome*, 18: 54–70.

Speier, H. (1954), 'Die Iliupersisschale aus der Werkstatt des Euphronius', in R. Lullies (ed.), *Neue Beiträge zur klassischen Altertumskunde* (Stuttgart), 113–24.

Stansbury-O'Donnell, Mark D. (1989), 'Polygnotos's *Iliupersis*: A New Reconstruction', *AJA* 93: 203–15.

Steidle, W. (1968), *Studien zum antiken Drama* (Munich).

Stenico, A. (1953), 'Nuovi frammenti della kylix berlinese con l'Iliupersis di Euphronios conservati nei Musei Vaticani', *Acme*, 6: 497–508.

Stevens, P. T. (1971), *Euripides: Andromache* (Oxford).

Stinton, T. C. W. (1965), *Euripides and the Judgment of Paris* (London), reprinted in id., *Collected Papers on Greek Tragedy* (Oxford, 1990), 17–75.

Taplin, O. (1977), 'Did Greek Dramatists Write Stage Instructions?', *PCPS* 203, NS 23: 121–32.

—— (1986), 'Homer's Use of Achilles' Earlier Campaigns in the *Iliad*', in J. Boardman and C. E. Vaphopoulou-Richardson (eds.), *Chios* (Oxford), 15–19.

—— (1988), 'The Mapping of Sophocles' *Philoctetes*', *BLICS* 34: 69–77.

—— (1992), *Homeric Soundings: The Shaping of the Iliad* (Oxford).

Tiverios, M. A. (1976), *Ο Λυδος και το εργο του* (Athens).

Touchefeu, O. (1981), 'Aias II', *LIMC* i (Zurich and Munich), 336–51.

—— (1984), 'Astyanax I', *LIMC* ii (Zurich and Munich), 929–37.

Touchefeu-Meynier, O. (1981), 'Andromache I', *LIMC* i (Zurich and Munich), 767–74.

van der Valk, M. (1964), *Researches on the Text and Scholia of the Iliad*, vol. ii (Leiden).

Vermeule, E. (1965), 'The Vengeance of Achilles', *BullMFA* 63: 35–52.

—— (1966), 'The Boston Oresteia Krater', *AJA* 70: 1–22.

—— (1969), 'Some Erotica in Boston', *AK* 12: 9–15.

Waldock, A. J. A. (1951), *Sophocles the Dramatist* (Cambridge).

Walters, H. B. (1898), 'On Some Black-Figured Vases Recently Acquired by the British Museum', *JHS* 18: 281–301.

Webster, T. B. L. (1967), *The Tragedies of Euripides* (London).

Welcker, F. G., *Der epische Cyclus oder die homerischen Dichter* (Bonn, vol. i² 1865, vol. ii 1849).

Wescoat, B. D. (1987), *Poets & Heroes: Scenes of the Trojan War* (Atlanta), catalogue of an exhibition held at Emory University, 8 Nov. 1986 to 28 Feb. 1987.

West, M. L. (1985), *The Hesiodic Catalogue of Women: Its Nature, Structure and Origins* (Oxford).

—— (1990), *Aeschylus: Tragoediae* (Stuttgart).

West, S. (1990), 'Ajax's Oath', *ZPE* 82: 1–3.

Wiencke, M. (1954), 'An Epic Theme in Greek Art', *AJA* 58: 285–306.

Wilamowitz-Moellendorff, U. von (1884), *Homerische Untersuchungen, Philologische Untersuchungen*, 7 (Berlin).

—— (1921), *Griechische Verskunst* (Berlin).

Williams, D. (1976), 'The Iliupersis Cup in Berlin and the Vatican', *Jahrbuch der Berliner Museen*, 18: 9–23.

—— (1991), 'Onesimos and the Getty Iliupersis', *Greek Vases in the J. Paul Getty Museum*, v (Malibu, Calif.), 41–64.

Zarker, J. W. (1965), 'King Eëtion and Thebe as Symbols in the *Iliad*', *CJ* 61.3: 110–14.

Zeitlin, F. I. (1965), 'The Motif of Corrupted Sacrifice in Aeschylus' *Oresteia*', *TAPA* 96: 463–508.

—— (1966), 'Postscript to Sacrificial Imagery in the *Oresteia* (*Agamemnon* 1235–37)', *TAPA* 97: 645–53.

Catalogue of Art Works Discussed

1.* Fig. 1. Tabula Iliaca Capitolina, Rome Capitoline Museum. Kossatz-Deissmann (1981) no. 543, Sadurska (1964) pl. 1.

2.* Figs. 2(a) and (b). Terracotta pithos from Mykonos, Mykonos Museum 2240, 7th c. BC. First published by M. Ervin in *AD* 18 (1961) and discussed again by the same author in *AJA* 80 (1976) under the name M. E. Caskey. A fragment of the vase which surfaced separately was published by J. Christiansen (1974). See also Sadurska (1986) no. 23, and Schefold (1966) pls. 34, 35a, 35b. For the last fragment see M. E. Caskey (1976) fig. 19.

3. Black-figure amphora, London BM 1897.7–27.2. *ABV* 97.27 and 683, *Para.* 37, *BA* 26, Tyrrhenian amphora of the Timiades Painter, 565–550 BC. The sacrifice of Polyxene. Walters (1898) pl. 15.

4.* Fig. 3(a) and (b). Black-figure amphora frr., Paris Louvre F29. *ABV* 109.21 and 685, *Para.* 44, *BA* 30, Lydos, 560–540 BC. A: Aias and Kassandra; Neoptolemos, Astyanax, and Priam; B: Herakles and Kyknos. Demargne (1984) no. 83, Tiverios (1976) pl. 1b (whence illustration), Touchefeu (1984) no. 8.

5. Black-figure amphora, Berlin F 1685. *ABV* 109.24, *BA* 30, Lydos, *c.*550 BC. A: Helen and Menelaos; Neoptolemos, Astyanax, and Priam; B: Achilles and Troilos. Carpenter (1991) fig. 36, Touchefeu (1984) no. 9, Wiencke (1954) fig. 14.

6. Black-figure column-krater. Beazley Archive no. 643, manner of the Lysippides Painter, *c.*530 BC. A: Aias and Kassandra with others present; B: Menelaos and Helen. For illustrations see *Kunstwerke der Antike, Münzen und Medaillen*, Basle sale catalogue for auction 56, held on 19 Feb. 1980, pl. 25 no. 70 (A, B); Touchefeu (1981) no. 33a.

7. Black-figure neck-amphora. Beazley Archive no. 59, *c.*520 BC. A: Neoptolemos and Priam; B: Aias and Kassandra. For illustrations see Christie, Manson and Woods sale catalogue *Important Classical Antiquities* for auction in Geneva on 5 May 1979, pl. 22.63 (A, B).

8.* Fig. 4. Black-figure hydria, Rome Vatican (previously Naples) Astarita 733. *Para.* 147.30, *BA* 91, Leagros Group, Priam Painter, 525–500 BC. Body: Aias and Kassandra, Aineias and Anchises, Priam, Andromache, and Astyanax. Schauenburg (1964) fig. 4, Touchefeu (1981) no. 38.

9. Black-figure hydria, Munich Antikensammlung 1700. *ABV* 362.27, *Para.* 161, *BA* 96, Leagros Group, Priam Painter, late 6th c. BC. Body: Achilles and Troilos, or Neoptolemos and Astyanax. Childs (1991) figs. 2a–c, Touchefeu (1984) no. 29, Wiencke (1954) figs. 19a and b.

10. Black-figure hydria, Berlin 1902. *ABV* 363.37, *Para.* 161, *BA* 96, Leagros Group, late 6th c. BC. Body: Neoptolemos? and Polyxene. Vermeule (1965) fig. 6.

11. Red-figure cup fragment, Malibu J. Paul Getty Museum 80.AE.154. Attributed to Oltos (R. Guy), 515–505 BC. Exterior: Menelaos and Helen, Neoptolemos and Priam, Aias and Kassandra. Kahil (1988) no. 336*bis*.

12. Red-figure cup frr., Akropolis 212, *c.*500 BC. I: Peleus and Thetis; A and B: Aias and Kassandra; Priam, Neoptolemos, Astyanax; Helen and Menelaos; archer; other scenes? Langlotz (1933) pl. 10, Touchefeu (1984) no. 17, Wiencke (1954) fig. 28.

13. Red-figure cup frr., Vienna University 53 C 23–5, 20. *ARV* 314.1, *BA* 213, the Eleusis Painter, *c.*500 BC. Exterior: Aias and Kassandra, other Ilioupersis scenes. *Corpus Vasorum Antiquorum* Germany 5 pl. 10.1–4 and 7, Touchefeu (1981) no. 45, Wiencke (1954) fig. 26.

14. Red-figure cup, Boston MFA 08.30a. *ARV* 135(a), *BA* 177, wider circle of the Nikosthenes Painter, late 6th c. BC. A: Parodic depiction of Ilioupersis episodes, Aias and Kassandra, Aithra? Touchefeu (1981) no. 105, Vermeule (1969) pls. 4–12.

15. Red-figure cup frr., Vatican no inv. no. and Berlin 2280 and 2281. *ARV* 19.1 and 2, *BA* 153, Onesimos, *c.*500 BC. I: Neoptolemos, Astyanax, Priam, and Polyxene; A: Duels between Trojans and Greeks; B: Greeks pursue Trojan women. Speier (1954) pls. 25 and 26, Williams (1976) figs. 6 and 7.

16.* Fig. 8(*a*)–(*c*). Red-figure cup, Malibu J. Paul Getty Museum 83.AE.362, 84.AE.80, and 85.AE.385. Onesimos, 500–490 BC. See §13.5 for the subjects represented. Williams (1991) figs. 8a–n.

17. Red-figure cup frr., Princeton y1990–20. Attributed to Makron, 490–480 BC. Helen and Menelaos, Priam?

18.* Fig. 9(*a*) and (*b*). Red-figure skyphos, Boston MFA 13.168. *ARV* 458.1, *Para.* 377, *BA* 243, Makron, *c.*485 BC. A: Paris, accompanied by Aineias, abducts Helen; Aphrodite and Peitho assist; B: Chryses, Chryseis, Aphrodite, Helen, Menelaos, Priam. Kahil (1988) no. 166 (for side A) and no. 243 (for side B), Simon (1981) pl. 166.

19.* Fig. 7(*a*) and (*b*). Red-figure cup, Louvre G 152. *ARV* 369.1, *Para.* 365, *BA* 224, the Brygos Painter, 480–470 BC. I: Briseis and Phoinix; A: Polyxene and warrior; Neoptolemos, Priam, and Astyanax; B: Duels between Greeks and Trojans, Andromache swings a pestle, Astyanax flees. Arias (1962) pls. 139–41, Touchefeu (1984) no. 18.

20. Red-figure cup frr., Paris Cab. Méd. 571. *ARV* 386(a), 'in the manner

of the Brygos Painter . . . connected with the Castelgiorgio Painter',
490–470 BC. A and B: Menelaos and Helen, other Ilioupersis figures.
Davreux (1942) fig. 107, Kahil (1988) no. 247, Wiencke (1954) fig. 24.

21. Red-figure cup frr., Akropolis 355. *ARV* 828.29, the Steiglitz Painter,
480–470 BC. Exterior: Neoptolemos and Priam, Aias and Kassandra, a
Greek soldier murders a Trojan woman. Langlotz (1933) pl. 26.

22.* Fig. 6(*a*)–(*c*). Red-figure cup, Leningrad 658. *ARV* 817.3 and 1671,
Para. 515, *BA* 292, the Telephos Painter. I: Astyanax?; A: Neoptolemos
and Priam; B: Aias and Kassandra. Nobile (1968–9) pls. 5–6, figs. 10–12.

23. Red-figure hydria (the Vivenzio Hydria), Naples 2422. *ARV* 189.74,
Para. 341, *BA* 189, the Kleophrades Painter, *c.*480 BC. Shoulder
scene 1. Aineias escapes together with his father and son; 2. Aias and
Kassandra; 3. Neoptolemos, Priam, and Astyanax; 4. A Trojan woman
confronts a Greek warrior; 5. Akamas and Demophon rescue Aithra.
Boardman (1976) fig. 3, Touchefeu (1984) no. 19.

24. Red-figure kalyx-krater, Ferrara T 936. *ARV* 601.18 and 1661,
Para. 395, *BA* 266, the Niobid Painter, 475–450 BC. A: Neoptolemos
and Priam; B: Aineias and Anchises, Menelaos and Helen. Aurigemma
(1960–5) pl. 130.

25. Red-figure volute-krater, Bologna 268. *ARV* 598.1, *Para.* 394, *BA*
265, the Niobid Painter, 475–450 BC. A: Neoptolemos, Priam, and
Astyanax; B: Aithra and her grandsons; Aias and Kassandra. Arias
(1963) pls. 111–13, Kron (1981) no. 68, Touchefeu (1984) no. 23.

26. Red-figure volute-krater, Bologna 269. *ARV* 599.8, *Para.* 395, *BA* 266,
the Niobid Painter, 475–450 BC. A: Helen and Menelaos; Aithra; B:
warriors setting out with chariot. Arias (1963) pls. 114 and 116.1,
Kron (1981) no. 69.

27.* Fig. 5(*a*) and (*b*). Red-figure kalyx-krater, Boston MFA 59.176.
ARV 590.11, *Para.* 394, *BA* 264, the Altamura Painter, 470–460 BC.
A: Aias and Kassandra; Neoptolemos, Priam, and Astyanax; B: Aineias
and his family. Caskey and Beazley (1963) iii, suppl. pls. 22 and 23,
Touchefeu (1984) no. 24.

28. Red-figure column-krater, Rome Villa Giulia 3578. *ARV* 290.9 and
1642, *BA* 210, the Tyszkiewicz Painter, 475–450 BC. A: Neoptolemos,
Priam, and Astyanax; B: woman wielding pestle (Andromache?), soldier,
and woman fleeing. *Corpus Vasorum Antiquorum* Villa Giulia 2 pl. 18
(57), Touchefeu (1984) no. 21, Touchefeu-Meynier (1981) no. 48.

29. Red-figure hydria fr., Athens National Museum 14983. *ARV* 1032.60,
Polygnotos, 450–445 BC. Shoulder: Menelaos and Helen; Aias and
Kassandra (incomplete). Kahil (1988) no. 269.

30. Red-figure volute-krater fr., Malibu J. Paul Getty Museum 79.AE.198.
Polygnotos, 440–435 BC. Body: priestess, Aias, Kassandra, statue of
Athena, Athena, and Menelaos? and Helen? Matheson (1986) figs.
1a–c.

31. Red-figure neck-amphora, Cambridge Corpus Christi College. *ARV* 1058.114, *BA* 323, Group of Polygnotos, *c.*450 BC. Aias and Kassandra. Davreux (1942) fig. 49.

32.* Fig. 10(*a*)–(*c*). Red-figure cup, Ferrara T 264. *ARV* 1280.64, *BA* 358, the Marlay Painter, second half of the 5th c. BC. I: Klytaimestra and Kassandra; A: Aias and Kassandra; B: youth pursues maiden. Aurigemma (1960–5) pls. 203 and 204.

33. Etruscan amphora, London BM 1948.10–15.2. M. Robertson (1949) reviewing Beazley (1947) adds this vase to Beazley's Praxias Group. Beazley (1947) 195 dates the Praxias Group to the first half of the 5th c. BC A: Menelaos and Helen; B: Aias and Kassandra. Touchefeu (1981) no. 79. See also Moret (1975) 58.

34. Red-figure volute-krater, Attic or Italian, Ferrara T 136 VP, 400–390 BC. Aias and Kassandra, Andromache and Astyanax, Priam and Neoptolemos. Touchefeu (1981) no. 91.

35. Red-figure kalyx-krater, Etruscan, Rome Villa Giulia 1197. Beazley (1947) 92.2, the Nazzano Painter, early 4th c. BC. Trojan? archer, or perhaps the Greek Philoktetes; Menelaos, Aphrodite, and Helen; Neoptolemos, Astyanax, Priam, and Trojan? warrior; gods seated above to left and right. See Beazley (1947) 7 and 94–6 and pl. 23.

Index